MALEVICH

MALE

VICH

Artist and Theoretician

Flammarion
26, rue Racine
75006 Paris

Contributors:

Evgeniya Petrova
Irina Vakar
Charlotte Douglas
Evgeny Kovtun
Dmitry Sarabianov
Irina Karasik
Galina Demosfenova

Designed by Mikhail Anikst
and Konstantin Zhuravlev

Translated from the Russian
by Sharon McKee

© Avant-Garde, Moscow–Paris, 1990
Printed and bound in the USSR

Paper: Ikonorex special-
matt, Zanders GmbH & Co

ISBN 2-08-013507-4

Evgeniya Petrova

Charlotte Douglas

Irina Vakar

Charlotte Douglas

Evgeny Kovtun

Dmitry Sarabianov

Irina Karasik

Kazimir Malevich

Text edited, introduced and commented
by Galina Demosfenova

Evgeniya Petrova

Introduction

Kazimir Malevich was one of the greatest reformers of 20th century art. He was the first to test the limits of expressiveness in painting as it was traditionally understood.

His Suprematism, perhaps the most radical of the trends to come out of the first half of this century, continues to influence artists. The special significance of Malevich's ideas is demonstrated by the fact that they have not only survived, but continue to bear fruit, though they led an all but underground existence for decades in the Soviet Union.

Malevich's career is principled and instructive, his biography dramatic and filled with conflict. He emerged in the first decade of this century, a time of creative ferment in the Russian art world. Outstanding names, marvellous works and a rich variety of styles were the hallmarks of the cultural boom. At first Malevich drank in this tumultuous atmosphere, gained experience and worked on his painting. But he was soon dissatisfied with the prevailing aesthetic principles. His subsequent attempts to reach zero and beyond culminated in *Black Square*—a work that marked the dawn of a new age in art.

From then on Malevich was to be a god to some, a devil bent on overturning the familiar tenets to others. The controversial myth surrounding him overshadowed his own large and complex personality. Why was that myth so long-lived? The difficult times in which Malevich lived and worked hold the key. They were to prove a millstone around his neck and those of his successors. As a result, the meaning of Malevich's work was distorted, while the image of the artist presented to the world bore no resemblance to the man himself.

The career of this innovative painter, teacher, theoretician and cultural figure got off to a sensational and brilliant start. Later Malevich shared the fate of many of his contemporaries who could not adapt to the changing times, although he had the good fortune to die not in a prison cell or camp, but in his own bed, surrounded by his family.

The drama of his career, which was essentially broken off by force, casts a tragic light on his works. Given the messianic fervour with which he preached the new art, it is logical that he should have become the head of the Institute of Artistic Culture [GINKhUK] in 1924. He was not simply ready to interpret realistically the changes then occurring in art; by the mid-1910s, he was one of the most energetic exponents of aesthetic renewal. A group of outstanding artists and thinkers headed by Malevich came up with a well-designed programme of study and developed special courses and lectures. But this renaissance was cut short when the Institute of Artistic Culture was closed in 1926. Its collections, which Malevich was directly involved in culling from studios and exhibitions, went to the State Russian Museum (Leningrad) and were soon likewise declared *non grata*. Among the works that disappeared into the museum's vaults for many years were pieces by Malevich himself. These miraculously escaped destruction.

But the Russian Museum did not obtain Malevich's entire collection. The story of what became of the remaining works is no less dramatic, indeed possibly even more so.

In March 1927 Malevich took a selection of paintings, drawings and theoretical charts to Berlin for exhibition. Compelled to return home in June of the same year, before the show had opened, he left the works with a friend. He intended to return to Berlin shortly, whence he would embark on a tour of Europe. But fate had other things in store. Malevich never saw his works again. Some of them were sold to buyers in America during the artist's lifetime, others were hidden by his friends when the Nazis came to power, as symbols of Bolshevism and Abstractionism were hated by Hitler with equal passion.

Twenty years after the end of World War II, the works which Malevich took to Berlin were obtained by the Stedelijk Museum (Amsterdam). There they found refuge and were at last displayed in splendid galleries. Thus, the majority of Malevich's works ended up in two countries—the Soviet Union and the Netherlands. For many years it was impossible to view these collections together. That has finally changed.

In November 1988, for the first time in five decades, the works that now belong to Soviet and Dutch museums, hung side by side at Leningrad's Russian Museum, with which Malevich was closely associated during the final years of his life. The exhibit subsequently moved on to Moscow and Amsterdam. In each city the public response was enthusiastic. The paintings, drawings, architectural ideas, sketches for the opera

Introduction

Victory Over the Sun and essays in architectural design shown in Leningrad, Moscow and Amsterdam resurrected Malevich, revealing his power and scope to today's generation. Viewers witnessed the development of an artist who experimented with Impressionism, Cubism and Futurism and then transformed these global achievements into a profoundly individualistic and at the same time universal artistic world.

The legend of Malevich gained substance. An event of enormous significance had occurred, particularly for the artist's countrymen, who for all practical purposes had not seen his work since the early 1930s.

This does not mean, however, that Malevich was unknown. Paradoxical as it may seem, his fame preceded him. Only a few of his works could be viewed, and then only by the lucky few who visited Amsterdam, New York or the handful of other cities where they were on display. Malevich was mainly judged on the basis of reproductions, and they were quite limited in number. Even art historians could not always verify their conclusions by viewing the original works.

Nevertheless, interest in Malevich and the Russian avant-garde in general was growing among scholars, particularly in the West. It is not the fault of Soviet art historians that this process was only recently sanctioned here. For obvious reasons, there are few Soviet publications on the Russian avant-garde; because of this, schools devoted to the study of this complex and multifaceted phenomenon have not have time to form. Nevertheless, interest n the art of the first decades of the 20th century is great and steadily growing. The visual and theoretical material found in the archives and museums of this country is vast. Its study will require the concentrated efforts of many scholars.

Malevich is a central figure in the history of the Russian avant-garde. There are very few recent works on him in Russian. The book now before the reader was compiled primarily from papers presented by scholars from the USSR, the United States, France and Holland at the conference held in Leningrad in conjunction with the 1989 show at the Russian Museum. That symbolic and logical cooperation among Malevich scholars underlines once again both the unity of scholarship that knows no borders, and international recognition of the Russian avant-garde's significance. The first major action involving the study of an outstanding figure in Soviet culture of the 1910–30 period became in essence a demonstration of internationalism.

That is why I, as the organizer of the conference and the editor of this book, consider it my duty to express my profound gratitude to our foreign colleagues—John E. Bowlt (USA), Charlotte Douglas (USA), Nicoletta Misler (Italy), and Jean-Claude Marcadé (France). They gave their lively and active support to our efforts to appraise the marvellous traditions of our native art and resurrect names that had been struck from its history. Their papers, together with those of Soviet scholars, are the basis of this book. Malevich the artist, Malevich the theoretician, Malevich the teacher and Malevich the man all appear in them. Their authors add to our knowledge of his life by clarifying certain biographical facts and offering new insights. In several articles Malevich is considered in the broader context of the European avant-garde. The authors also examine his links with the artistic and academic intelligentsia of the day, the degree and nature of the influence exerted by the philosophical and aesthetic doctrines then current, and the meaning of his theories and their relationship with his work, legend and myth. The story of how the famous *Black Square* came into being, the analysis of the iconography, iconology and style of this and other Malevich works, along with the other material published herein, represent important strides in the appraisal of his creative legacy.

This may well be the first book to provide, at least to the Soviet reader, such a clear picture of Suprematism and the circumstances surrounding the birth of this trend, mysterious to so many. In contrast, the influences on the style and genesis of Malevich's peasants is a problem that has long been the object of scholarly attention, and the existent literature does not yet offer a definitive answer to this fundamental question. The authors of the articles featured in this book are likewise at odds. Some trace the origin of the peasant images to, for example, Picasso or African art, others to the Russian icon. This disagreement can be explained first and foremost by natural differences in approaches to research. Moreover, they indicate that even now too little is known about Malevich and his work. Many documents are still unavailable, the publication of his theoretical treatises has been fragmentary, and the practice of interpreting an artist's works is too new. That is why it is so important that research on Malevich be wide-ranging in genre and concept.

Evgeniya Petrova
Vice-Director of Academic Affairs
State Russian Museum, Leningrad

Biographical Outline

Kazimir Severinovich Malevich was born in Kiev in 1878, one of six children. Both his parents were Russified poles, and the family spoke Polish at home. The artist spent his childhood in small Ukrainian agricultural centres where his father was employed as manager in sugar refineries. All his life Malevich retained vivid memories of an unfettered childhood in idyllic provincial towns. A passion for art developed during Malevich's teens, but while he lived in the Ukraine he was largely self-taught. At eighteen he moved with his family to the town of Kursk, and, while avidly pursuing his painting, he went to work as a clerk for the railroad. With savings from this job he moved to Moscow in 1904 to study art, for several years returning in the summer to his family in Kursk.

In Moscow he lived in a communal house with other young artists, and attended the well-known studio school of Fedor Rerberg. In the years before 1910 he produced Symbolist, Impressionist and Art Nouveau paintings and drawings. From 1907, together with his friends David Burliuk, Mikhail Larionov, and Natalia Goncharova, he contributed regularly to the large annual 'Moscow Association of Artists' exhibitions.

Cubo-Futurism

The Cubo-Futurist movement evolved between 1910 and 1914 among a continually shifting group of Moscow poets and artists. Associated originally with the Jack of Diamonds exhibition society, they shared its interest in Fauvism and, as it gradually became defined in Russia, Cubism.[1] Led by David Burliuk, the group included his two brothers (Vladimir, a painter, and Nikolai, a poet) and Vladimir Mayakovsky, the renowned Russian poet 'discovered' by David. The primary theorists of the movement were the poets Velimir Khlebnikov and Alexei Kruchenykh. Larionov and Goncharova were also associated with the Jack of Diamonds at first, but, in the extremely competitive pre-war artistic atmosphere, they and Malevich left it in 1911, forming a group that advocated a more vital Primitivism and a Futurist aesthetic. The new association produced its own exhibitions—'The Donkey's Tail' in 1912 and 'The Target' in 1913. Early in 1913 yet another rearrangement in artistic affinities allied Malevich, the Burliuks, and the Union of Youth, an exhibition society based in St. Petersburg. There Malevich made the acquaintance of the Petersburg painter Olga Rozanova, and a life-long friend, the composer and violinist Mikhail Matyushin.

Central to the Cubo-Futurist understanding of the new art was Kruchenykh's and Khlebnikov's notion of *zaum* language, a transcendental language of the future that was the outward manifestation of a writer's highly-advanced consciousness. *Zaum*, which means 'beyond reason' or 'beyond the logical mind', is a higher, more evolved level of consciousness which produces a greatly expanded sense of logic and reason. Kruchenykh's *zaum* poetry is formed of grammatical confusions, neologisms, absurd and strange comparisons, and sound 'words', invented to express primal emotions without the intermediary of rational thought. Khlebnikov attempted to construct a 'language of the future' based on his recovery of units of meaning that he believed were common to all languages. The notion of 'beyond the mind' poetry drew upon Eastern religious ideas, such as the superconscious states of yoga, as well as those of Russian religious sectarians who practised 'speaking in tongues'.

Malevich characterized his 1912–13 Cubist works, like *Morning in the Village after the Snowstorm* and *Portrait of Ivan Kliun*, as *'Zaum* Realism.' Like his counterparts in poetry, he viewed Cubist distortions of form as an expression of a higher order of perception, available to the advanced psyche of the modern artist. This was not merely an anti-rational stance in favor of creative intuition. In the summer of 1913 the artist explained to Mikhail Matyushin: 'We have come as far as the rejection of reason, but we rejected reason because another kind of reason has grown in us, which in comparison with what we have rejected can be called "beyond reason", which also has law, construction and sense, and only by learning this shall we have work based on the law of the truly new "beyond reason". This reason has found for Cubism the means of expressing a thing.'... 'We have arrived at beyond-reason. I don't know whether you agree with me or not, but I am beginning to understand that in this beyond-reason there is also a strict law that gives pictures their right to exist, and not one line should be drawn without the consciousness of its law; only then are we alive.'[2]

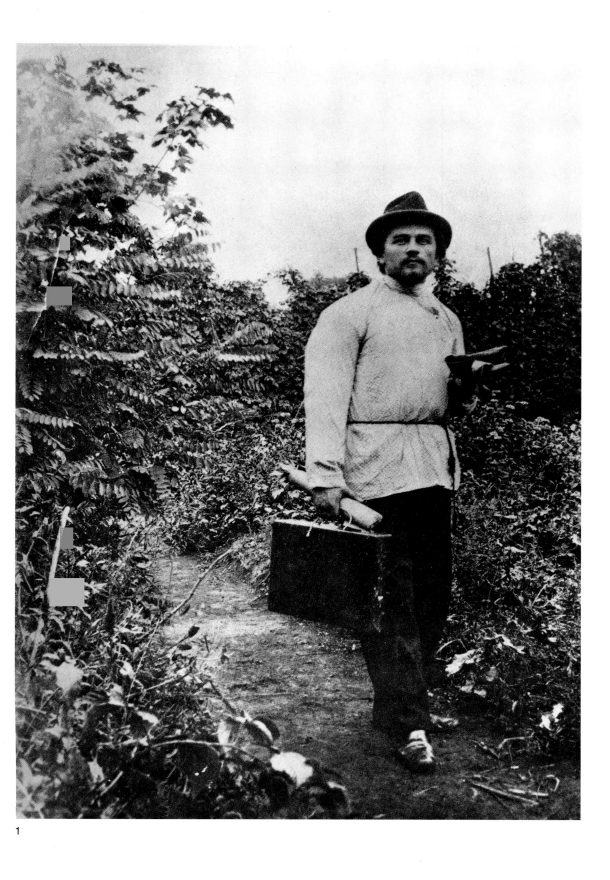

1

1 Malevich in Kursk, c. 1900

Malevich worked out a visual *zaum* in the design of the Cubo-Futurist opera, *Victory Over the Sun*. Conceived by Kruchenykh, Malevich and Matyushin at the composer's dacha in Finland during the summer of 1913, it was performed under the sponsorship of the Union of Youth at the end of the year. Kruchenykh composed the text of the opera (Khlebnikov contributed a prologue), Matyushin wrote the music, and Malevich designed the sets and costumes. It was given two performances, alternating evenings with Vladimir Mayakovsky's play 'Tragedy', on the third and fifth of December at the Luna Park Theatre in St. Petersburg. The performances were greeted by boos and applauses, cheers and whistles; the Cubo-Futurists acquired instant notoriety.

The opera has two acts, the first set in the 'present' and the second in the 'future'. The central event is the capture of the sun, which marks the transition from the present into an undefined 'future'. 'The sun of cheap appearances', as Matyushin called it, was understood to be the creator of everything visible, and of the illusion of reality. The Cubo-Futurists associated the sun with earth-bound logic, an unimaginative rationality. 'We picked the sun with its fresh roots,' the captors sing in the opera, 'They're fatty, smelled of arithmetic'.[3] Yet their vision of the new age is not unambiguous. The new men of the future are strong and glow from within, but all sentiment is gone, there are no memories, no dreams or love. Kruchenykh's language is poetic and abstract, built of neologisms, plays on words, and *zaum* sounds; emotion bursts out directly in unexpected and surreal images. The action has little narrative structure and often seems unmotivated and violent. Kruchenykh attempted to work directly on the senses, disrupting customary modes of thought through surprise effects, and shocking the audience into a new way of perceiving, reflecting a higher level of existence.

Malevich's design for *Victory* attempts a similar *zaum* effect. His costume designs are rendered in brightly-coloured geometric shapes related to those of his 1912–13 Cubist figures. The Strongman, for example, is composed completely of triangles, and the legs of the Attentive Worker are built of doughnut-shaped rings. The sketches for the backdrops show geometric forms and mysterious shadows, portions of objects, and letters of the alphabet. Often the back plane recedes or is marked by a central area that opens into infinity. Spatial ambiguity was to be augmented by the movement of the actors onstage, which would activate the background geometries, an effect enhanced by roaming spotlights. The artist sought to animate the decor, creating a continuously variable, but disorienting and illogical spectacle.

After the *succès de scandale* of *Victory Over the Sun*, Malevich planned a second production of the opera, this time in Moscow. The beginning of the Great War at the end of July, however, forced him to abandon this project. He would take up *Victory* again in 1915, when Kruchenykh and Matyushin began work on another edition of the text.

During 1914 Malevich experimented with several other approaches to Cubism. He adapted French synthetic Cubist vocabulary to a series of 'alogist' paintings. These works, analogous to the absurdities of Kruchenykh's poetry, present dense collections of incongruous images, mixed scales and styles, collage and assemblage elements, in compositions with hidden meanings. To the exhibitions '1915' and 'Tramway V' in the spring of 1915 Malevich sent his new paintings *Woman at a Poster Column*, *The Aviator*, and *An Englishman in Moscow*. He spent the spring and summer of that year working in the village of Kuntsevo, near Moscow.

'The Last Futurist Exhibition: "0.10"'' opened at Petrograd's Dobychina Gallery, a few blocks from the Winter Palace, in December, 1915. There for the first time Malevich revealed his Suprematism, an uncompromising, geometric style of painting that has had a lasting impact on the history of Western art. The clarity with which Malevich indicated future directions of modern painting seems startling even today. By the time the exhibition opened, Malevich had been working on his new style for the better part of a year. The decisive step into Suprematism was taken either just before, or during, the time that Malevich was working on new drawings for the second edition of *Victory Over the Sun*.[4] Suprematism had been 'discovered', a preliminary theory worked out, and a collaborative journal to propagate the new art planned, by the middle of May, 1915. Throughout this period Malevich urged his fellow artists to abandon Cubo-Futurism. He wrote to Matyushin in Petrograd about his new work and the reactions of his colleagues: 'In Moscow they are beginning to agree with me that we have to appear under a new flag. But I wonder, will they produce a new form?' And a few days later: 'In Moscow now the critical question of creating a movement has been raised, but how and what, no one knows, and they are asking me to read something from my notes....'[5]

Although the development of Suprematism has yet to be completely explained, several elements in the process of Malevich's thinking can be identified. At this time he was experimenting with certain kinds of visual diagrams, and he continued to associate the new forms with an elevated level of consciousness and an evolutionary state of mind. In Suprematism also, Malevich said he was looking for 'inherent form' which 'flows out of the painted mass', a 'painted form as such' and 'purely coloured motion', concepts that he understood to be the most essential elements of Cubism and Futurism. Although his coloured geometries on a

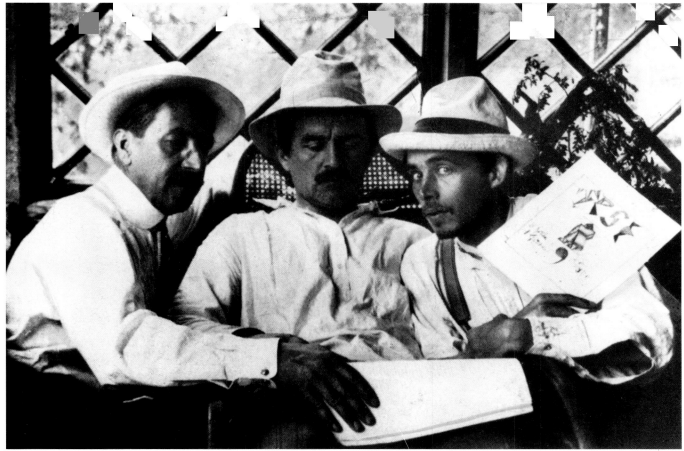

2

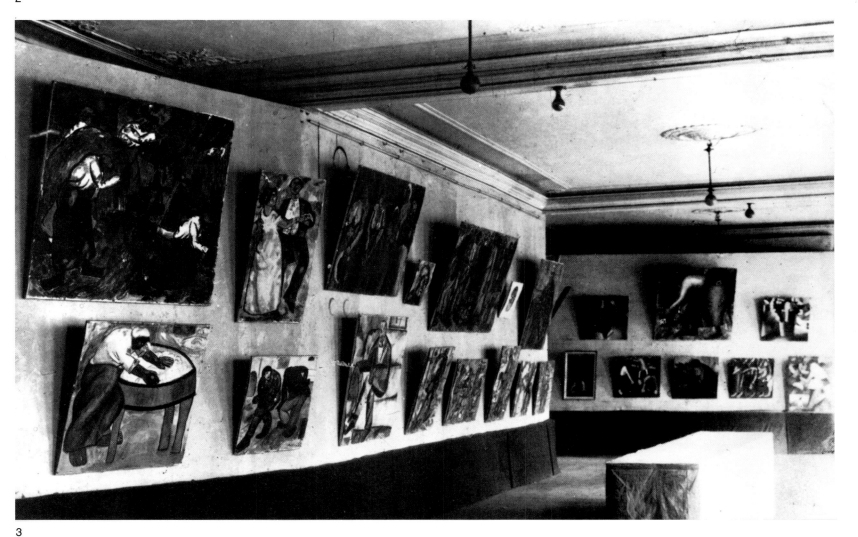

3

2 From the left: M. Matyushin, Malevich and
A. Kruchenykh in Uusikirkko, July 1913
Cover design for the Futurists' miscellany
'The Three' is in Kruchenykh's hand

3 Malevich's work at the 'Donkey's Tail'
exhibition. Moscow, 1912

white ground may have derived initially from schematic diagrams, such as illustrations of hyperspace solids or aerial maps, or from forms that originated in his Cubist works,[6] Malevich instantly grasped their wider philosophical, stylistic and historic significance. Suprematist paintings, he believed, functioned as contemplative images, aids to attaining the *zaum* state. In this sense, Suprematist images were for him images of a supreme reality. He also understood immediately that Suprematism was an enduring 'next step' in a sequence of Western styles, a position he laid out in the brochure, *From Cubism to Suprematism in Art, to New Realism in Painting, to Absolute Creation*, distributed at the exhibition '0.10.'

Malevich further realized that the individual elements of Suprematism might be regarded as 'units' in a new formal 'system' that would work within every medium. Having himself worked out a Suprematism of painting, he encouraged fellow artists to search for analogus inherent forms in poetry, music and sculpture. The next year, he and a small group of artists began to redesign the world, then in the process of being devastated by the War, on the Suprematist model. They initiated projects in the applied arts, including designs for clothing, architecture, theatre, musical compositions, and fabric decoration.

The First World War brought devastation to Russia. In 1915 there were two million casualities, and three million refugees from Western regions were flooding across the rest of the country. By 1916 the Tsarist government found itself in such dire straits militarily that it called up the most unlikely of intellectuals, including Velimir Khlebnikov and Malevich. The artist's greatest concern was for the fate of Suprematism in case of his death: 'You see we don't have a book yet, and it is needed, necessary. A book—a small history of our art. The New Gospel in art. A book that is the sum of our days, *the key that has created our thoughts in us.*... Christ revealed heaven on earth, which put an end to space, established two limits, two poles, wherever they may be—in oneself or "there". But we will go past thousands of poles, as we pass by millions of grains of sand on the shore of the sea or a river. Space is bigger than heaven, stronger, more powerful, and our new book is the teaching about the space of emptiness.'[7]

Revolutionary Politics

Malevich was saved from combat by a wave of revolutionary sentiment sweeping through the army and the country. There is no doubt about his initial political sympathies. From the time of the first (bourgeois) Revolution in February, 1917, he threw himself with vigour and enthusiasm into the new arts organizations. Under the Provisional Government, he sided with the most radical revolutionary groups. Despite patriotic anti-German posters that he produced in the early years of the war, by 1917 he clearly sympathized with the anti-war stance of the left.

In September 1917 the Moscow Soldiers' Soviet recalled Malevich from the army to be the Deputy Director of their newly organized Art Section.[8] He immediately set about organizing a 'People's Academy' in Moscow and Petrograd, and made plans to open affiliated schools in provincial centres. Malevich's program for the art schools, made public at the beginning of October 1917, was the first of such proposals, which later were established throughout the country as Free State Art Studios (Svomas).[9] According to Malevich's plan,[10] the schools would be accessible to everyone. Malevich argued that they would serve as a training ground for the thousands of unemployed war invalids, no longer able to earn their living by physical labour. The schools also would put artists to work, he said, propagate arts and crafts throughout the country, and raise the aesthetic taste of the people.

For Malevich, this educational empire was undoubtedly the structure through which he hoped to remake the world in the Suprematist image. This had been his fondest dream since the 'discovery' of Suprematism two years before the Revolution. Such a grand project necessitated training people with the requisite skills, and motivated the Suprematists' eager move into educational activities. Utilitarian Suprematism, as it became known, was not, however, to be merely a new style of industrial design. It retained the Cubo-Futurist philosophical content. The new applied abstraction was understood to indicate a transformed consciousness and to be emblematic of a new, cosmically oriented age. Malevich wrote: 'In transforming the world I await my own transformation; perhaps in the final day of my transfiguration I shall assume a new form, leaving my present image behind in the dying green animal world.'[11]

After the October Revolution, Malevich taught for a time at the Free State Art Studios in Moscow, but in October 1919 he departed for the Vitebsk School of Art, where he soon acquired a large following and became more of a guru than a teacher of painting.[12] Within three months of his arrival, he was followed by a devoted band of students, and by June 1920, under the name of UNOVIS,[13] they had taken over most of the school's curriculum. In Vitebsk, he produced *On New Systems in Art*,[14] which he had finished the summer before he left Moscow. But life in Vitebsk was far from idyllic; the artist became the target of narrow-minded local officials, and in 1921 the school suffered extreme privations brought on by a grinding famine. Refused

4

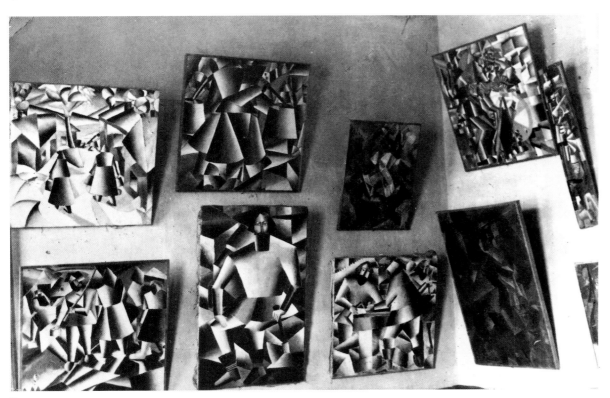

5

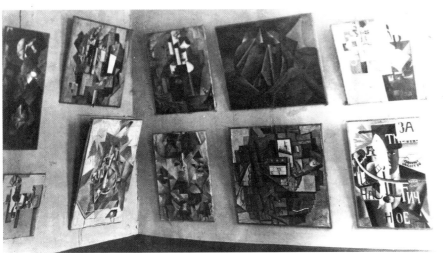

6

4 Alogical Portrait of the Futurists
M. Matyushin, A. Kruchenykh and Malevich
St. Petersburg, December 1913

5 Installation photograph of the Malevich
Exhibition, entitled 'His Way from
Impressionism to Suprematism'
Moscow, December 1919

6 Malevich's work at the 'Tramway V:
First Futurist Exhibition'. Petrograd,
March–April 1915

assistance by every educational and professional organization, Malevich and a group of staff and students left Vitebsk in the spring of 1922 to join the cultural life of Petrograd. There his teaching and administrative work continued: in August, 1923 he became Director of INKhUK, the Museum of Artistic Culture, and shepherded its transformation the following year into GINKhUK, the research-oriented Petrograd Institute of Artistic Culture.

Theoretical-Philosophical Writings

The years from 1920 to 1927 were primarily occupied, not with painting, but with teaching and with all aspects of design. The kernel of Malevich's philosophical thought is set out very explicitly in three major works written between 1919 and 1926. *On New Systems in Art*, 1919, describes modern styles as transitional sign systems in a discontinuous evolution that moves in time toward an ultimate cosmic unity. *God is Not Cast Down*, 1922, is the most direct and finished statement of his concept of the world. His 'magnum opus' is *The World as Objectlessness*, 1923–26,[15] which is modeled on, and in some ways a response to, Schopenhauer's *The World as Will and Representation*. He worked on *The World as Objectlessness* over the course of some six years; it embodies aesthetic and philosophical ideas as well as his polemics with the state and with contemporary views of art and social utility. Often contradictory, and written at times in a stream of consciousness style, it has flashes of brilliance and serves as a compendium of his thinking as of about 1925–26.

Malevich's concept of art was essentially Symbolist in nature. He considered Suprematism the art of an ultimate state of being beyond objects, and hence beyond all questions of either the material or religious world. Relying heavily on the philosophy of Schopenhauer,[16] the artist postulated an unchanging unified state of existence, devoid of the duality of spirit and matter, a distinction which he considered purely human in origin. 'The world is the world,' he wrote, 'not spirit or matter.'[17] Since all our perceptions are necessarily filtered through our body, he believed, we normally have no access to this ultimate reality. All human distinctions are illusory; ultimately there are neither objects, nor qualities, nor social morals. True nature lies beyond emotion or reason. Malevich compares the apparent multiplicity of forms with the endless forms seen in a kaleidoscope—it is not possible ever to know what is actual and what is reflection. 'You cannot break the kaleidoscope for that would entail smashing your own brain; i. e. to see yourself, to see that there is nothing in the brain, we will find the brain but we will not find a chair there, nor God, nor the spirit'.[18] Malevich's objectless world is accessible only to the unconscious, which is the counterpart of Schopenhauer's 'will', and which motivates the conscious mind. The objectless world is similar to Schopenhauer's notion of a special aesthetic perception. Malevich describes it as a momentary timelessness, a condition of absolute rest. Suprematism is the mirror that reflects this higher world, rather than the changing objects in the human kaleidoscope.[19] It is an eternal art, outside of ideas, and unrelated to any culture.

Malevich described the material world as a reflected world, a finite form of reality, an image. To this realm he relegated human concerns: scientific, religious and artistic. He expressed little regard for conventional religious thought, labelling it, 'The world as world and hell', and 'spiritual utilitarianism'. When Lenin died in 1924, Malevich added a long section to *The Objectless World* about the quasi-religious cult he saw emerging around the dead leader—the preservation of his body, the glass coffin and funeral ritual, the setting up of corners devoted to his memory, the production of 'holy' portraits. 'In the image he (Lenin) has been transposed from material existence into sanctity, he has emerged from materialistic Communism into spiritual religious Communism, he rises above the materialistic plan of the action, like God he orders matter to take on a new order of relationships in his name'.[20] From now on the new religion will be Leninism, he wrote, and he ascribed this state of affairs not to Lenin personally, but to the kernel of a religious spirit hidden within the Communist ideology itself. 'All his life he (Lenin) fought against the corner shrine, freed himself from it and wanted to free others. He wanted to lead everybody out of the icon corner, he fought for reality, he was opposed to both God and the devil, and when he was alive it seemed to go unnoticed that the revolution carries a new cult within itself with newly transformed devils [the bourgeoisie].'[21]

While Malevich was quite aware of the fact that his theories did not directly serve the utilitarian needs of the state, he repeatedly avoided taking an outright stand against Marxism or materialism *per se*. More than once he indicated that Suprematism and Marxism were mutually irrelevant. His art was related to nature itself, he said, and so was beyond ideas of culture and class struggle.

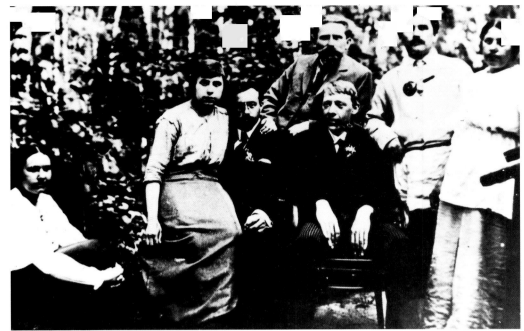

7

А. Крученых,
И. Клюн,
К. Малевич.

ТАЙНЫЕ
ПОРОКИ
академиков

1916 г.

8

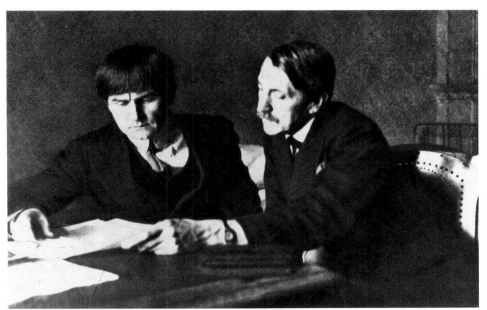

9

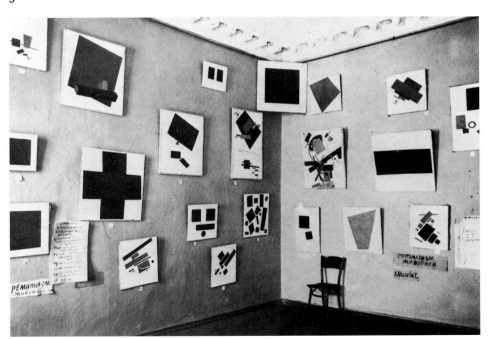

7 At Malevich's dacha in Nemchinovka,
1915. From the left: (seated) Malevich's
wife, S. Rafalovich, (right) V. Tatlin;
(standing) I. Kliun and (right) Malevich

8 Cover of Kruchenykh's 'Secret Vices
of the Academicians' (Moscow, 1916),
cover illustration by I. Kliun

9 Malevich and Mikhail Matyushin
Petrograd, 1918

10 Malevich's work at the '0. 10' exhibition
Petrograd, 1915

10

The Supplementary Element

Aside from his body of philosophical thought, Malevich developed a separate, formalist explanation of painting styles, that was closely connected with his teaching practices. He included this theory as a chapter in *The Objectless World*. Malevich regarded his 'theory of a supplementary element' as a science, which treated a painting as data for the investigation of the causes of its form, structure and colouration. He understood stylistic transitions from a 'norm' as the result of 'supplements' that have 'managed to creep into the painter and change his behaviour'. In this way, he ascribed the changes in modern painting styles to cognition of the physical environment, that is, to the perception of one or another external plastic form, depending on the environment and the state of consciousness of the artist.

From his analysis of Cubist, Suprematist, and other styles in their various phases, the artist isolated fundamental structural elements that dominate and characterize each. The Suprematist element, for example, was a short, inclined, straight line. The Cubist element was sickle-shaped, the Cézannist element an elongated 'S'. In theory, such an informing plastic shape could be isolated for any style of any period. These elements Malevich compared to the bacilli discovered by the biologist Robert Koch; they acted as a kind of infective agent responsible for a radical change in an entire system. Malevich might well have been interested in Koch and bacilli. He himself had once contracted tuberculosis, and his second wife, Sofiya Mikhailovna Rafalovich, died of the disease in 1923. (It was Koch who isolated—and stained so it could be seen clearly—the tubercle, as well as other bacilli.) The charts Malevich prepared to illustrate this work show his supplementary elements in circular areas, as if seen through the lens of a microscope. Similarly, his analyses of characteristic colour ranges for the various styles resemble chemical chromatography, in which complex mixtures are separated into bands of different colours.

The theory of the supplementary element arose in part to explain Malevich's earlier discussions of the abrupt alternation of stylistic systems. It has much in common with the theories of the literary Formalists, especially Viktor Shklovsky, who understood the evolution of prose style to be discontinuous and triggered by the appearance of certain literary genres. Malevich and Shklovsky were acquainted. In fact, it may have been Shklovsky who first introduced the medical metaphor into Suprematist critical vocabulary. In an article published just before Malevich left for Vitebsk he wrote, 'The Suprematists did for art what chemistry has done for medicine: they isolated the active factor in the remedies.'[22] But Malevich went much further than any literary Formalist in his translation of the structural stylistic laws he believed to be universal and immanent, into a specific pedagogical method.

The 'bacteriological' model of the theory of the supplementary element was part of the extended medical concept Malevich applied to all aspects of his teaching: the name itself came from the terms of a medical prescription. He called students his 'patients' and himself the 'doctor'. Students new to his studio underwent an 'incubation period', during which they submitted a still life to be analyzed for a 'diagnosis' and 'prescription'. The 'doctor' made his 'rounds' once a week, questioning the 'patients' and examining their work. Questions and responses were duly recorded on a 'chart' by the 'assistants'.[23]

Malevich believed his formal analysis of a student's work revealed the aspiring artist's psychological condition, the state of his psychic and artistic evolution. His method of teaching consisted less in direct instruction of the student than in the observation of his or her behavioural reaction to set stylistic problems. His aim was to free the student from 'eclecticism' and encourage a 'pure' style. Once the aspiring artist's cognitive condition was determined, the work assigned could be tailored to an efficient and full realization of the student's natural style.

On The Defensive

In Petrograd the UNOVIS group continued to work together and to exhibit collectively, often without attributing works to individual artists. At the 1923 'Petrograd Artists of All Trends' exhibition, UNOVIS exhibited sixty works, divided into three stylistic groups: Cubism, Futurism, and Suprematism. Most of the works in the last group were entitled either 'Suprematist Structure' or 'Suprematist Section', but it also included two monochrome 'empty' canvases entitled, *The Suprematist Mirror*.[24]

Malevich's open idealism was increasingly vulnerable to attack as right-wing artistic opinion gained ground, and served to support AKhRR (Association of Artists of Revolutionary Russia), an aggressive group of realist artists that went for the jugular. AKhRR argued statistics. Because its naturalistic treatments of well-known people and events were loved by the masses, and its exhibitions invariably drew the largest crowds,

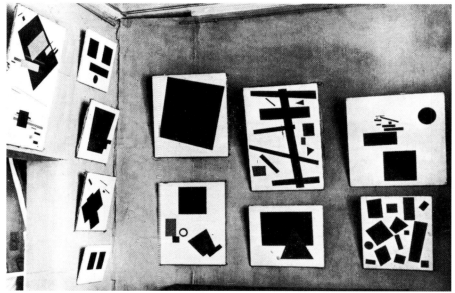

11

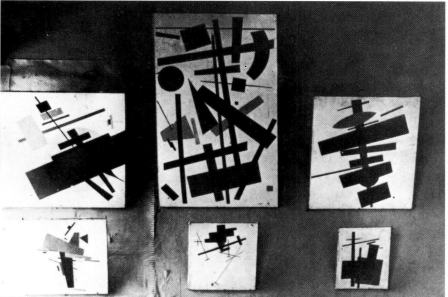

12

13

11, 12 Installation photographs of the Malevich
Exhibition, entitled 'His Way from
Impressionism to Suprematism'
Moscow, December 1919

13 Members of the UNOVIS group departing
to Moscow from Vitebsk, 1920. In the centre:
Malevich holding a Suprematist circle

14 Cover of Malevich's 'From Cézanne
to Suprematism' (Petrograd, 1920)

Художника
КАЗИМИРА МАЛЕВИЧА.

От Сезанна до
Супрематизма.

КРИТИЧЕСКИЙ ОЧЕРК.

ИЗДАНИЕ
Отдела Изобразительных Искусств
НАРКОМПРОСА.

14

AKhRR artists maintained that theirs was the one genuine proletarian art, and as such should be supported by the government. AKhRR was not associated with the Commissariat of Education, which in the mid-twenties was still arguing in favour of stylistic pluralism. Initially, even the Party avoided endorsing AKhRR's militant views. AKhRR built its support in the socially aggressive and artistically conservative labour and military organizations. In the late twenties AKhRR itself came under sharp criticism for a 'bourgeois' approach to art, but by that time the class war and the 'cultural revolution' in art—led by the Central Committee's 'agit-prop' section—was in full swing, and the Party eventually took over the administration of the arts.

Malevich's philosophical publications were particularly difficult to reconcile with the idea of a new art based in materialism. *God is Not Cast Down* had come in for criticism in 1923 by Sergei Isakov, who styly raised questions about Malevich's political reliability by suggesting that his 'ideological instability' was comparable to that of the German revolutionary partisans.[25] In 1924 Malevich's colleagues at GINKhUK, Pavel Mansurov and Vladimir Tatlin, env.ous of his pre-eminent administrative position, mounted a campaign against his directorship, suggesting that he be replaced by Isakov.[26] By 1925, Malevich's imperfect materialism was worrying some of his own students. In remarks prepared for a lecture at GINKhUK, Konstantin Rozhdestvensky, one of Malevich's best students, noted that Malevich had not painted in five years and, quoting at length from the artist's booklet *God is Not Cast Down*, accused his teacher of idealism and a non-Marxist interpretation of art. Although he was an enthusiatic supporter of Malevich's theory of the supplementary element, Rozhdestvensky denounced the idealism of his concept of an objectless world, and demanded it be eliminated from the school.[27]

A more public denunciation came in June, 1926 on the occasion of GINKhUK's end-of-the-year show where, along with the work of his colleagues Mikhail Matyushin and Pavel Mansurov, Malevich's architectural models and graphic charts demonstrating the theory of the supplementary element were displayed. The leading party newspaper, *Leningradskaya Pravda*, published a condemnation of the exhibition by the militant young critic Grigory Seryi. Entitled, 'A State-Supported Monastery', it was polemical and deliberately crude: 'This exhibition shows conclusively the depths to which the Leningrad objectless artists—who have been painting in creative impotence all these past years—now have sunk.' The writer professed himself shocked at a young woman's forthright responses to his questions about Malevich's architectural models. Yes, the models express 'inner experience', she tells him, 'but cleansed of all cultural layers, etc. We reject all utility; it doesn't matter to us whether these things are needed or not. What is important to us is to comply with our personal sensations.' Seryi was equally derogatory about Matyushin's and Mansurov's art, and ended his piece:

'A monastery has taken shelter under the name of a state institution. It is inhabited by several holy crackpots who, perhaps unconsciously, are engaged in open counter-revolutionary sermonizing, and making fools of our Soviet scientific establishments. As for any artistic significance in the "work" of these monks, their creative impotence hits you right in the eye at the first glance.

'The time has come to say: it is an utter scandal that Glavnauka [the Main Science Administration] hasn't yet put an end to this disgrace that it has let loose under its protection.

'The Control Commission and the Workers and Peasants Inspection should investigate this squandering of the people's money on the state support of a monastery.

'Now when gigantic tasks are towering before proletarian art, and when hundreds of really talented artists are going hungry, it is criminal to maintain a huge, magnificent mansion so that three crazy monks can, at government expense, carry on artistic debauchery or counter-revolutionary propaganda that is not needed by anybody.'

The complaints put not only Malevich, but Mansurov and all of GINKhUK, in jeopardy. The Leningrad branch of the Main Science Administration,[28] fearing for its own reputation, began to move against GINKhUK and Malevich, quickly setting up a review committee and starting an investigation. Malevich was particularly bitter that the Science Administration did not at least support his work on the supplementary element. As he saw it, the theory was beyond reproach, since it was based on an objective analysis of a painting as scientific data.[29] To his colleagues he complained about the Science Administration: 'In another situation it would have been possible to set [the theory] out brilliantly and provide an interesting basis for the study of painting, but unfortunately, that they don't understand.'[30]

With the prospect that Seryi and the investigation committee were about to descend on the Institute the following day, Malevich warned the staff and students that it might not be possible to continue their meetings, and that the investigation could 'suspend and put an end to all GINKhUK's artistic activity, which could have been of great benefit to the study of art and to the clarification of its nature.'[31]

Malevich's colleague, the artist Vera Ermolaeva, wrote to Mikhail Larionov in Paris, 'This spring we had to withstand a brutal attack by all those same AKhRR people. (Maybe you don't know this ogre? They are

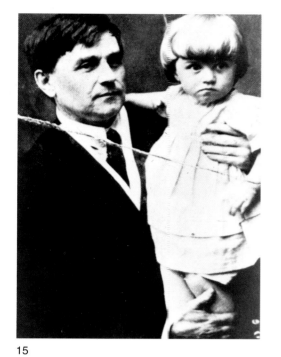
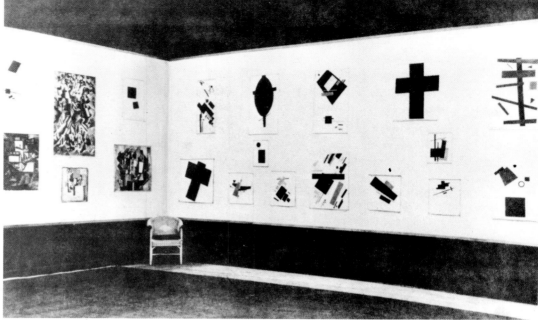

15

16

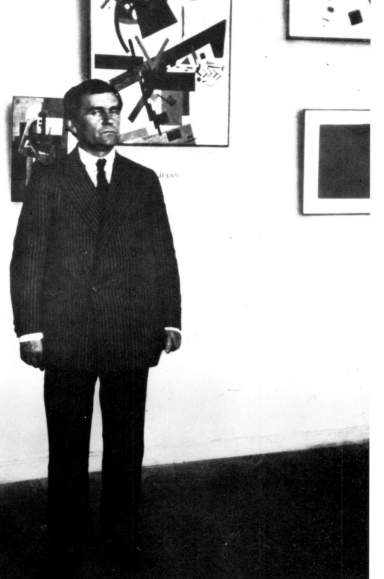

18

15 Malevich and his daughter Una,
early 1920s

16 Malevich's work at the 'Grosse
Berliner Kunstausstellung'. Berlin,
May–September 1927

17 Malevich standing in front of his work
in the collection of GINKhUK. Leningrad,
c. 1925

18 Cover of Malevich's book 'God is Not
Cast Down: Art, the Church, the Factory'
(Vitebsk, 1922)

17

contemporary Wanderers, their mission is to express the revolutionary essense of the proletariat through "healthy realism", while they remove themselves from the revolutionary course of art of that very creative proletariat, and paralyse all the new artistic methods. Their exhibition is a sea of the most untalented canvases, without any naturalistic literacy, on the most blatantly revolutionary themes.) So it is they who want to disrupt our work, they are accusing us of mysticism and idealism, and conducting a newspaper witchhunt under the heading "A State-Supported Monastery"....'[32] Malevich hastily applied for a three-month visa to visit Larionov in Paris, but in the end did not go.

GINKhUK was closed at the end of the year.

A Visit Abroad

As far as can be determined now, Malevich painted little, if at all, from 1920 until he went to Poland and Germany in the spring of 1927. In 1920, just one year after the exhibition of more than 150 of his paintings in a one-man show in Moscow, he had written, 'There can be no question of painting in Suprematism; painting was done for long ago, and the artist himself is a prejudice of the past'.[33] Instead, beginning in Vitebsk, he devoted himself entirely to teaching, writing and the design of architecture and objects of 'utilitarian suprematism'.

Malevich's trip to Warsaw, where he had a show of almost a hundred works and lectured on current art,[34] and Berlin, where he showed at least 55 works at the 'Grosse Berliner Kunstausstellung', had significant consequences for the further course of his art. Outside his native country, the artist was surprised to encounter such a flourishing diversity of painting styles. In Berlin at that time there was everything from abstraction to Expressionism to the unsentimental figures of the Neue Sachlichkeit (New Objectivity). For a long time Malevich had looked to the West as a source of inspiration, and finding this multiplicity of styles there had a liberating effect on him. It must have been disconcerting, too, when instead of his theory of the supplementary element—his primary creative work for the past several years and a major focus of his trip—his works of art were the main centre of attraction for his Western colleagues. They urged him to resume painting and proposed further exhibitions. Thus encouraged, and while still abroad, Malevich began to paint again.

During his absence from home the political situation in the arts underwent further change. In the spring of 1927 the official tolerance of artistic pluralism by Narkompros and the Science Administration (organs of the state government rather than the Communist Party) came under increasing pressure from the Central Committee's agitation and propaganda section. Lunacharsky, the head of Narkompros, was accused of being soft on bourgeois (i. e. non-Realist) art, and the Science Administration's supervisory role in art research was replaced by Glaviskusstvo, a new Central Arts Administration.[35] But as the movement toward ideological fundamentalism—led by young, zealous proletarians—picked up speed, Glaviskusstvo, too, was soon suspect. By the end of the decade the Party was seeing enemies on every side and waged a repressive battle against perceived 'conspiracies', 'deviations' from ideological purity and 'bourgeois elements' in society.[36] For artists it was no longer possible to be above the fray.

Malevich left Berlin for home on 5 June 1927, leaving his paintings on exhibition there until the show closed at the end of September, as well as a package of manuscripts that comprised the text of *The Objectless World*. Before his departure he wrote out a will concerning the manuscripts he was leaving, but wrote nothing about the disposition of his paintings. Clearly, he felt more at ease about the ultimate fate of the paintings than about his writings. The book was important as the repository of his philosophy and the theory of the supplementary element, but he feared repercussions if it were to appear in Russian. 'In case of my death or permanent imprisonment,' he wrote, '... [the manuscripts] may be studied and then translated into another language; for living at this time beneath the forces of revolution, there might be strong exceptions taken to that form of the justification of art that I now have, i. e. in 1927'.[37]

The paintings were left in Germany and part of that collection was acquired in the 1930s by Alfred Barr for the Museum of Modern Art, and by the Stedelijk Museum in 1957. As Malevich perhaps had foreseen, in the years of his repression in the Soviet Union, when even his name could not be found in Russian encyclopedias or histories of art, the availability of these paintings in the West did much to keep his memory alive.

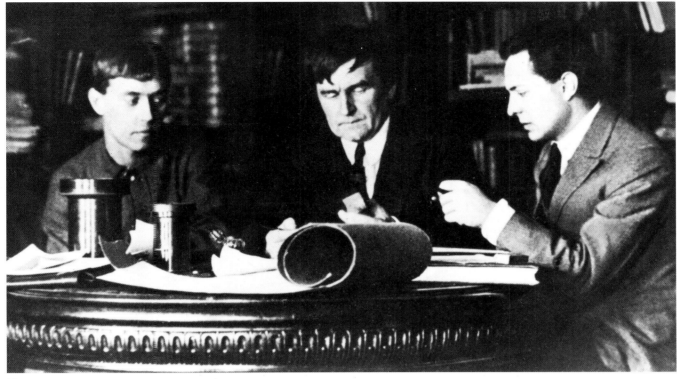

19

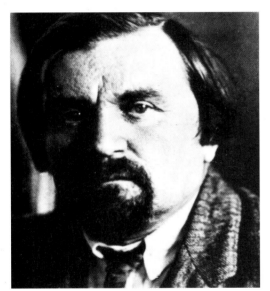

20

21

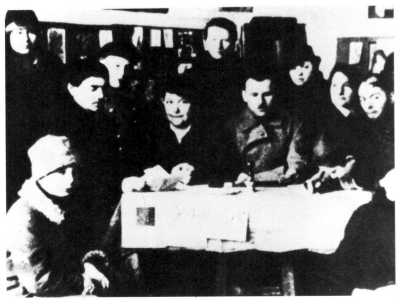

22

19 N. Suetin (left), Malevich
and I. Chashnik at INKhUK. Petrograd, 1924

20 Malevich, 1926

21 Malevich and his assistants of the
Formal-Theoretical Department of GINKhUK,
c. 1925. From the left: Malevich and
A. Leporskaya (seated),
V. Ermolaeva (standing), Gipsi (actor),
K. Rozhdestvensky, R. Pozemsky and,
L. Yudin. Leningrad, 1925

22 UNOVIS group, Vitebsk 1920.
Seated at the table is V.Ermolaeva
and to her right are L.Yudin
and Malevich. At the extreme
right is El Lissitzky

The Return to Painting

Back at home Malevich began to paint again. Aside from Western opinion, there were practical reasons for doing so. Most immediately, Malevich anticipated further exhibitions abroad, and after so many years of almost total abstinence from painting, he was badly in need of an extensive body of work to exhibit. Then, too, he had the time. With the increasing ideological restrictions, his teaching activities were sharply curtailed and it was virtually impossible for him to publish. The figurative work he saw abroad and the demand for representational art at home must have contributed to his turning back to former, pre-Suprematist subjects. But instead of painting entirely new works, Malevich attempted to reproduce the old ones, falsely dating them twenty years earlier. For the next several years Malevich painted impressionist portraits and landscapes, and primitivist peasant scenes, and back-dated them to the years 1903 to 1910.

It is not yet possible to pinpoint Malevich's motives with certainty. It is apparent, however, from many of the backdated pictures, that the return to painting after such a long hiatus was difficult. Much of the work is tentative and awkward. Paintings such as *At the Dacha* are embarassingly bad. In many cases, it is easy to distinguish the late from early paintings of similar subjects. Malevich was not careful to integrate the false dates into the original chronology of his development. He could not resist placing improbably early dates on these works, attempting to establish a new chronology. Nor did he reproduce the earlier paintings slavishly. Although he apparently often worked from old sketches and drawings, he introduced variations in composition and colour that reflected later experiences and interests. Between the time of the original work and later 'imitations', the artist's painting had gone through the profound stylistic changes that ended in Suprematism, and this could not but have an effect on his repainting.

Most notable is the difference in composition of the later works, which are markedly more vertical and horizontal in their structure than earlier paintings. Even in the most loosely painted scenes, such as *The Carpenter*, the figures are upright and static, often in the centre of the canvas, and facing the viewer directly. The details of the surroundings—here the trees, fence, paths—are arranged to emphasize the underlying cross shape. It is this symmetrical composition that carries much of Malevich's cosmic symbolism in the late 1920s and early 1930s. The device can be quite successful, such as in the icon-like *Head of a Peasant*, where the geometric central head is divided into bilateral areas of contrasting colour, and the peasant figures are lined up horizontally behind it. But there is a dramatic distinction between this work and the 1913 *Portrait of Ivan Kliun*, a stunning painting that went to the Russian Museum from the Museum Section of GINKhUK in 1926.

There are some major paintings among the back-dated works, most strikingly *At the Harvest (Marfa and Vanka)*, from the Russian Museum, and *Haymaking*, from the Tretiakov Gallery.[38] Both paintings have a clearly expressed horizon line (not introduced by Malevich until his Suprematist period) and a large vertical static figure (related to the large figures of Russian icons and church mosaics). In contrast to the early work, such as the 1912 primitivist *Woman with Buckets and Child*, no attempt is made to integrate the figure into the landscape; instead, the heads of the figures are seen above the horizon, against the blue sky. *At the Harvest* repeats the subject of an early small drawing, *In the Field*, and a lost painting of the same name that was exhibited in December, 1912.[39] In these early works, however, the large figure is embedded in a complex and angular space pieced together from figures of similar size and shape, and diagonal landscape elements. This interest was taken to the extreme in the years preceeding The Great War and resulted in such masterpieces as *The Woodcutter*, 1912–13, *Woman with Buckets* (Museum of Modern Art, New York). The backgrounds of *At the Harvest* and *Haymaking*, on the other hand, are divided horizontally, the distant figures are small and upright and directly face—or face away from—the viewer. The large figures occupy a greater percentage of the pictorial area, their heads projected above the horizon against the sky.[40] A similarly composed painting, but with the large figure centred and facing the viewer, is labelled: 'No. 22 Study for the painting *Harvest* 1909' (1928–32). The late Primitivism sometimes moves into a peculiar monumental decorativeness. The most absurd of all such late figures in the exhibition is undoubtedly *Peasant in a Field*, in which a tall awkward male figure with wide shoulders and long skinny arms stands with a head like a bead against the sky. Here what was meant to be cosmic fails utterly and becomes merely silly.

The procedure of supplying himself with a new past shifted the centre of gravity of Malevich's *oeuvre* from Suprematism to earlier subjects and styles more apt to find critical approval in the Russia of the late 1920s, while ingeniously avoiding overt capitulation to the insistent demands for realism.[41] It was also a solution to the artist's pressing practical problems, since it provided him with a large number of figural works suitable for future exhibitions at home, and, as he hoped, for exhibit and sale in the West.

The repainting also served the crucial function of masking the fact that almost all of Malevich's early peasant paintings were still in the West. To call attention to this fact in 1928 clearly would have put him in

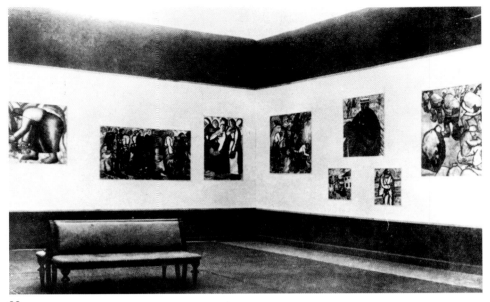

23

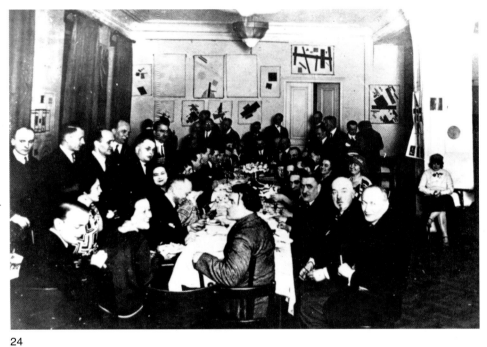

24

ГОСУДАРСТВЕННАЯ ТРЕТЬЯКОВСКАЯ ГАЛЛЕРЕЯ

ВЫСТАВКА
ПРОИЗВЕДЕНИЙ
К. С. МАЛЕВИЧА

МОСКВА — 1929
ИЗДАНИЕ ГОСУДАРСТВЕННОЙ ТРЕТЬЯКОВСКОЙ ГАЛЛЕРЕИ

25

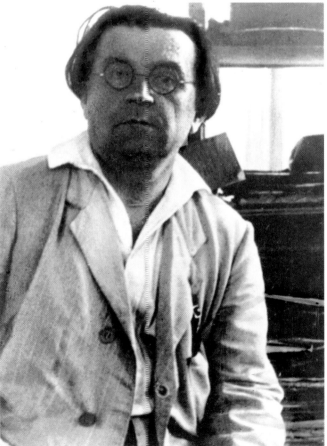

26

23 Malevich's work at the 'Grosse Berliner Kunstausstellung'. Berlin, May–September 1927

24 Banquet in Malevich's honour at Hotel Polonia, organized by the Polish artists during his stay in Warsaw in March 1927

25 Cover of catalogue of Malevich's retrospective at the Tretiakov Gallery. Moscow, November 1929

26 Malevich, c. 1930

great jeopardy. Stalin's class warfare and anti-religious campaigns were gaining in tempo by then, and they were accompanied by public witch-hunts for 'wreckers' and spies. The artist's solution remedied this awkward situation in the most expedient way possible.

At the present stage of research, however, it would be unjustified to think that Malevich did not return to abstract Suprematist works at this time entirely because of ideological pressures. He had not produced any new Suprematist paintings for years, having been concerned primarily with Utilitarian Suprematism and the theory of the supplementary element. Nor had he urged Suprematism upon his students; many of them, in fact, concentrated on becoming good Cubists. But at the same time, he does not seem to have been reluctant to exhibit his old Suprematist works, as he might have been had he wanted to avoid controversy. Malevich always worked with history in mind, and he would not have capitulated easily to short term goals.

Ultimately, Malevich painted in the past at least in part because there were vast philosophical and artistic problems posed by returning to painting, and for a long time he was unable to move beyond them, either in the direction of Suprematism or beyond it. In taking up the brush again, he faced the question of the next visual move, the crucial step beyond the empty canvas of the *Suprematist Mirror*. To begin again must have been especially difficult given his philosophical beliefs, along with his teaching that painting reveals the state of the artist's psyche, his soul. One can imagine that his search for a new style, long postponed, was really rather desperate, but because it took place on back-dated work, it at least was conducted in private. The question must have occurred to him: where was the next supplementary element? Could the doctor minister to himself?

Late in 1929 Malevich's last one-man show opened in Moscow. Alexei Fedorov-Davydov, a respected Marxist art historian of considerable erudition, was chosen as the 'spin-doctor'. His catalogue essay was a masterpiece of defending the exhibition while rejecting the art: 'Although Malevich's art is to a significant extent ideologically foreign to us, nevertheless the formal quality and mastery of his works are so substantial for the development of our art, that familiarity with his work is very useful both for young artists and the new viewer.' Fedorov-Davydov presents Malevich and other left artists as unwitting pioneers of industrial art: 'While subjectively far from the basic positive tendencies of the new art of industrialism, they objectively enabled its birth through their work. To this...type of artist belongs K.S.Malevich.' Throughout the essay the writer, undoubtedly led astray my Malevich himself, dates the artist's various styles several years too early. Malevich's revenge for such shabby critical treatment had been unimpeachable documentation of his false dates.

But the artist's fears of imprisonment were well founded: on the heels of his one-man exhibition, he was arrested and incarcerated for three months on suspicion of being a German spy. His friends and relatives burned many of his papers and manuscripts, from fear that they might be used against him. Later he told Pavel Filonov about the interrogators' questions: ' "What kind of Cézannism do you talk about? What kind of Cubism do you preach?" AKhRR wanted to completely destroy me. They said "Do away with Malevich and all of Formalism will die." But see, they didn't destroy me. I'm still alive. It's not so easy to get rid of Malevich!'[42]

The painting of the past did not stop with the Tretiakov Gallery exhibition. After the show closed, El Lissitzky ran into Malevich, and wrote to his wife, 'He is getting old, and is in a very difficult position. He is to go abroad in the autumn, and paints, paints representational art and signs it with 1910, etc. Pitiful state of affairs. Does it very seriously and thinks he'll catch out fools.'[43] But the process of repainting sparked genuinely new approaches to the figure. A series of decorative figures was derived from his utilitarian work in Suprematist design. In *Woman with a Rake*, for example, the horizontal/vertical composition of his peasant pictures is retained, but areas of flat colour now resemble fantastic clothing, transforming the subject into a visitor from some interplanetary world. Malevich also began to explore a new Surrealism at this time, spare figures with colourful clothing and featureless heads set in a minimal landscape.

At the Leningrad 1932 jubilee exhibition commemorating fifteen years of Soviet rule, Malevich was allotted his own room in which he displayed his new decorative and surrealist painting, along with architectural models and pre-Revolutionary Suprematist works. But when the exhibition moved to Moscow in 1933[44], it was reorganized to express a more rigid didactic and ideological point of view, and Malevich and the other 'objectless artists'—including Altman, Kliun, Popova, Filonov, and Tatlin—were squeezed into one small room.[45] 'The small room,' wrote one of the more sympathetic critics, 'where examples of the quests and achievements of Tatlin, Malevich, Kliun, Filonov and their rare present-day descendents and adherents are assembled, is one of the most memorable for, as it were, its curious tragedy. Here are people who thought and invented and worked, but they elicited such a centrifugal force in their art, that it carried them out of art to the beyond, to nowhere, to non-existence.'[46]

27

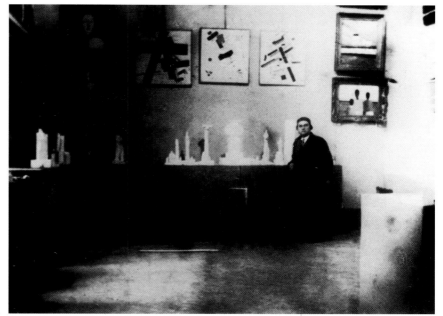

28

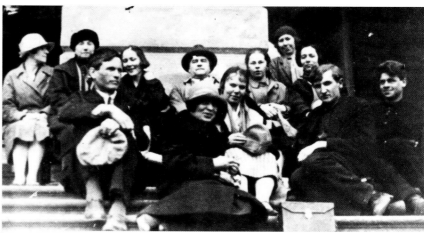

29

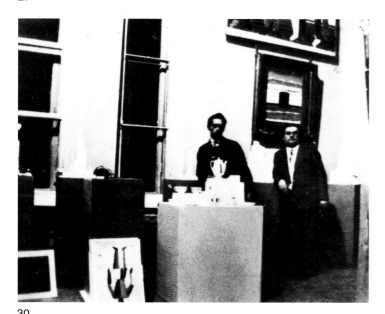

30

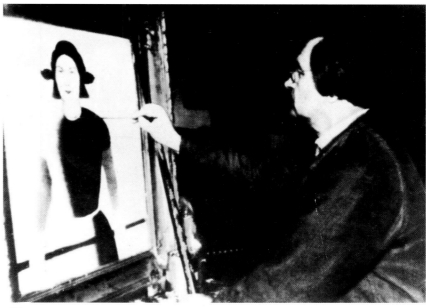

31

27 Malevich, 1931

28 Malevich standing in front of his work
at the 'Artists of the RSFSR over the Last
15 Years' exhibition at the Russian Museum
Leningrad, 1932–33

29 Malevich (centre) and his associates
by the Russian Museum entrance
Leningrad, 1931

30 N. Suetin (left) and Malevich arranging
the display of the latter's pictures at the
'Artists of the RSFSR over the Last 15 Years',
held at the Russian Museum
Leningrad, 1932–33

31 Malevich before the easel: *Girl with
a Red Pole*. Leningrad, April 3, 1933

In spite of the mounting atmosphere of state terrorism and his own increasing ill health, Malevich continued to work after 1932. At a time in Russian history when many modern artists were reduced to painting endless children and bouquets of flowers, Malevich painted portraits of himself and his friends in bright fantastical clothing rendered in a style reminiscent of Holbein or Cranach. *Portrait of Nikolai Punin*, for example, bears a certain resemblance to Piero della Francesca's *Duke of Urbino* (1465–72). Such works are to an extent a response to the increasing critical attention which Soviet art historians devoted at this time to the Renaissance, but Malevich's depictions are also derived from Russian icons, and bear the imprint of his continuing interest in the higher 'objectless world'.[47] In the last year of his life his portraits, such as the *Portrait of the Artist's Daughter, Una*, became warmly expressionistic and intense. Four such works, including his *Self-Portrait*, were on exhibition at the time of his death in 1935.[48]

A state funeral was conducted at the Leningrad Union of Artists.[49] From there the Suprematist coffin, on an open car bearing a black square, was followed by a large procession of mourners, walking the length of Nevsky Prospect to the Railway station. Malevich's body was taken to Moscow, cremated, and buried in a field in the suburban village of Nemchinovka. Nikolai Suetin, his student and friend, devised a cement cube with a black square on one side as a marker. Malevich's work was carefully put away by his heirs; not until the 1960s would any of it be seen publicly again. World War II erased all traces of his grave.

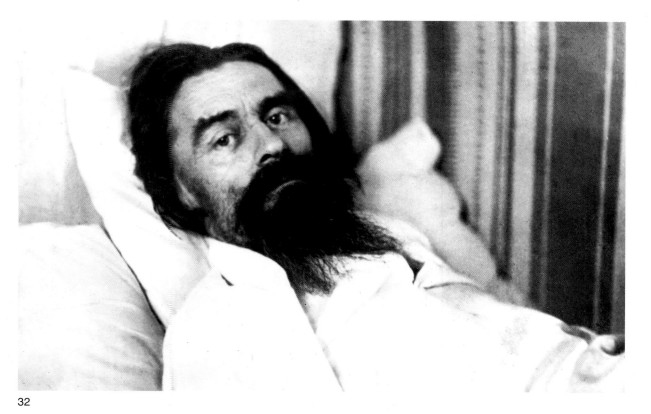

32

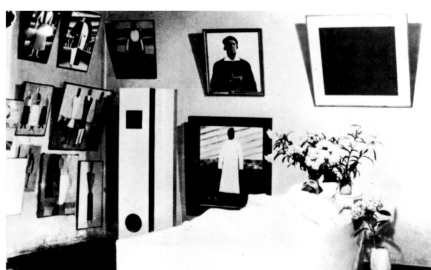

33

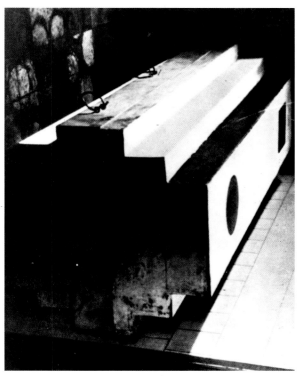

34

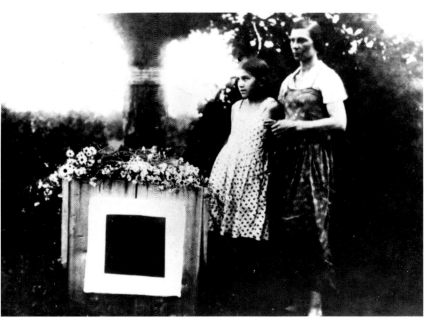

35

32　The ailing Malevich. Leningrad, 1934

33　Malevich lying in state in his apartment
Leningrad, 1934

34　Malevich's Suprematist-style coffin

35　Una and Natalia Malevich at Malevich's
tomb in Nemchinovka near Moscow, 1935.
The site is marked with white cube and
black square, designed and made
by N. Suetin

Irina Vakar

Malevich's Student Years in Moscow: Facts and Fiction

Despite the wealth of literature available on Kazimir Malevich, much about his life—even the very first fact of the artist's biography, the date of his birth—remains uncertain and obscure. Was he born on February 11 (23 Gregorian calendar) or February 14 (26 Gregorian calendar)? Larissa Zhadova[1] gives the first date; Troels Andersen[2] gives the second, and is joined later by Evgeny Kovtur, who cites Malevich's sister, Wiktorija, as the source[3]. Some Western scholars simply write that Malevich was born 'on February 23 or 26, 1878, it is impossible to determine which.'[4]

We do have Malevich's own testimony on the point, contained in a brief manuscript owned by his widow, Natalia. *A Short History of My Life* was dictated to Natalia in 1928 or 1929 on the occasion, as she recalls, of Malevich's departure from the State Institute of Artistic Culture for the Institute of Art History; in it Malevich states: 'I was born in Kiev in 1878 on February 11.' Mention of the city is important: it is usually said that he was born in the vicinity of Kiev.[5]

But Malevich's testimony is not always trustworthy. Take what may well be the most obscure point in his biography, his artistic training. Traditionally, anyone writing on the subject goes to the brochure by Alexei Fedorov-Davydov, published for Malevich's first one-man show at the Tretiakov Gallery in 1929.[6] Fedorov-Davydov probably took his biographical information from the artist; at very least, Malevich would have checked it for errors. Thus, according to Fedorov-Davydov, Malevich was enrolled in the Kiev School of Drawing from 1895 to 1896, and the Moscow School of Painting, Sculpture and Architecture from 1904 to 1905. From 1905 to 1910 he studied under Fedor Rerberg at the latter's studio; but the *Short History of My Life* gives a different version of events: 'In 1904 I passed the entrance examination to the Moscow Art School,' says Malevich, 'which I discovered had shortcomings detrimental to artistic development.' No other formal training is mentioned.

But in a letter addressed to a representative of the Free State Art Studios and dated December 7, 1918, Malevich gives a radically different interpretation of events: 'My diploma is from a five-year school of agronomy. In artistic matters I am self-taught.'[7] And in reminiscences from the early 1930s included in the book *On the History of the Russian Avant-Garde* [K istorii russkogo avangarda][8] Malevich mentions in passing that he 'attended a studio' during his first years in Moscow. In the accompanying commentaries, Nikolai Khardzhiev explains that the artist is referring to the studio of Rerberg. These reminiscences lack Malevich's usual attempt to create an image, and thus they inspire a certain trust in what he writes.

We are left with three accounts of Malevich's studies in Moscow:
1) He attended the Moscow Art School and Rerberg's studio.
2) He did not study anywhere.
3) He only attended Rerberg's studio.

The first account seems dubious on the face of it, as it is hard to imagine an artist of the early 20th century quitting the Moscow Art School to study with Rerberg. (One of the School's aims, as stated in its promotional literature, was to prepare students for admittance to the Moscow School of Painting, Sculpture and Architecture.[9]) Western scholars sometimes explain this strange fact by saying that the teaching at Moscow Art School was too academic, and that Malevich preferred a more 'leftist' and 'avant-garde' training.[10] In reality, this was not the case. Instruction at the studio was based on academic principles, and Rerberg himself, an Impressionist and a Symbolist but never an extremist, was not a member of the avant-garde, though he took an indulgent attitude towards experimentation by his pupils.

As for young artists, in 1904–5 they were still quite loyal to the Moscow Art School. The teaching staff included Serov and Korovin, whose studio enjoyed great prestige, while the future members of the Blue Rose group, whose experiments were in large part responsible for the lively creative atmosphere at the School, were nearing the end of their studies. (We may recall Alexander Kuprin, who dreamed of studying under Serov and applied to the Moscow School of Painting, Sculpture and Architecture in 1904.) The behaviour of that future iconoclast, Mikhail Larionov, is particularly telling. He only began taking part in Moscow exhibitions in 1905, and then his efforts were directed to making a 'peaceful' entry into the

Moscow art world, certainly not to a break with its leading circles.[11] Larionov's conflict with his teachers, which resulted in his 1905 suspension from the Moscow Art School for a year, concluded in a decidedly unusual manner: the School only succeeded in expelling him by buying him a ticket and putting him on the train!

The future proponents of avant-garde painting only became disillusioned with the teaching methods at the Moscow Art School somewhat later, during the final phase of their studies. They started grumbling openly in 1908–9, and by 1913 disenchantment was considered 'good form' by David Burliuk, Vasily Chekrygin, and Vladimir Mayakovsky. Even as independent and daring a thinker as Malevich, however, could scarcely have taken this view of the Moscow Art School in the mid-1900s after just two years there.

And we have another, more exact source of information—Archive no. 680 at the Central State Archives of Art and Literature. It does not contain a file on Malevich, nor is he listed among the students of the years covered—but his name appears three times as an applicant.

The first application from 'Kazimir Severinovich Malevich, gentleman' is dated August 5, 1905. In it Malevich asks to take the drawing examination 'for admittance as an auditor to the department in which I demonstrate ability.'[12]

On June 30, 1906 Malevich once more asked to take 'the entrance examination for the head class in the art department...as an auditor. Should I be accepted to the School I shall choose *painting* as my area of specialization' [emphasis mine — *I.V.*].[13] In both instances Malevich gives Kursk as his place of residence.

Finally, on August 13, 1907 Malevich applied to enter the freshman class.[14] For the first time, he listed a Moscow address.

In all three instances someone has written a similar note on the application: 'Papers and cards received.' Evidently Malevich was admitted to the entrance examination three times but never managed to pass—a failure all the more surprising,[15] as by this time he had produced a number of Impressionist landscapes that demonstrated great painterly skill.[16] Presumably he did not have a sufficient grounding in drawing to meet the requirements. If so, he was in good company: among the applicants who were rejected, but went on to fame as artists were Liubov Popova, Olga Rozanova, Leopold Stürzwage (later Survage), and Vera Pestel.[17]

The only question that remains is whether Malevich studied with Rerberg and, if so, when—and all Rerberg scholars maintain that Malevich attended the studio. A brief newspaper item about an exhibition of works by Rerberg's students (held March 22–25, 1909) states: 'Drawings, studies and sketches are on display. Most noteworthy among the works are those produced by Zakharov, Engels, Rabinovich and Miss Zernova, followed by Shirshov, Silin, Starov and Volosatikov. Finally, there are pleasant first efforts by Iv. Rerberg (the artist's son), Roggen and Malevich.'[18] In 1912 Malevich signed the guest book at the latest exhibition of works by Rerberg's students.[19] Thus the date Malevich gave for the conclusion of his studies with Rerberg—1910—seems plausible. More difficult to ascertain is when he began. This question is related to another of importance: when did Malevich move from Kursk to Moscow?[20]

Unfortunately, the Kursk archives contain no trace of the artist, in particular documents indicating when he resigned from the Railway Authority. The only source of information to date is Malevich's reminiscences in *On the History of the Russian Avant-garde*, where he describes his first arrival in Moscow in the fall of 1904, living in the 'commune' of Moscow Art School students until the spring, and returning to Kursk for the summer months. This was evidently the pattern for several years, which would explain why Kursk is given as his place of residence in the applications, and why 'Kursk' appears on several paintings, one dated as late as 1908.[21] Although all the evidence points to 1907 as the year Malevich made the final move to Moscow, his ties with Kursk remained: his family were there.

If this is true, it is very likely that Malevich did indeed begin attending Rerberg's studio in 1905. Having failed the entrance exam, he might have decided not to waste time and begun preparing to storm the Moscow Art School again. Rerberg's training would have suited his goal perfectly; and the acquaintance proved doubly useful, because it introduced Malevich to the Moscow Association of Artists, with whom he would exhibit his work from 1907 until 1910 (1907, indeed, was a watershed for Malevich in many ways. He began participating then in Moscow exhibitions and made the acquaintance of 'independent' artists like Mikhail Larionov, Natalia Goncharova, and David Burliuk; and it may be that an intuitive understanding of the new direction young Russian painting was taking prompted him to abandon any further attempts to enter the Moscow Art School.) None of this, however, determines with any certainty whether Malevich really arrived in Moscow in 1904, as he claimed, or in the following two years. The first documentary evidence—the application cited above, and exhibition catalogues giving Malevich's Moscow addresses—dates from 1907.[22]

Any list of shows displaying Malevich's work invariably begins with the 14th exhibition of the Moscow Association of Artists (1907), although Malevich himself repeatedly claimed that he began participating in exhibitions organized by the art circle in Kursk, in which he played a prominent role, in 1898, and that the

members of this circle had invited Moscow artists to take part (Malevich writes about this in *On the History of the Russian Avant-garde*). No evidence to contradict this claim has been found to date. What does exist, however, is a catalogue from a joint display of works by Moscow and Kursk artists held in Kursk in 1905 and called *An Exhibit of Paintings by Moscow and Out-of-Town Artists*. This is the earliest exhibition for which we have documentary proof that Malevich took part, and in it he showed the following works:

104.	*Weeders*	108.	*Dusk at the Cemetery*
105.	*Witch*	109.	*It Happened in May*, study
106.	*Madwoman*, sketch for the Painting	110.	*Winter*, study
107.	*Leisure* (Study)	111–115.	Studies

Malevich's friend Lev Kvachevsky contributed fifteen works, and Valentin Loboda, another member of the Kursk circle mentioned in Malevich's reminiscences, provided twenty-five more. The Muscovite contingent were almost exclusively members of the Moscow Association of Artists: Rerberg, Gugunava, Shesterkin, Yasinsky, et al. Konstantin Yuon also took part. Two works by Victor Borisov-Musatov were displayed: 165. *Golden Rays*; and 166. *A Stroll at Sunset*. Although the month is not indicated in the catalogue, the absence of a black cross next to Borisov-Musatov's name suggests that the exhibition was held before his death, i. e., no later than the fall of 1905.

As far as anyone knows, this exhibition remains the only example of collaboration between artists from Moscow and Kursk—which is not surprising, since Kursk had scarcely any artistic life to speak of, judging by the sketchy notion of it that local art historians possess.[23] It is natural to assume that Malevich himself, with his leadership and his tireless desire to stimulate everyone around him, brought his Kursk friends together with the Moscow artists he knew. If that is true, then he must indeed have arrived in Moscow in the fall of 1904, not 1905. By the spring he would have been familiar with the Moscow art community and made acquaintances among the members of the Moscow Association of Artists, and could thus have interested both groups in the idea of putting on a joint show and, upon his return to Kursk, done the necessary organizational work.

The catalogue is also of interest because it shows that in 1904 and 1905 Malevich was not just experimenting with Impressionism (such works could be displayed as studies), but was very interested in Expressionist themes (as titles like *Madwoman* and *Witch* indicate) and the depiction of mood in landscape (*Dusk at the Cemetery*, *It Happened in May*). We may thus conclude that Malevich entered Rerberg's studio in 1904–5, and was enrolled for about five years. We do not know how regularly he attended or how diligently he pursued his studies, but the very fact that he remained so long is suggestive, as the level of instruction was serious and Rerberg lectured constantly. Unfortunately, we do not have any student drawings or paintings that would enable us to judge his progress. Nevertheless, the notion that he was a born artist, an unpolished, natural talent, needs to be amended.

In conclusion, we can re-examine the accounts of Malevich's artistic education rejected here, which tell us a great deal about him. By declaring in 1918 that he was a self-taught artist, and making a fleeting reference in 1930 to having 'attended a studio', Malevich was emphasizing what little significance he attached to the tuition he had received, indeed to the traditional system of instruction. In 1918 he set about creating his own method of education and, feeling liberated from the pressure of tradition, insisted that his was a 'native talent'. And prior to a one-man retrospective exhibition in the late 1920s, when Malevich was fifty, he created a legend more appropriate to his status, as he then saw it, of a recognized master. At the same time he changed the dating of his paintings, creating, to use Charlotte Douglas's phrase,[24] a 'new chronology' that asserted his primacy at the head of several trends in pre-Revolutionary painting. A desire to look more respectable in the eyes of his contemporaries cannot alone explain the legend that Malevich studied at the Moscow Art School. He had many ties with the school; in his reminiscences from the 1930s he tells how, long before in Kursk, he was struck by the fresh, unrestrained painting of Vladimir Golikov, a student of the Moscow School of Painting, Sculpture and Architecture, and how he was drawn to the Moscow school of painting rather than the academic style exemplified by Lev Kvachevsky. It is worth imagining how ardently and persistently Malevich wanted to study at the Moscow Art School, and what hardships that dream entailed.[25]

Perhaps he did see 'shortcomings' in the Moscow School of Painting, Sculpture and Architecture after his association with V. Kurdiumov's 'commune' and the less talented and diligent of his pupils, or later when he heard the nihilistic opinions on the School expressed by Larionov, Burliuk or Mayakovsky. Nevertheless, and strange as it may seem, Malevich's references to the Moscow Art School suggest not so much disillusionment as the reverence and respect he had once felt for the inaccessible teachers, and the bitterness of recognition denied—a fate he suffered to a greater degree than most.

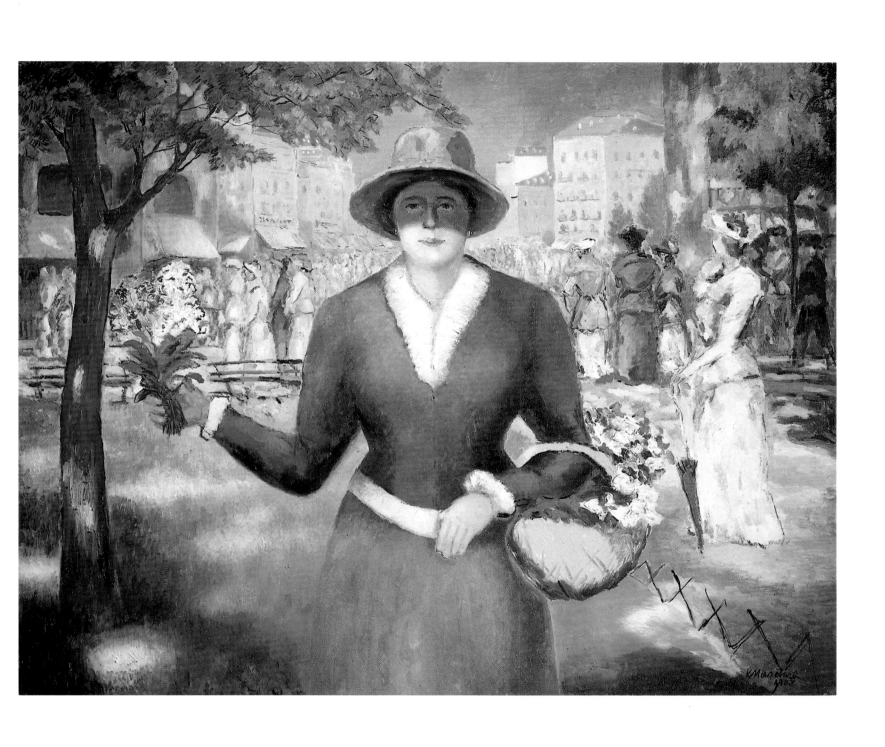

1 Flower Girl, 1903. *Oil on canvas. 80×100 cm*

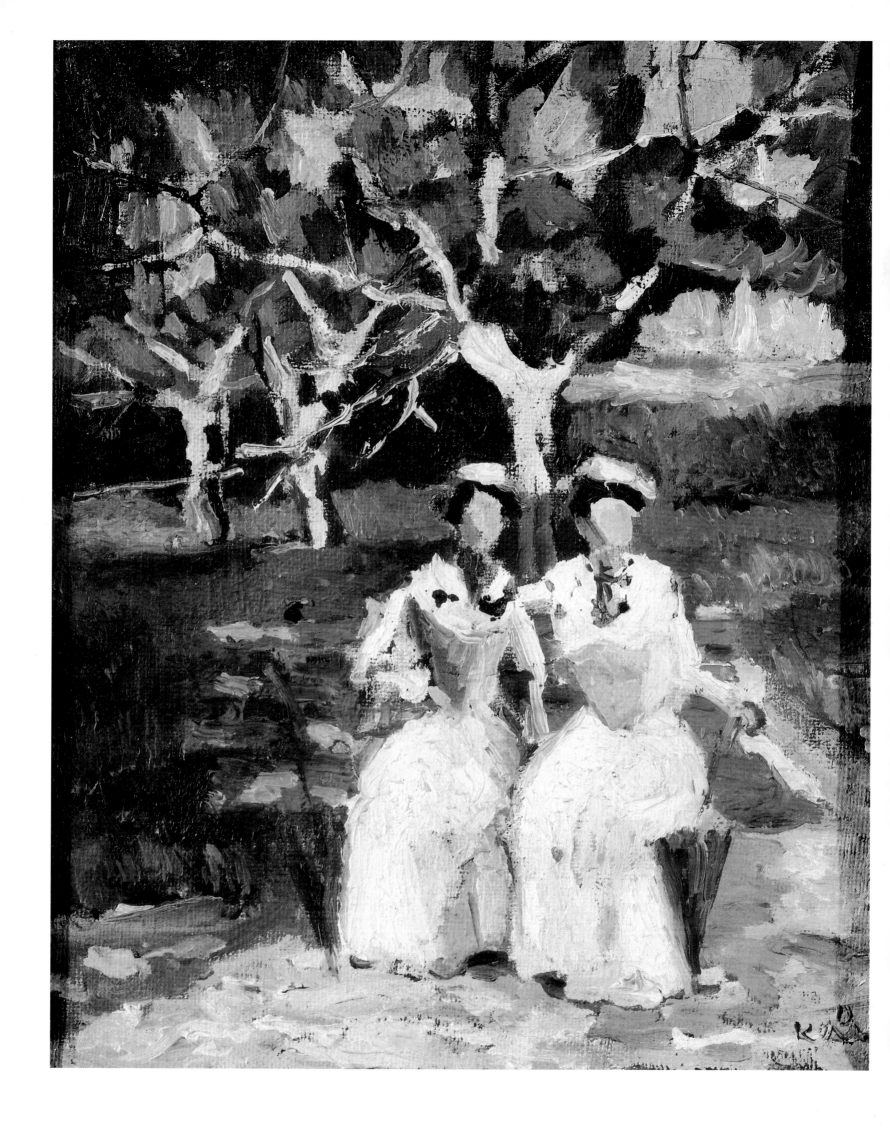

2 Two Women in the Garden. *Oil on canvas. 28×21.5 cm*

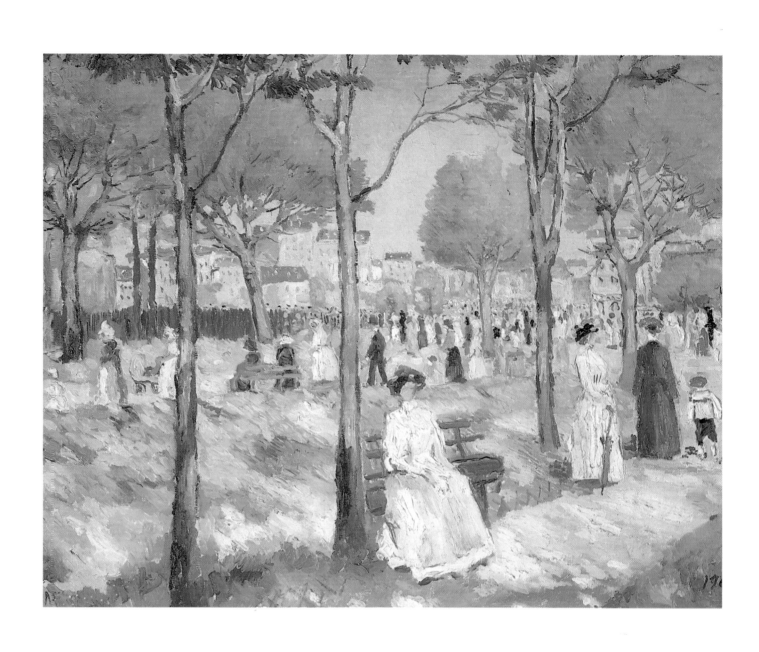

3 **On the Boulevard, 1903.** *Oil on canvas. 55×66 cm*

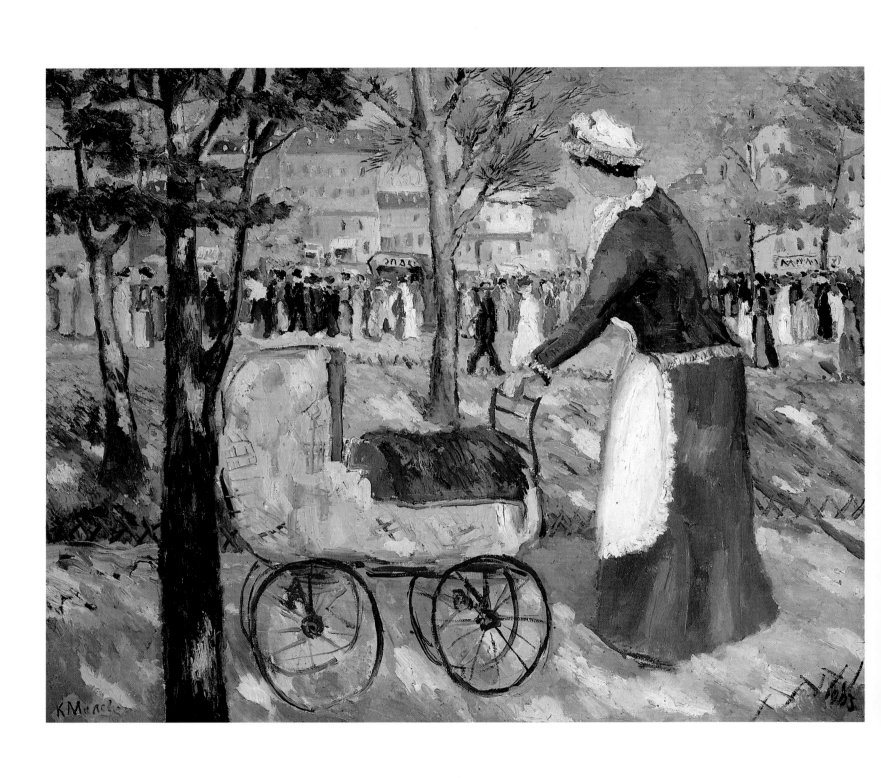

4 Boulevard, 1903. *Oil on canvas. 56×66 cm*

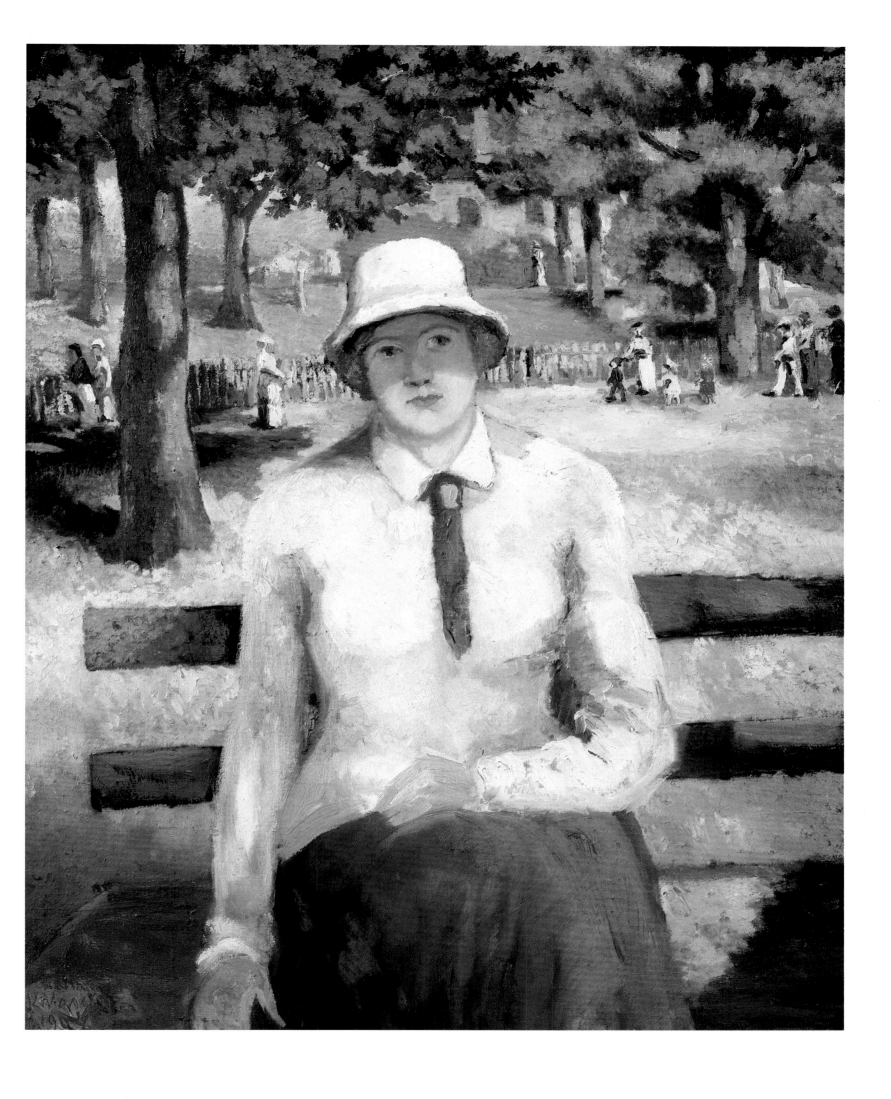

5 Jobless Girl, 1904. *Oil on canvas. 80×66 cm*

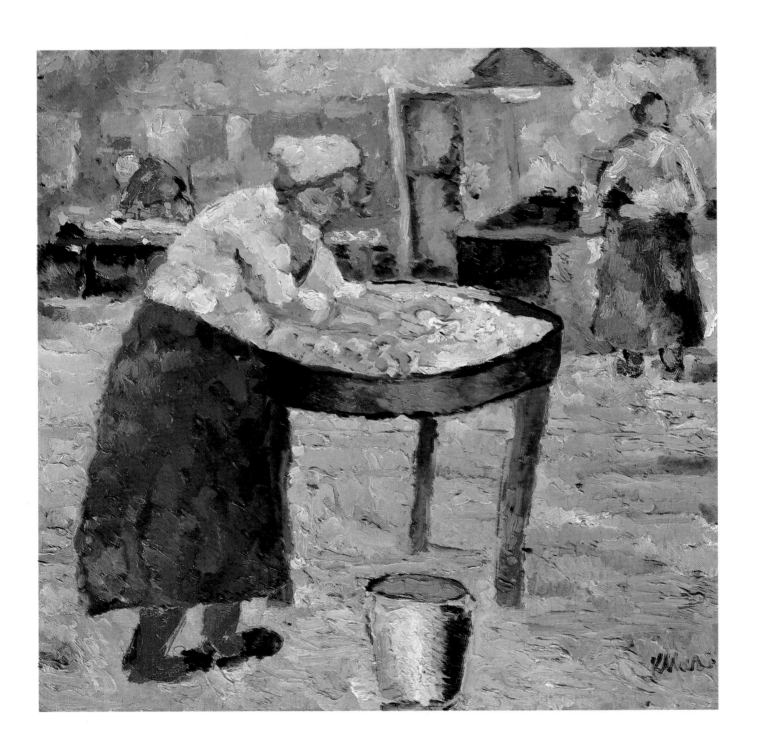

6 Washerwoman, 1907. *Oil on plywood. 39.5×39.5 cm*

7 Spring: Garden in Bloom, 1904. *Oil on canvas. 44×65 cm*

8 Fields, study, 1904–7. *Oil on canvas. 25×35 cm*

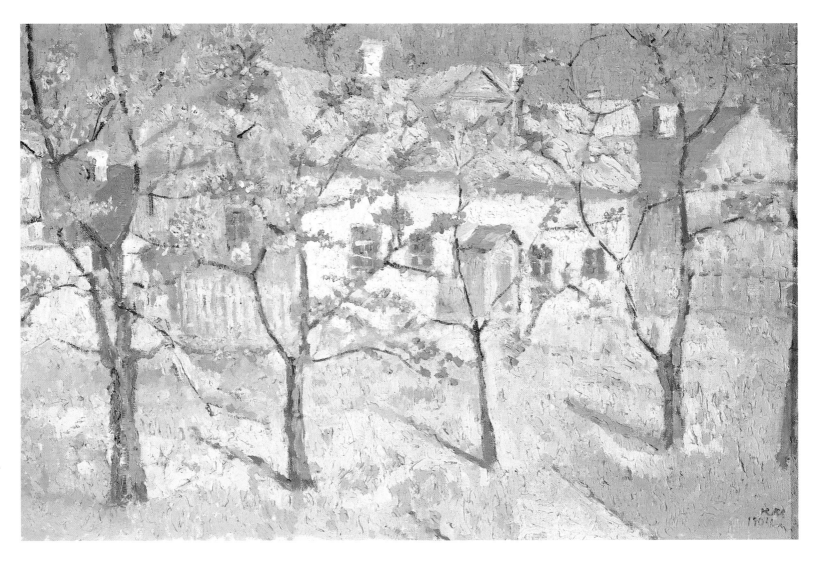

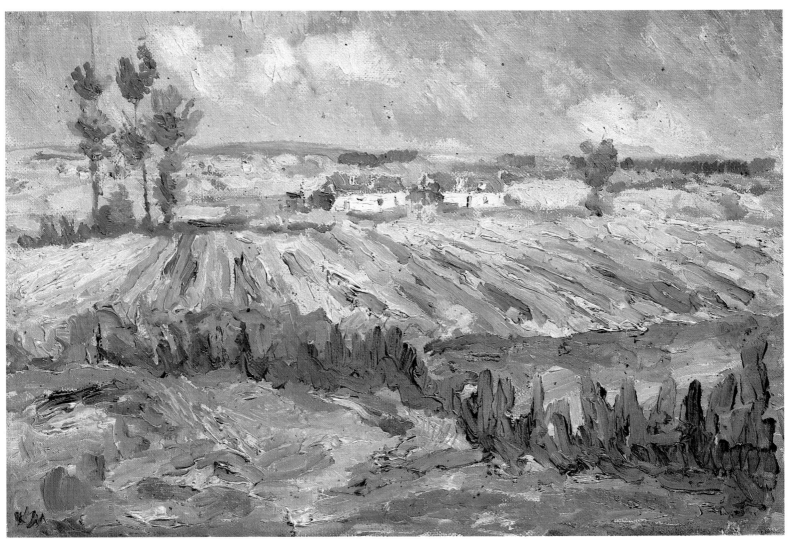

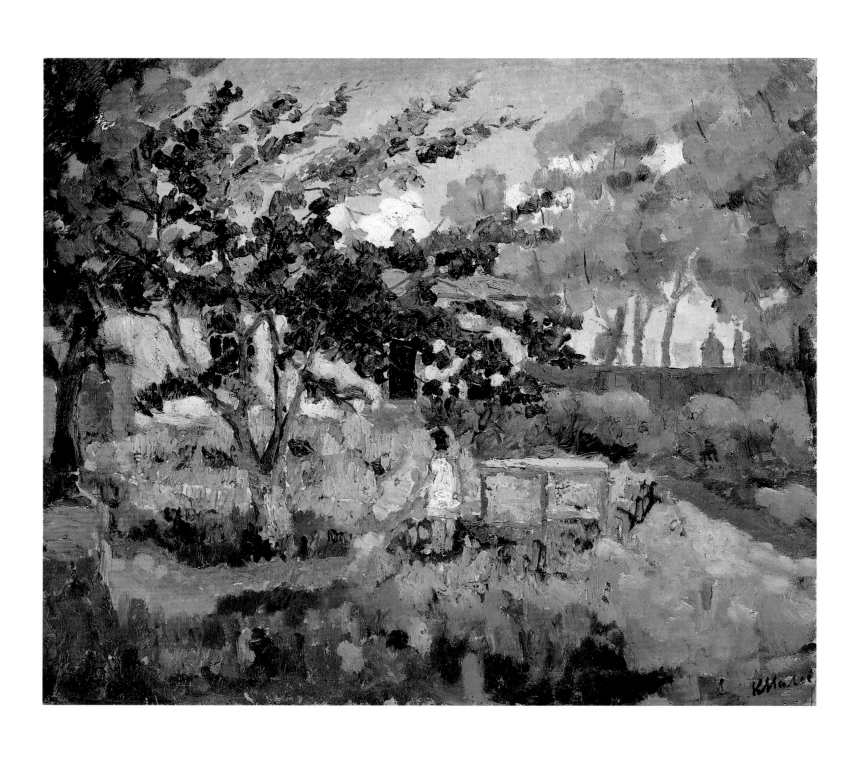

9 Summer. Landscape. *Oil on canvas. 48.5×55 cm*

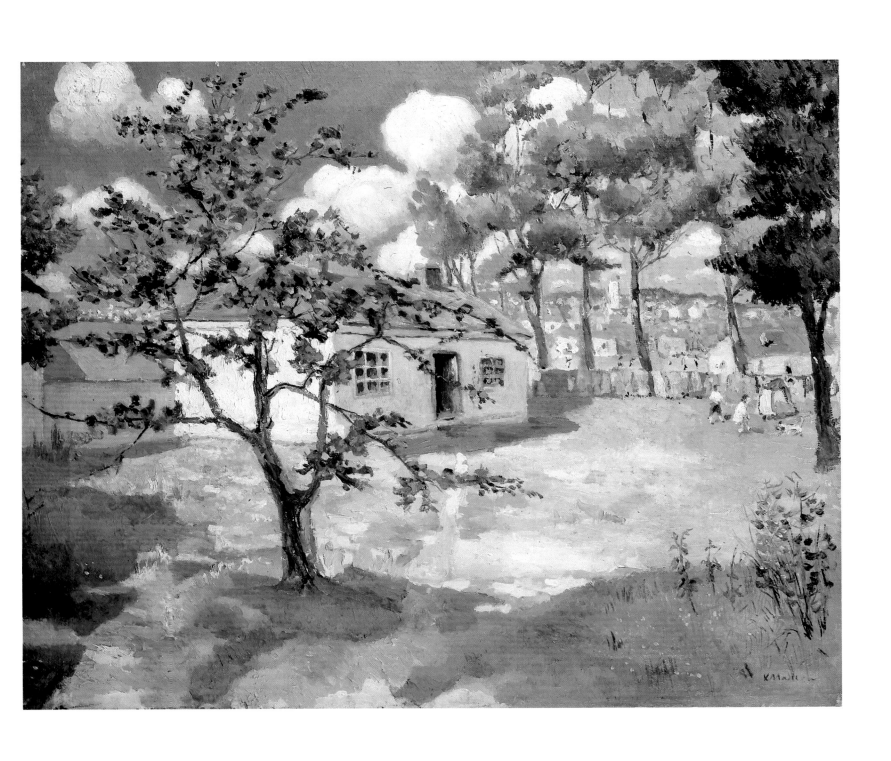

10 Spring, 1905–6. *Oil on canvas. 53×66 cm*

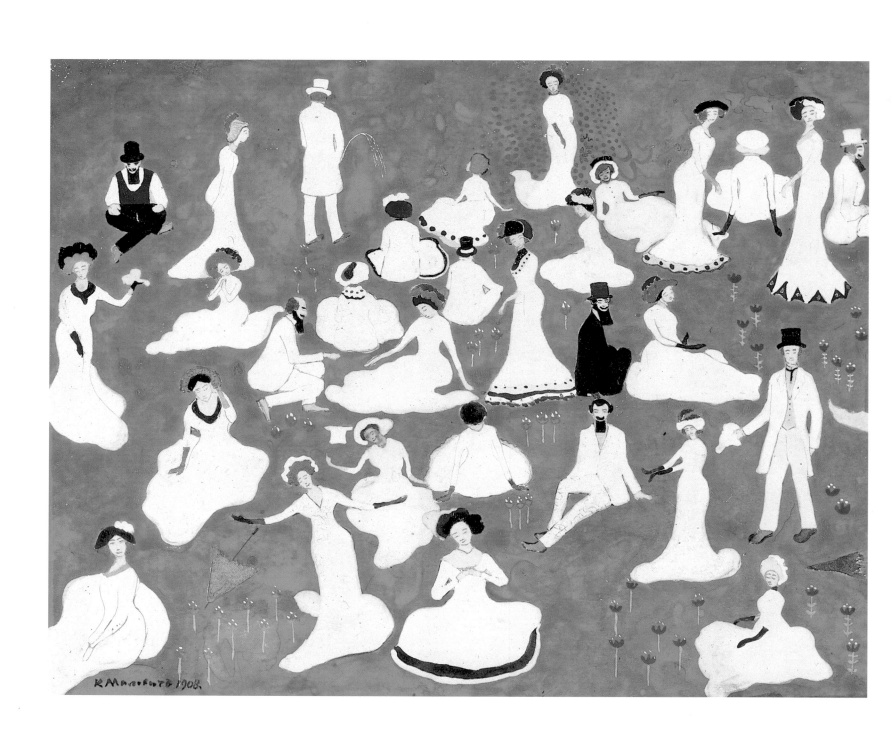

11 Relaxing. High Society in Top Hats, 1908
Watercolour, gouache, Indian ink, and whiting on cardboard. 23.8×30.2 cm

12 Study for fresco painting: Self-Portrait (?), 1907. *Tempera on cardboard. 69.3×70 cm*

13 **Study for fresco painting, 1907.** *Tempera on cardboard. 69.3×71.5 cm*

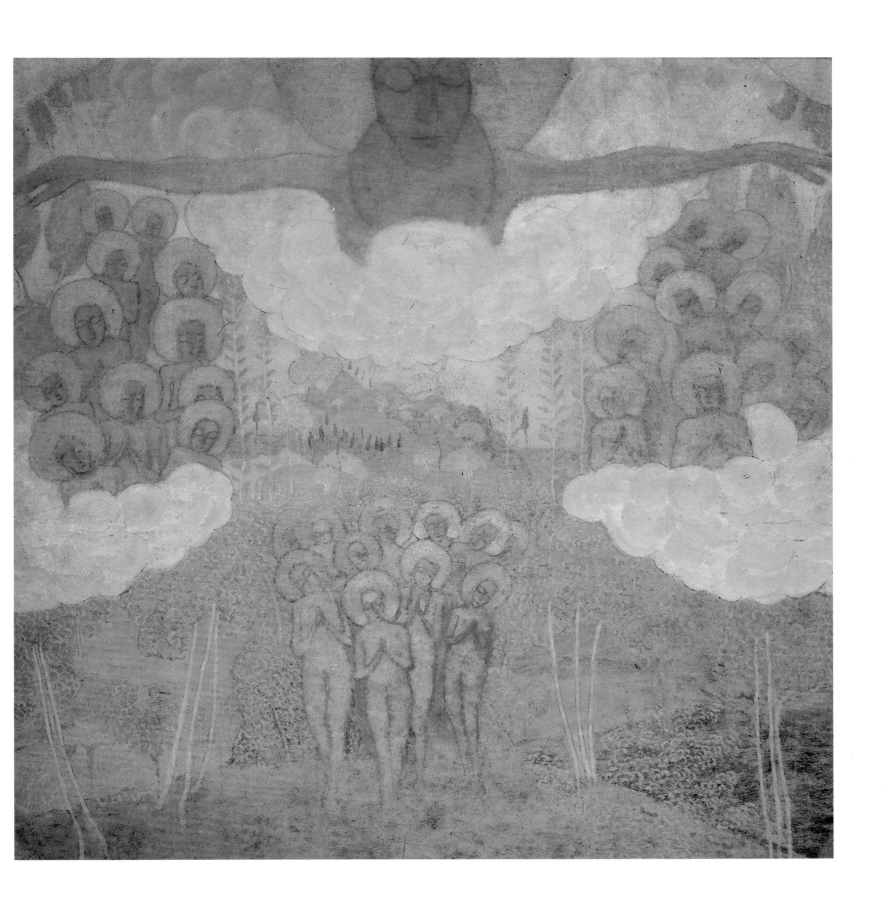

14 Study for fresco painting: Triumph of the Heavens (?), 1907. *Tempera on cardboard. 72.5×70 cm*

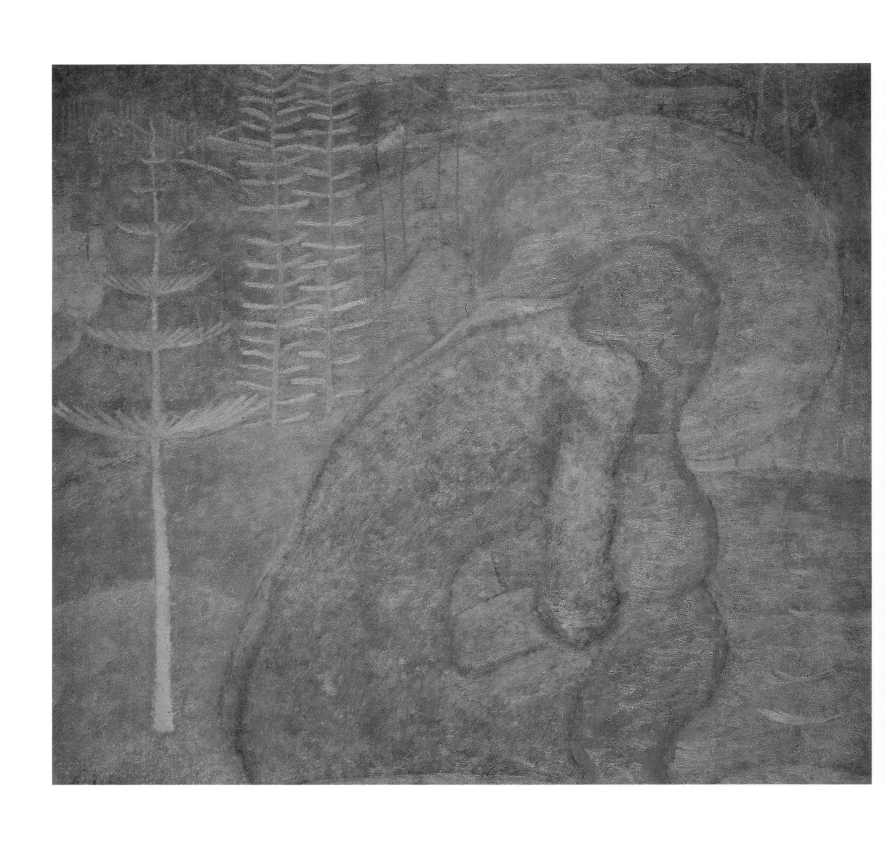

15 Study for fresco painting: Prayer (?), 1907. *Tempera on cardboard. 70×74.8 cm*

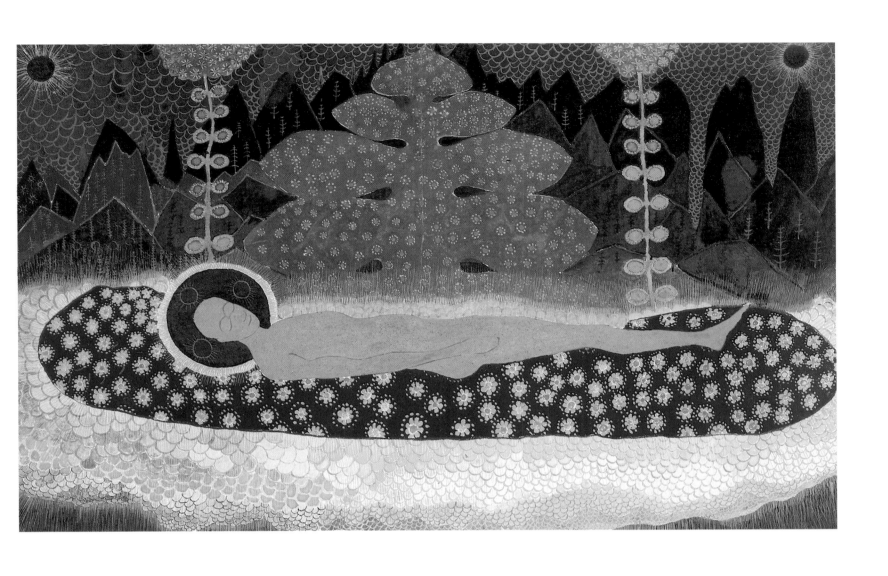

16 Shroud of Christ, 1908. *Gouache on cardboard. 23.4×34.3 cm*

17 Spring. Landscape with a House. *Oil on canvas. 58.4×48 cm*

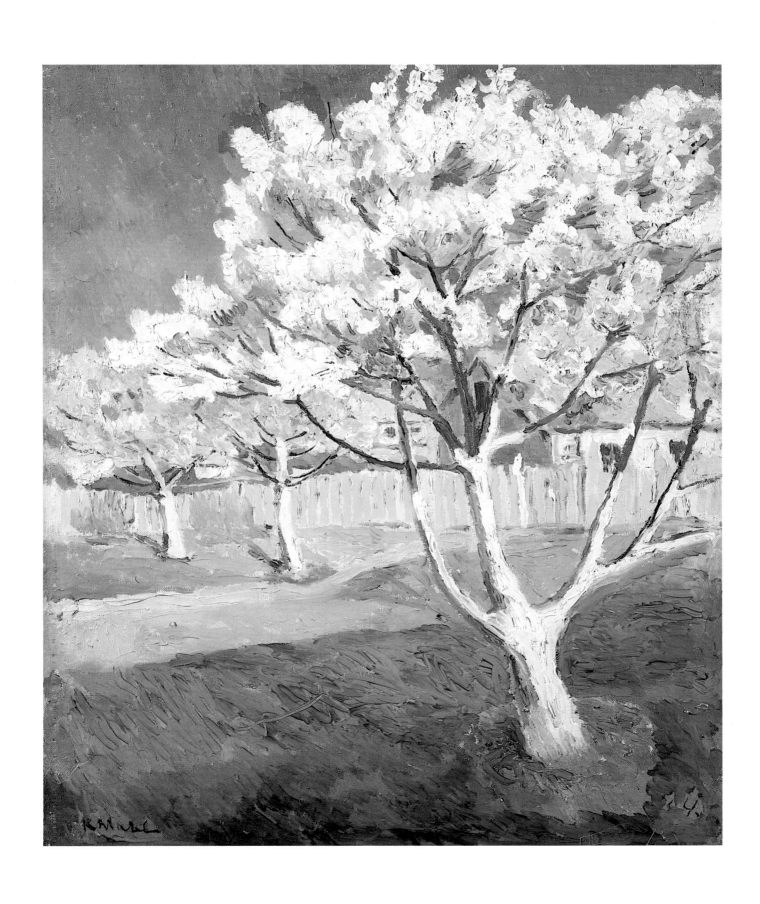

18 Apple-Trees in Blossom. *Oil on canvas. 57.5×49 cm*

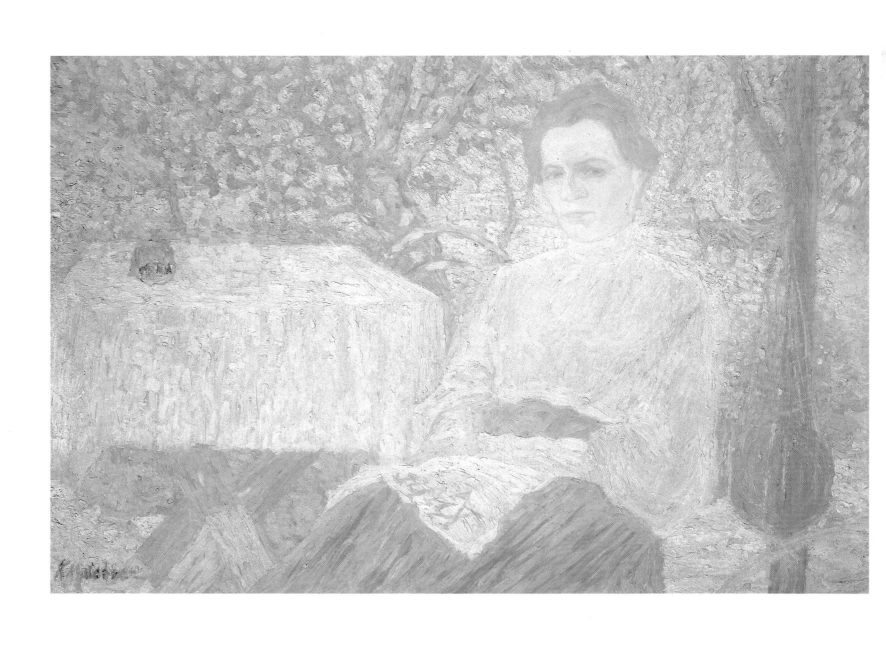

19 Portrait of a Member of the Artist's Family, c. 1906. *Oil on canvas. 68×99 cm*

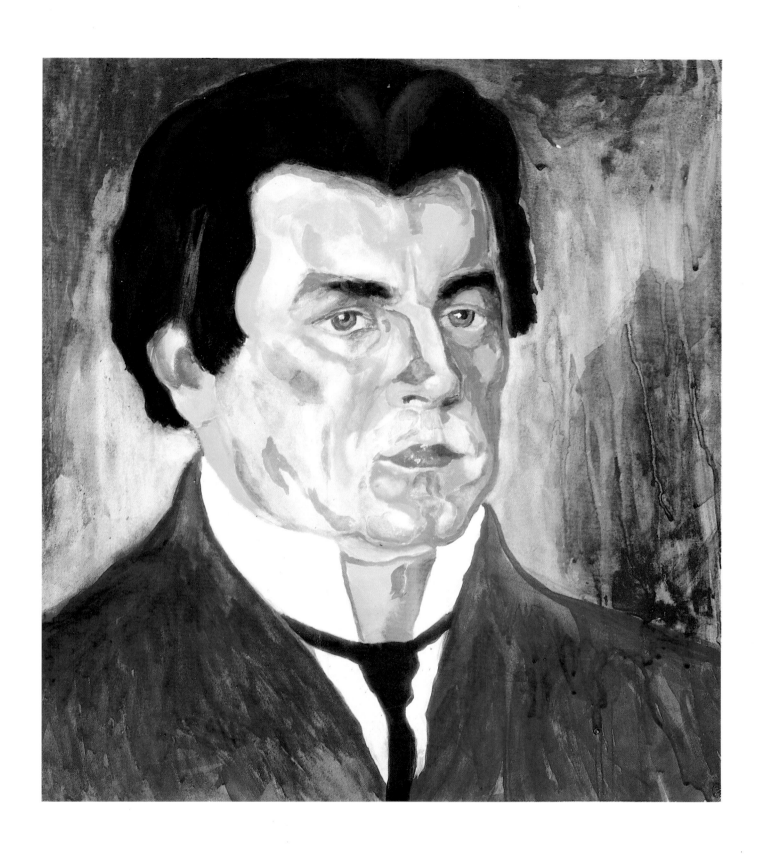

20 **Self-Portrait, 1908 or 1910–11?** *Gouache, watercolour, Indian ink, and varnish. 46.2×41.3 cm*

21 Landscape with a Yellow House, 1906–7. *Oil on cardboard. 19.2×29.5 cm*

22 **Landscape, 1906—8.** *Oil on cardboard. 19.2×31 cm*

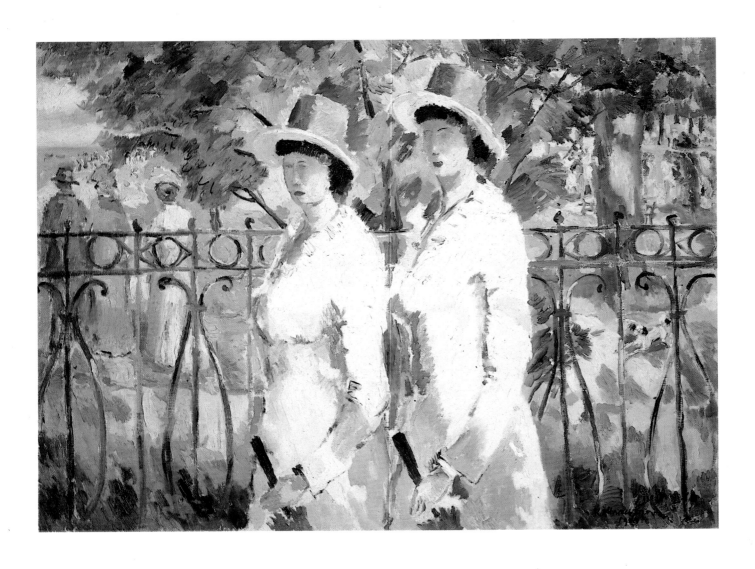

23　Sisters, 1910. *Oil on canvas. 76×101 cm*

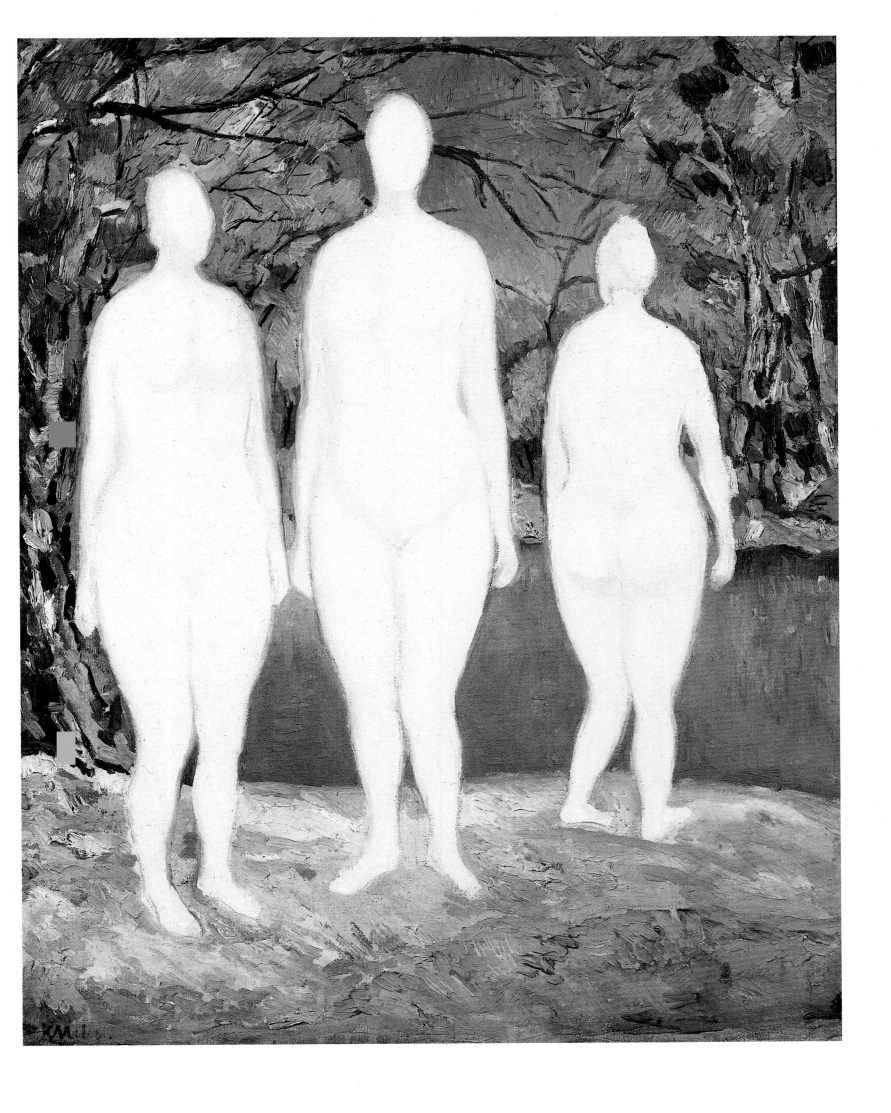

24 **Bathing Women, 1908.** *Oil on canvas. 59×48 cm*

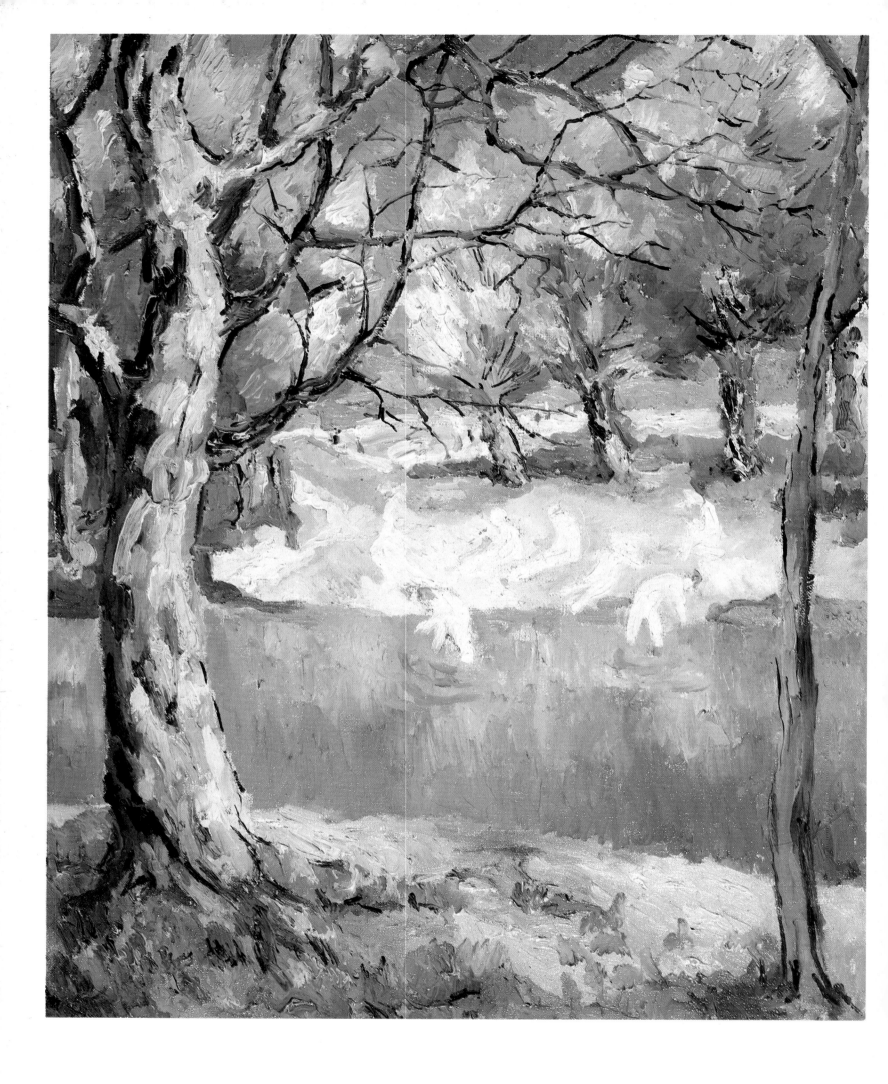

25 River in the Forest, 1908. *Oil on canvas. 53×42 cm*

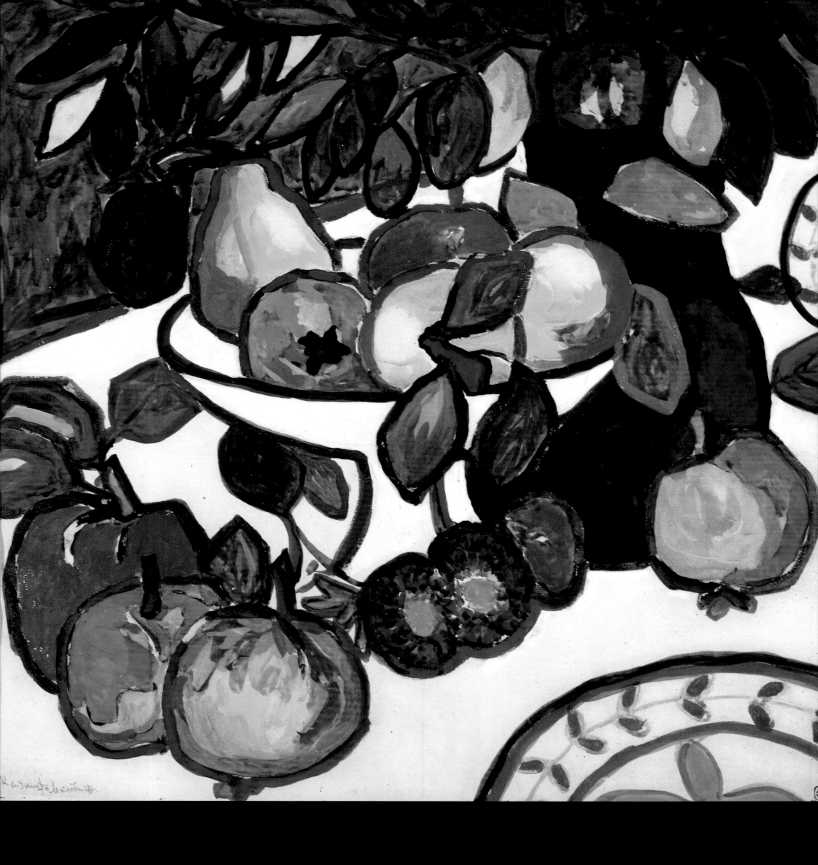

26 **Still Life, 1908 or 1910–11?** *Watercolour and gouache, 52.5×51.8 cm*

Malevich and Western European Art Theory

Malevich's theories of Cubism and Suprematism were not isolated or even especially unique: they existed within a continuum of art historical concepts that underlie much of European modernism in the first years of this century. Malevich shared his view of the universe and his basic propositions about the role of art with the Cubists, Orphists and Italian Futurists, among others, and they reveal a fairly detailed understanding of contemporary discussions of modern painting. When the artist took the further step into objectless art, he extended these concepts to explain the disappearance of objects in Suprematism.

This paper compares the early theories of Malevich with those of Albert Gleizes, Jean Metzinger, Robert and Sonia Delaunay, and Umberto Boccioni—compares Malevich's Cubo-Futurism and Suprematism on the one hand, and Cubism, Orphism and Italian Futurism on the other. Similar analogies, with similar results, could be drawn between the theoretical positions of many of the avant-garde—Francis Picabia, František Kupka, or Franz Marc, to name only three; but since the close historical and biographical connections between Western European modernists and the Russian art world are very well known and need not be described in detail, only a few points should be made here.

We now think of Cubism, Orphism (or Simultanism) and Italian Futurism as separate movements, but in fact the *theories* associated with these very distinct styles of painting—and aesthetic intentions—had much in common. The historical reasons for the theoretical affinities are clear. The artists in question all responded to the same scientific, philosophical and religious ideas pervading Europe at the time; they all knew one another personally, and in several cases they pursued their theoretical investigations together, discussing one idea after another over the months and years.

Metzinger and Robert Delaunay, who earlier were Neo-Impressionists, had long been close friends. They became intimate with Albert Gleizes in 1910, and the scandal associated with the works of these three and Fernand Léger, in Room 41 of the 'Salon des Indépendants' in 1911, gave Cubism its name. Umberto Boccioni went to Paris from Italy in October of that year, met Metzinger and visited him in his studio. Prior to that, Boccioni seems to have had a liaison with a Russian woman and spent October, 1906 in Moscow and Petersburg. There is ample evidence that Russian artists, including Kandinsky (he and Robert Delaunay were in correspondence in 1912 about their colour theories), recognized the importance of Orphism immediately, while the Cubists did not. Gleizes in 1934 admitted this: 'We judged it monotonous from the point of view of form....'[1]

This consideration of their artistic theories is based on works written between 1910 and the beginning of the First World War.

Metzinger published 'Notes of a Painter' in 1910. Boccioni wrote 'The Technical Manifesto of Painting' in the same year; he delivered an important lecture on Futurist painting in Rome in May, 1911, and published 'The Technical Manifesto of Sculpture' in the spring of 1912. Gleizes and Metzinger wrote *Du Cubisme* during 1912 and published the book that fall. Gleizes and Metzinger were friends of the three Duchamp brothers at that time, as well as and the Delaunays, Kupka, and Picabia. They all discussed art continually, and *Cubism* can legitimately be considered the result of shared thinking to some extent. Robert Delaunay's work was to appear in the volume, but in the end he withdrew, in part because he was developing his Orphist style, and stopped considering himself a Cubist. He published his own essays, written in 1912: 'Reality of Pure Painting' in *Der Sturm* in December, 1912 and 'Light' in the same journal the following month. (Herwarth Walden's Der Sturm Galerie in Berlin was something all of these painters, including the Italians, had in common.[2])

While the stylistic groups were very anxious to distinguish themselves from one another, even to the point of fisticuffs, they all acknowledged major changes occurring in the way the world was viewed, due to the popularization of new scientific concepts and the rush of new technology. All occupied the same territory. They were vaguely uneasy with the mechanical, Newtonian universe, but had not yet assimilated the

revolutionary theories of Minkowski or Einstein, and inclined to a 'cosmic dynamism' bolstered by the ideas of Henri Bergson, whose books were very popular and who travelled about giving public lectures. The universe was both material and immaterial; matter and energy were related, and space and time could no longer be considered separately. Perhaps because of flying, the newly popular means of transport, everyone was suddenly aware of a cosmos of immense proportions, in which the earth was but a tiny part; and the whole was continually in motion, not with the tidy circularities of Newton's orbits, but with a kind of superfluidity of waves, oscillations, vibrations and currents.

Such a universe was difficult to visualize precisely, but world of discrete, opaque objects now seemed clearly false. Electrical energy, x-rays, magnetic lines of force—all immaterial phenomena—could obviously penetrate so-called solid objects which, according to scientific explanations, were composed not of matter but of space and atomic forces. Even the new technology demonstrated this. Wireless telegraphy and radio proved that solid bodies presented no obstacles at all to energy and 'forces'.

This vision was accompanied by the belief in continuous universal and inevitable progress, an idea derived from Darwinian evolution and reinforced by technological advances. Living matter was thought to possess a vital force, and its specific outer changes were conditioned by an inherent and essential principle of form, associated with the material itself. Thus matter and spirit, material and vital energy were considered two aspects of the same phenomenon. This was closely analogous to the late-eighteenth century rhapsodizing over nature, the understanding of matter as dormant spirit, and spirit as matter in the process of becoming. In the twentieth century, however, the philosophical basis of a dynamic and unified nature accessible only to the senses seemed welded to a solidly scientific footing.[3]

Sonia Delaunay throughout her life remained in constant touch with various Russian artists and poets. The Delaunay archives in the Bibliothèque Nationale in Paris include letters from Alexander Archipenko, Vladimir Baranov (Baranov-Rossiné), Georgi Yakulov, Vasily Kandinsky, and Vladimir Mayakovsky, among many others.[4] Yakulov was very close to the Delaunays, Ludmila Vilkina and Nikolai Minsky visited them in 1912, and a draft of Robert's letter to Minsky from 1912 is among the best descriptions we have of his colour theory.[5] Sonia's old friend, the future medievalist Alexander Alexandrovich Smirnov, not only visited them, but from 1904 he carried on a lively correspondence with her. The archives from 1904 to 1914 contain almost 200 cards and letters from Smirnov alone[6]; and on Sunday evening, 22 December 1913, Smirnov read a lecture at the Stray Dog club on the subject of 'simultané', showing photographs and displaying Sonia's simultaneous 'book', the long poem *La Prose du Transsibérien et de la Petite Jehanne de France*, by the poet Blaise Cendrars[7] (who was a close friend of the Delaunays and travelled several times to Russia).

Smirnov took note of 'the basic contradiction between *sjuzhet* [subject] and painterly tasks in Western art', and the unsuccessful attempts of Cubism and Futurism to resolve it. Many artists and writers participated in the ensuing debate, including some who knew Sonia Delaunay personally. Among those involved in the discussion after the lecture were Pavel Kuznetsov, Iosif Shkolnik, Mstislav Dobuzhinsky, Pavel Filonov, Dmitry Filosofov, Sergei Gorodetsky, Nikolai Gumilev, Anna Akhmatova, Mikhail Kuzmin, Nikolai Kulbin, Igor Severianin, Nikolai Burliuk, Georgi Chulkov, Alexei Tolstoy, and Yakulov.[8]

Both Malevich and Robert Delaunay showed in the second 'Blue Rider' exhibition in Munich early in 1912. In the fall of 1912, Alexander Archipenko and Alexandra Exter took part in the 'Section d'Or' exhibition together with Gleizes and Metzinger, whose book *Du Cubisme* appeared in Russia in several translations the following year.[9] 'The First German Fall Salon' at Der Sturm Galerie in Berlin in September, 1913 included Boccioni and other Italian Futurists, the Delaunays, the Burliuk brothers, Yakulov, Gleizes and Metzinger, Kandinsky and Kulbin. And in 1914 Sonia Delaunay, Malevich, the Burliuks and all the French contingent appeared in the 'Salon des Indépendants' in Paris.

In connection with the interrelationships of aesthetic theory, special note should be taken of the article 'Free Music', by Nikolai Kulbin, published in Kandinsky's *Blue Rider Almanac* in May, 1912. This was a restatement of his small 1910 book of the same title. In 1910 he also published the important 'Free Art as the Basis of Life' in the collection *The Impressionists' Studio*.[10] Kulbin, a physician, was an agitator for the new art and a supporter of the Cubo-Futurists. Between 1910 and 1912 he carried on a correspondence with Kandinsky.[11] More important, he understood the scientific theory on which much of the aesthetic theory was based.

While the influence of Kulbin's ideas on the Russian avant-garde are clear, one should also examine his influence further West. In her 1982 book on Robert Delaunay, the American art historian Sherry Buckberrough notes the similarity between the colour activity in Delaunay's *Window* paintings (1912) and Kulbin's description of colour painting and analogies to music in his article published in *The Blue Rider Almanac*.[12] Since Delaunay's paintings preceded the publication of the *Almanac*, however, she was forced to leave the matter unresolved, nor was she aware that the *Blue Rider* essay is merely a condensation of Kulbin's booklet

Free Music and his essay *'Free Art as the Basis of Life'*, both from 1910. Given the close connections the Delaunays maintained with the Russian art world, it would be very strange indeed if Delaunay had not known about Kulbin's theories.[13]

Four aspects of aesthetic theory are of particular note to this comparative study: sensation as the primary information that the artist receives, and in turn transmits, through the work of art; the notion that human psychology, and especially the psychology of the artist, is undergoing some sort of radical transformation; universal dynamism; and the role of colour in art.

According to all of these artists, any art that took into account the new understanding of the world could not be tied to normal optical experience, because that experience is clearly illusory. It was their challenge to discover what lay behind the apparent world of opaque bodies, and to find the visual means of demonstrating that more basic reality to the viewer...and *demonstrating*—not depicting, not describing—was very precisely their task. In this sense modern painting became an experimental activity, and the role of the artist grew close to that of the experimental psychologist. The Delaunays, Gleizes, Metzinger and Boccioni believed that the most reliable indication of the external world lay, paradoxically, within ourselves. Not that objects did not have an independent existence, but that we, human beings, could know only what our senses told us. In *Du Cubisme*, Gleizes and Metzinger write:

'There is nothing real except the coincidence of a sensation and an individual mental direction. Far from us is any thought of doubting the existence of the objects which strike our senses; but being reasonable, we can only have certitude with regard to the images which they make blossom in our mind.'[14]

The term 'sensation' is a central one to aesthetic theory at this time. Like the Cubists, Boccioni maintained that 'the true reality is sensation'.[15] It is the only thing we can be sure about, the entirety of our experience of the world outside. Our artists here are following the extremely popular Henri Bergson, and, at a somewhat greater remove, the 18th-century Irish philosopher of immaterialism, George Bishop Berkeley, whose sensationism enjoyed a resurgence at this time. Berkeley was also important for Bergson's philosophy, and in 1907–9 Bergson gave lectures about him at the Collège de France.[16]

The discovery and measurement of sensations was also one of the principal topics in mainstream medical research of the day. The German scientist Wilhelm Wundt defined sensations as physiological, i. e., material, but of a kind that acts upon a person's 'soul' or 'psyche', either subliminally (when the sensations are weak) or consciously (when they are stronger).[17] Sensations, produced in human beings by such 'immaterial' things as energy and colour, were regarded as the edge, the transfer point between the immaterial and the material realm. Nikolai Kulbin, a practising physician, was also a medical researcher, a specialist precisely in the mechanism and effects of subliminal sensations. His brochure *Sensitivity: Essays on Psychometry and Clinical Application of its Data*, published in Petersburg in 1907, was a study of sensations and the 'subliminal consciousness' that exists below the threshold of feeling.[18]

And it was not only scientists and physicians who read Wundt. Alexander Smirnov in November, 1904 recommended him to Sonia Delaunay: 'I understand you are especially interested in the connection between psychic and bodily phenomena. A major work is Wundt, *Physiologische Psychologie*; there is a Russian translation.'[19] By January of 1910, Kulbin was giving public lectures in which he maintained that 'our world consists of sensations', and had developed a theory of artistic creation in which he connected sensation with consciousness and the creative imagination.[20]

Gleizes and Metzinger, along with Boccioni, also believed that the recipient of sensations—the psyche or soul—was becoming more sensitive as the human species evolves. Advanced people, and especially artists, were becoming capable of detecting more and more subtle immaterial influences. Boccioni in his 1911 lecture said: 'A radical change has come about in our spirit. Our time initiates a new era, naming us the primitives of a new, completely transformed sensibility.'[21]

Malevich developed his aesthetic ideas within the same conceptual structure. For him also the picture comes from within, is a product of biology and psyche and a way of communicating sensation. Like his Western counterparts, he meant by sensation not emotional feeling but the inner psychological, yet physically based, sensation. Alexei Kruchenykh, whose writings provided the theoretical foundation for Cubo-Futurism, comes closer to Malevich's conception than anyone else. Several of Kruchenykh's concepts, in turn, were based on the theories of Kulbin.

The Cubo-Futurists argued that the evolution of the psyche over time accounted for the succession of styles in art, especially the newest painting styles. In the manifesto in *Sadok sudei II* (A Trap for Judges, II), they declared that '...We know feelings which had no life before us. We are the new people of a new life.' In 'New Ways of the Word', they insisted that 'Art marches in the vanguard of the psychic evolution.'[22] The historical context in which Malevich placed Suprematism sprang explicitly from the assertion that external form in art gave evidence of psychic or psychological states of being and of physiological evolution—

Boccioni's 'transformed sensibility'. Art and psyche were so closely associated in Malevich's thinking that when he began to teach, he judged students' psychic evolution by the style of their drawing.[23]

Central to the Cubo-Futurist understanding of the new art is Kruchenykh's notion of *zaum* language, a transcendental language of the future that would be the outward manifestation of the artist's evolutionary change in consciousness, as well as the mode for conveying his consequent altered perceptions. Malevich, before he discovered Suprematism, hoped that his Cubist style of painting could function as the visual expression of the *zaum* state. He characterized work closely related to Italian Futurism, like *Morning in the Village after the Snowstorm* (1912) and *Carpenters* (1912), as '*zaumnyi* realism'. In 1913 and 1914 he worked on several variants of Cubism in an effort to depict the world as perceived through a transformed consciousness. He wrote to Matyushin in July, 1913:

'We have come as far as the rejection of reason, but we rejected reason on the strength of the fact that another kind of reason has grown within us, which in comparison with the one we rejected can be called "beyond reason" [*zaumnyi*], which also has law and construction and sense, and only by learning this will we have work based on the law of the truly new "beyond reason". This [new] reason has found Cubism as the means to express a thing.'[24]

The Cubist form for Malevich came to act as a *sign* of the evolved psyche, an indication that such a transformation or evolution of the psyche had taken place within the individual artist, who was seeing the world with the new sensitivity. *Woman at the Tram Stop* (1913) is composed mainly of rectangular planes of colour organized in a Cubist structure. But since Malevich wants the viewer to be fully aware that this is the everyday world perceived at a higher level of experience, in places he reveals the objects standing behind the planes. A man in a bowler hat looks out through one rectangle, and the artist shows another 'pulled down' to reveal the bottle lurking behind it. In many other works, such as *Woman at a Poster Column* (1914), he conceals just half of a figure behind a coloured rectangle, his so-called 'partial eclipse'.

Western artists claimed a kind of clairvoyance for the artist, 'a psychic force that empowers the senses to perceive what has never been perceived before,' as Boccioni said in 1911. 'What needs to be painted is not the visible, but what has hitherto been held to be invisible, that is, what the clairvoyant painter sees. This will be *natural* for the future.'[25] Clairvoyance and the ability to see through solid objects is a property also of Kruchenykh's *zaum* state:

'We started seeing "here" and "there". The irrational (transrational) is conveyed to us as directly as the rational....

'We split the object open!

'We started seeing the world through the core.'[26]

Some of Malevich's first Suprematist works were indeed composed like 'slices' of earlier paintings. The Museum of Modern Art's *Suprematist Composition* (c. 1917) is made up of geometrical 'sections' of the Stedelijk Museum's earlier *Woodcutter* (c. 1913), and the outline of the pale, flat figure can be seen amidst 'slices' of the logs. In the process of evolution, the artist's intuition or psyche becomes ever more perceptive of subtle energies; a similar demand for sensitivity was made on the viewer in the *White on White* series of 1917. The woodcutter in *Suprematist Composition* (1918) has become a barely visible shadow of his former self.

Prior to this draining of even colour from his works in 1917–18, Malevich regarded colour and the sense of dynamism as the two most fundamental elements of painting. He and Western artists agreed that colour does not inhere in objects in nature, nor is it related to moods. They also rejected any symbolic meaning. Colour, they believed, is internal, produced in the mind by the vital energy of the world, and experienced directly. Malevich wrote:

'The picture—paint, colour—lies within our organism. Its outbursts are great and demanding.

'My nervous system is coloured by them.

'My brain burns with their colours.'[27]

Colour, understood as formless energy, demanded a corresponding expression without forms in art. Boccioni predicted just this as the psyche of the artist evolved:

'The human eye will see colours as feeling materialized. Colours...will not need forms to be understood, and pictorial works will become whirling musical compositions of enormous coloured gases. On a stage free of horizons, these works will excite and electrify the complex soul of a crowd we cannot yet conceive of.'[28]

The Delaunays had an analogous view. In their 'Disk' paintings, the contrasting colours seem to move towards or away from the viewer in a push-pull effect. Here, the Delaunays believed, we are actually perceiving the vital movement of the universe, the immaterial dynamic energy that is essentially formless.

In view of the importance of dynamic colour for Malevich, it is not surprising that one of the names he considered for his new Suprematist style was 'Orpho-Futurism'.[29] In his 1915 essay *From Cubism to*

Suprematism, he stated explicitly that movement and colour sensations are prior to form, and he ponders how they can be conveyed without objects:

'It seems to me that it is necessary to convey purely coloured motion in such a way that the picture will not lose a single one of its colours. Motion, the running of a horse, a locomotive, may be conveyed by a monotone pencil drawing, but not the motion of red, green, and blue masses.

'Therefore it is necessary to turn directly to the painted masses as such, and to look for inherent forms in them.'[30]

In Suprematism only the dynamic colour sensations remain, conveyed simply by rectangles of colour. They may be related to earthly objects, or to energies arriving from, or flying off into, space. But they are as close as the artist could come to a rendition of the sensations themselves, as perceived by the evolved psyche of the artist.

Proceeding from similar premises about nature and the role of art, many avant-garde artists arrived eventually at versions of objectlessness. The abstract styles, although closely associated with scientific ideas and advances in technology, are not at all the result of the destruction or breaking apart of an old harmony. Just the opposite is true. Abstract styles were the attempt to see deeply into the structure of the world, to bring together former dichotomies—matter and spirit, material and energy—and paint that unique place in nature where everything becomes one.

Malevich's view of art in the modern world had much in common with Cubism, Orphism, and Italian Futurism, but his approach to the objectless world was the most uncompromising pictorially, the one most exclusively based upon the properties inherent in the application of paint to canvas, and his Suprematist depiction of the deeper reality was the one farthest removed from the world visible to common sight.

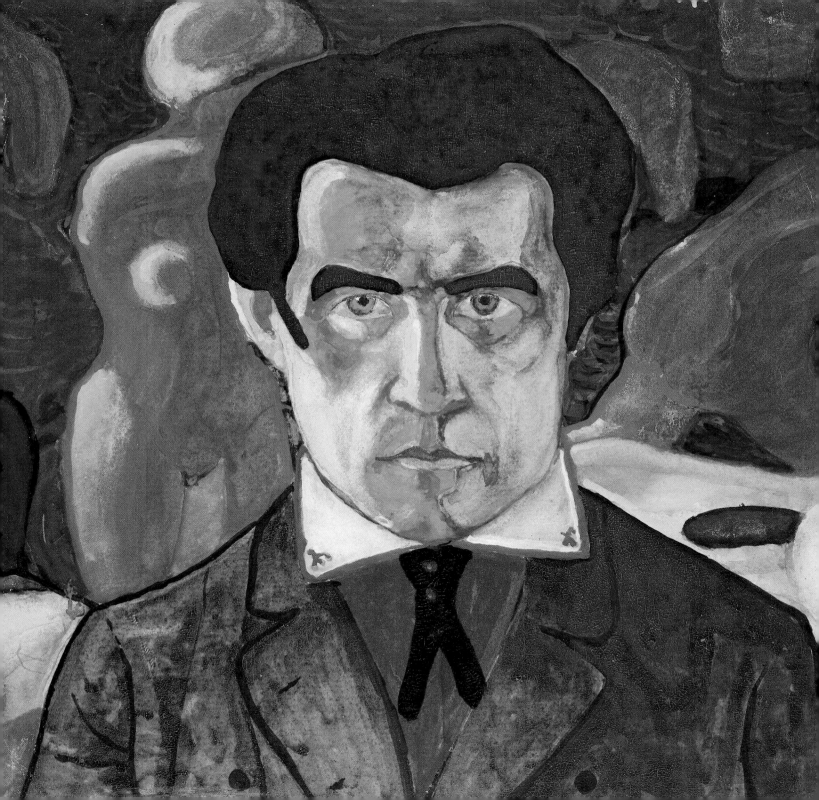

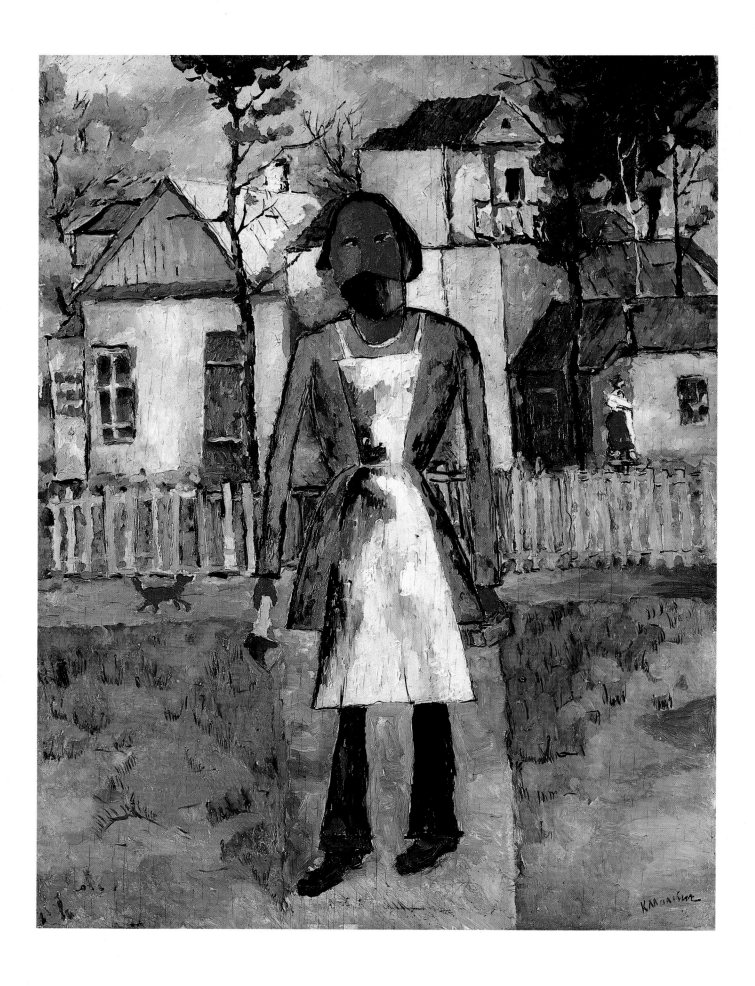

28 Carpenter, 1908–10 or after 1927? *Oil on plywood. 72×54 cm*

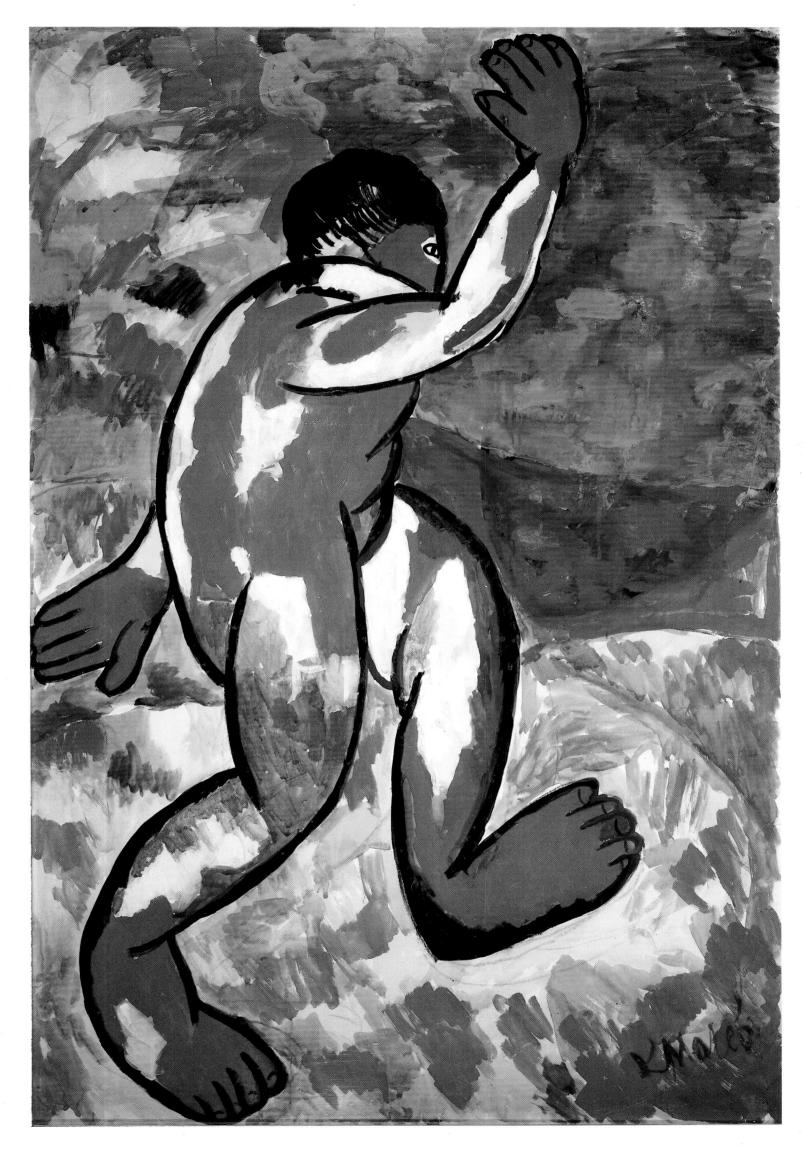

29 Bather, 1911. *Gouache. 105×69 cm*

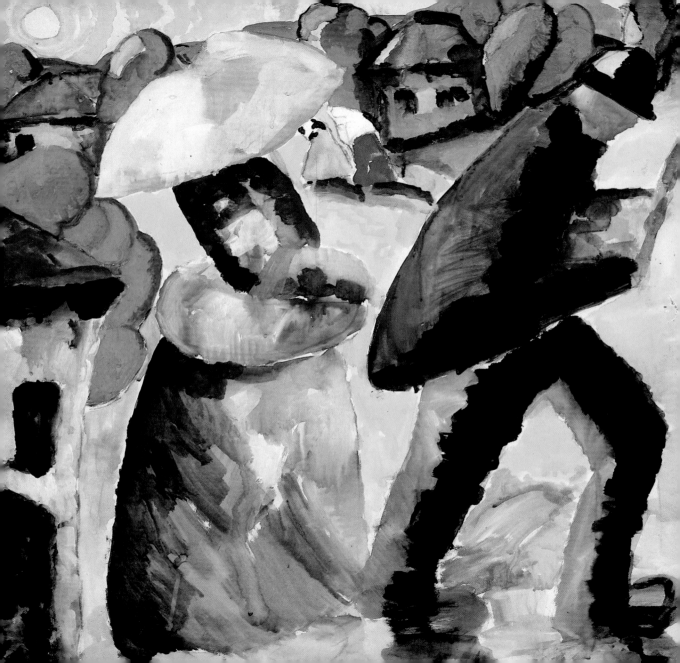

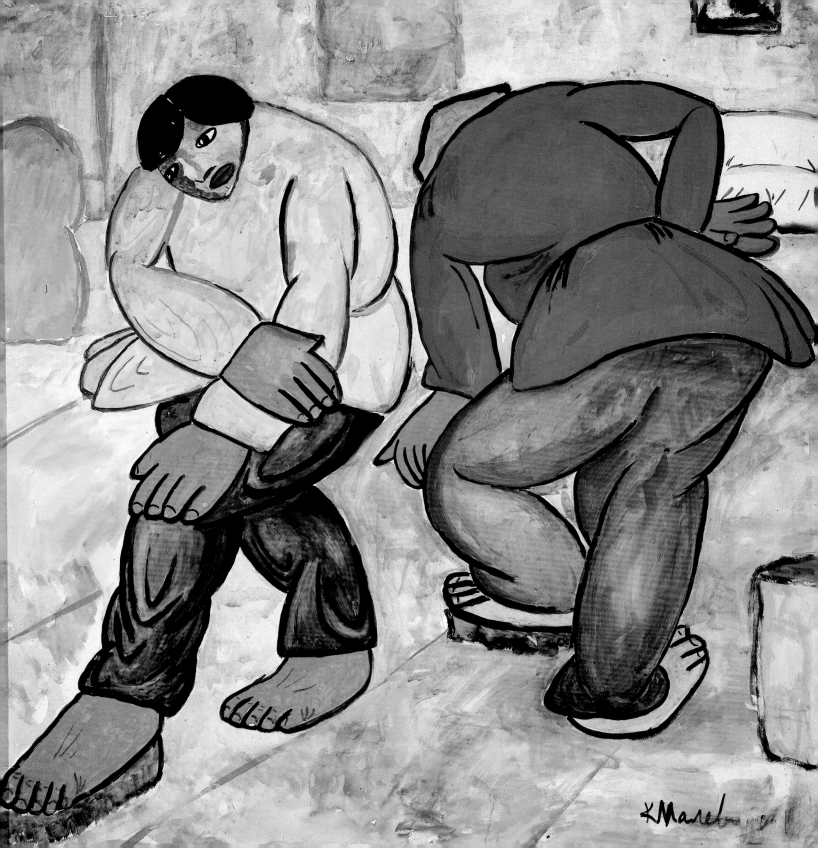

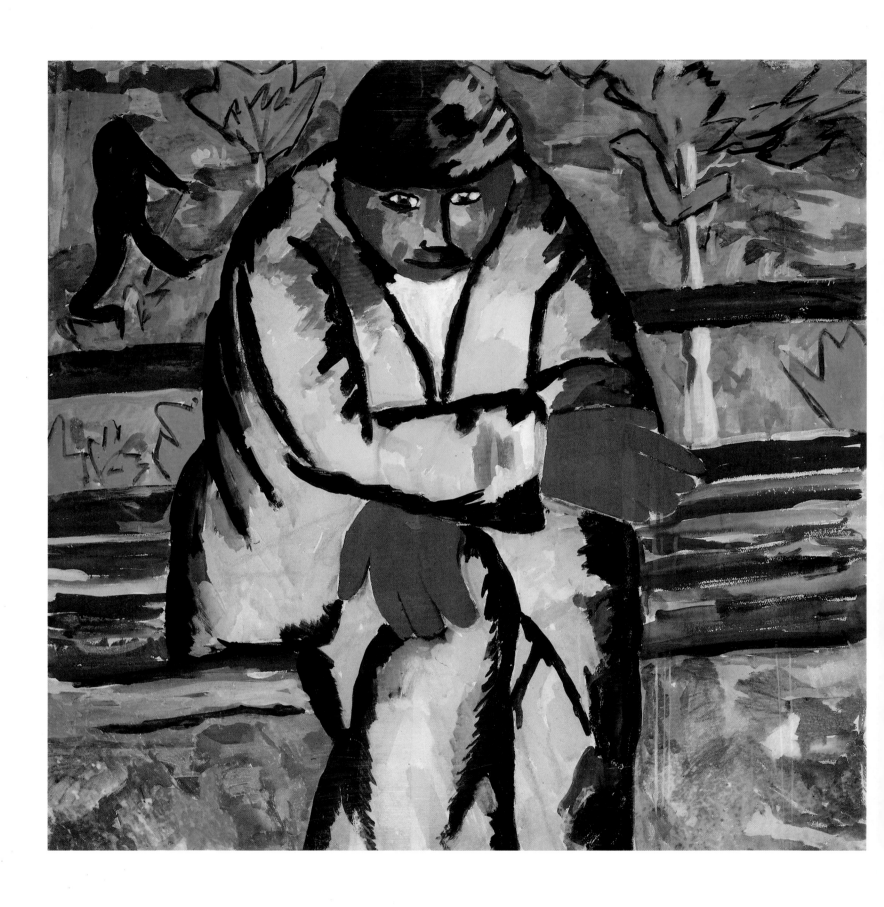

32 **On the Boulevard, 1911.** *Gouache. 72×71 cm*

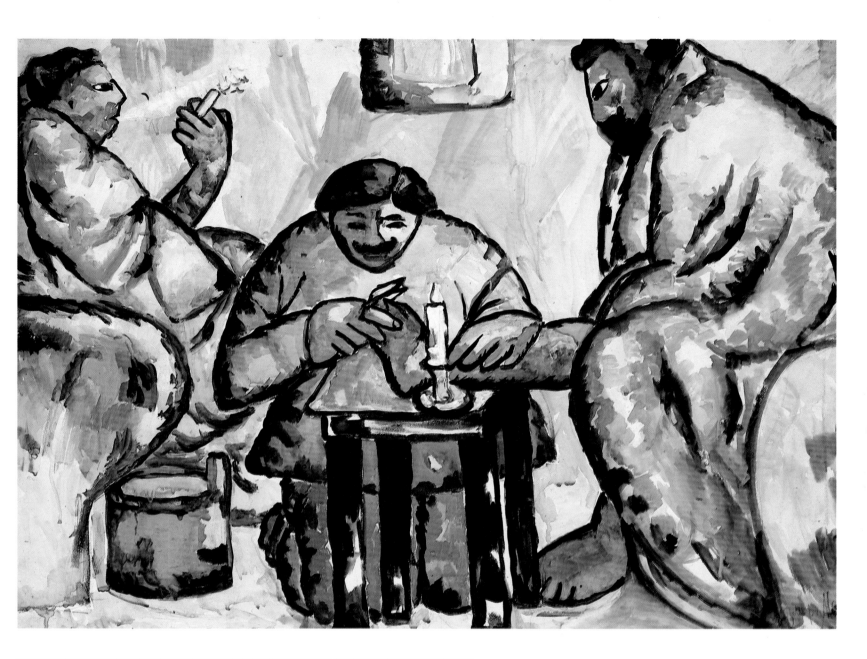

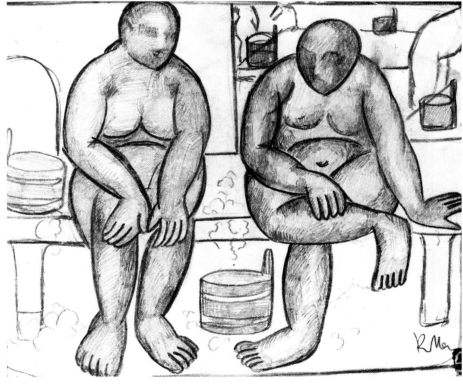

33 **Chiropodist at the Baths, 1911–12.** *Gouache. 77.7×103 cm*

34 **At the Bath-House, 1910–11.** *Pencil drawing. 13.3×16.2 cm*

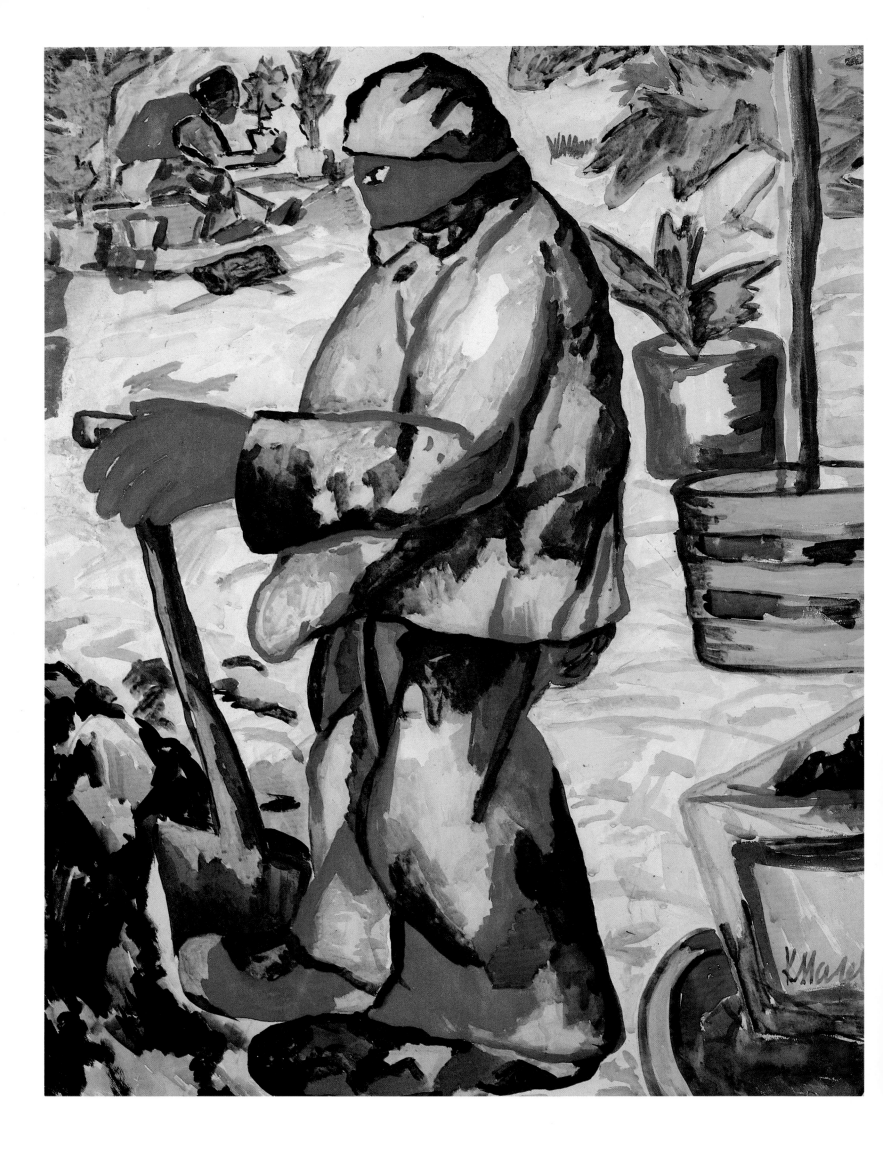

35 The Gardener, 1911. *Gouache. 91×70 cm*

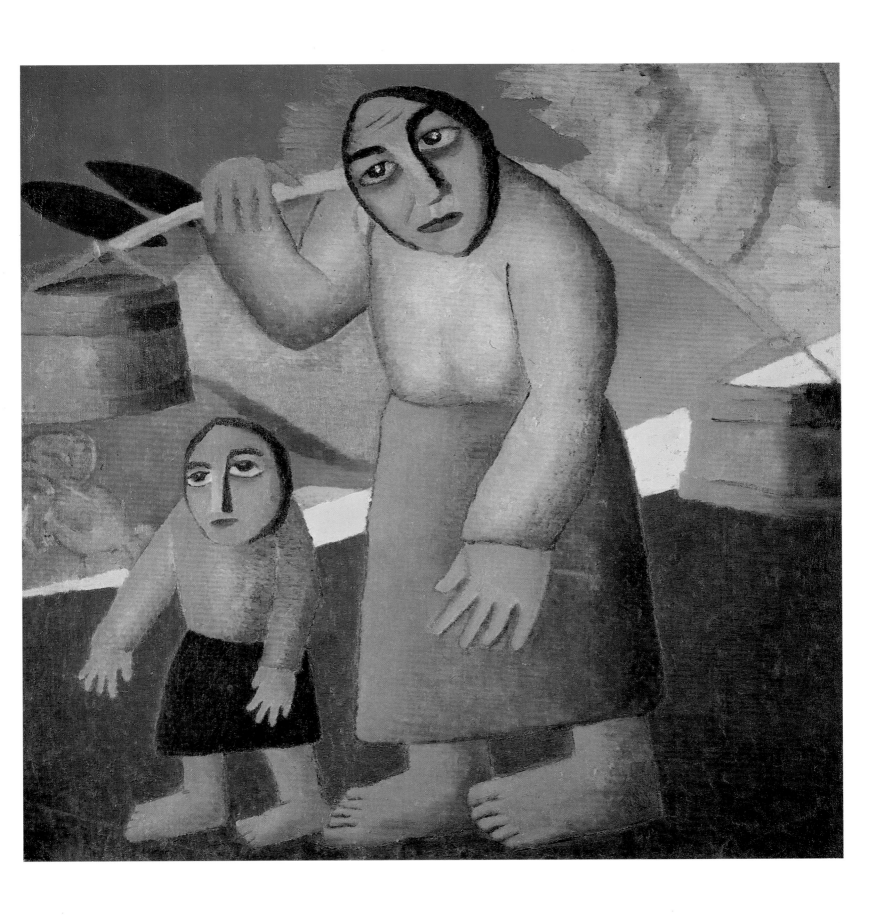

36 Peasant Woman with Buckets and Child, 1912. *Oil on canvas. 73×73 cm*

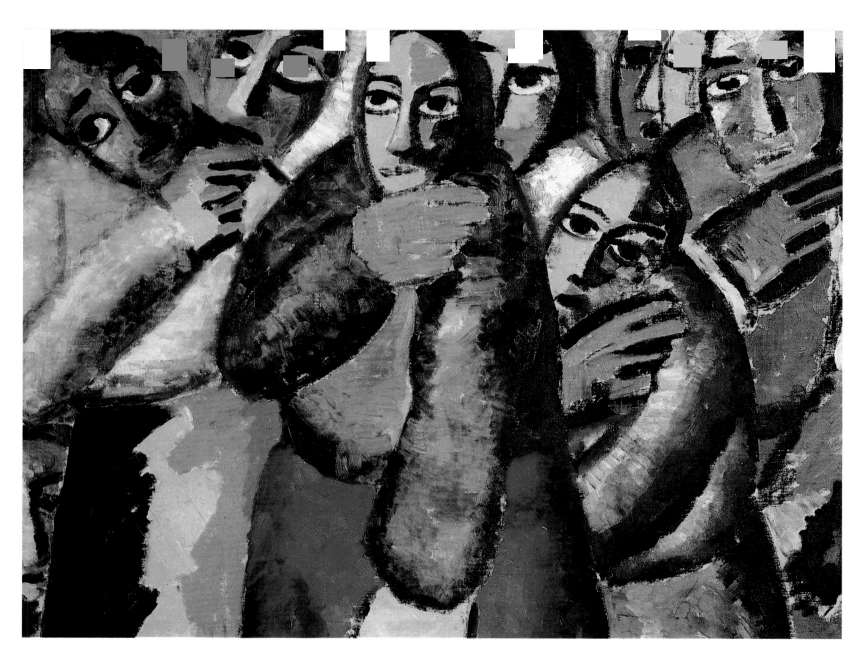

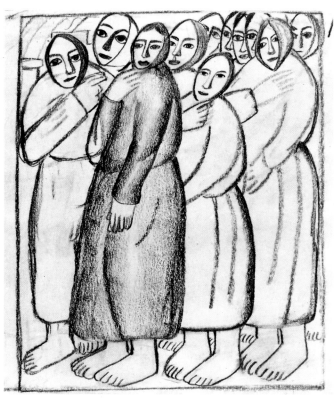

37 **Peasant Women at Church, 1911.** *Oil on canvas. 75×97.5 cm*

38 **Peasant Women at Church, 1911–12.** *Pencil drawing. 21.9×18.4 cm*

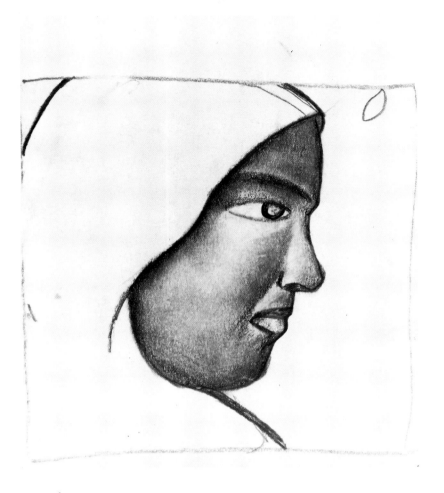

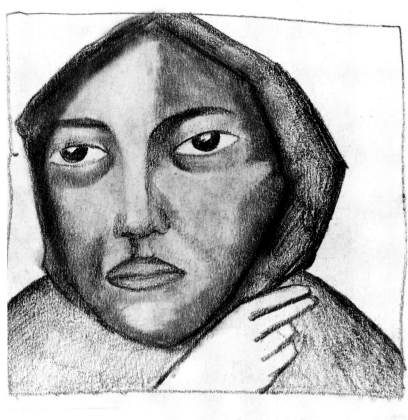

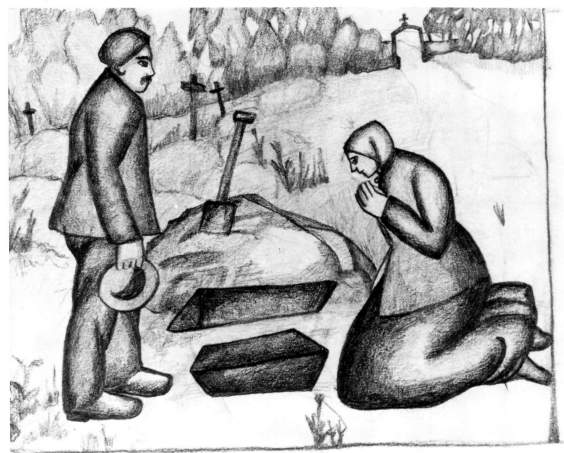

39 **Woman's Head in Profile, 1911–12.** *Pencil drawing and shading. 18.6×14.2 cm*

40 **Woman in Prayer, 1911–12.** *Pencil drawing. 18.6×14.2 cm*

41 **At the Cemetery, 1910–11.** *Pencil drawing. 15.2×17.7 cm*

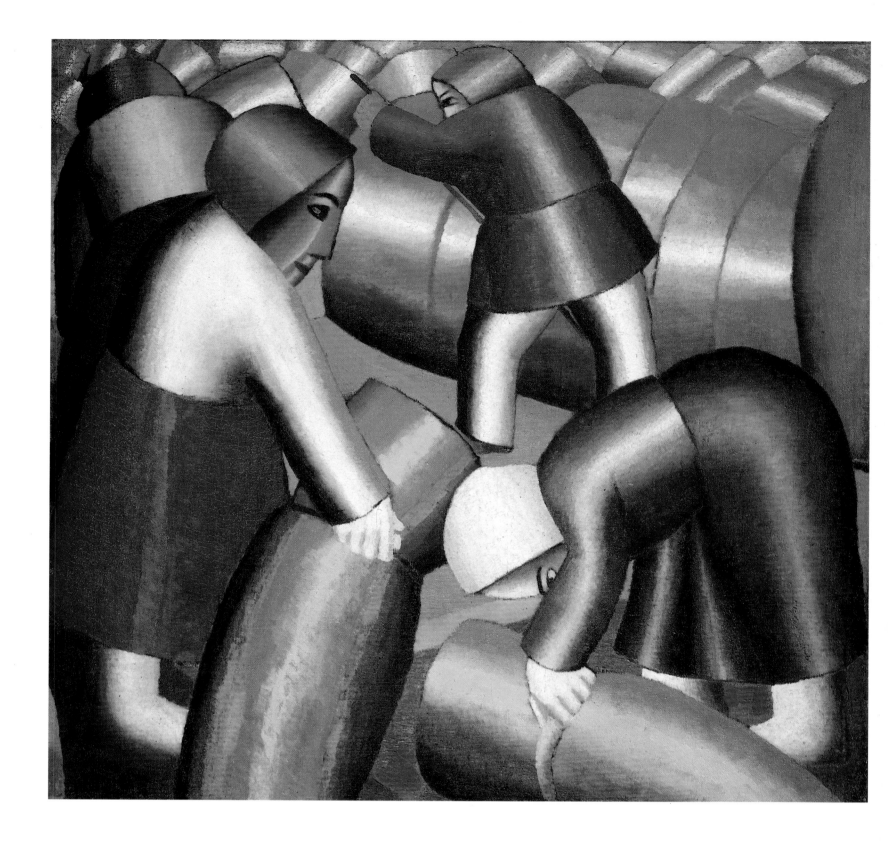

42 Taking in the Rye, 1912. *Oil on canvas. 72×74.5 cm*

43 **Woodcutter, 1913.** *Pencil drawing. 17.1×17.7 cm*

44 **Study for the Portrait of a Builder (Portrait of Ivan Kliun?).** *Pencil drawing.49.6×33.4 cm*

45 **Peasant Woman with Buckets, 1912–13.** *Pencil drawing. 10.5×10.7 cm*

46 **Peasant Woman with Buckets, 1913.** *Illustration in Alexei Kruchenykh's* Let Us Grumble! *Lithograph. 9.7×10.5 cm*

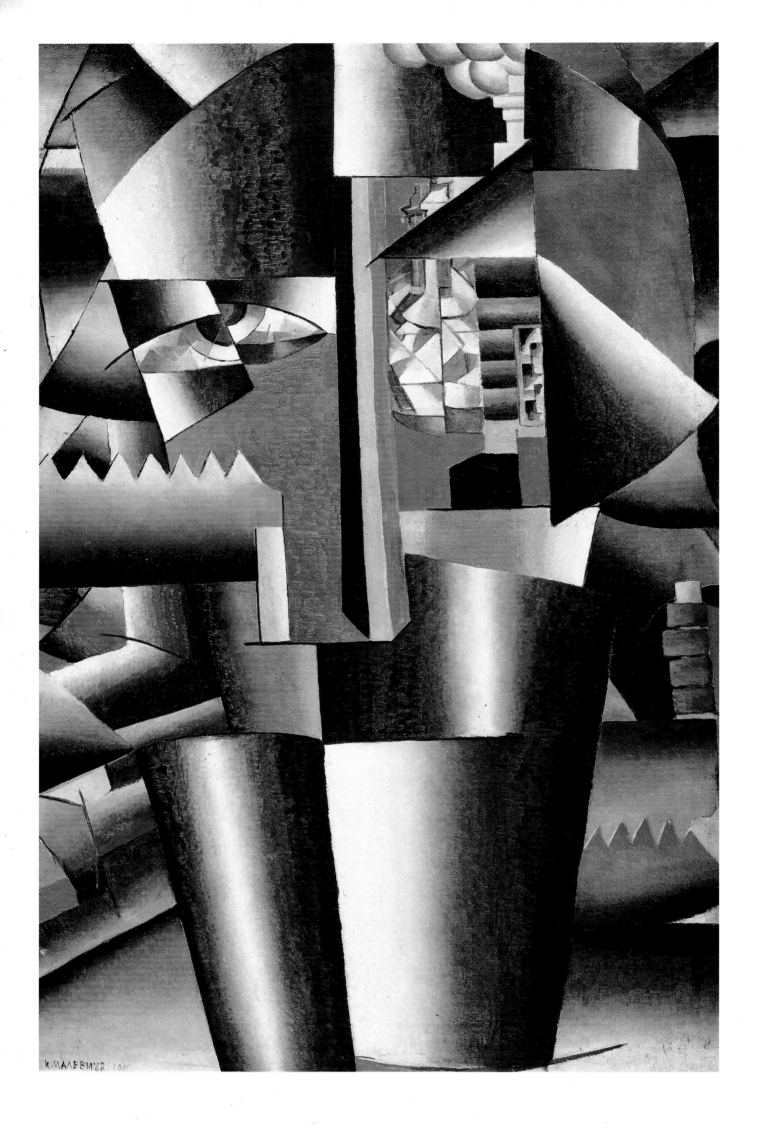

47 **Portrait of Ivan Kliun, 1913.** *Oil on canvas. 112×70 cm*

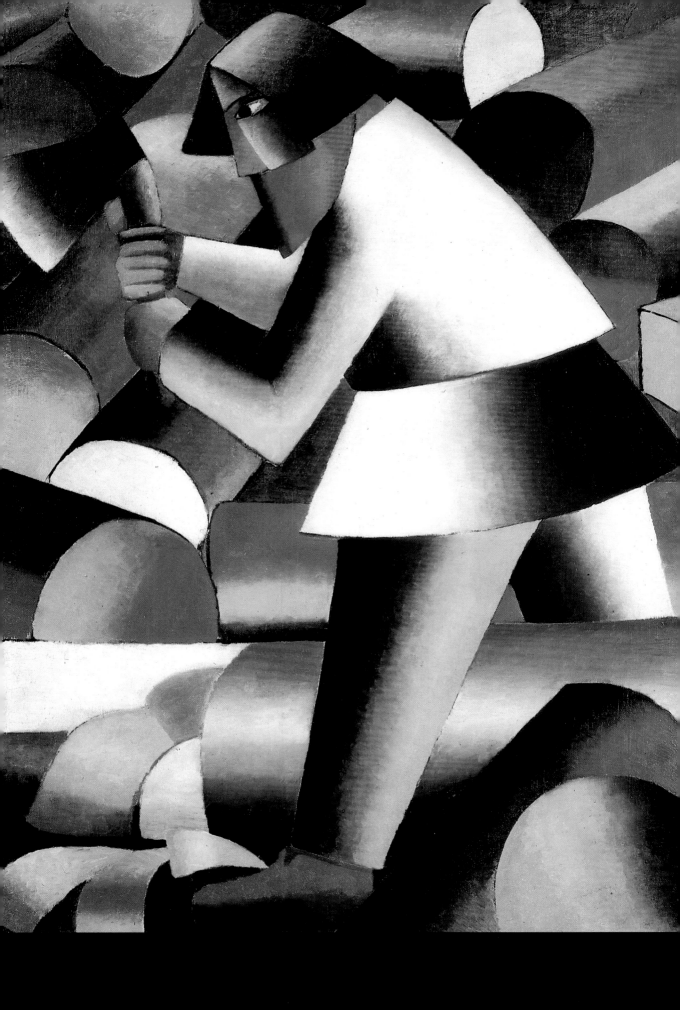

48 The Woodcutter 1912–13 *Oil on canvas, 94 × 71.5 cm*

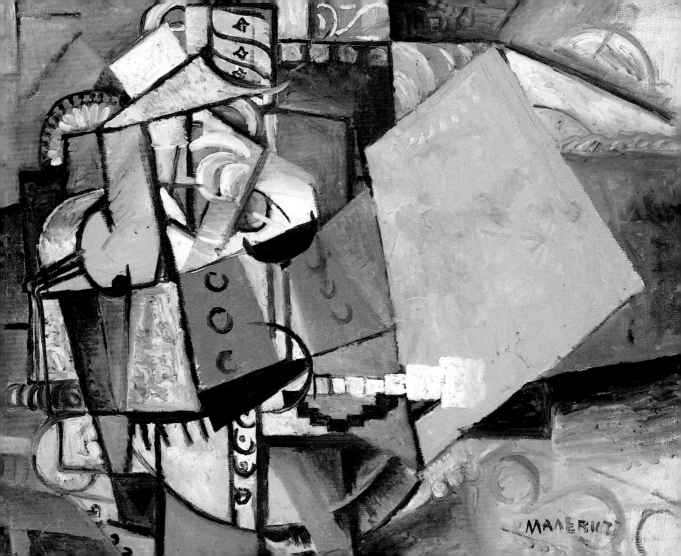

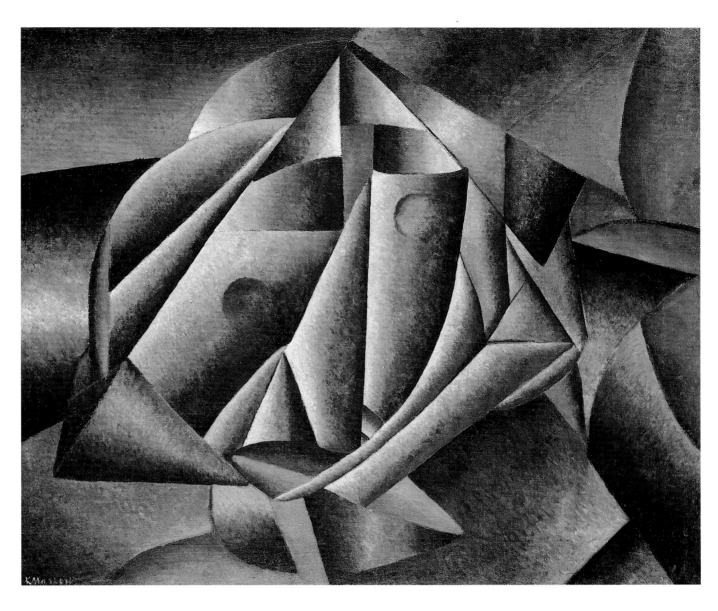

50 Head of Peasant Girl, 1912–13. *Oil on canvas. 72×74.5 cm*

51 Head of Peasant Girl, 1913. *Illustration in* The Three *by Velimir Khlebnikov, Alexei Kruchenykh and Elena Guro. Letterpress. 11.4×13 cm*

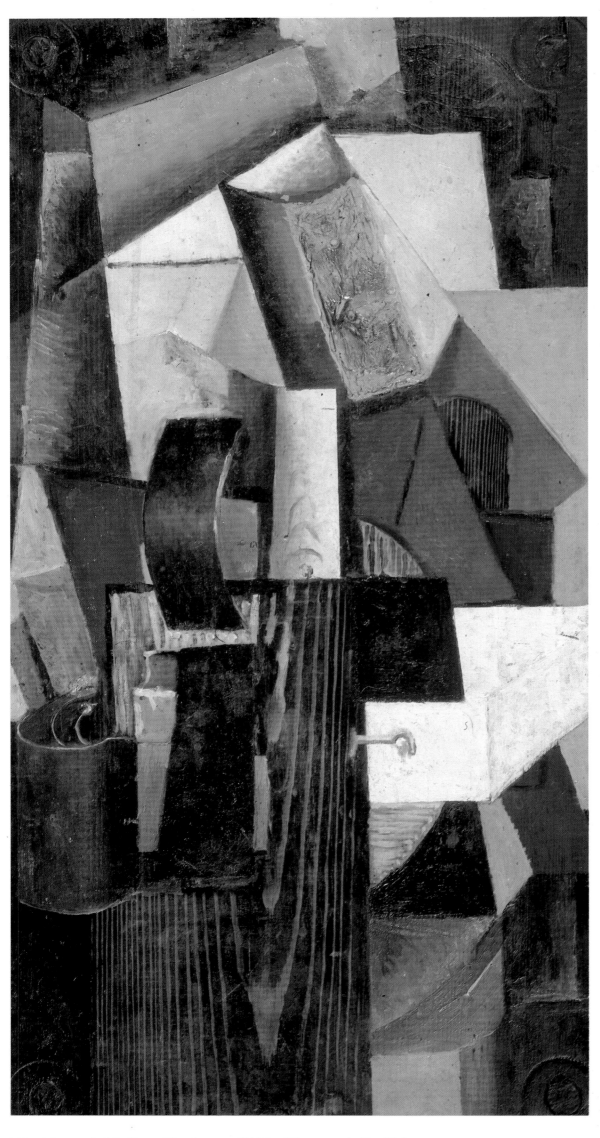

52 **Through Station: Kuntsevo, 1913.** *Oil on panel. 49×25.5 cm*

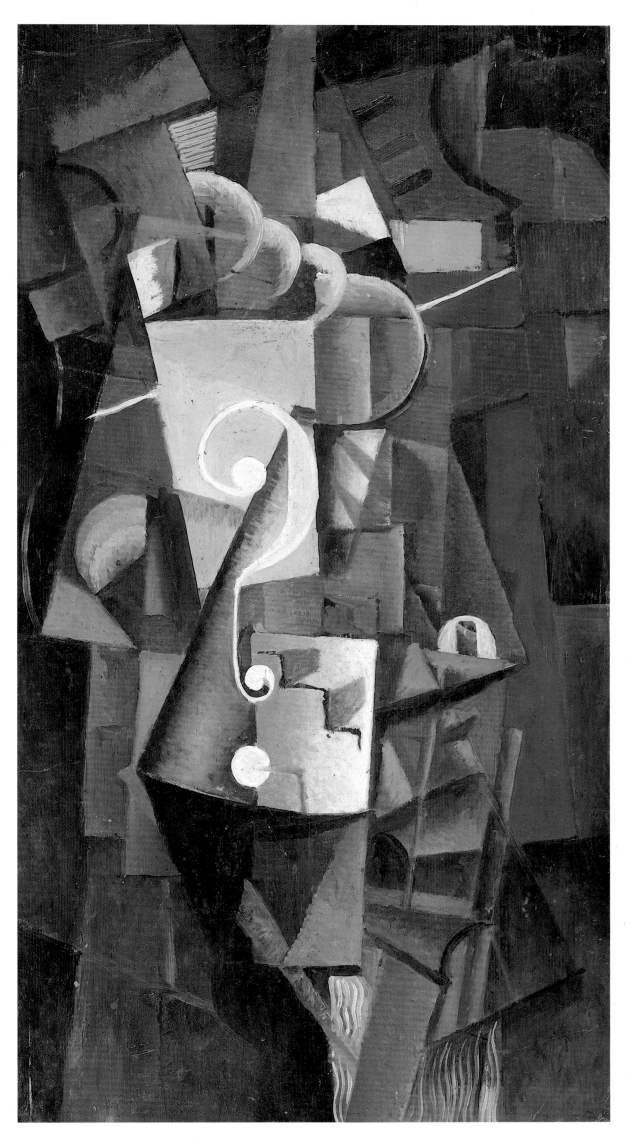

53 **Vanity Case, 1913.** *Oil on panel. 49×25.5 cm*

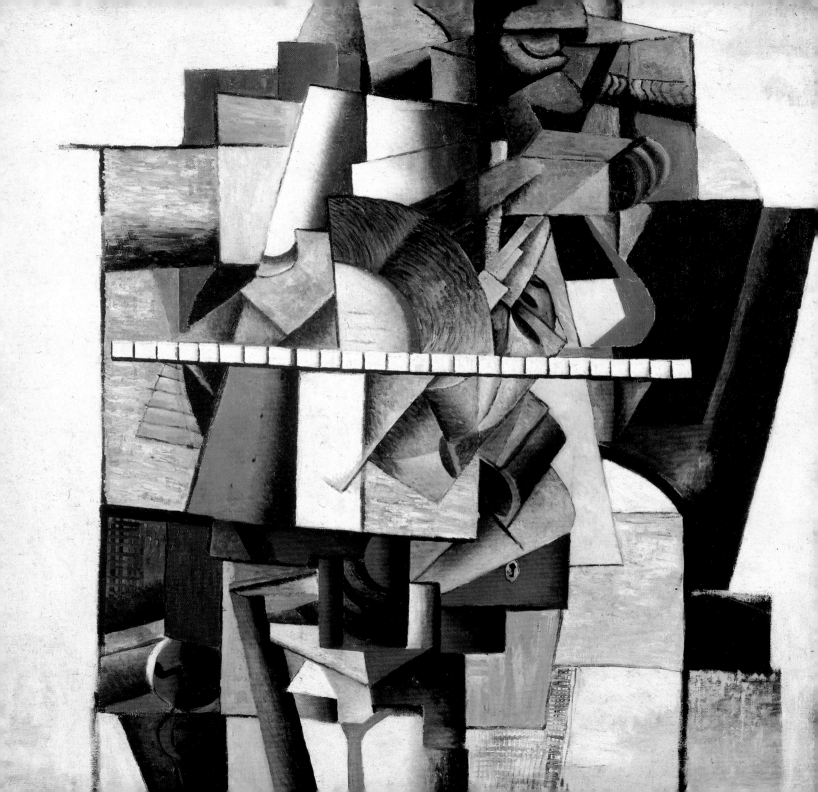

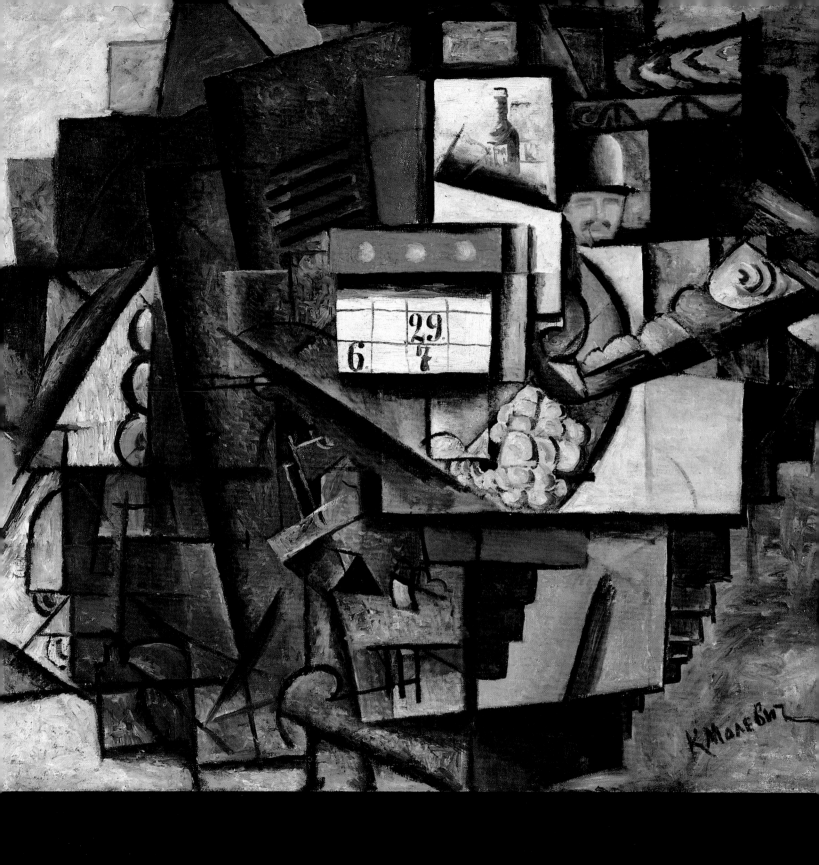

55 **Woman in Tram / Woman at the Tram Stop, 1913** *Oil on canvas, 88 × 88 cm*

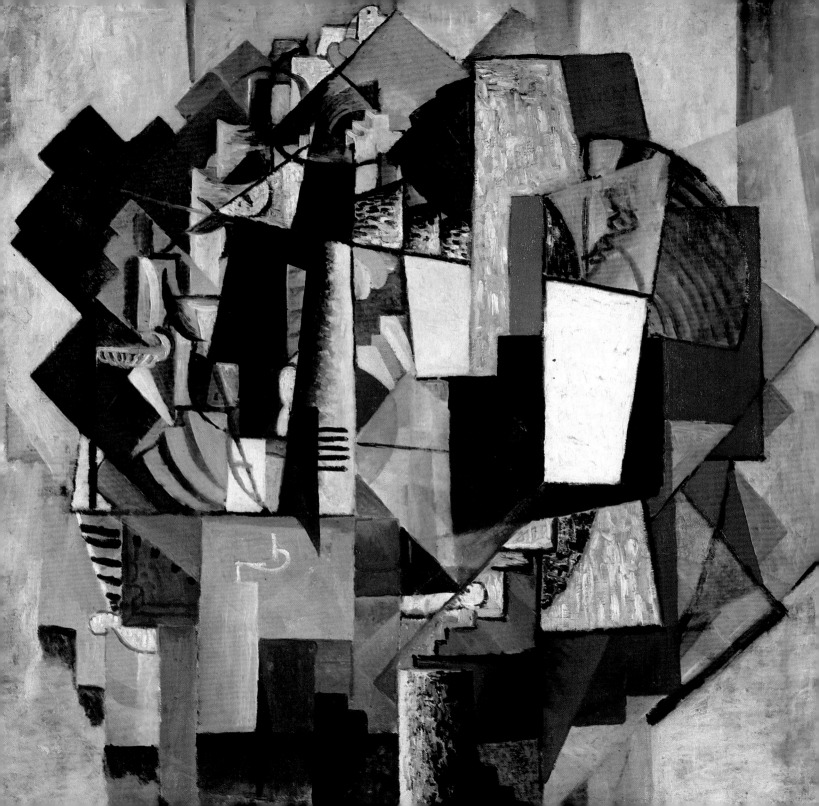

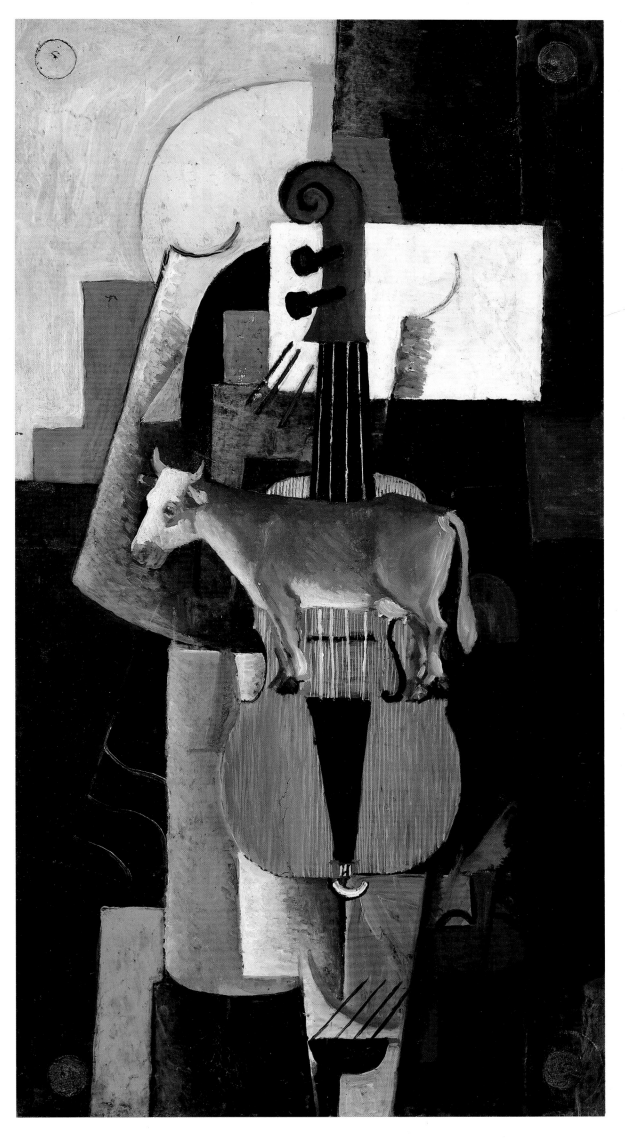

57　Cow and Violin, 1913. *Oil on panel. 48.8×25.8 cm*

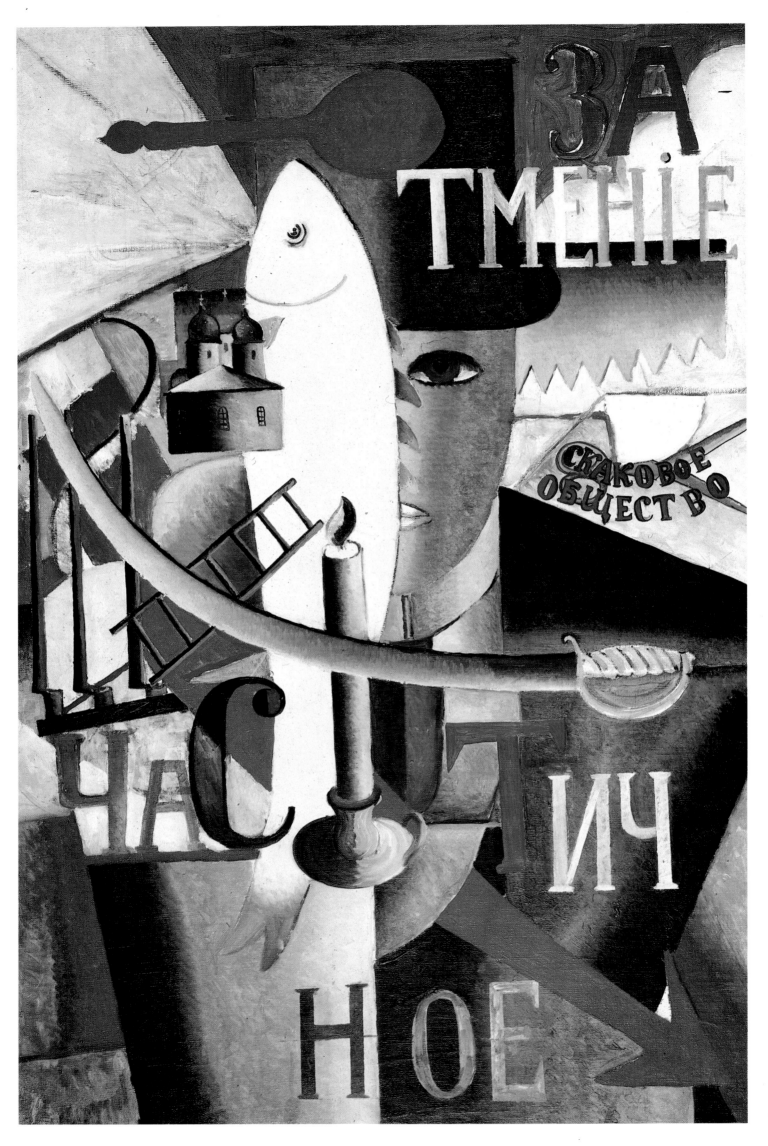

58 **An Englishman in Moscow, 1914.** *Oil on canvas. 88×57 cm*

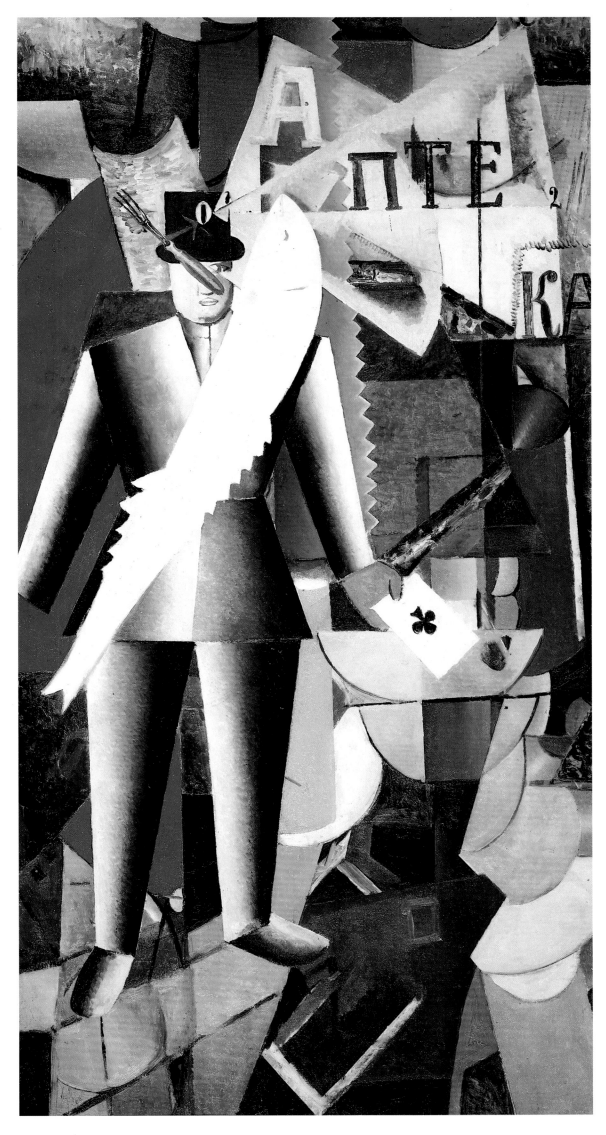

59 Aviator, 1914. *Oil on canvas. 125×65 cm*

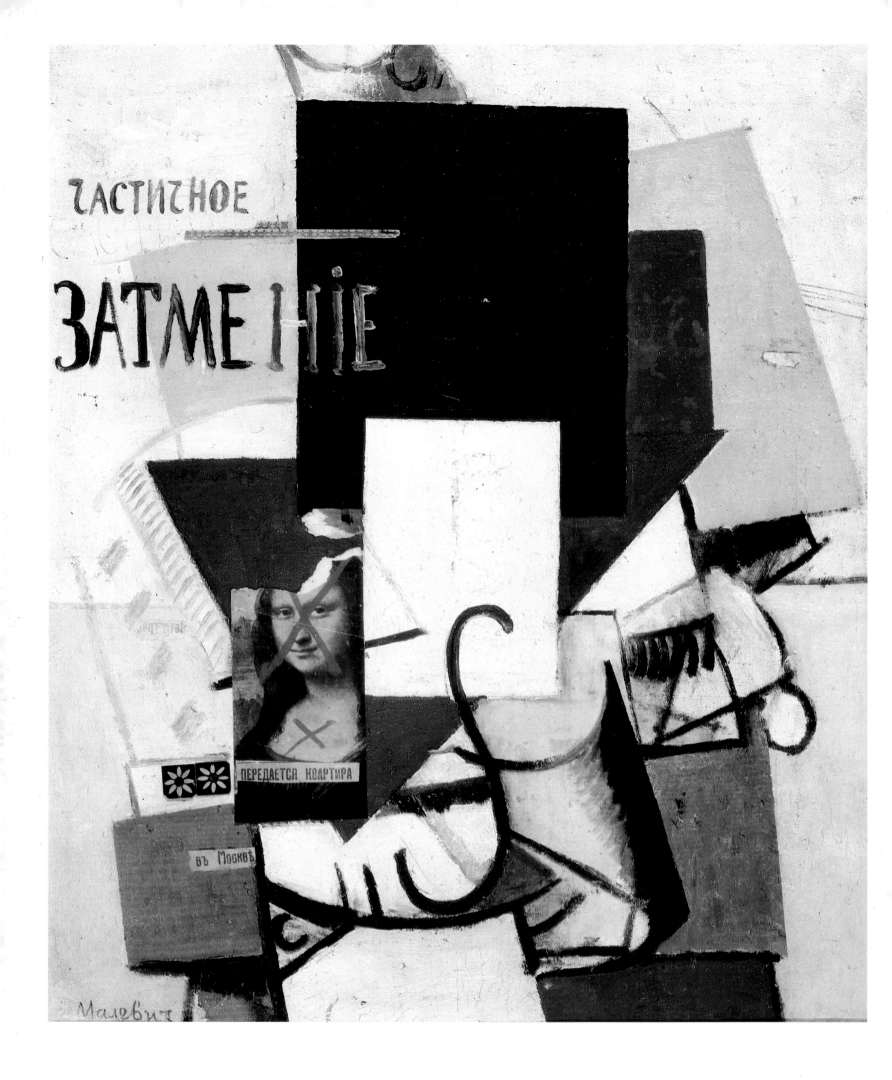

60 Partial Eclipse. Composition with Mona Lisa. *Oil on canvas*

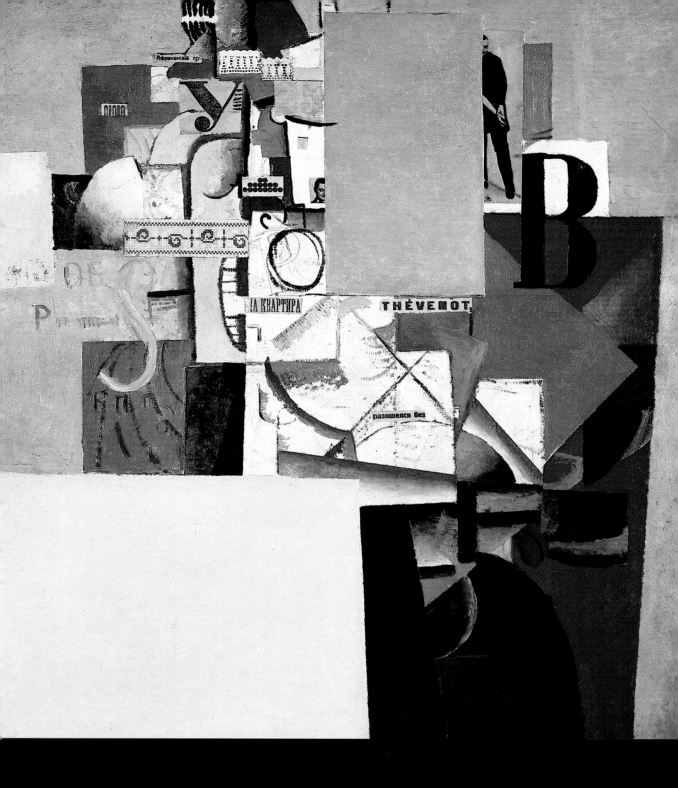

51 Woman at a Poster Column, 1914 *Oil on canvas, collage, 71×64 cm.*

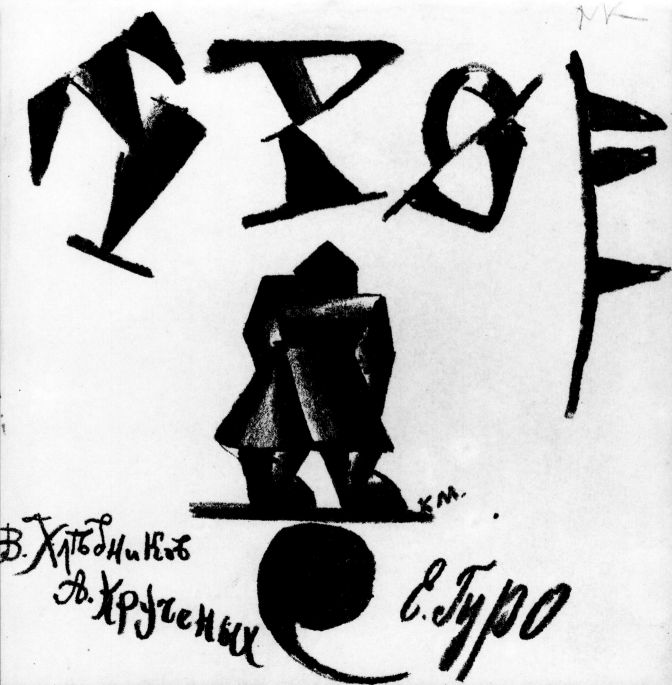

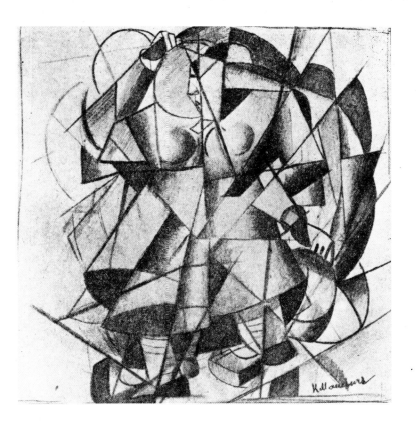

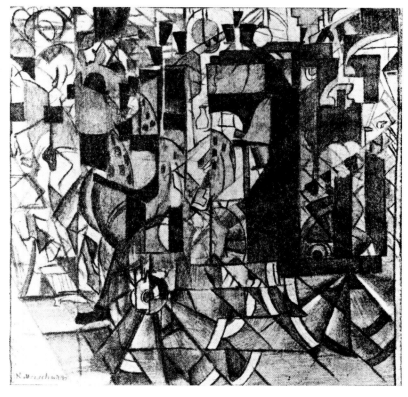

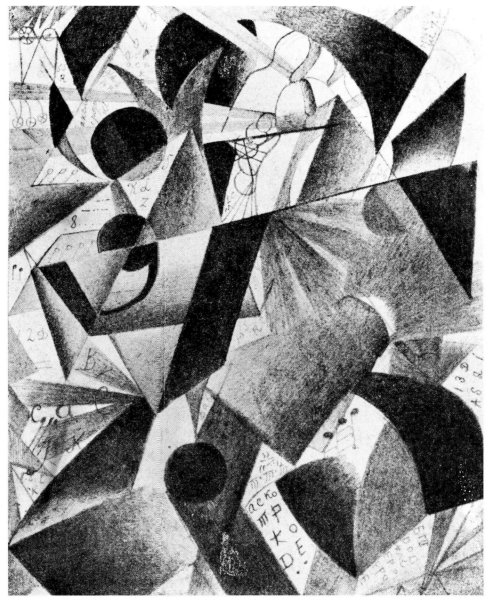

63 **Woman Reaping.** *Letterpress. 13.8×13 cm*

64 **Horse-driven Coach in Motion.** *Letterpress. 11×9.8 cm*

65 **Pilot.** *Letterpress. 13×10.2 cm*

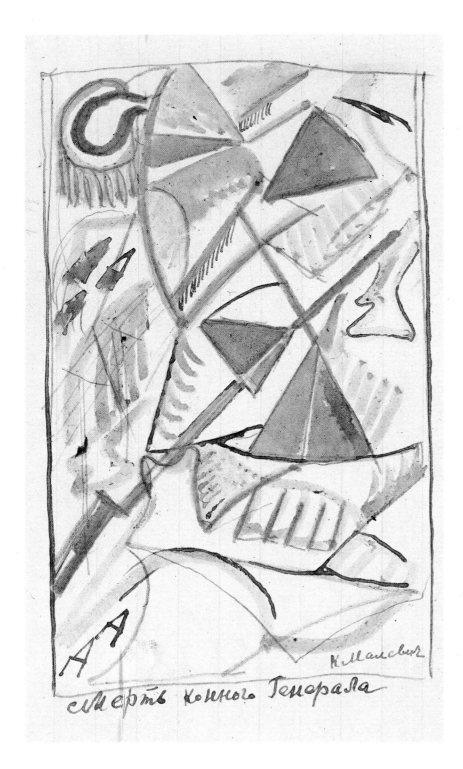

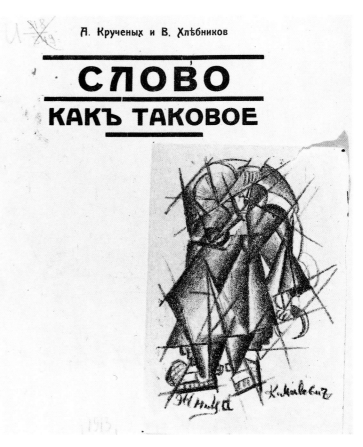

А. Крученых и В. Хлѣбников

СЛОВО
КАКъ ТАКОВОЕ

66 **Death of the Cavalry General, 1914.** *Brown Indian ink, pen, and pencil on ruled paper. 16.8×11.5 cm*

67 **Woman Reaper, 1913.** *Cover illustration of* The Word as Such *by Velimir Khlebnikov and Alexei Kruchenykh. Lithograph. 13.2×8.7 cm*

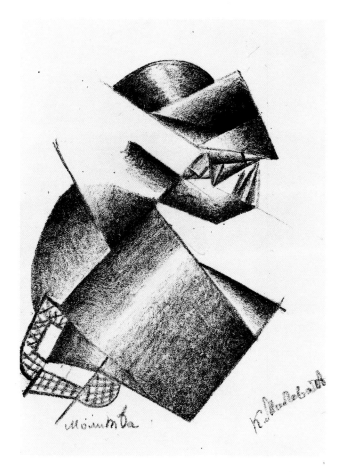

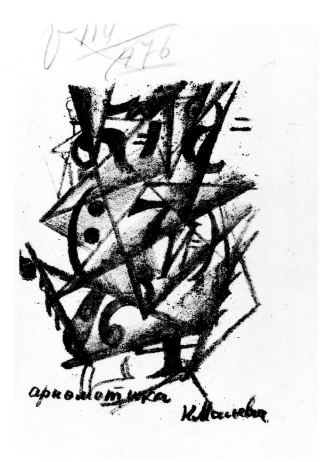

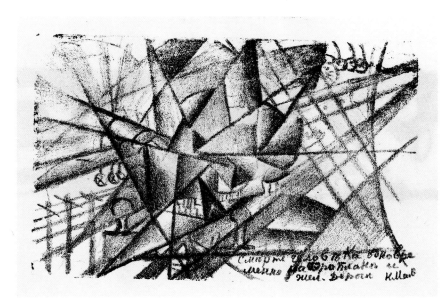

68 **Prayer.** *Lithograph. 13×10 cm (image size)*

69 **Arithmetic.** *Lithograph. 12.7×8.6 cm (image size)*

70 **Simultaneous Death of a Man in an Airplane and on the Railroad**
 Lithograph. 9×14 cm (image size)

Costume
Designs
for the Opera
**'Victory
Over
the Sun'**
1913

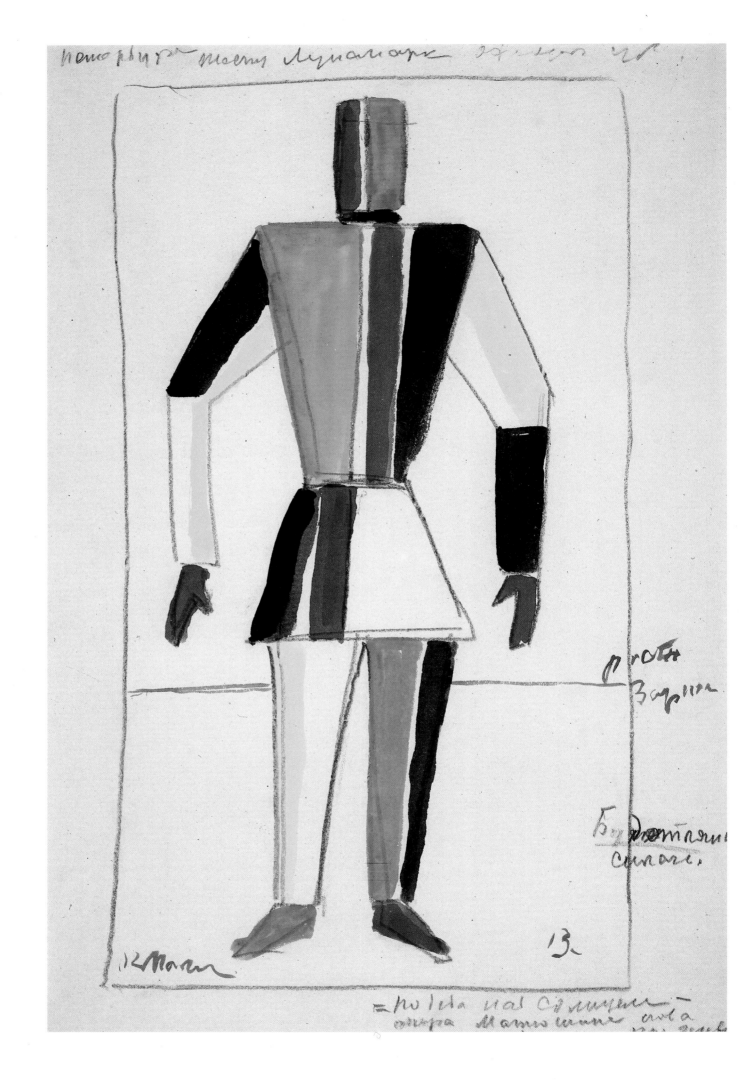

71 Futurist Strongman. *Watercolour and pencil. 53.3×36.1 cm*

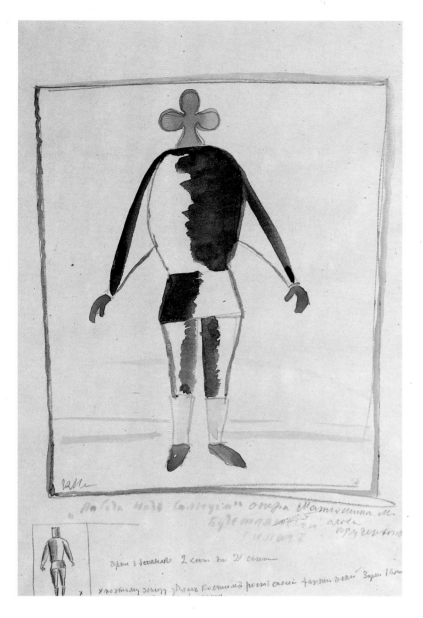

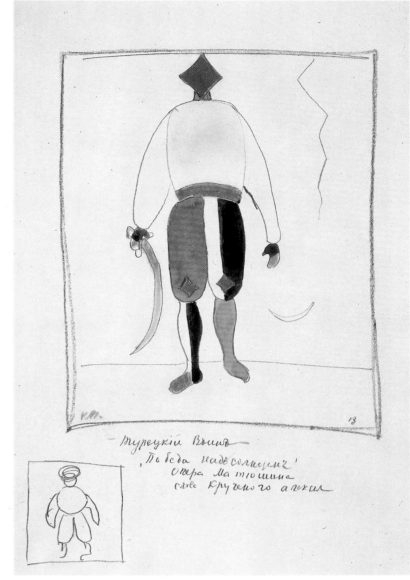

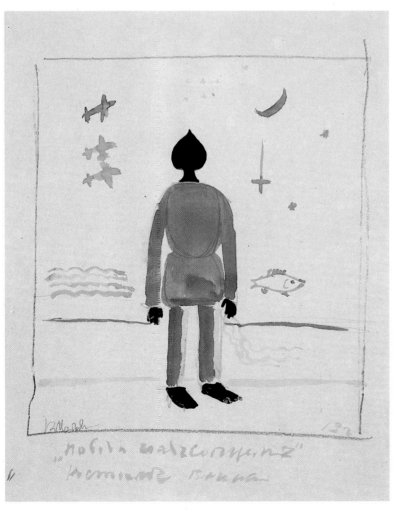

72 **Futurist Strongman.** *Watercolour and pencil. 54.4×36.2 cm*

73 **Turkish Warrior.** *Watercolour and pencil. 54.3×36.4 cm*

74 **Warrior.** *Watercolour, Indian ink, and pencil. 54.2×35.6 cm*

Costume
Designs
for the Opera
**'Victory
Over
the Sun'**
1913

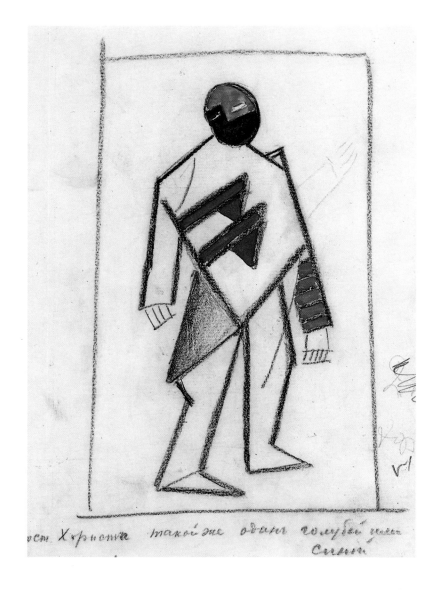

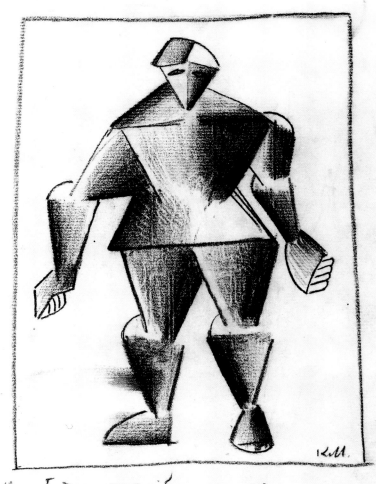

75 **Singer in the Chorus.** *Black chalk and watercolour*
27.3×21.3 cm

76 **Traveller.** *Black chalk. 27.2×21.3 cm*

77 **Many and One.** *Black chalk, watercolour, and Indian ink*
27.1×21 cm

78 **Futurist Strongman.** *Black chalk. 27×21 cm*

79 **Coward.** *Black chalk, watercolour, and Indian ink. 26.9×21 cm*

80 **Pallbearer.** *Black chalk and watercolour. 27×21.1 cm*

Overleaf:

81 **Enemy.** *Black chalk, watercolour, and Indian ink. 27.1×21.3 cm*

82 **The New.** *Black chalk, watercolour, and Indian ink. 26×21 cm*

83 **Mugger.** *Black chalk and watercolour. 26.7×21 cm*

84 **Nero.** *Black chalk. 27×21.5 cm*

85 **Reciter.** *Watercolour, Indian ink, and charcoal. 27.2×21.4 cm*

86 **Someone with Bad Intentions.** *Black chalk, watercolour,*
and Indian ink. 27.3×21.3 cm

87 **Old Timer.** *Black chalk, watercolour, and Indian ink. 27×21 cm*

88 **Sportsman.** *Watercolour, Indian ink, and charcoal*
27.2×21.2 cm

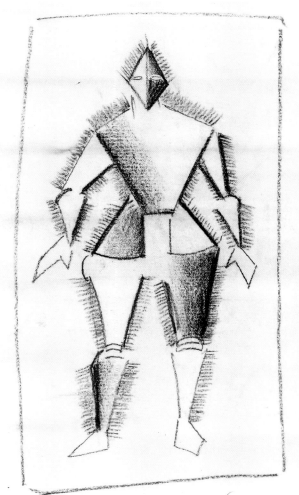

Путешественник. костюмъ бѣлый и черный

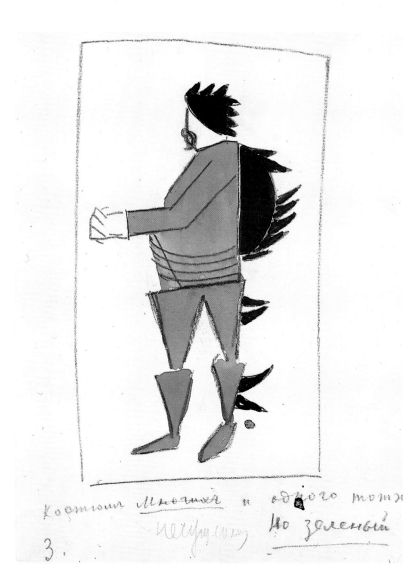

Костюмъ многихъ и одного тоже Нѣкусы но зеленый

3.

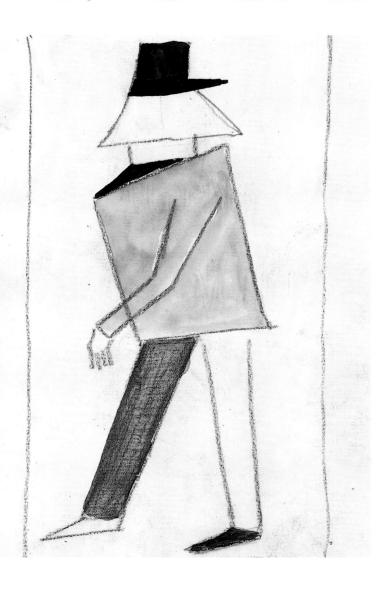

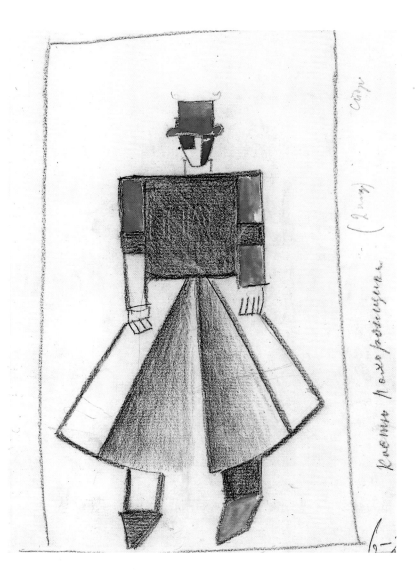

клеенка похоронщикъ — (2-й) Отр.

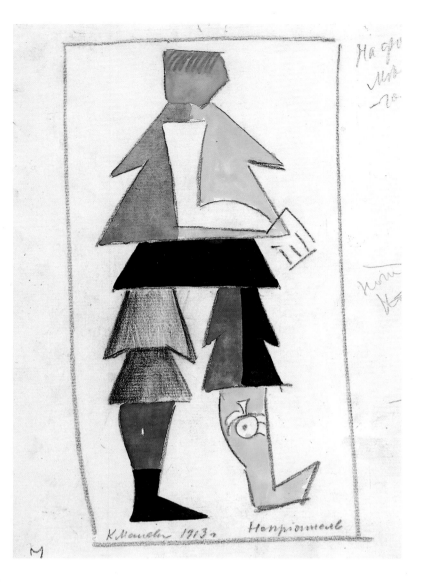

K. Малевич 1913 г. Непріятель

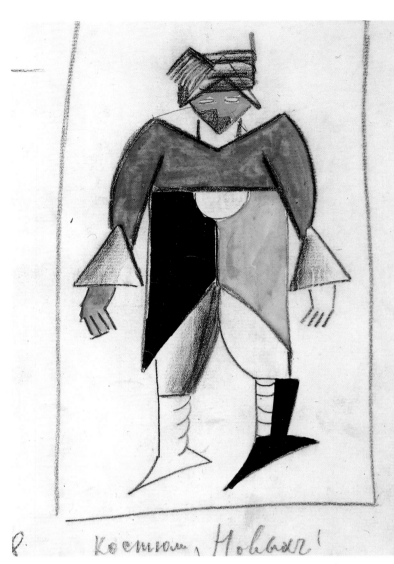

В. костюм Новый!

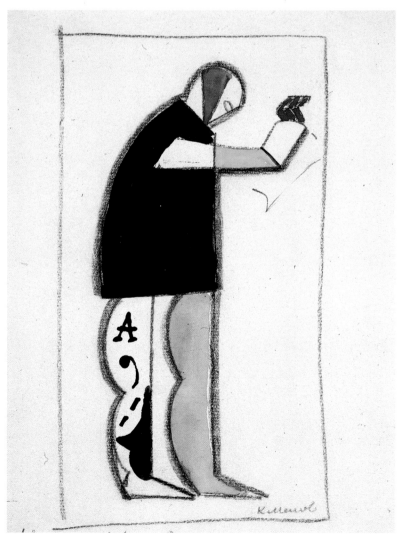

К. Малевич

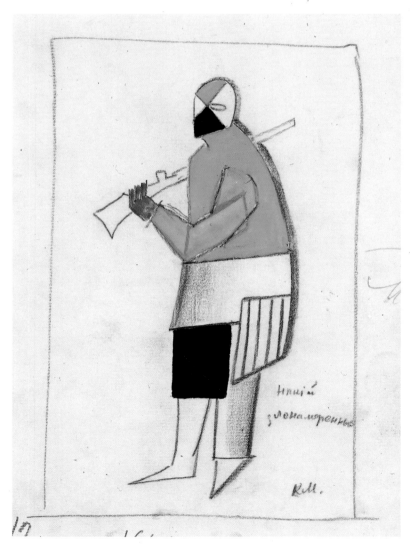

Низкій
злонамѣренный

КМ.

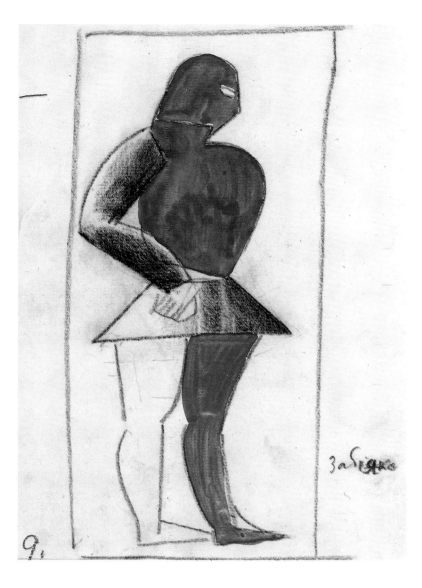

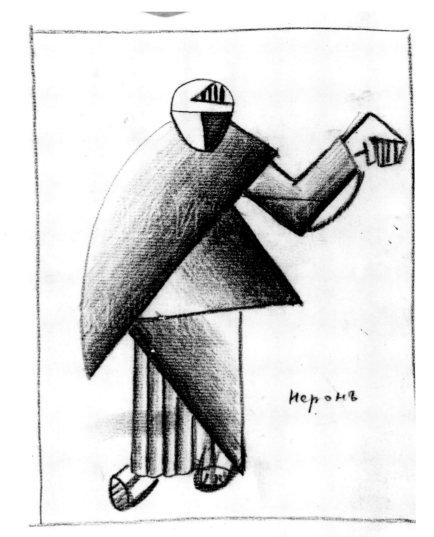

Неронъ

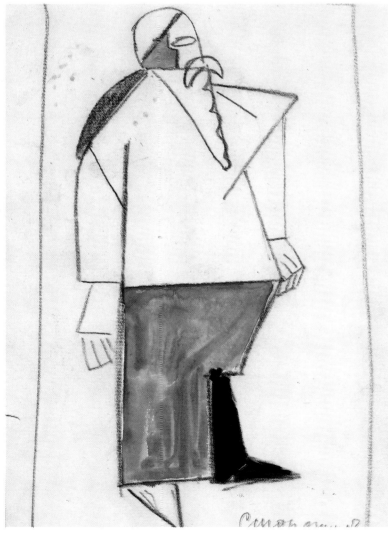

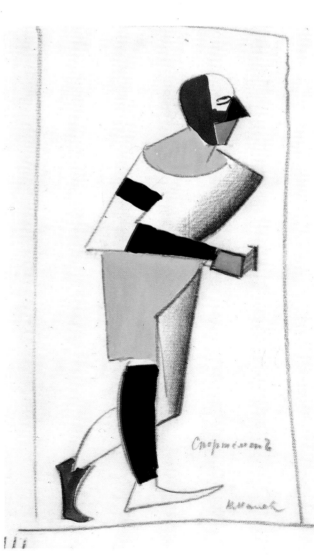

Costume
Designs
for the Opera
**'Victory
Over
the Sun'**
1913

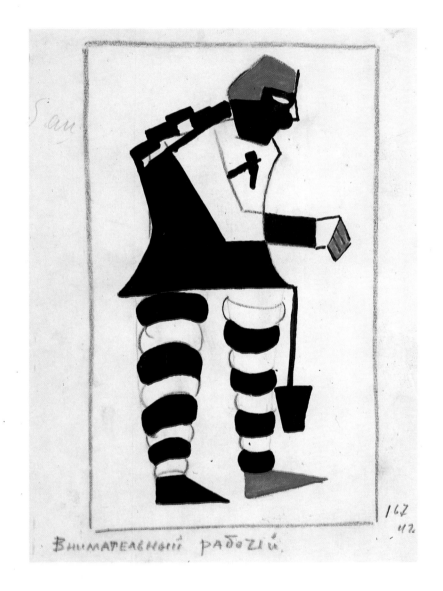

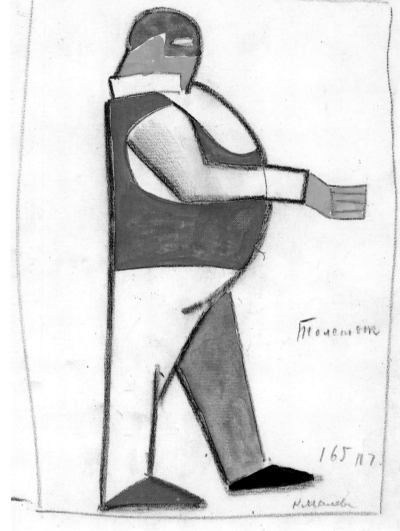

89 Attentive Worker. *Black chalk, Indian ink, and gouache. 27.2×21.2 cm*

90 Fat Man. *Black chalk, watercolour, and Indian ink. 27.2×21.2 cm*

Stage
Designs
for the Opera
**'Victory
Over
the Sun'**
1913

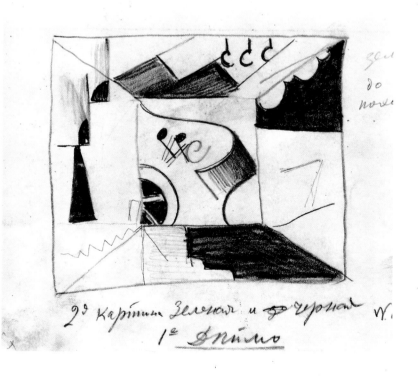

91 **Stage design for Act 1, Scene 3.** *Black chalk. 17.7×22.2 cm*

92 **Stage design for Act 1, Scene 1.** *Black chalk. 25.9×20.2 cm*

93 **Stage design for Act 2, Scene 6.** *Black chalk. 21.3×27 cm*

94 **Stage design for Act 1, Scene 2.** *Black chalk. 17.5×22 cm*

Глядь, поглядь, ужъ близко Вислы
Нѣмцевъ пучитъ, значитъ кисло!

Propaganda Posters, 1914

95 "Look, oh look! Near the Vistula…". *Lithograph. 51.3×33.4 cm*

96 The Carousel of Wilhelm. *Lithograph. 33.3×52.3 cm*

ВИЛЬГЕЛЬМОВА КАРУСЕЛЬ.

"Подъ Парижемъ на краю А я кругомъ бѣгаю
Лупятъ армію мою, Да ничего не сдѣлаю".

У союзниковъ французовъ А у братцевъ англичанъ
Битыхъ нѣмцевъ полный кузовъ, Драныхъ нѣмцевъ цѣлый чанъ.

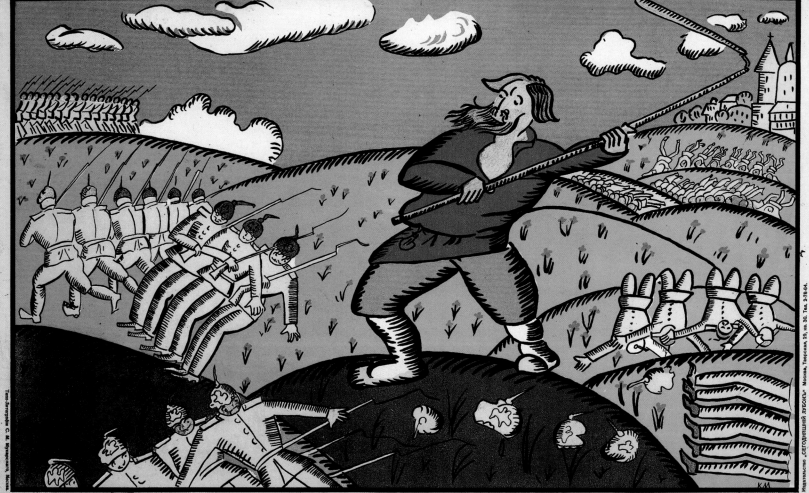

Ну и трескъ-же, ну и громъ-же
Былъ отъ нѣмцевъ подлѣ Ломжи!

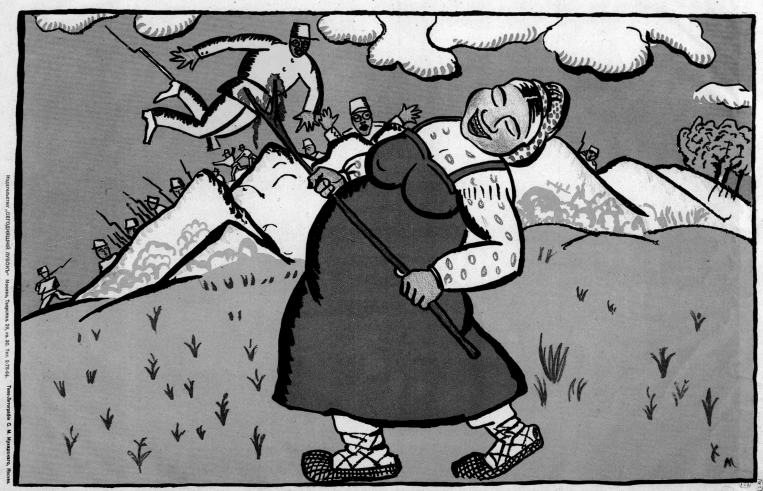

Шелъ австріецъ въ Радзивилы,
Да попалъ на бабьи вилы.

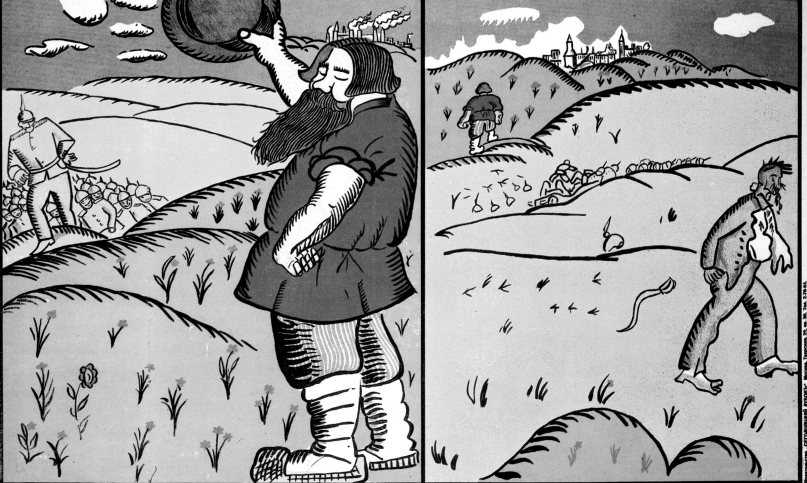

Подошелъ колбасникъ къ Лодзи
Мы сказали: „Панъ добродзи!"

Ну, а съ Лодзью рядомъ Радомъ
И ушелъ съ подбитымъ задомъ.

Evgeny Kovtun

The Beginning of Suprematism

In the first decade of the 20th century, avant-garde painting throughout the world moved unswervingly in a non-figurative direction. The French Cubists stood at the very brink of non-objectivism, but never took the final step. Albert Gleizes and Jean Metzinger, two theoreticians of Cubism, conceded in 1912 that 'not every reminder of existing forms should be entirely banished, at least at the present time.'[1]

It fell to the Russian avant-garde to channel non-objectivism into art and analyse its properties. Between 1910 and 1914 there existed several non-objective trends in Russian art, the first of them initiated by Kandinsky, whose abstract works appeared in 1910. That December Kandinsky showed a wide range of abstract water-colours and other paintings at two exhibitions—the 'Jack of Diamonds' in Moscow, and the 'International Exhibit' at Izdebsky's Salon in Odessa. The first reproduced abstract work was the Kandinsky drawing on the cover of the catalogue for the Odessa show.

In 1910 the artist completed work on his book, *Über die Geistige in der Kunst*, subsequently published in December 1911 in Munich. At the All-Russian Congress of Artists held the same month, Nikolai Kulbin read a paper by Kandinsky, *Concerning the Spiritual in Art (Painting)*[2], which outlined the main points of his book. Kandinsky's non-objectivism took the form of abstract expression.

Mikhail Larionov arrived at non-objectivism on his own. Critics regarded his Rayonism as a type of abstract art, but its origins were actually more complex. Impressionism, with its keen interest in colour, had pushed the plastic element into the background, while Cubism had developed structure to the detriment of the painterly element. Larionov did not want to sacrifice either. His Rayonism was an amazing attempt to combine the incompatible—the painterly vibrancy of Impressionism and the structural clarity of Cubism. The earliest 'signs' of Rayonism can be seen in his illustrations to Alexei Kruchenykh's *Old-Time Love*, published in mid-October, 1912.

After Kandinsky's and Larionov's work came the versions of non-objectivism created in 1914 by Vladimir Tatlin and Kazimir Malevich. These four artists saw non-objectivism not as a rejection of the old art but as the logical continuation of its forms. 'Non-objective art,' Kandinsky wrote, 'is not the cancelation of all previous art but merely the extraordinarily and primally important division of the old trunk into two main branches, without which the green tree's crown could not be formed.'[3]

Malevich also thought of his Suprematism as a rung on the ladder that world art was climbing. In May, 1916 the artist defended his new style to Alexandre Benois: '…I am glad that the face of my square cannot become merged with a single master of age. Is not that so? I did not listen to my parents, and I do not resemble them. And I am a rung.'[4] Malevich's own published writings have greatly confused the question of when Suprematism came into being, but he also provided the key to its solution with his little-known and unpublished letters.

How did Suprematism come about? From the Malevich texts that have been published, Suprematism was apparently a conscious derivation of Cubism.

When did it come about? Malevich dates *Black Square* to 1913.

But what really happened?

In Malevich's 1911–14 works, which he called 'Alogism' or 'Non-sense Realism', changes occurred that foreshadowed a departure from the plastic system of Cubo-Futurism. *Portrait of Ivan Kliun*, *Aviator* and *An Englishman in Moscow* feature large planes of solid colour and show a growing tendency toward non-objectivism. The paintings still have a 'top' and a 'bottom', but there is a sense that Malevich is striving to achieve weightlessness and overcome the force of gravity by plastic means. The figure of the aviator, to use V. Sterligov's words, 'hangs but has no weight'. He seems to hover in space.

The final step leading to Suprematism was the opera *Victory Over the Sun*, by Matyushin and Kruchenykh, performed in Petersburg's Luna Park Theatre on December 3 and 5, 1913. Malevich was responsible for the sets and costumes, and worked on them in the fall of that year.

Malevich's costume sketches were based on the principles of Cubism, but with an inclination towards the non-objective. The drawings for the *Futurist Strongman*, the *Pallbearer* and *Someone with Bad Intentions*

feature planes of solid colour, rectangles and black squares. Malevich's 'Suprematist Reorientation' is still more evident in the backdrops for certain scenes: Act two, Scene five boasts a fully 'Suprematist' square. The innovation did not yet have a name, nor did the artist himself realize what he had done, but these drawings in fact represent the breakthrough to Suprematism.

Malevich's letters show that he mode the breakthrough spontaneously. In 1915, when Matyushin was preparing a second edition of the opera with a fuller score and a larger selection of drawings, Malevich wrote: 'I would be very grateful if you could put one of my drawings in the act where the victory takes place....The drawing will have great significance for painting. What was done unconsciously is now bearing extraordinary fruit.'[5] In the next letter he encloses the drawing and adds, 'The curtain depicts a black square, the germ of all potential, [which] acquires awesome force as it develops. It is the father of the cube and the sphere. Its disintegration will elevate painting astoundingly.'[6]

In 1915 Malevich understood the full significance of the departure he had made. Later, when he developed the theory of the additional element in painting, he derived Suprematism from Cubism, imparting to that transition the nature of a scientific innovation. But in 1913 he had made the transition spontaneously and empirically—as is often the case with artists. First art, then theory.

When were the first Suprematist canvases painted? The excerpts from the 1915 letters quoted above show that work on non-objective painting was then underway, and the impetus given by the sketches for *Victory* clearly carried over into painting. On March 5, 1914, while telling Matyushin about his work, Malevich noted that 'Planes are emerging.'[7] *Black Square*, 'the germ of all potential,' shown at the '0.10' exhibition, was probably executed in 1914. Its 'disintegration' was the source of all of the other 48 pictures at the 1915 exhibit.

Black Square became the visual manifesto of a new trend. Everything about it—the colours, the forms, the structure—was reduced to zero, and the artist began to create new worlds, like a demiurge, out of that 'nothing'. 'O awareness!' Malevich wrote to Matyushin on November 12, 1916. 'What a good thing it is, what can't be done with it. Here is a device that creates havoc tirelessly. Most important, NOTHING creates havoc. Oh, what wonders await us, how can we anticipate them?'[8]

Once born, the new trend was nameless for a time. The word 'Suprematism' first appeared in print on the cover of a Malevich brochure, *From Cubism and Futurism to Suprematism: New Painterly Realism*, printed in late 1915. The credit for chosing that name (from the Latin *supremus*, or supreme) goes to Malevich, though attempts have been made to attribute it to Matyushin or Puni. Matyushin, however, did not actually like the choice: 'Welcoming every quest for what is new and joyous, though it may not be fully attained, we recognize that Malevich's *New Painterly Realism*, unaccountably given the academic name *Suprematism*, is just such a quest.'[9] As we shall later see, Puni learned of Suprematism on the eve of the '0.10' exhibit.

Malevich did not invent the name immediately. *Red Square* (1914), displayed at the 1915 exhibit, is inscribed on the reverse: 'A Peasant Woman. Supranaturalism.'[10] In this instance it is particularly clear why Malevich chose the term: he wished to define the invisible, supernatural essence of the phenomena revealed in his new work. In this, Malevich took a view similar to that of the German Supranaturalists of the early 19th century. An entry on this philosophy was contained in the 32-volume *Brokgauz and Efron Encyclopedic Dictionary* (St. Petersburg, 1901), then popular in Russia, but I believe that Malevich's choice of the same term was coincidential. It reflected a similarity of concept, but once Malevich realized this he rejected Supranaturalism as an 'alien' term that was already 'taken'.

The brochure with 'Suprematism' in the title was authorized for printing in June 1915, so by then the name was fixed. Coming to agreement with Matyushin in September on publication of the brochure, Malevich noted: 'I think that Suprematism is the most appropriate, since it signifies pre-eminence.'[11]

Much of the credit for establishing Suprematism as a new trend in Russian art must go to Matyushin. At the artists' very first meeting, in 1912, he was struck by Malevich's work, and Matyushin devoted many pages to him in his unpublished book *The Career of an Artist* [Tvorcheskii put khudozhnika, 1934]. When Malevich found himself confronted with non-objectivism, he felt a need to discuss it; and in May of 1915 he wrote Matyushin: 'Working on your opera *Victory Over the Sun* in '13 has brought me much that is new, but I simply did not notice. Material on this score is accumulating and should be published somewhere. But I need someone with whom I can be open, who would help me set forth the theory on the basis of its origins in painting. I think that you alone can be that person.'[12]

In 1915 Malevich sent Matyushin several dozen letters discussing the problems Suprematism posed, as well as theoretical charts explaining the principles of non-objectivism in art. In October of 1915 Matyushin received a package containing the text of Malevich's brochure, *From Cubism to Suprematism*. 'The author and I edited the book,' Matyushin recalled.[13] Nothing came of Malevich's request that Matyushin write the foreword, but Matyushin penned a profound and exact explanation of what Suprematism brought to art in his 1916 article, "The 'Last Futurists' Exhibit": 'Objectivism embodies qualities unknown to human

reason; their main essence can be sensed not in concrete form but only when transformed by higher intuitive reason.'[14]

While Suprematism was being developed, the deep-seated rivalry between Tatlin and Malevich, the two focal points of the Russian avant-garde, came to the surface. Both had arrived at non-objectivism, but Tatlin's Constructivism was firmly planted on the earth, while Malevich's Suprematism 'strained skyward', into space. In speaking of Tatlin and Malevich, Nikolai Punin recalled: 'Theirs was a special fate. When it started I do not know, but for as long as I knew them they divided the world between themselves; the earth and the sky and the interplanetary space, establishing their spheres of influence everywhere. Tatlin usually secured the earth and attempted to push Malevich into the sky for non-objectivism. Malevich, while he did not reject the planets, would not concede the earth, justly presuming that it, too, was a planet and could therefore be non-objective.'[15]

Tatlin and Malevich kept a jealous watch on each other, concealing their new works until exhibition time. Vera Pestel says that at the studio where Tatlin was making counterreliefs, 'the blinds are drawn because Tatlin...is afraid of Malevich, who might pass by on Griboedov Lane and see in the window.'[16] Malevich, in turn, also nurtured his Suprematism secretly. Until the fall of 1915, no one but Matyushin knew what was happening in his studio. The artist planned to show his works all at once, thus presenting Suprematism as a fully formed new trend.

But it was not easy to keep the secret. 'Now I am in the soup,' he wrote to Matyushin. 'I was sitting there working, all my works out. Suddenly the door opens and in walks Puni. So the works have been seen. Now, no matter what, the brochure on my work must be put out and christened, to give notice of my authorship.'[17] Three days later he told Matyushin: 'Many people in Moscow already know about my works, but they don't know anything about Suprematism.'[18] On the eve of the exhibit he wrote: 'Everyone knows the name already, but no one knows what it stands for. Let it be *a secret*.'[19]

The Moscow artists busily prepared for the exhibit, which was to be the culmination of Cubo-Futurism in Russian art. Everyone was summing up, but Malevich intended to establish a new trend that ran counter to Cubo-Futurism. Ivan Kliun and Mikhail Menkov, the first to adopt the ideas of Suprematism, went along with him. The disparity between Malevich's goals and those of the rest of the participants in the exhibit sparked an unexpected conflict. 'The whole exhibition group,' Malevich wrote, 'protested against my leaving Futurism and wishing to write a few words in the catalogue to call my things Suprematism. They have bridled me, but I do not know whether they will be able to make me take the bit. The rationale is, "we aren't Futurists anymore either, but we do not know how to define ourselves yet, and we have not had much time to think about it."...I backed down for the sake of preserving the exhibit's unity.'[20] But he had a surprise up his sleeve in the brochure on Suprematism, which was sold at the exhibition. In addition, under his works the artist placed signs reading, 'Suprematism of Painting'.

'The Last Futurist Exhibition of Pictures "0.10" (Zero-Ten)' opened on December 17, 1915 at Nadezhda Dobychina's Art Bureau on the Field of Mars (St. Petersburg). No one gave any thought to the strange number at the end of its title, evidently regarded as the latest Futurist caprice, but there were always rational explanations for the names of their exhibitions, including 'Jack of Diamonds', 'Donkey's Tail', and 'Target'. The critic Rostislavov noted that the name was 'arithmetically illiterate',[21] and in fact 0.10 or one-tenth was at variance with the explanation provided in parentheses: 'Zero-Ten'.

A letter from Malevich to Matyushin gives us a clue to what the artists had in mind. On May 29, 1915 Malevich wrote, 'We are starting a journal and have begun to discuss how to go about it. As we intend to reduce everything to zero in it, we have decided to call it *Zero*. Later on we ourselves will go beyond zero.'[22] The idea of reducing all objective forms to zero and 'stepping beyond zero'—into non-objectivism—belonged to Malevich. It was expressed with extreme clarity in his 1923 manifesto, *The Suprematist Mirror*, but already in the brochure sold at the exhibit Malevich declared that he had broken completely with realistic forms.[23] 'I have reduced the forms to zero and gone beyond 0-1.'[24] The other nine participants in the exhibition also strove to 'go beyond zero', and consequently the explanation in parentheses, 'Zero-Ten', is correct. This interpretation of the name is born out by a letter from Puni to Malevich written in July of 1915: 'We have to produce a lot of work now. The space is very large and if we ten each paint 25 pictures, that will barely be enough. As far as judges and new part[icipants] are concerned, I have nothing against it, but, *naturally*, we must ask all the other participants.'[25] The ten artists were: Xeniya Boguslavskaya, Ivan Kliun, Kazimir Malevich, Mikhail Menkov, Vera Pestel, Liubov Popova, Ivan Puni, Olga Rozanova, Vladimir Tatlin, and Nadezhda Udaltsova. They were joined by Natan Altman, Maria Vasilieva, Vasily Kamensky, and A. Kirillova.

In concluding, we should note that the beginning of Suprematism, the crucial years of Malevich's creative development—1913, 1914, 1915—present the whole range of problems posed by the movement, problems the artist would grapple with in the years to come.

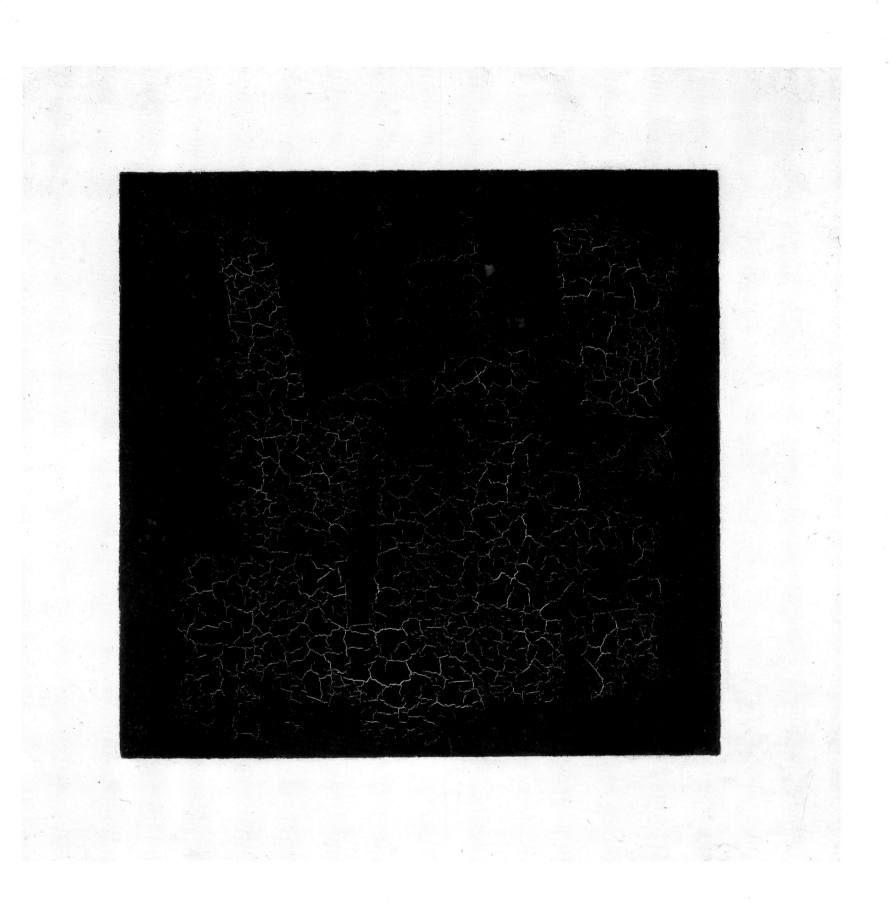

101 Black Suprematist Square, 1914–15. *Oil on canvas. 79.6×79.5 cm*

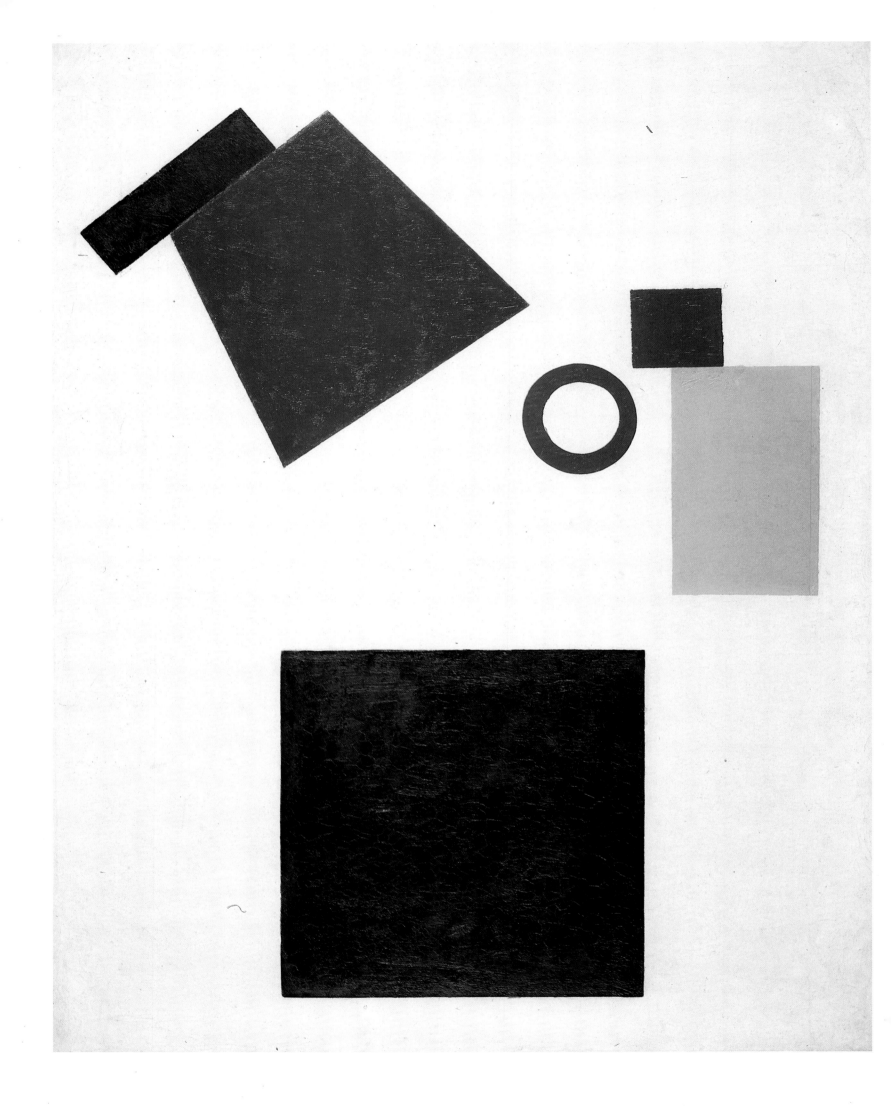

102 **Suprematism: Self-Portrait in 2 Dimensions, 1915.** *Oil on canvas. 80×62 cm*

103 **Suprematism: Painterly Realism of a Football Player. Colour Masses
of the Fourth Dimension, 1915.** *Oil on canvas. 70×44 cm*

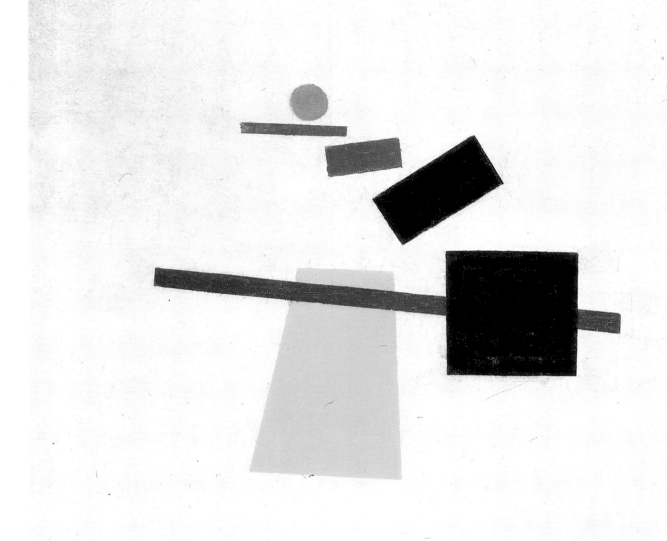

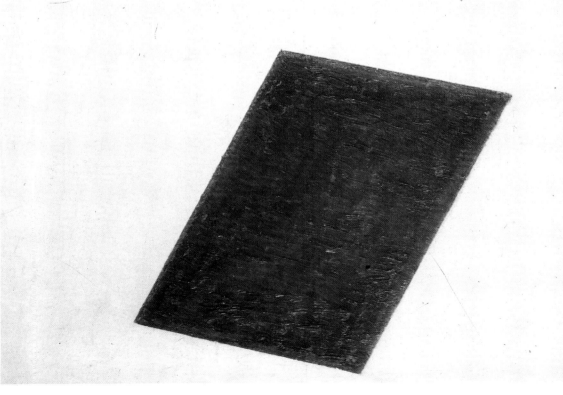

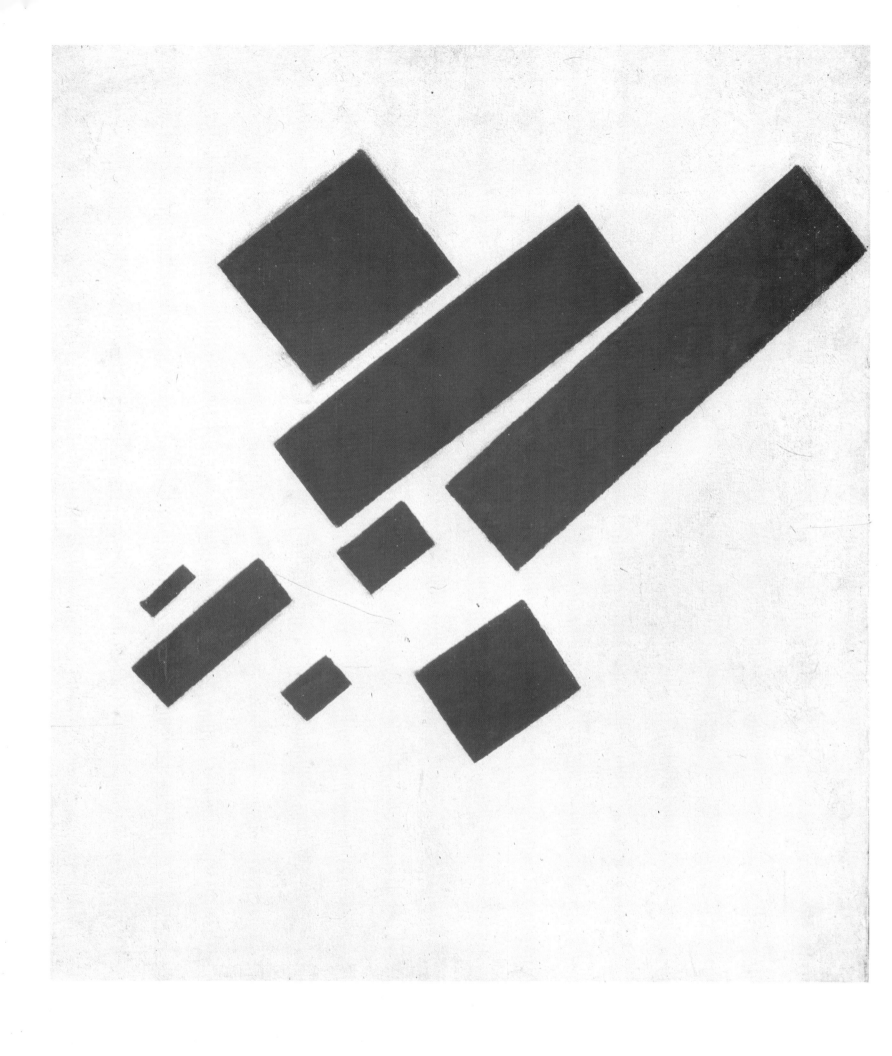

104 Suprematism (with Eight Red Rectangles), 1915. *Oil on canvas. 57.5×48.5 cm*

105 Red Square: Painterly Realism of a Peasant Woman in 2 Dimensions, 1915
Oil on canvas. 53×53 cm

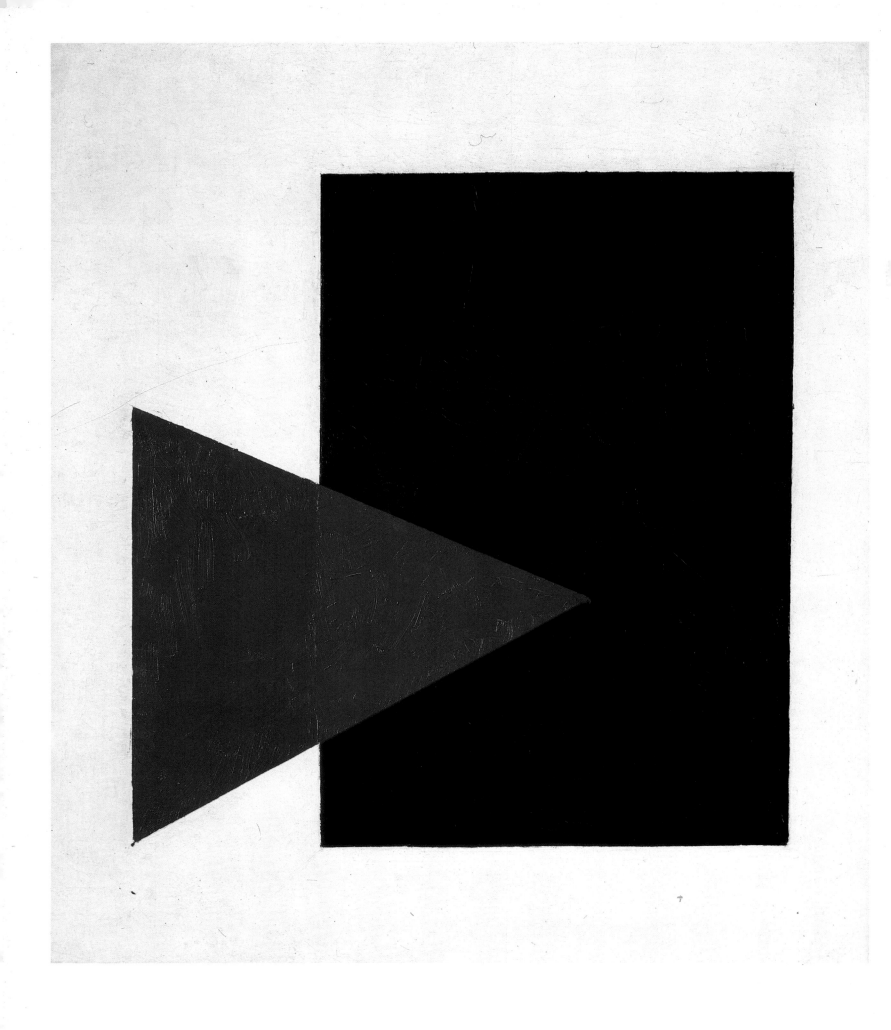

106 Suprematism (with Blue Triangle and Black Rectangle), 1915
Oil on canvas. 66.5×57 cm

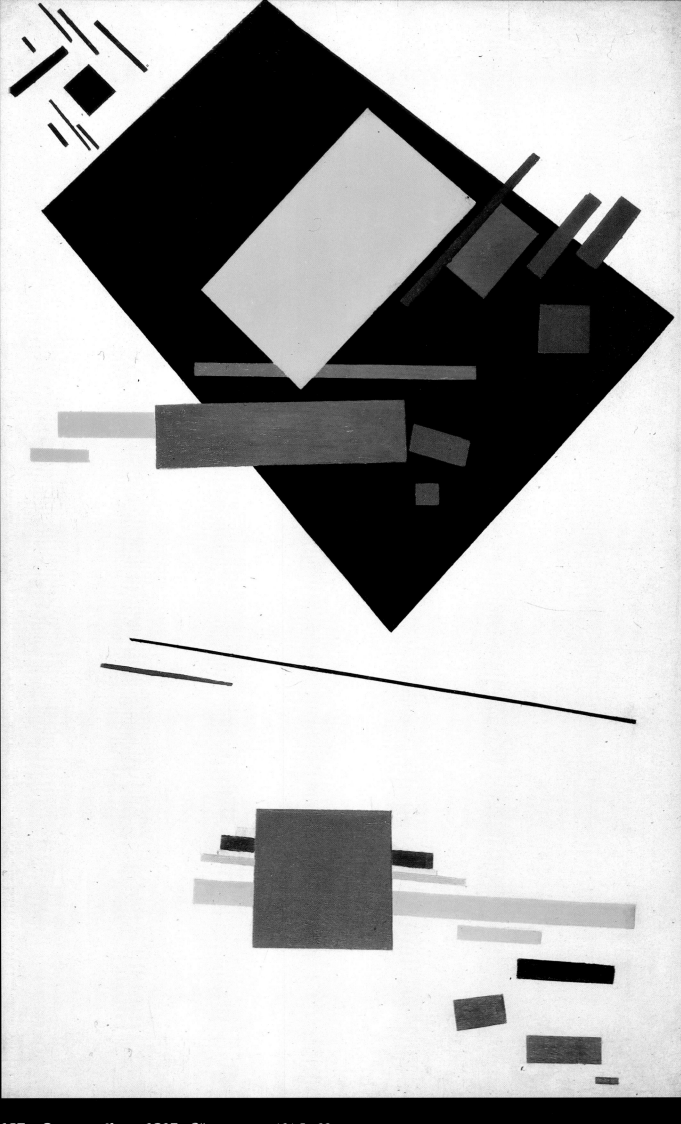

107 Suprematism, 1915. *Oil on canvas. 101.5×62 cm*

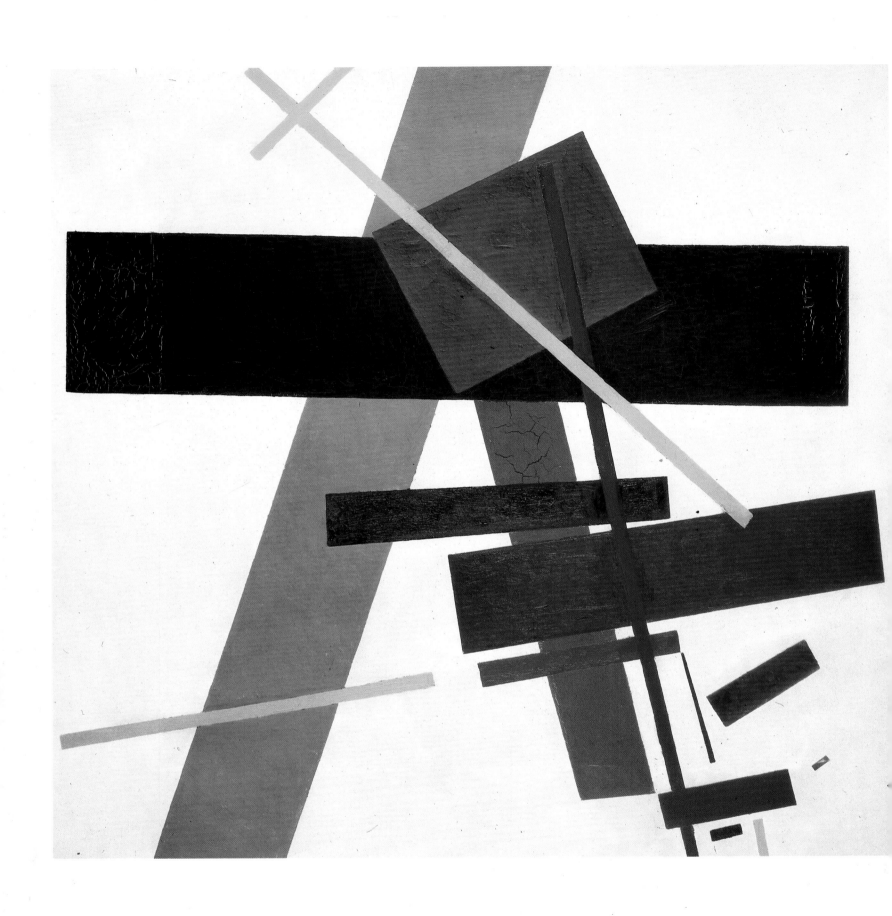

108 Suprematist Construction. *Oil on plywood. 72×52 cm*

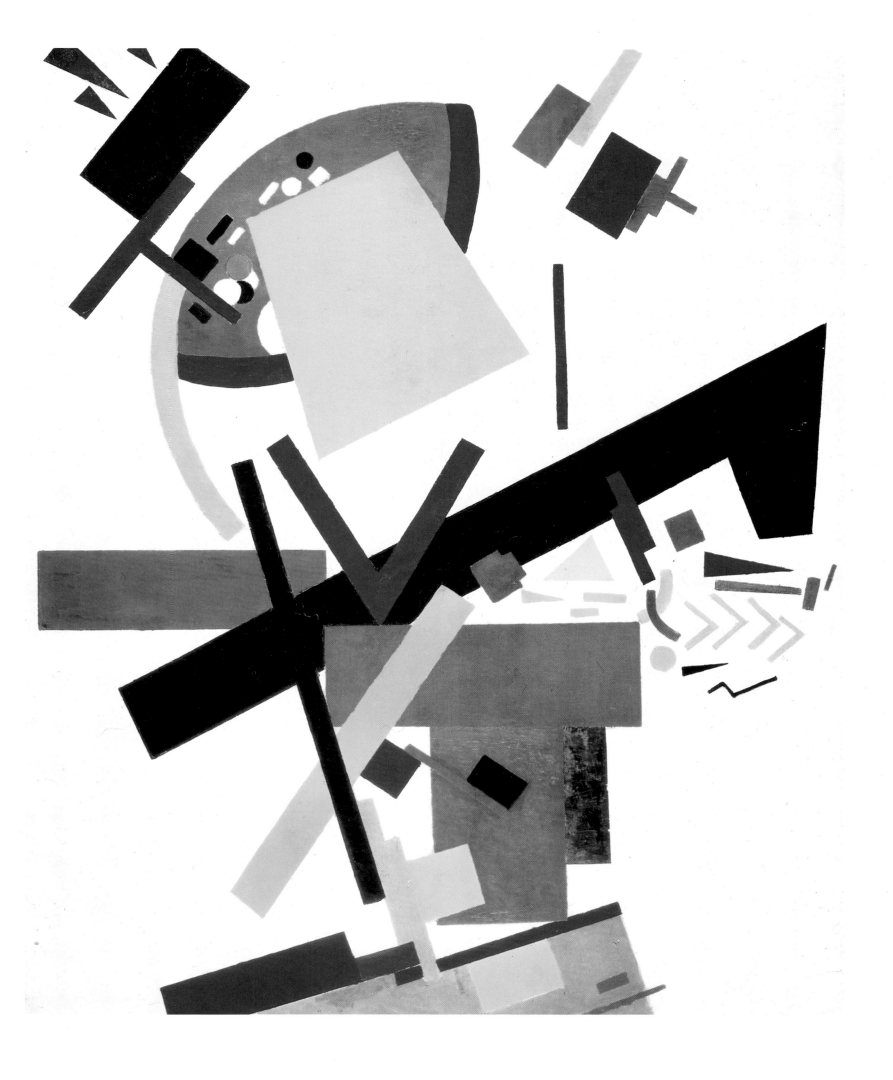

109 Suprematism. *Cil on plywood. 71×45 cm*

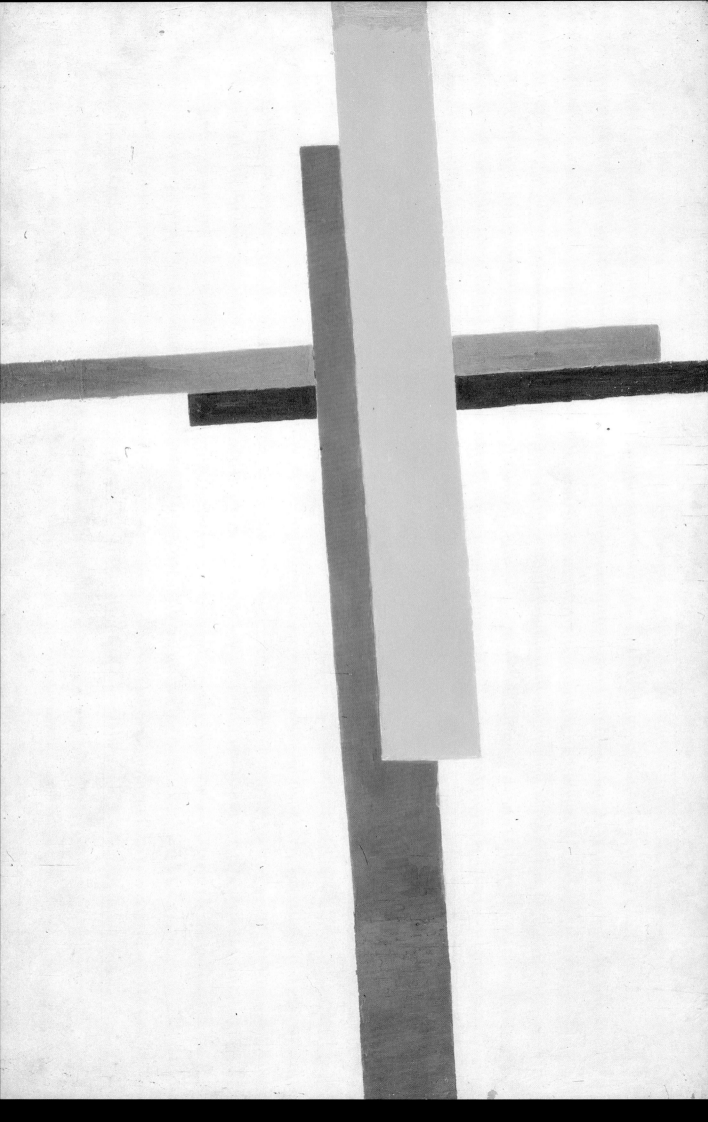

110 **Suprematism, 1916.** *Oil on canvas. 80.5×81 cm*

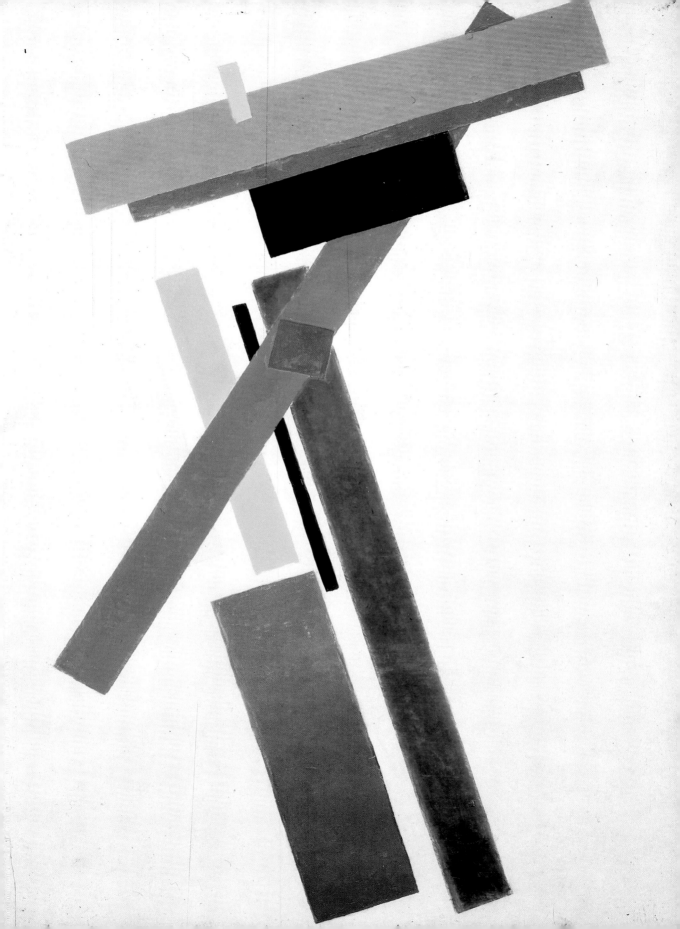

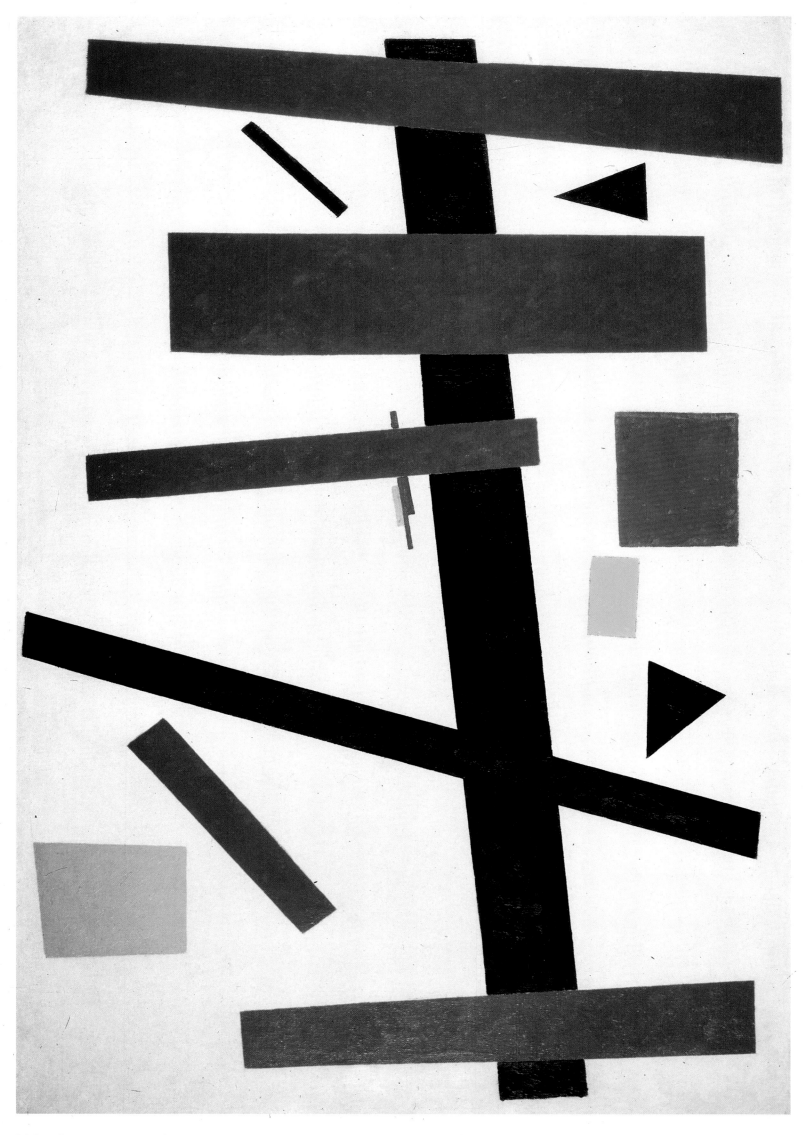

112**Suprematism (Supremus no. 50), 1915.** *Oil on canvas. 97×66 cm*

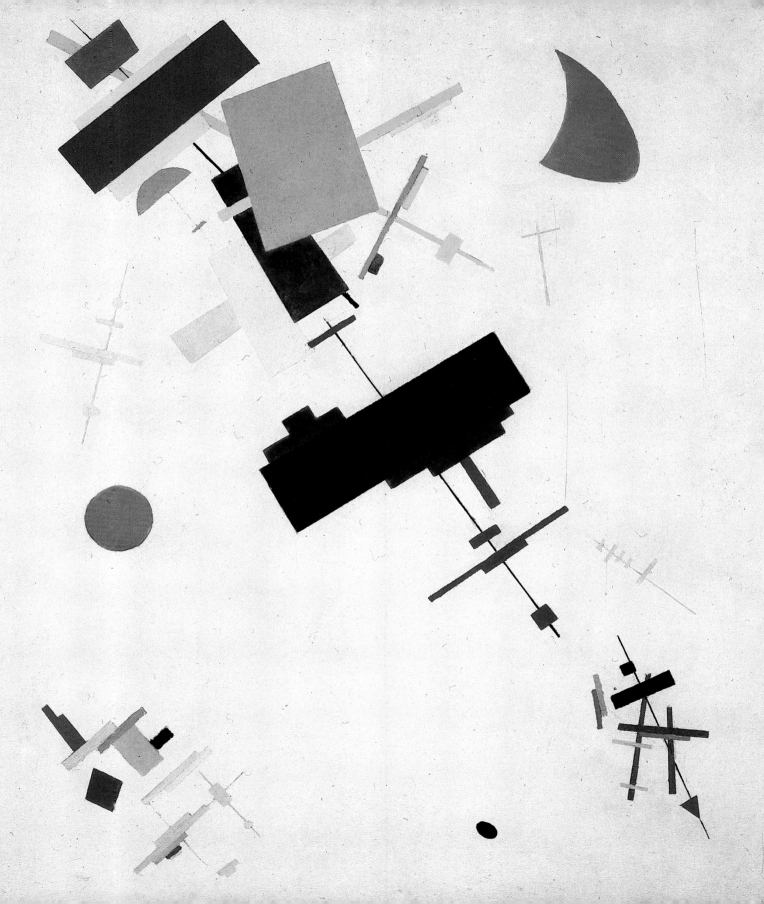

1936

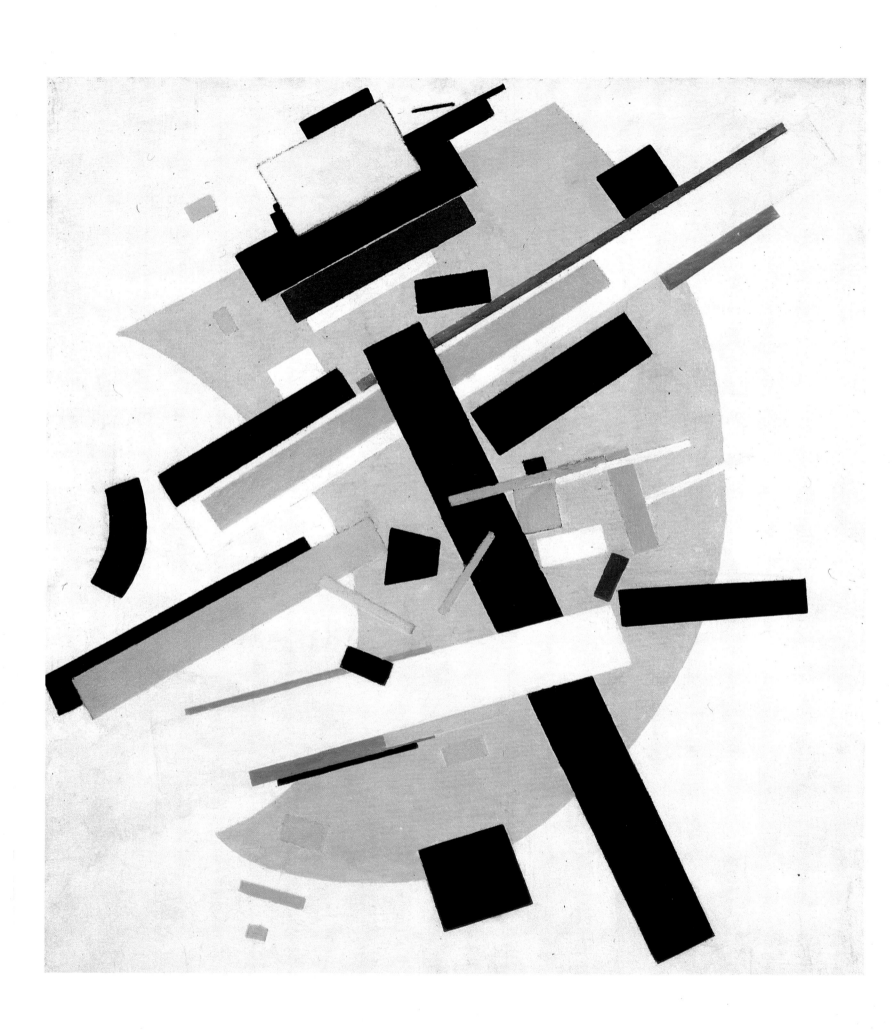

114 Suprematism (Supremus no. 58: Yellow and Black), 1916
Oil on canvas. 79.5×70.5 cm

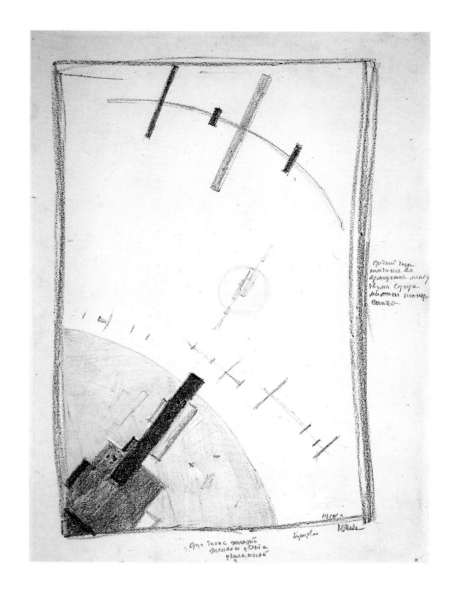

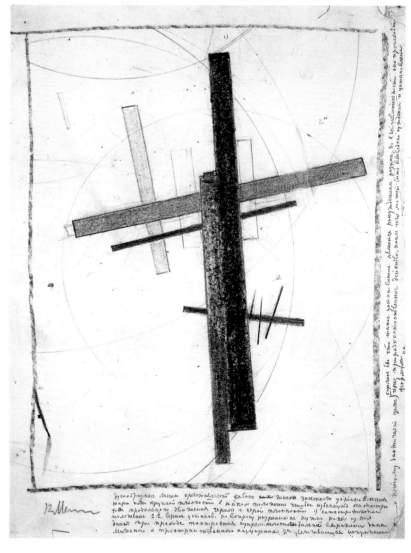

115 Study Suprematis 52 System A4, 1917
Black crayon and watercolour. 69×49 cm

116 Suprematism, 1917. *Black crayon. 32×24.5 cm*

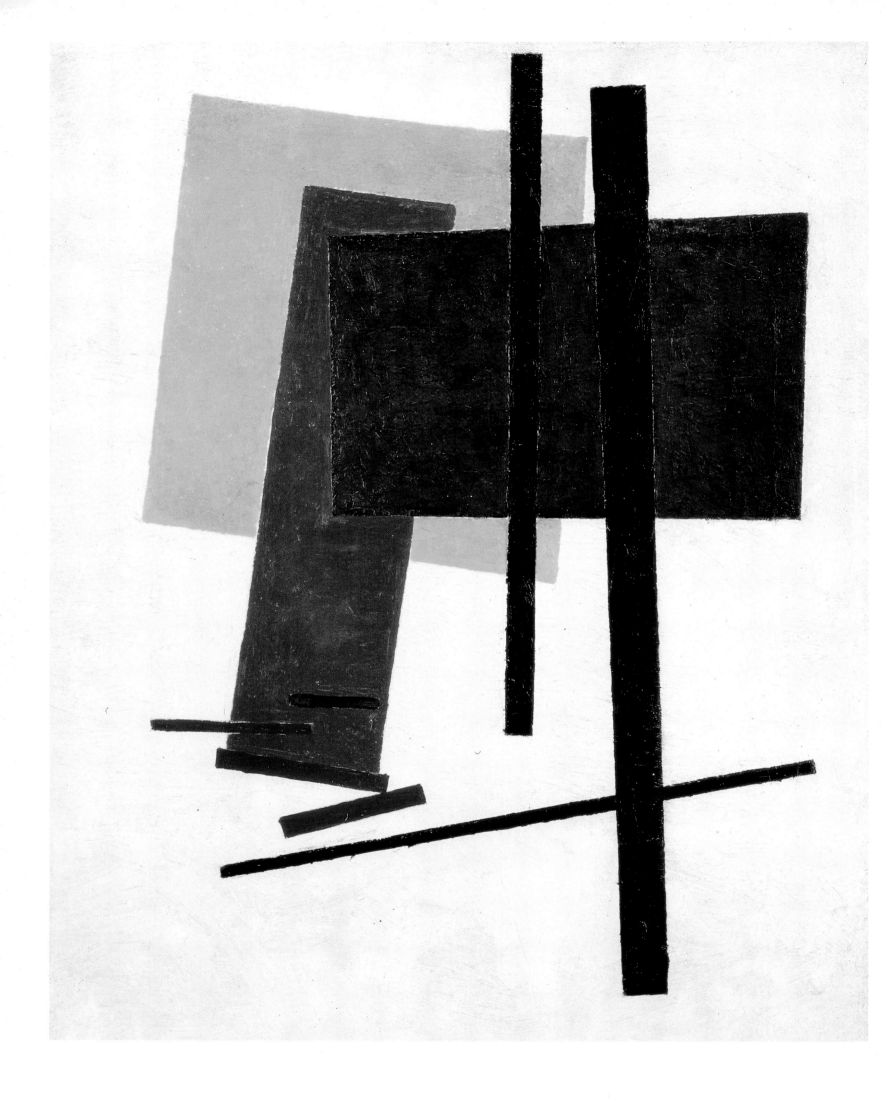

117 Suprematism, 1915. *Oil on canvas. 44.5×35.5 cm*

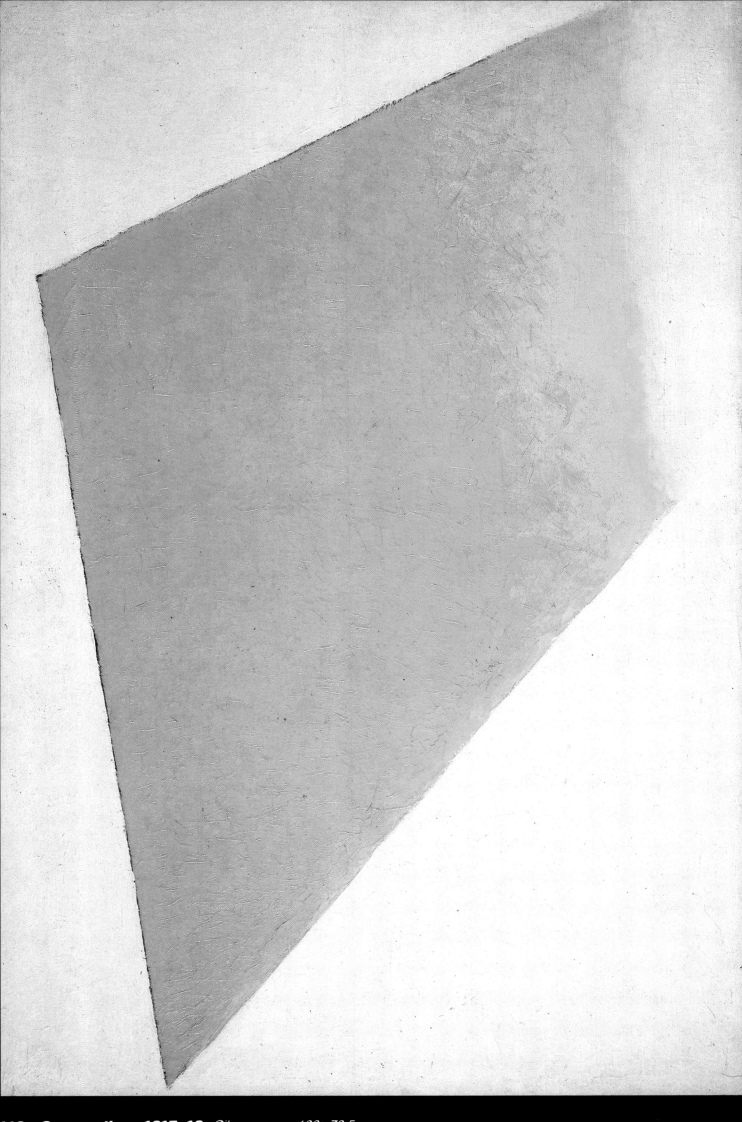

118 Suprematism, 1917–18. *Oil on canvas. 106×70.5 cm*

119 Suprematism, 1918. *Oil on canvas. 97×70 cm*

120 Suprematism, 1918. *Oil on canvas. 97×70 cm*

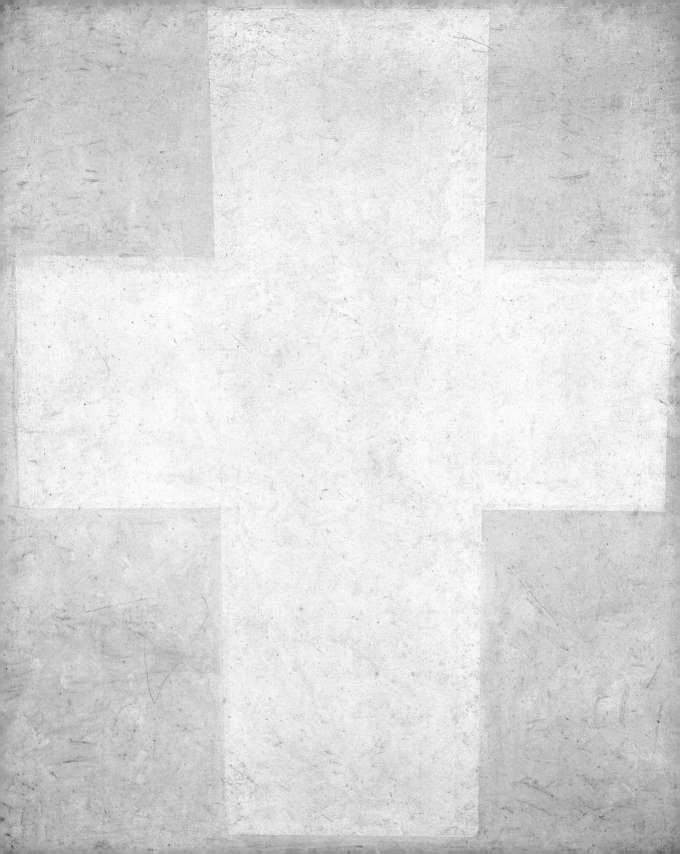

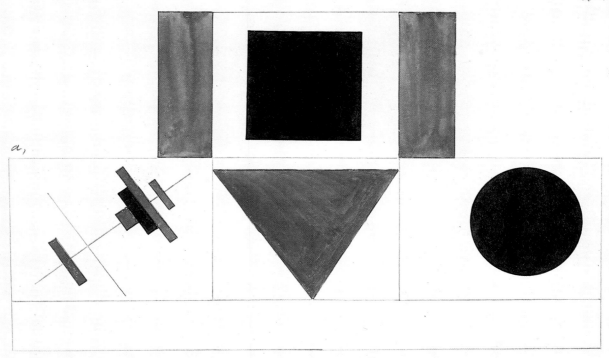

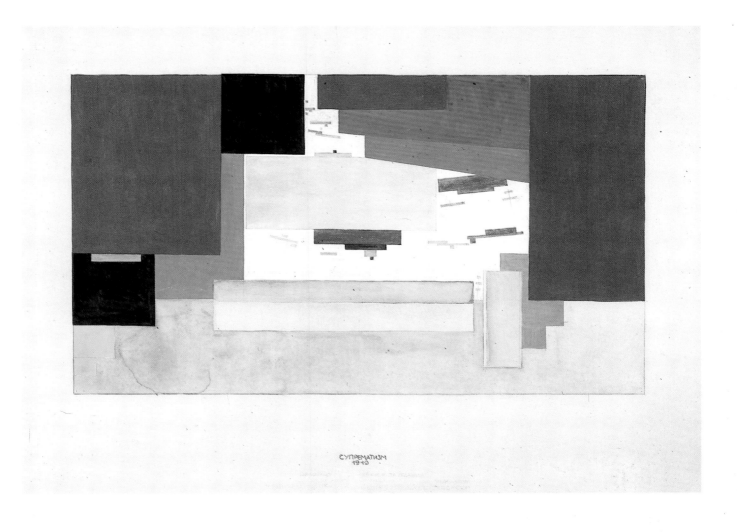

122 Speakers' Rostrum, 1919. *Watercolour and Indian ink. 24.8×33.8 cm*

123 Suprematism, 1921–27. *Oil on canvas. 84×69.5 cm*

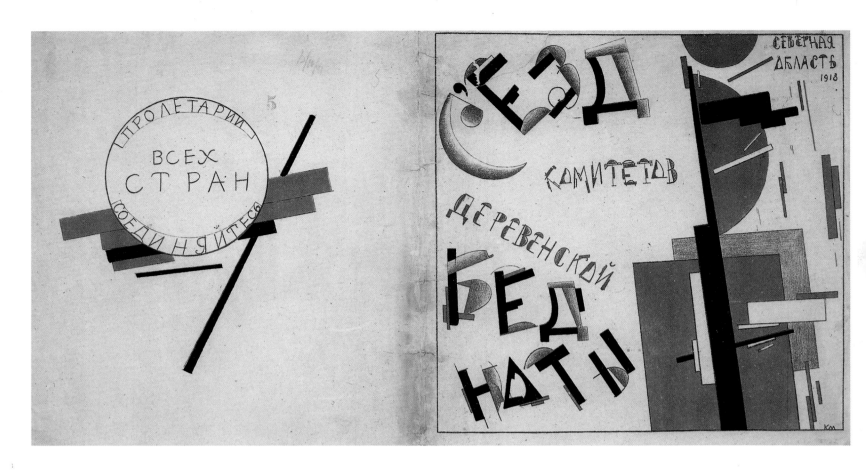

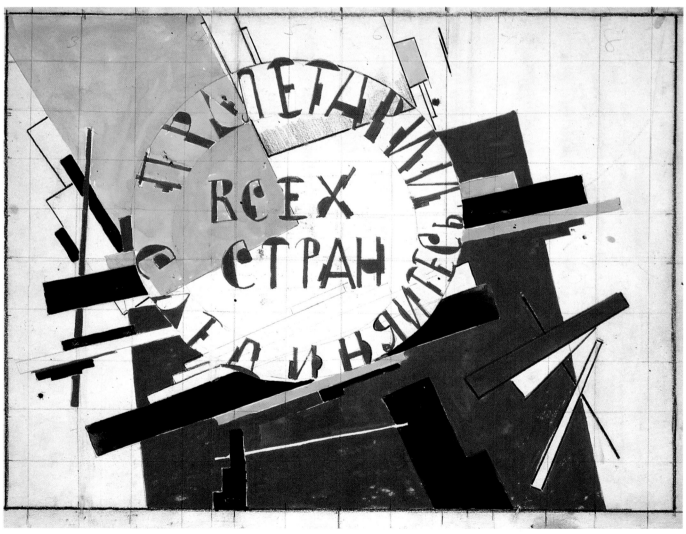

124 **Cover of Portfolio 'Congress of Committees on Rural Poverty', 1918**
Colour lithograph. 28.9×29 cm

125 **Design of back cover for Portfolio 'Congress of Committees on Rural Poverty', 1918**
Watercolour, gouache, pencil, and Indian ink. 32.7×41.3 cm

126 Front cover of Nikolai Punin's 'First Cycle of Lectures', 1920
Colour lithograph. 21.4×14 cm

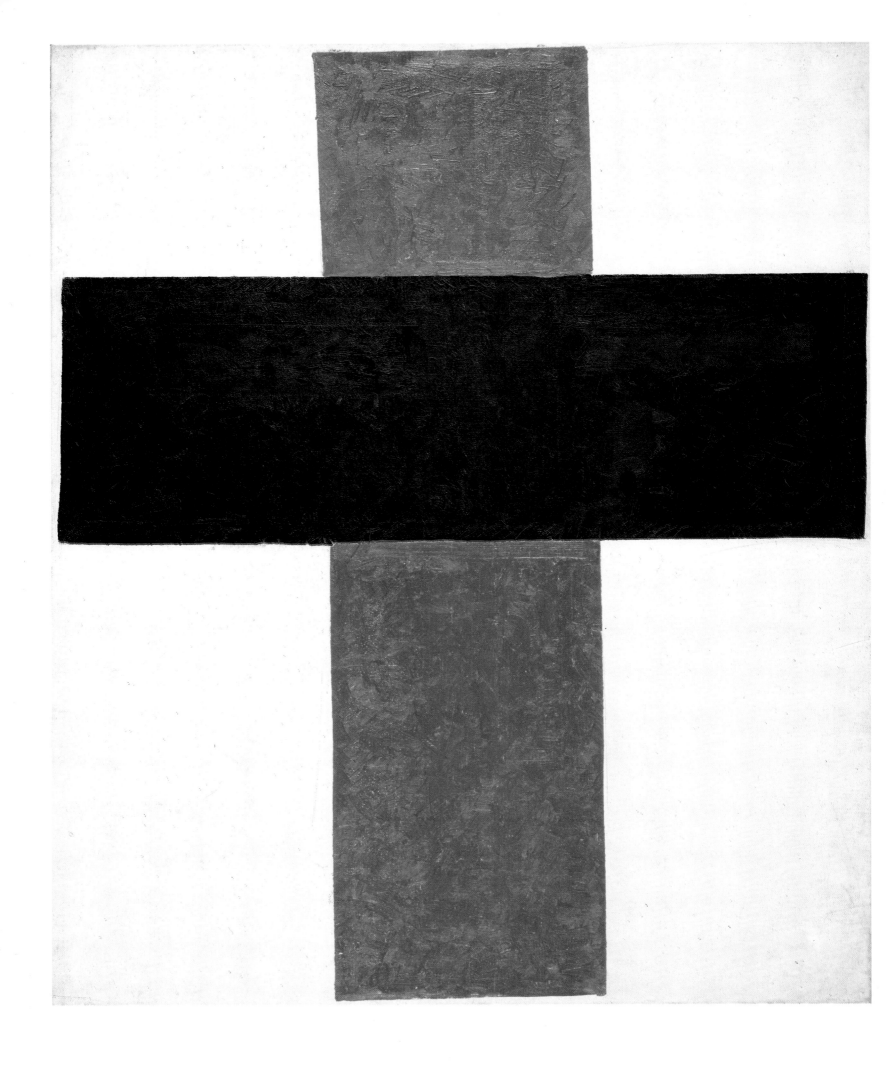

127 Suprematism: Study for a Curtain, 1919. *Gouache, watercolour, and pencil. 45×62.5 cm*

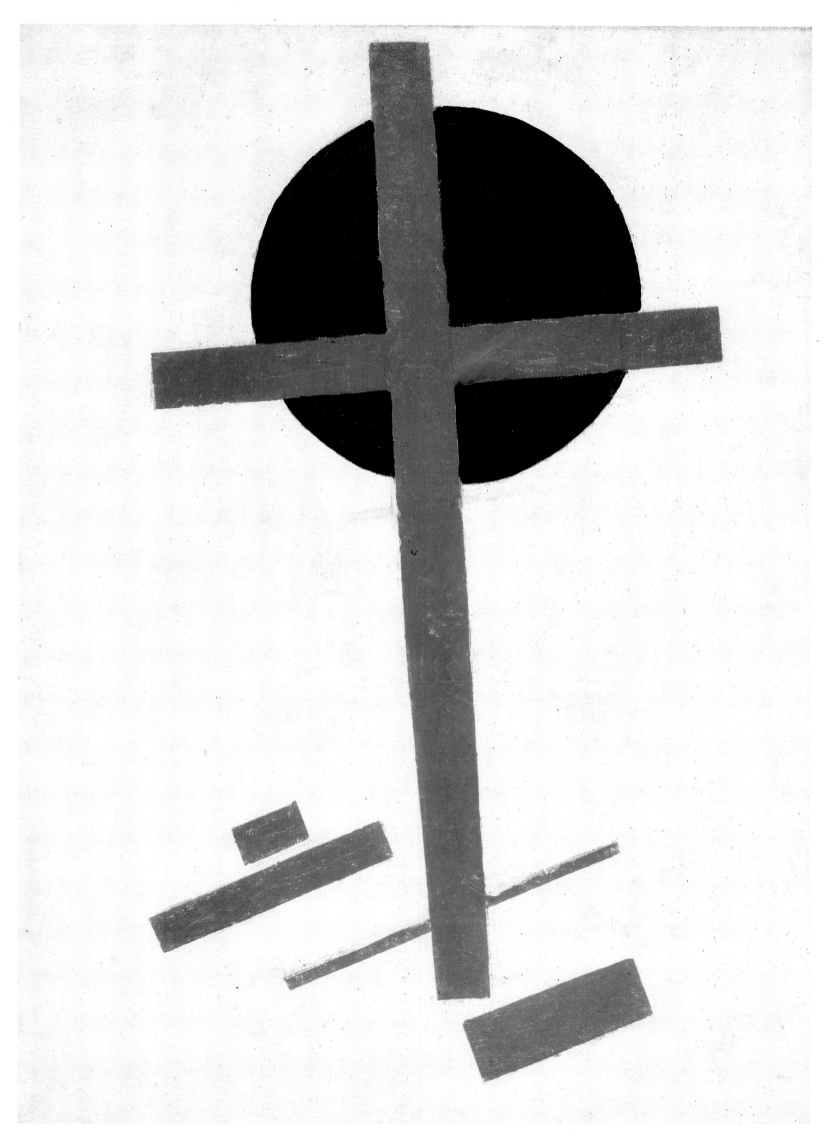

128　Suprematism, 1921–27. *Oil on canvas. 72.5×51 cm*

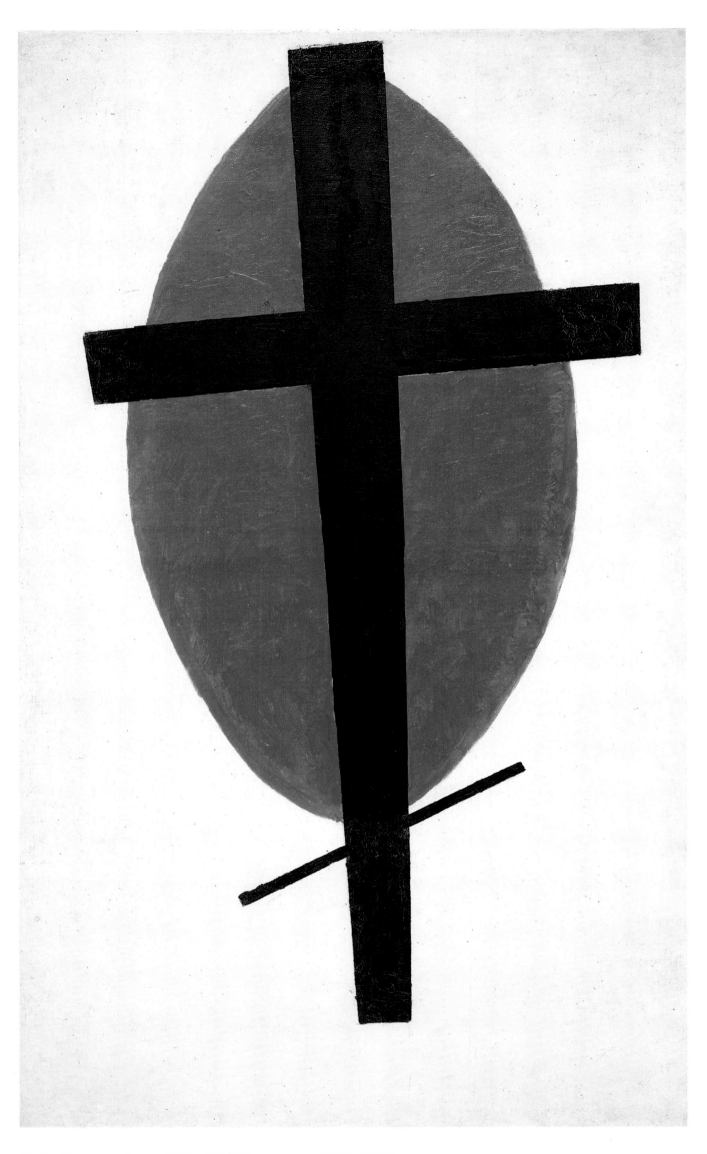

129 Suprematism, 1921–27. *Oil on canvas. 100.5×60 cm*

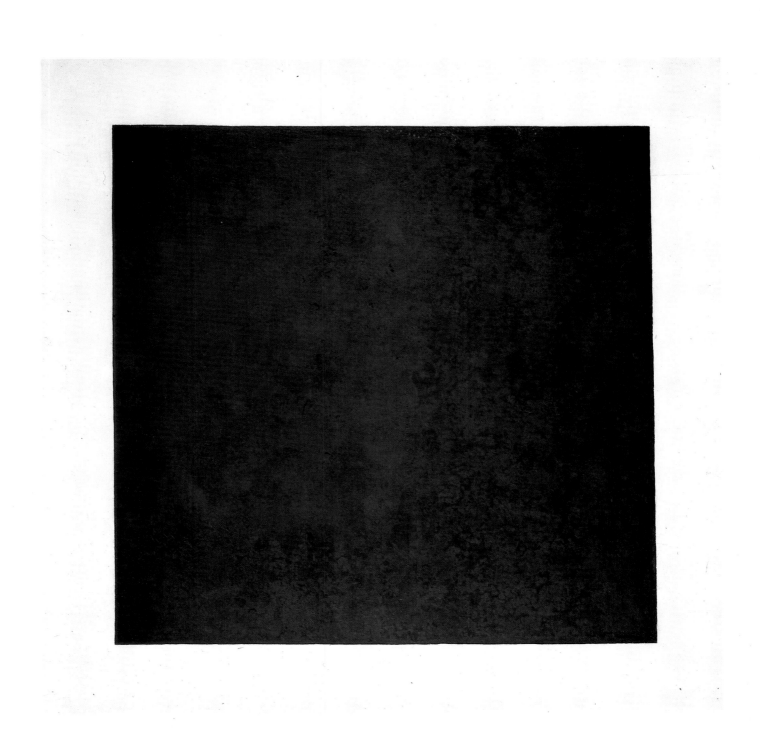

130 Black Square, early 1920s. *Oil on canvas. 106×106 cm*

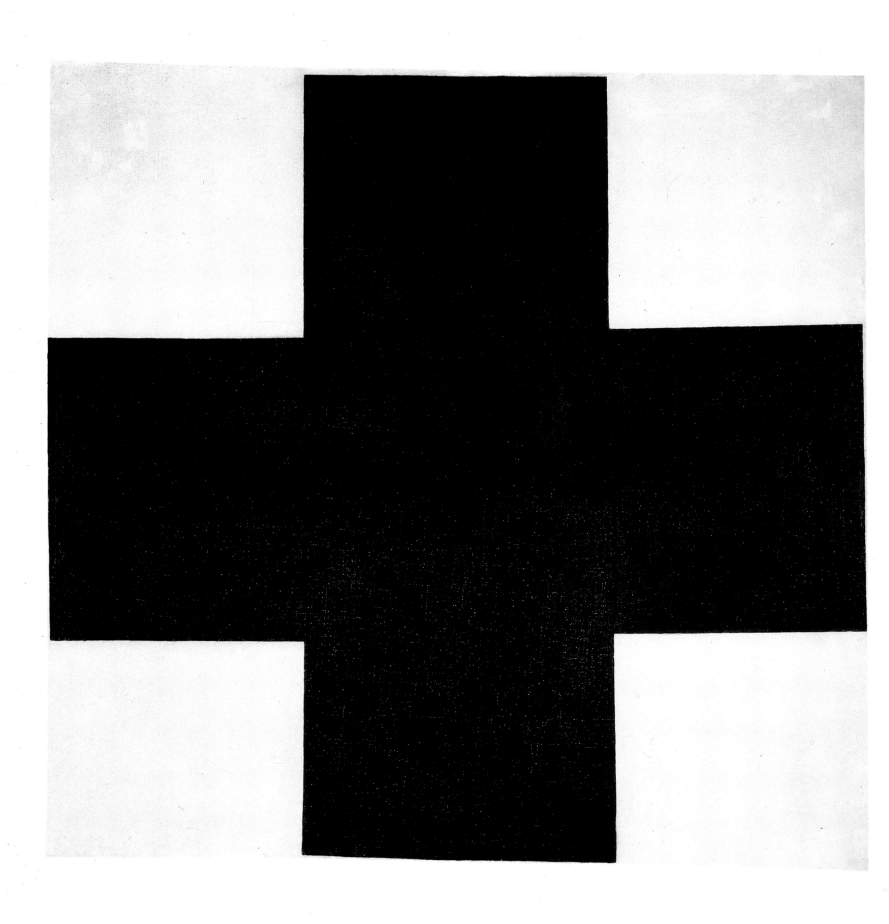

131 Black Cross, early 1920s. *Oil on canvas. 106×106 cm*

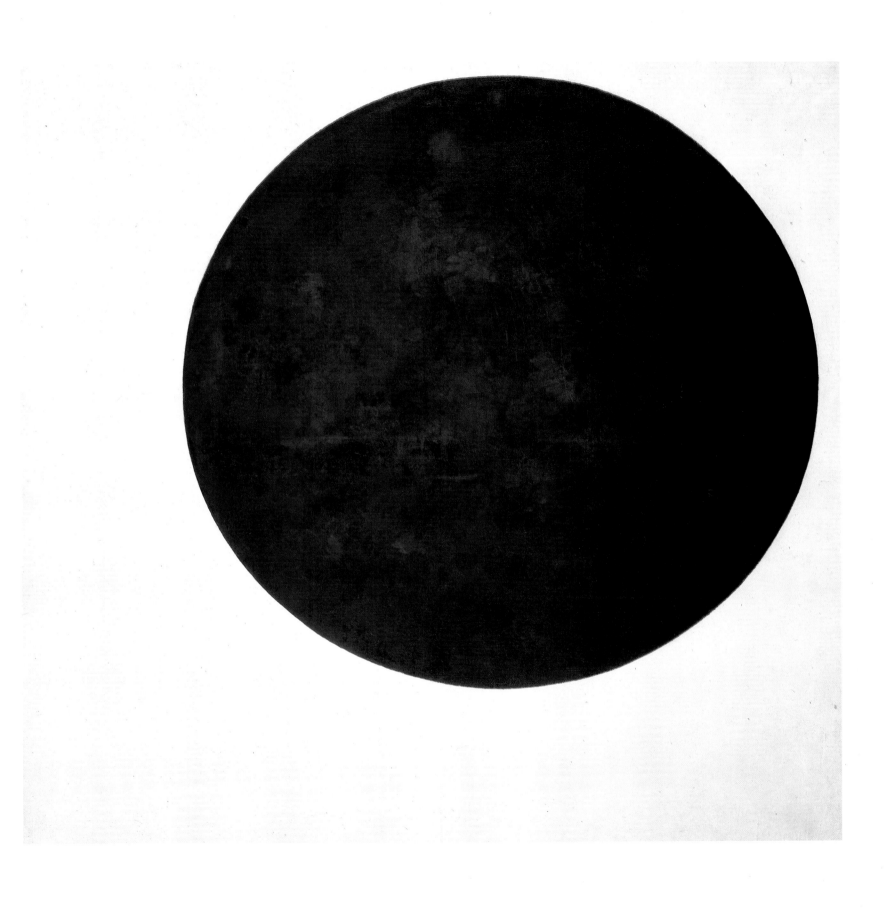

132 Black Circle, early 1920s. *Oil on canvas. 105×105 cm*

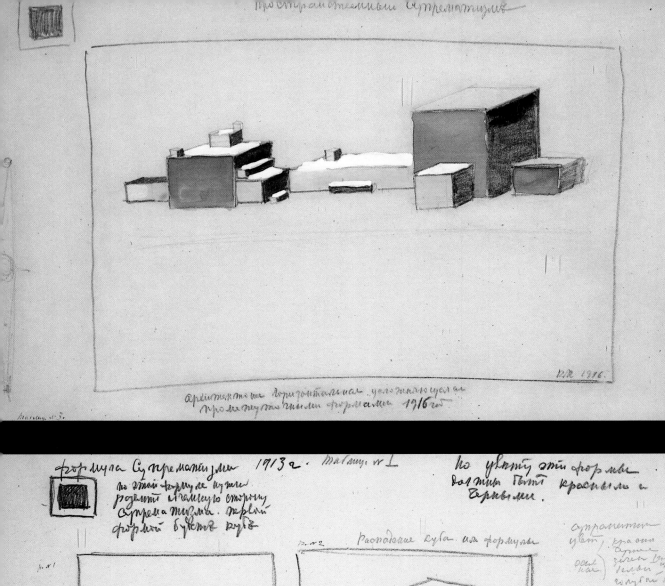

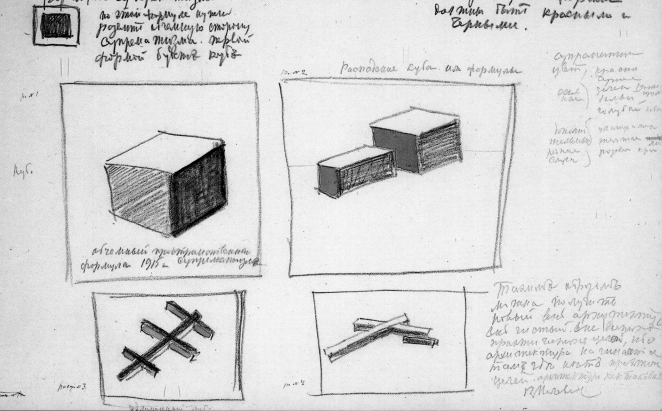

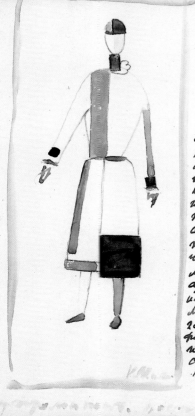

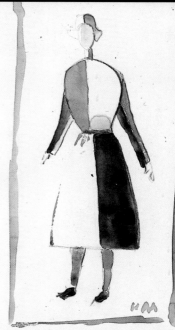

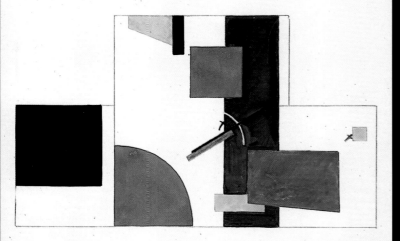

135 Design for a Suprematist Dress, 1923. *Watercolour. 18.9×16.9 cm*

136 Design for a Suprematist Dress, 1923. *Watercolour and pencil. 19×17 cm*

137 Principle of Mural Painting, 1919. *Watercolour, Indian ink, and gouache. 34×24.8 cm*

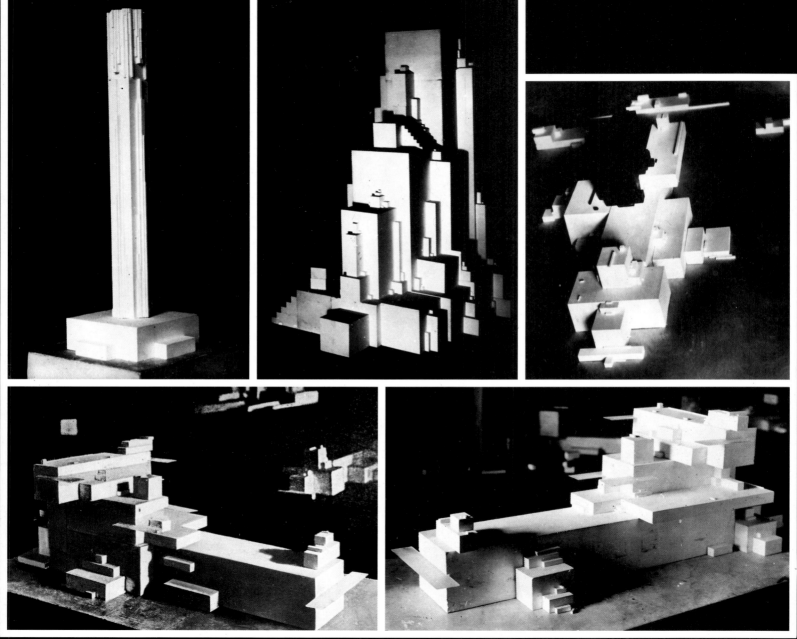

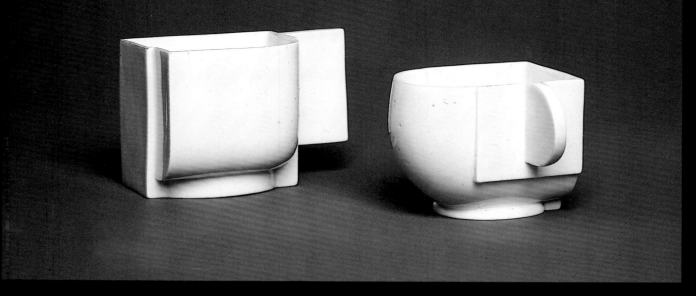

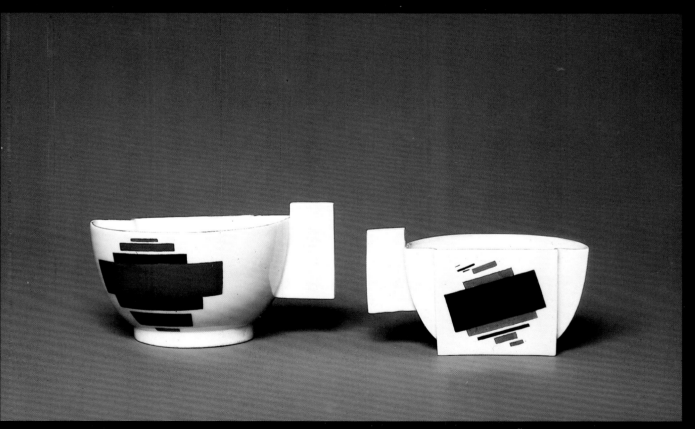

143 Two cups, 1923. *Porcelain. Heights, 7.8 cm (left), 7 cm (right)*

144 Two cups Suprematism, 1923. *Porcelain with underglaze painting*
Heights, 7 cm (left), 6 cm (right)

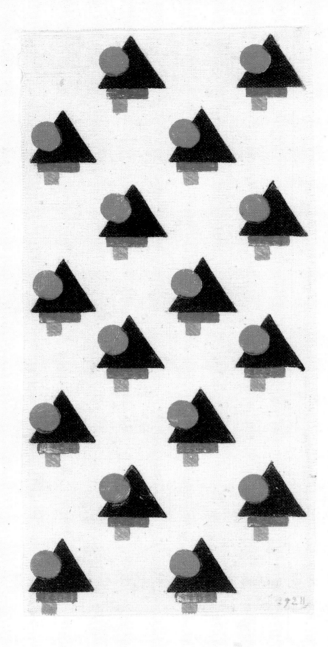

Первая ткань супрематически орнаментиробана
Выполнена в 1919 г. в Витебске.
К. Малевич

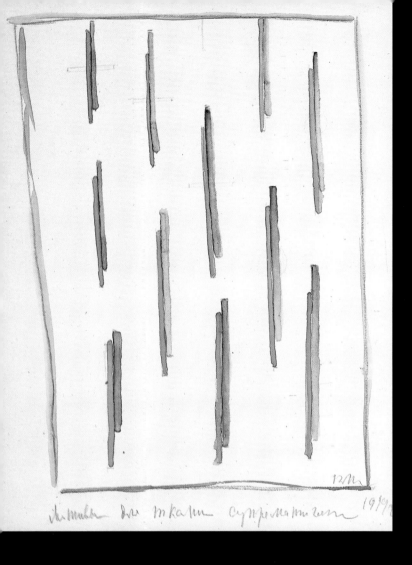

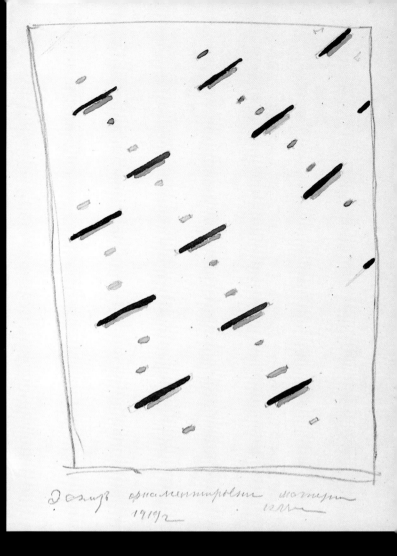

мотивы для ткани супрематизм 1919г.

Эскиз орнаментировки материи 1919г.

образцы для текстиль

орнаментировка ткани 1919

№ 15 орнаментировка ткани (ситец) и ситец 1919

Dmitry Sarabianov

Malevich at the Time of the 'Great Break'

A complex presentiment 1928–32. The composition is made up of the elements of the sensation of emptiness, loneliness and the hopelessness of life...

Kazimir Malevich, Inscription on the reverse of the painting *Half-Length Figure in a Yellow Shirt*

For years scholars have agonized over the dating of individual paintings and whole series by Kazimir Malevich. His works on peasant themes have posed particular problems. The exhibition which, at long last, brought together works from the State Russian Museum of Leningrad, the Stedelijk Museum of Amsterdam, the Tretiakov Gallery of Moscow, and a number of other museums, bore out the contention of those scholars who attributed most of the works on peasant themes to the late 1920s and early 1930s.[1] This article will primarily concern that second peasant series.

It should be unnecessary to analyze in detail here the reasons for Malevich's 'regression' from Suprematism to figurative pictures on rural themes. We may recall, however, that at the height of his Suprematist experimentation, Malevich subtitled *Red Square* (1915), *Painterly Realism of a Peasant Woman in 2 Dimensions*. In addition, some figurative pictures were termed Suprematist, like *Suprematism: Female Figure* (1928–32), or *Suprematism Within the Contour of a Peasant Woman* (as Malevich himself called his *Woman with a Rake*, 1928–32, Tretiakov Gallery). In the second instance the artist intentionally introduced a concrete human form into his system of universal existence. These examples alone point to the ties that existed between two distinct periods in the artist's career. Talk of a 'regression' is therefore inappropriate.

Malevich returned to rural themes for various reasons. Some were circumstantial and resulted from the 'exhibition situation' in which the artist found himself. In 1927 most of Malevich's paintings from the first rural series were in Germany, where he had left them, along with manuscripts, study charts and other works shown first in Warsaw, then in Berlin. Evidently he planned to return and continue his tour of Europe, which had begun so splendidly in 1927. The second trip did not take place, however, and in the meantime a show at the Tretiakov Gallery in Moscow was coming up; it opened in November 1929. That seems to be when a number of works dated 1909 or 1910 (or marked 'a 1909 motif') were produced—and this 'exhibition impulse' accounts for other works as well. Still others could have been educational exercises: Malevich had his students produce works 'in various styles', and did the same himself. He frequently reproduced his early Impressionism, which in later years existed alongside his Suprematism and 'Peasant Cubism'. This 'educational impulse' was also bolstered by his repeated attempts to review the path he had taken and test its governing principles.

What was created over the course of a few years and usually dated 1928–32 went far beyond the initial goals. Events gave the second peasant series unexpected power. Malevich's return to the peasant theme coincided with national tragedy, wholesale death, famine, and destruction, a catastrophe that shook the rural world and condemned it to irreparable destruction. Was the artist ready to face this reality? Was he capable of responding to the call of the land and the people who perished on it or were alienated from it? Those questions must be answered by his works.

Rural life was not as fresh in the artist's mind as it had been in the first decade of the century, when he was brimming with impressions of the Ukrainian and Russian countryside. 'I preferred,' he said in his autobiography of his youth, 'to befriend peasant lads, as I considered them free as birds, living in the fields, meadows and woods with the horses, sheep and pigs.'[2] Of his adult years he said, 'Peasant life in all its aspects held a great attraction for me.'[3] That love for the peasants and the landscape of the rural steppe carried over into his art. Knowledge of icon painting enabled Malevich to comprehend peasant art once he began his professional studies in Moscow. 'Through icon art,' Malevich said, 'I came to understand the emotional art of the peasants, which I had loved before; but until I studied icons I failed to grasp the full meaning of it.... I had a clear picture of the entire continuum, from the great icon art to the horsemen and roosters, painted walls, distaffs and costumes, as the continuum of peasant art.'[4]

All of these vivid impressions from childhood and youth, the lessons learned from icon painting and folk art, the work of his neighbours, especially Mikhail Larionov and Natalia Goncharova, all fed into the early

peasant series, and between 1911 and 1913 they served as a fairly solid basis for such paintings as *Peasant Women at Church* (Stedelijk Museum, Amsterdam, hereafter designated SMA), *Mower* (Gorky State Art Museum), *Reaping Woman* (Kustodiev Gallery, Astrakhan), *Woman with Buckets and Child* (SMA), *The Woodcutter* (SMA), *Taking in the Rye* (SMA), *Morning after a Snowstorm in the Village* (Guggenheim Museum, New York), *Woman with Buckets* (Museum of Modern Art, New York), versions of *Peasant Heads* that have not survived, and numerous drawings that were often preliminary sketches for works which in some instances have been lost. In all of these works, and particularly in the series as a whole, there is a clear sense that a developed concept lies at the heart. Malevich's rural universe is a stable community of people and nature in constant interaction. Man lives his life in labour. Existence is elevated to labour. Peasant women, carrying buckets of water on yokes or heading off for the field, take their children by the hand, for the young ones have been introduced to the rhythm of working life, and their faltering steps over the land seem to make it theirs. The 'peasant universe' is presented to us as an organism with a purpose, where life-processes are determined by the simplest and most obvious actions, where nothing is superfluous, where everything is objective-ontological, where the purposefulness excludes any supplements and every truth is achieved as directly as possible. Nature does not permit excesses; it has set itself strict limits. The behaviour of the figures portrayed is governed by the principle of terseness; the restrictions on movement make the static element dominant. Malevich weighs the figures down and gravitates towards square forms, filling his canvases with building blocks that may be broken down into their analogous basic elements. Out of all these motifs and devices arises the world of rural Russia as constructed by the artist—significant, coarse, seemingly frozen in its grandeur, not without its tragic strictures, unique muteness, and inertia. Neither man nor his actions, neither the earth nor its fruits, attains individuality under Malevich's brush. An individualized picture of man or his actions in the first peasant series would have been in clear conflict with the aims of the artist, who was employing general categories.

The image of Russian rural life created by Malevich in the early 1910s, though inert, provided a basis for change. If we take the view that the artist's logical development was 'from Cubism to Suprematism', then the visual world of the peasant might not have been 'of any more use' to him, and the 'regression', though it occurred, was not necessary. In that case, for all the integral value of the 'first peasant period', we would have to stress its integral qualities and the role the peasant genre played in the early 1910s in the development toward Suprematism. Signs of Suprematism certainly are to be found in these works, and it is a subject worthy of special study here we can merely cite the 'chain' that leads directly from some paintings of the first peasant series, like *The Mower* and *The Woodcutter*, to the costumes for the opera *Victory Over the Sun* (1913), which by general consent and Malevich's own account in turn led directly to Suprematist painting.

More interesting and, for us, more important is the reverse development. The 'regression' took place, and an important milestone in that process was the synthesis of the peasant theme with the Suprematist innovations of the mid-1910s. The individual in the paintings of the post-Suprematist period has not only a bond with the land but a place in the cosmos. He is surrounded not by the 'rural universe' but by the whole universe.[5]

Of the works of the second peasant series, *Haymaking* may be among the earliest. It was once wrongly dated 1909 or 1911, by this author among others, but the catalogue of the latest exhibition reasonably assigns it to 1928–29. This painting was definitely displayed at the artist's 1929 one-man show at the Tretiakov Gallery (it is reproduced in the booklet by Fedorov-Davydov) and became part of the museum's collection the same year. The general similarity of the composition to the Gorky Museum's *Mower*, labelled 1911 (this painting was not included in the catalogue of Malevich's last exhibition), provides us with the key to the inscription on a later painting: 'a 1909 motif'. The two-year difference between the current dating and Malevich's own (vis-à-vis the birth of the theme, though not the same painting) is quite possible, given that the artist himself attributed many of the motifs of his later works to 1909, even though they probably appeared in the early 1910s. The motifs of the two paintings are indeed similar, as are the treatment, the figures that seem to have been beaten out of iron pipes and then painted, the general devices used to depict faces, and the markedly different eyes.

At the same time, fundamental differences appear. As Charlotte Douglas has noted, in the later works the horizon opens, and space is treated altogether differently from the way it was in the early peasant works. In *The Mower* the red earth, overlain with a pattern of brown flowers and pink leaves, forms a solid wall rising behind the figure to the top of the work. In the later painting the horizon opens out behind the mower, while his head is no longer bowed. The whole figure acquires a monumentality and fills the space from top to bottom, very nearly bursting the bounds of the painting, but leaving the minimal space needed to separate the feet and the head from the edges of the canvas. He hangs suspended between freedom and

confinement. The figure's height, his air of meaningfulness and his accentuated, ideally-constructed pose of imminence (lacking in *The Mower*) increase the sense of conflict between man and the world. The world has extended its borders, while man has extended his will to rule that world. They appear to be on a collision course that threatens alienation.

Several works of the second peasant series, including *Reaper*, *At the Harvest (Marfa and Vanka)* and sketch for *Reaper* (Russian Museum), suggest the first signs of alienation. Almost all of them are dated 1909–10 by the painter and have been executed in a single style, although each exhibits some feature characteristic of later experiments. There are similarities in the treatment of the landscape, which is not very strongly geometricized, and the line of the horizon has a certain lack of constraint. The small figures of peasants are grouped rather freely, and their movements are natural. It goes without saying that in listing all these features, I am making a relative comparison, particularly with the forms and devices that were soon to appear.

But certain advances can also be seen in this group of works. An interesting change takes place in the gestures of the hands, for example. At first the hands of the subjects are busy, as in works from the early 1910s: the reaper cuts rye with a sickle, Marfa carries a can and a bundle of food, the mower holds a scythe and a small bucket with a whetstone. Then the objects suddenly fall away, and the peasant woman in the sketch for *Harvest* stands frozen, fingers curled. The 'spread' arms, which appear to have just relinquished some burden and are without functional justification, would later become an independent expressive element which Malevich would long retain in his compositions—until he began to 'manipulate' the hands of his subjects in new ways. (More on that later.)

In the sketch for *Harvest*, the peasant woman's face loses all of its features and is depicted as a blank oval—a favourite device that Malevich frequently employed in his second peasant cycle. The 'eyeless' expressiveness of the oval heads is anticipated in the rear view of Marfa's and Vanka's heads in *At the Harvest*. Malevich experimented with the same motif in the 1912 painting *In the Field* (location unknown), but in that instance it was mitigated by the figures of peasant women walking towards the viewer, and did not achieve a self-contained expressiveness.

In arranging these works in a logical sequence, I do not mean to present a strict chronology. We do not know enough to assign each painting a specific date, particularly as some motifs and methods of interpreting them go back to the early 1910s.

One such example is the motif of the flying aeroplanes above the *Head of a Peasant* (Russian Museum). They could be seen in costume sketches for *Victory Over the Sun* (1913), but there the aeroplane was one of a number of symbols, including fish in silhouette, a cross and a crescent. In *Head of a Peasant*, the planes symbolize civilization, the machine age, the antithesis of the old village huddled on the horizon at the left edge of the painting, which, with its church crosses, trees and noisy crows, figuratively recedes into the past. There is no reason to doubt that this contrast was intentional, or that the train rushing through the fields in another painting of the period, *Peasant in the Field* (1928–32, Russian Museum), is pregnant with significance.

From the standpoint of official Soviet iconography of the late 1920s and early 1930s, the new motifs Malevich introduced into the 'peasant genre' were fully in keeping with the spirit of the art then gaining momentum and soon to reign supreme. However, in bringing evidence of the new civilization into the rural world, the artist interpreted these phenomena as dissonant elements in a once stable, regulated world that had begun to fall apart. The bond between man and the land had been undermined. It is no accident that the peasant faces in both paintings occasion such thoughts: they are surprisingly distinct and tragically expressive. In comparison with the apathetically inscrutable face of the mower in *Haymaking*, the head of the *Peasant in the Field* is distorted by a grimace of fright or raging despair. The dark dots of the eyes gathered at the bridge of the nose (like buttons on the face of a doll), the pouting lip, the involuntarily long nose—this face, for all its abstract qualities, expresses a specific emotional state and gives the image a general message.

A similar balance between the specific and the general is struck in *Head of a Peasant*, which represents the culmination of several 'peasant heads' exhibited in the early 1910s. (See as well the *Portrait of Ivan Kliun* [1913, Russian Museum], with its anatomic study of an eye that seems both to perceive itself and to penetrate things to their core.) Here again Malevich concentrates the expression of the peasant's face in the eyes, where the look comes from within, from the earth, from a world no longer in harmony. The stark contrast of red, black and white, used for the main shapes of the composition, is extended to the depiction of the landscape, sky, and distant figures, and is all but unrelieved by other colours. In portraying the strange symbiosis of life and death in tragic confrontation, this sharp colour contrast intensifies the urgency of the question, and the energy of the negation, that emanates from *Head of a Peasant*.

In *Woman with a Rake*, the severely geometrical landscape has a draughtsman-like quality throughout, while the silhouettes of structures dotting the horizon no longer belong to peasant houses but to stone buildings, painted—like the parts of the figure—red, white, black and yellow. This backdrop also points to the intrusion of civilization into the rural world. But *Woman with a Rake* does not have the tension of *Head of a Peasant*: despite the similarity in colour scheme, the former, more formalized painting does not place man and the world in such stark contrast, and the patches of colour are distributed more or less evenly and serenely. The work lacks the 'harmony of despair' that imbues *Head of a Peasant*.

Girls in the Field (1928–32, Russian Museum), one of the largest canvases of the second peasant series, also lacks any extreme of tension. The painting, defined by Malevich himself as 'Supranaturalism', represents a true balance between objectivism and non-objectivism, between the shapes of the female figure and the symbols of Suprematist existence, realized in geometrical forms that infuse the entire surface of the painting with rhythm, according to a fairly strict law of variations and likenesses; but irritating 'signs of the mundane' remain, like the spread arms with unclenched fingers that have lost what they held, or the blank oval heads with their red and black halves. These 'signs' are subdued and seem to have dissolved in the geometry, but in fact they are simply hidden and can emerge as soon as 'Supra' makes way for 'Naturalism'—which would not necessarily correlate with the chronological sequence, as I have mentioned before. Nevertheless, the logical assumption is that most of the works I shall now consider were produced later than those have already discussed. Significantly, the paintings in this next group are dated by Malevich not 1909 or 1910, but 1913, 1914, 1915 or even 1919—none of which, of course, is correct. But it is interesting to note that the artist adhered to this particular sequence when creating the myth of his development.

The new cycle of experimentation begins with gestures, with the transformation of the subjects' hands. After hands lost their function and stopped performing actions, gestures took on symbolic meaning. This is true in *Harvest*, *Peasant Woman in the Field*, *Girls in the Field*, and *Sportsmen* (1928–32, Russian Museum). In *Peasant Woman* (1928–32, Russian Museum), the symbolism acquires evil overtones: the woman's hands, legs and head are black, in contrast to the white of her dress. The combination of black and white takes us back to the starting point of the Suprematist programme, while charging the entire composition with metaphysical, almost mystical, significance. As the woman's head is turned aside, and she almost stands in profile against the dark blue sky, her gesture becomes even more emblematic. Though outwardly reminiscent of the subjects of the paintings from the 1920s and 1930s, *Peasant Woman* makes a very different statement. The strict symmetry, the rigid parallelism of the horizontal and diagonal lines, stress the idea of isolation, grim immobility and the hopelessness of daily existence. The Suprematist element elevates this idea to the realm of the universal, making the feeling of hopelessness global.

Another work, *Three Girls* (1928–32, Russian Museum), presents a distinct and unusual treatment of this motif, in which the hands of each of the figures 'behave' in their own way. The girl in the middle has them crossed on her chest, the girl on the left has them clenched and hanging at her sides, while the girl with the flower has them raised toward her face. This variety, set against the almost complete monotony of other multi-figure compositions, is obviously deliberate. Malevich is probing, testing.

Hands and their gestures achieve new and more weighted interpretations. In *Two Male Figures* (1928–32, Russian Museum), they are pressed to the sides of bodies drawn to their full height; but in *Peasant* (1928–32, Russian Museum) they refuse to remain passive, and one hand, disproportionately large, directs our attention to the flat earth spread beneath the subjects' feet. Here again we have a complex image, in which the artist has striven to replace the immediate, obvious message with its diametrical opposite. The gesture, which could be an affirmation, becomes instead a bewilderment, a signal to us to witness the tragic fate of the land, the sky, and man.

Then hands and arms start to get in the way. At first they disappear below the picture (*Three Female Figures*, 1928–32, Russian Museum; *A Complex Presentiment*, 1928–32, Russian Museum; *Two Peasants Against a Background of Fields [Half-Figures]*, 1928–32, Russian Museum). Later they vanish altogether, turning the figures into monstrous armless creatures (*Suprematism. Female Figure*, 1928–32, Russian Museum; *Peasants*, 1928–32, Russian Museum; *Man and a Horse*, early 1930s, Musée National d'Art Moderne, Centre Pompidou, Paris). The evolution is eloquent testimony. Malevich continually sought new plastic means of depicting life's degradation, the irreversibility of the losses being suffered and the magnitude of the disaster that was occurring.

Evidence that the artist was indeed coiled in such thoughts rests in his inscription on the back of *A Complex Presentiment (Half-Length Figure in a Yellow Shirt)*. After the title and date (1928–32), Malevich wrote: 'The composition is made up of the elements of the sensation of emptiness, loneliness and the hopelessness of life. 1913, Kuntsevo.' The words are unambiguous; ambiguity arises only with the date. Malevich could not apply a phrase like 'the hopelessness of life' to the time the painting was produced, a period then called the Era of the Great Break in official histories. So he said a feeling of hopelessness had been born in 1913.

Was this a conscious attempt to conceal his thoughts, or an unconscious attempt to justify the age? Probably the former. Many people then tried to justify the age, of course, and Malevich could have been among them; but we must keep in mind the artist's own fate in the late 1920s and early 1930s, when he suffered a catastrophic loss of status and was subjected to persecution and arrest—when, in other words, he experienced the whole oppressive weight of the break then underway in Soviet Russia.

Malevich sought a formula for hopelessness in all the works of the second peasant series. In the faceless bearded men, in the slate-black figures of women, in the armless country folk, this formula acquired its plastic culmination. How could the artist approach the contradictions of his time? Critical passion could not be expressed through an edifying story. A straightforward approach—expressing the idea in the traditional genre of critical realism—would naturally have been dissatisfying to Malevich, whose work had swiftly evolved in the foregoing years from mystical depictions of life to symbolic imagery. Only a synthesis of the non-objectivism that had brought him to the point of direct interaction with the truths of the higher world, and the concrete imagery that had grown out of mundane reality, could enable him to develop productively. As in the case of *Peasant Women*, Suprematist symbolism merged with plastic imagery.

A Complex Presentiment (Half-Length Figure in a Yellow Shirt) displays a similar synthesis. The erect figure, stretching to the very top of the canvas and forming a cross with the strips of land that intersect it at the waist, contrasts with a red house on the horizon—simple forms recalling Suprematism. Like objects from outer space, the world of purified forms does not seem to know the concepts of up or down. It is a sultry world, of easy movements ungoverned by the laws of gravity; but this is an abstract interpretation of the painting: intertwined with the Suprematist concept is reality. The figure is cramped by the expanse, the neck is stretched, the arms extended. Edged to the right, the figure has lost its dominant position on the surface of the canvas and is torn from the centre. These devices symbolize the uprooting of mankind, its proximity and muteness, its captivity and doom.

This can be seen in the motif of the house—which was freighted with special significance in the second peasant series. It is stone, bleak and eyeless; it resembles a barracks or a prison,[6] not a peasant home. And the slabs of yellow, white and black against a dark blue background charge the image with a transparent remoteness. The Suprematist element is no longer in conflict with the 'naturalist' element, but merges to impart a sense of unending suffering, abandonment and aimless existence.

This 'plane of reality', an important element in the second peasant series, was embodied in various ways. I have already discussed the emblematic features that appeared in many of these works, a symbolism corresponding in some degree to the iconographic typology that had taken root in Soviet art by that time. The labourer, the model worker, the collective farmer, the athlete, the agitator, the Red Army soldier, the commander, the partisan, the switchman, the guard, the leader—a whole series of stereotypes, each with its distinctive features, was then established in painting, graphics and sculpture. More often than not, they were heroic figures, intended to reflect the changes under way. All had their 'marks of grandeur'.

Malevich's peasants would appear to belong to these 'emblematic subjects', but they also bear an antithetical charge. Their grandeur is tragic; they remain heroes; the spatial correlation between the figures and the background, the subordinate role of the surrounding objects, the compositional devices that infuse the image with a sense of monumentality, all bolster the heroic element. But this is heroism bordering on the grotesque. *Two Male Figures*—a painting in which heroism equals doom—illustrates Malevich's 'grotesquerie without laughter'. The great similarity of the two subjects (which differ only in height), the identical gesture of the arms pressed against the sides of the body, the sameness not merely of clothing and colouring but even of the black beards apparently blown to one side by the wind (in contrast to the static nature of the composition, which seems marked by an absolute stillness)—all of this turns the subjects into marionettes. They resemble not only each other, but millions of people whose lives are subjugated to inhuman laws and unearthly, superhuman forces. Cosmic grandeur exists side by side with equally universal insignificance.

The expression of protest on the faces of the *Bathers* (1928–32, Russian Museum) signals a significant change. The unusually concrete faces of the two outer figures hem the 'blank' face of the central one. By this juxtaposition, Malevich seems to be saying that no matter how distinct the individual features, these people share a single fate; no matter great the protest welling up inside them, they are helpless in their nakedness before the evil triumphant in the universe.

It was because Malevich had Suprematism to draw on when creating the second peasant series that he could depict the idea of evil, then ascendant, with such generalizing power. We do not witness evil deeds, nor does this evil have a specific source. It is dispersed throughout the universe and makes the latter absurd, alogical, governed by ridiculous laws that violate the natural order of things. The tragic world of Malevich in these years bears some similarity to that of Franz Kafka: a world directed by an invisible will. At the same time, Malevich's world is generally like that surrounding 20th-century man.

Towards the end of his work on the second peasant series, Malevich took up new motifs—the running man (running past a cross), the cross and crucifixion. Only one of these paintings is known to us—*Running Man* (early 1930s, Musée National d'Art Moderne, Centre Pompidou, Paris). Like the *Man and a Horse* mentioned above, *Running Man* differs compositionally from most of the works considered here. Motion replaces motionlessness, though the composition is still carefully balanced, and landscape acquires new features: elongated crosses loom over buildings. It is impossible not to see these details as symbolic, or the action of the man as an expression of a situation ridden with conflict. The statue-like quality of one figure and the headlong flight of another, point to this conflict in equal measure, but Malevich probably thought the runner would be particularly expressive, and his new plastic formula for tragic hopelessness is again displayed in an emblematic image. In contrast to the joyful races run by many heroic athletes, which in paintings of the 1930s embodied the baneful myth of the happy man in a flowering land, Malevich's *Running Man* faces the viewer with the life that had been destroyed, and the universal catastrophe. Piercing the curtain of lies, Malevich seemingly foretold what we now know about our own history.

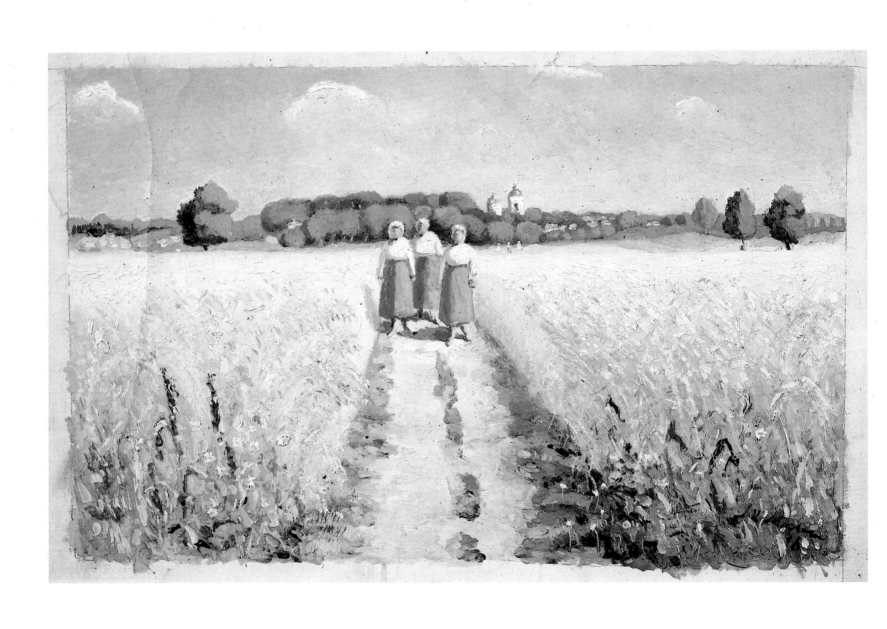

150 **Three Women on the Road.** *Oil on canvas. 28.5×43 cm*

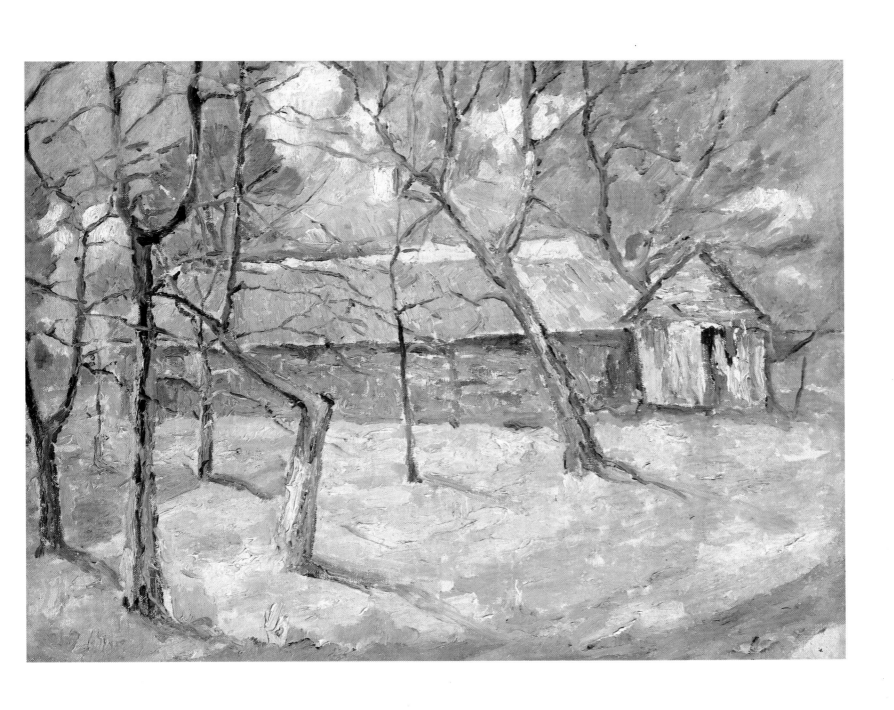

151 Landscape near Kiev, 1930. *Oil on canvas. 48.3×68.5 cm*

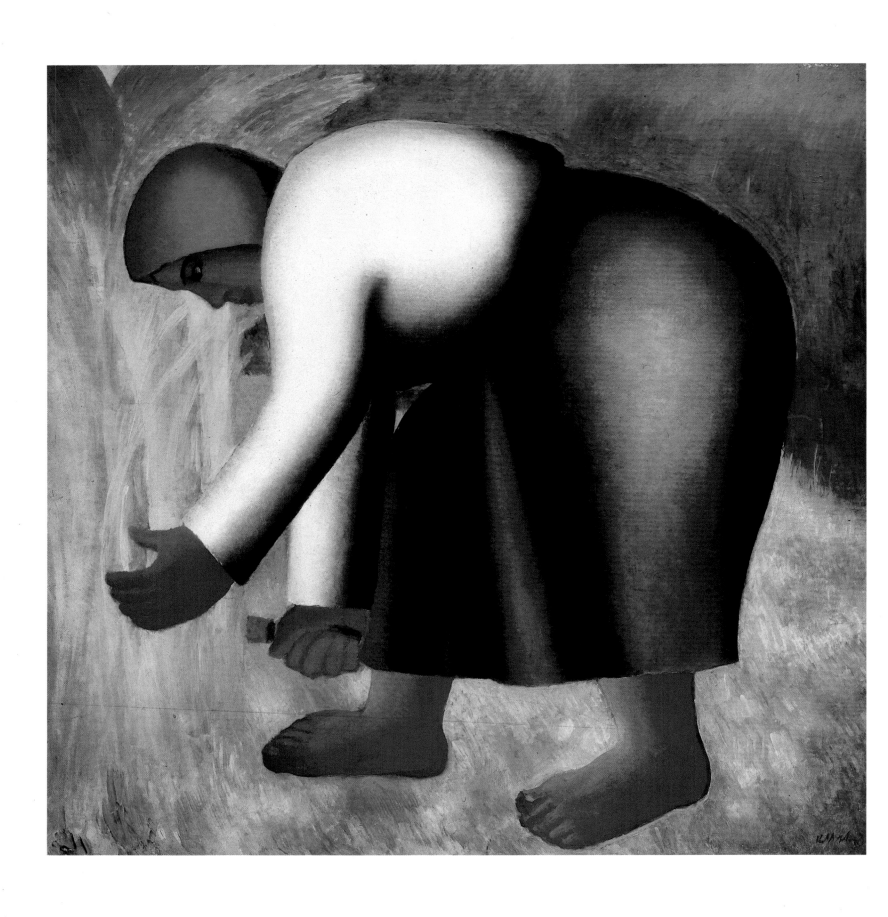

152 Reaper, 1928–32. *Oil on plywood. 72.4×72 cm*

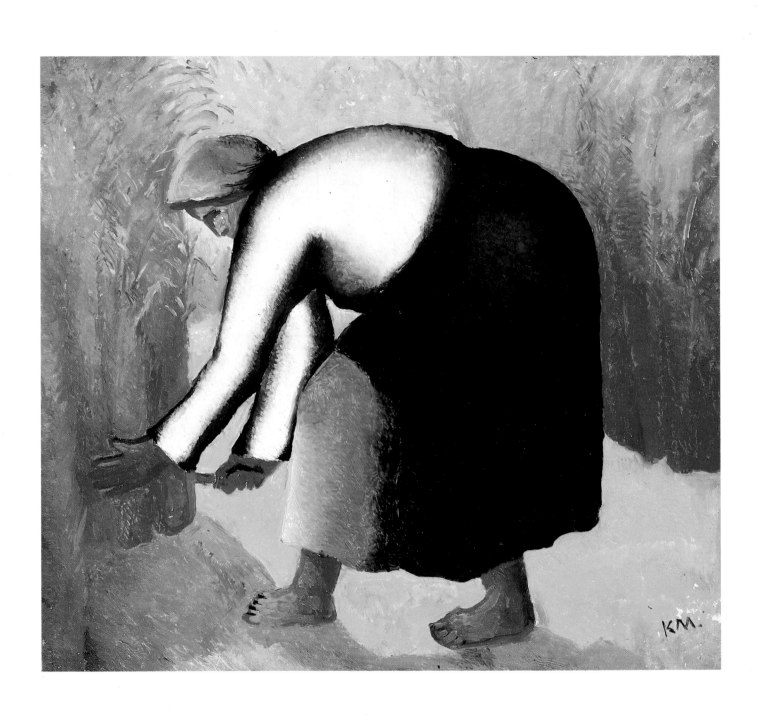

153 Reaper, study. *Oil on panel. 29.5×31.3 cm*

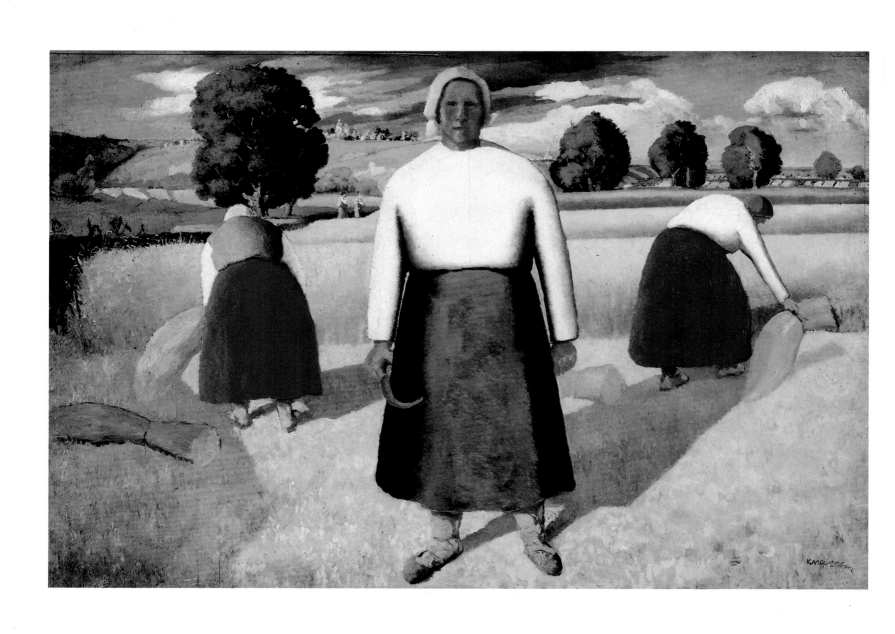

154 **Reapers, 1909–10 or after 1927?** *Oil on panel. 71×103.2 cm*

155 **At the Dacha, 1910–12 or after 1927?** *Oil on panel. 108×72 cm*

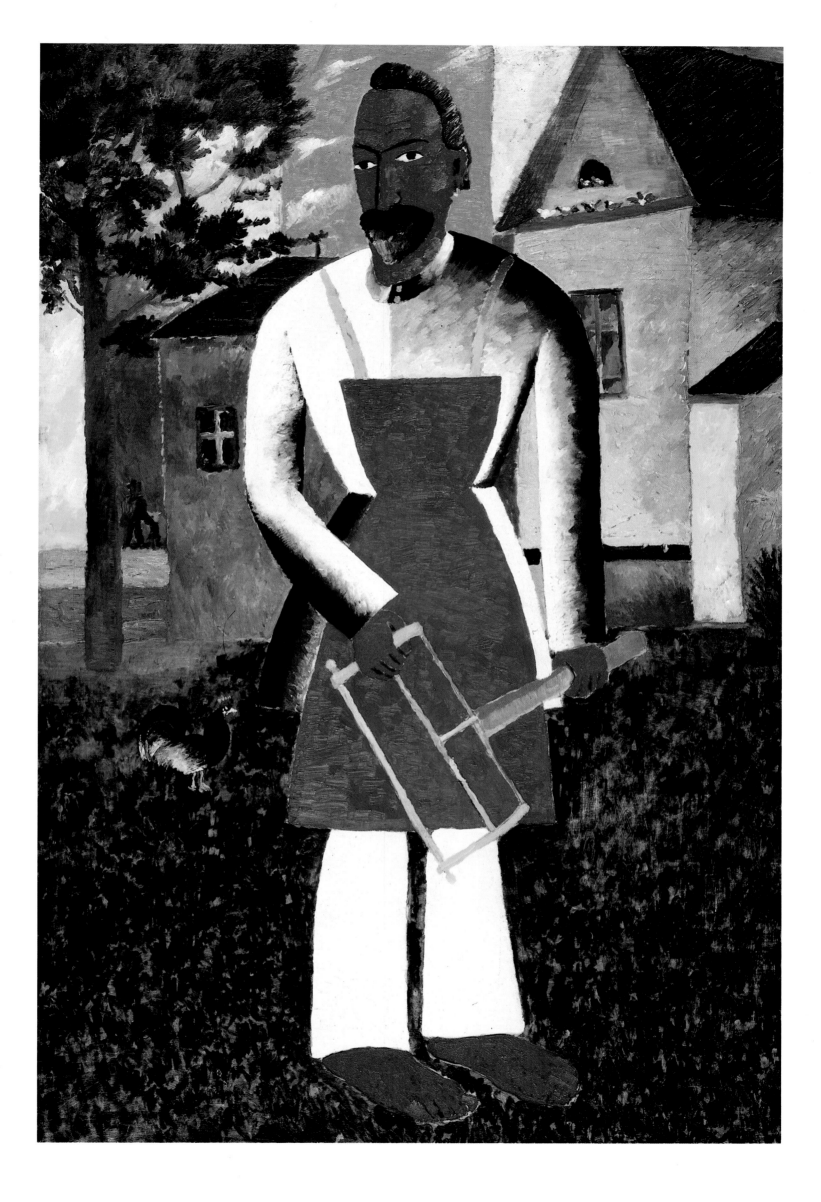

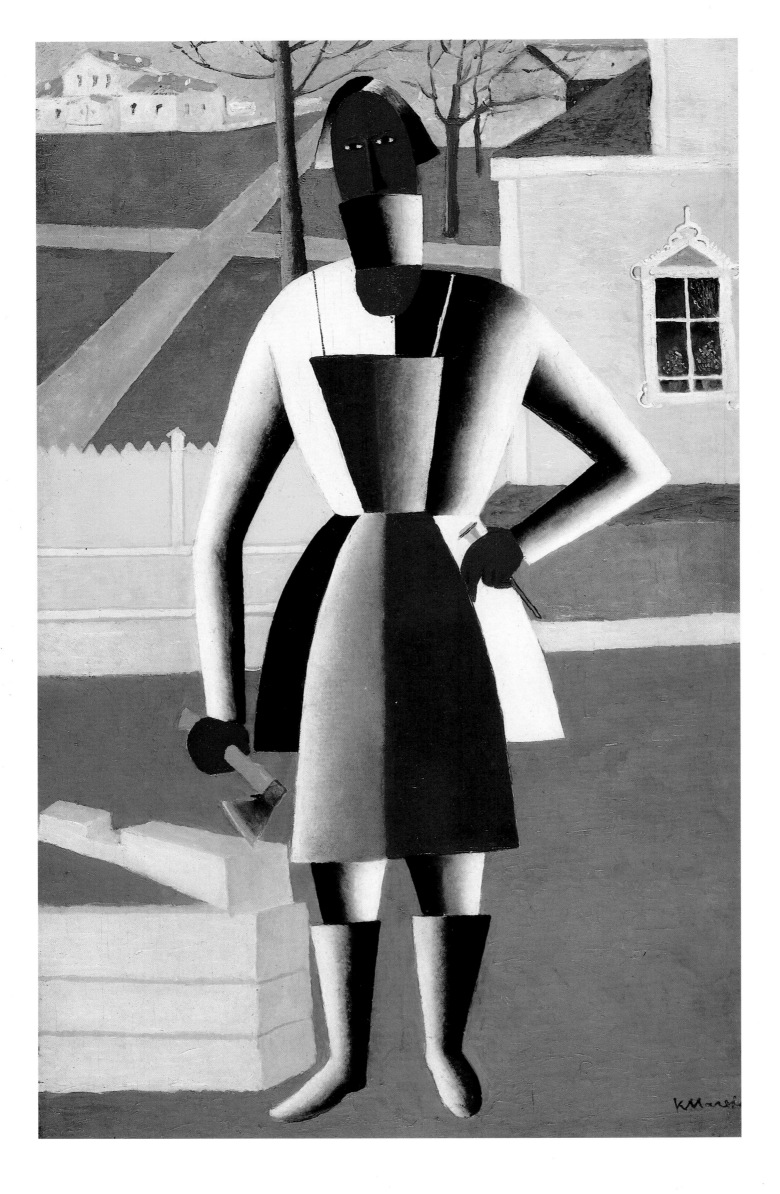

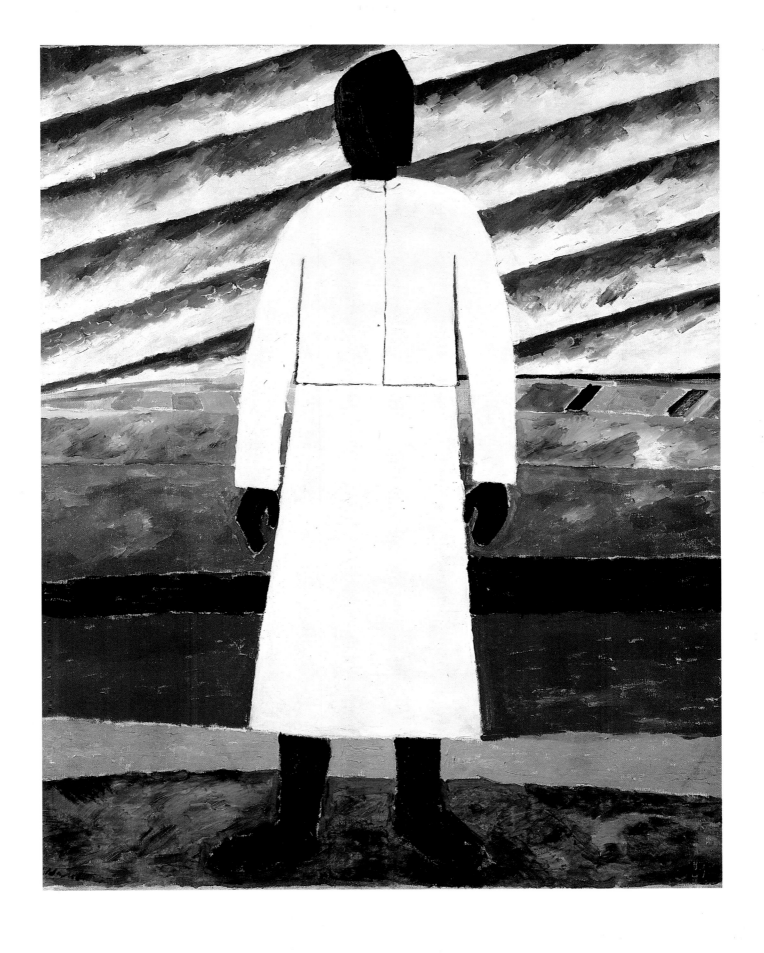

156 **Carpenter, 1920 (?)** *Oil on plywood. 71×44 cm*

157 **Peasant Woman, 1928–32.** *Oil on canvas. 98.5×80 cm*

158 Standing Figure, 1927 or later? *Colour pencil. 35.5×22.5 cm*

59 Boy (Vanka), 1928–32 *Oil on plywood. 72×51.5 cm*

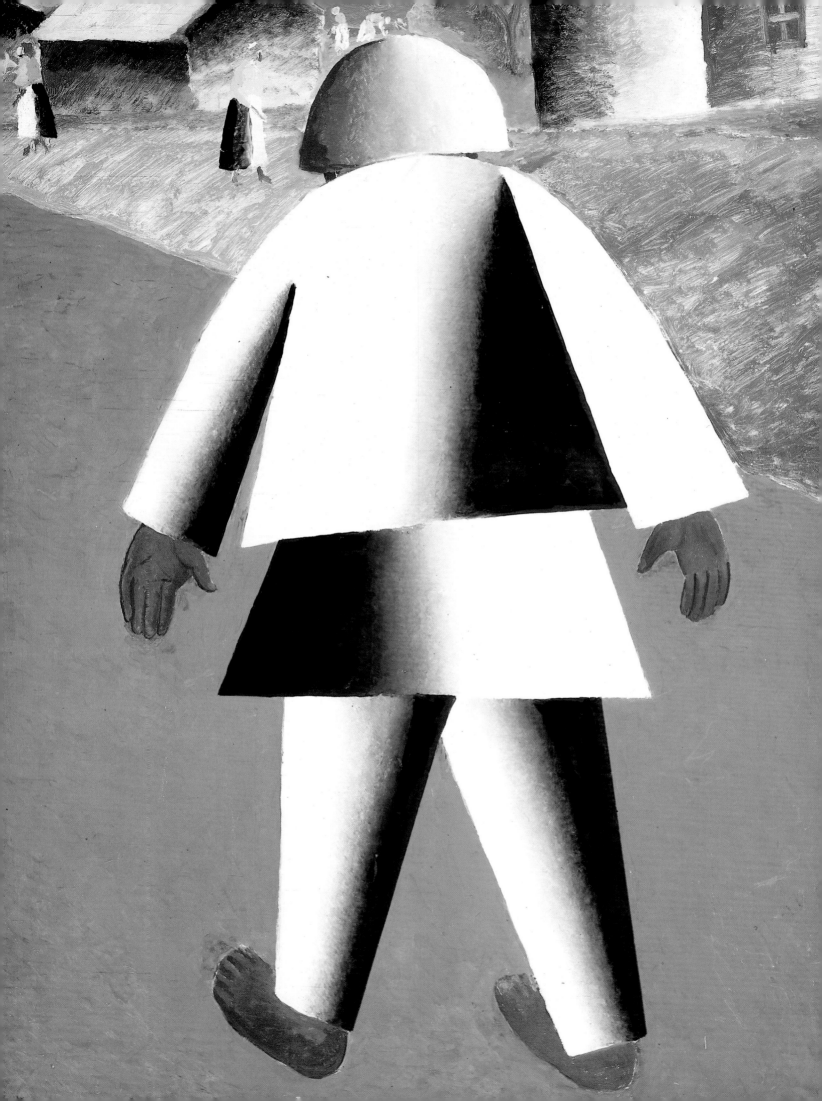

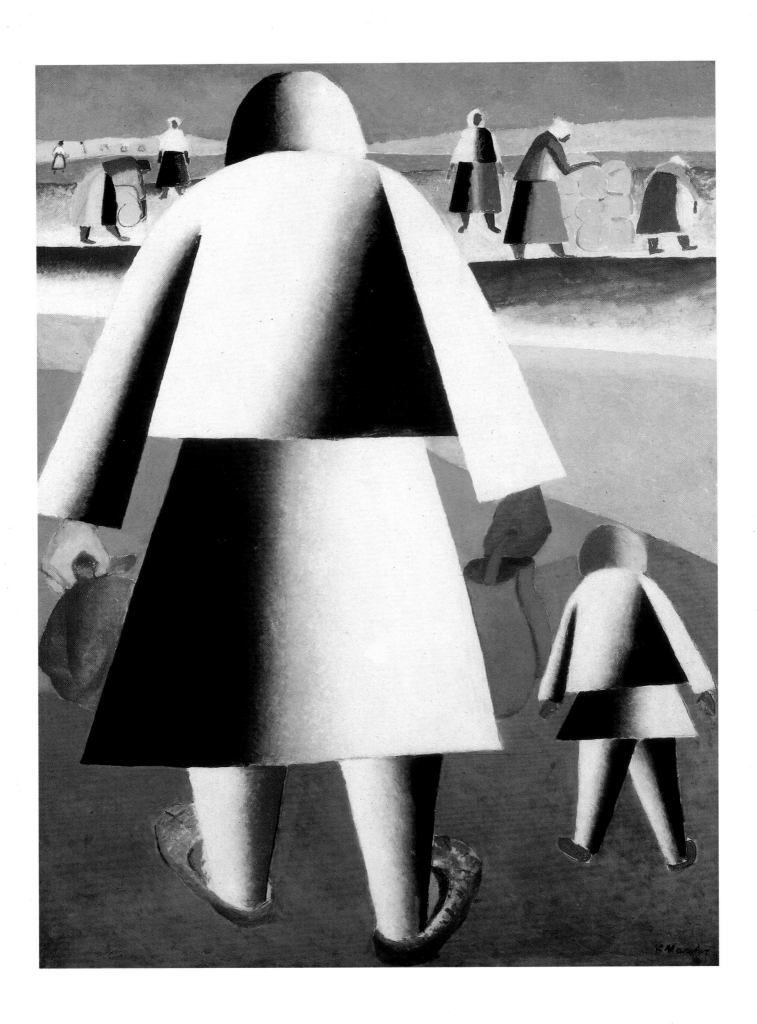

160 At the Harvest (Marfa and Vanka), 1928–32. *Oil on canvas. 82×61 cm*

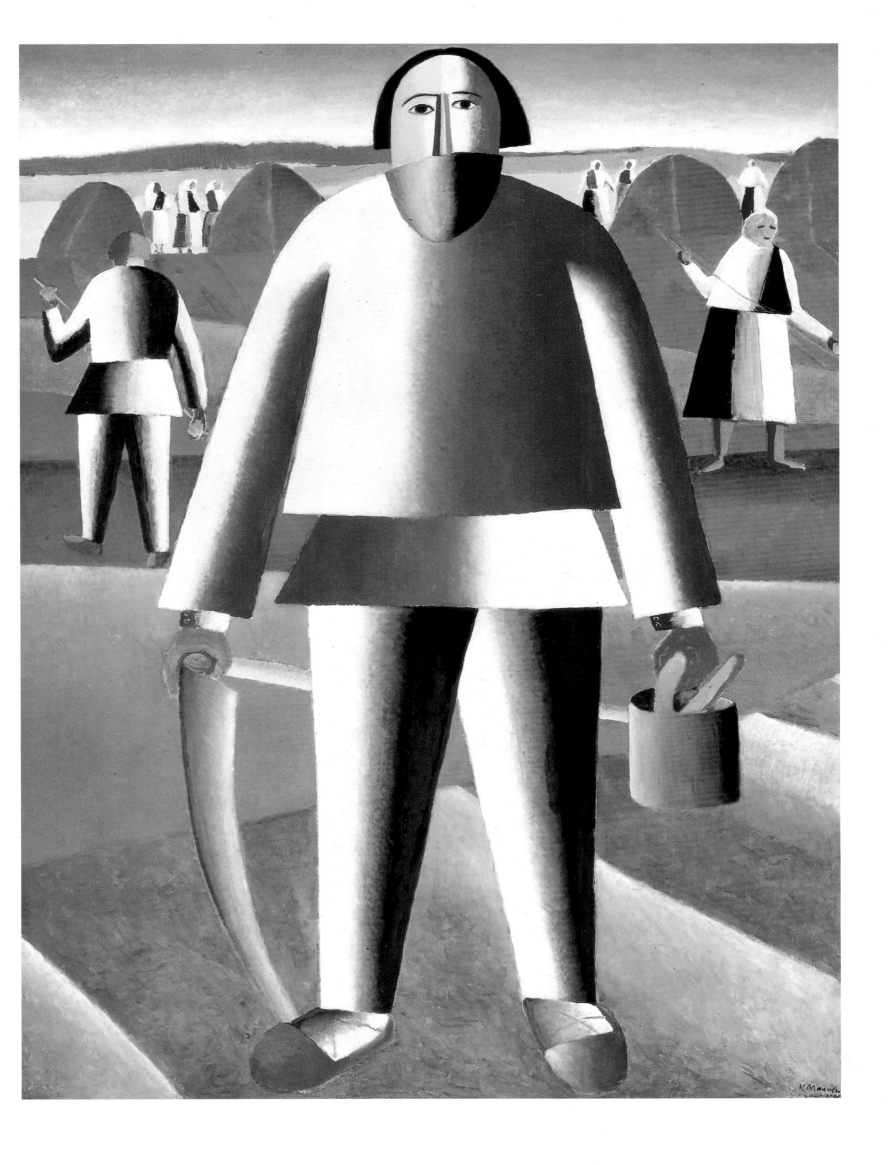

161 Haymaking, 1928—32. *Oil on canvas. 85.8×65.6 cm*

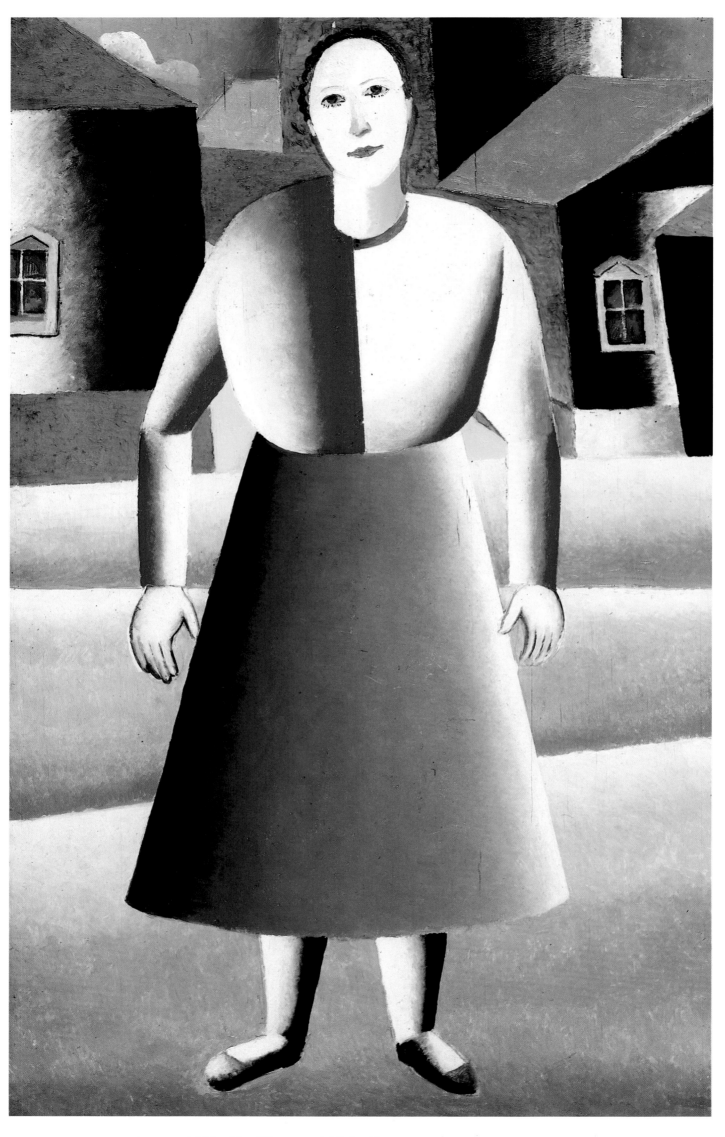

162 Girl in the Village, 1928–32. *Oil on panel. 70.5×44 cm*

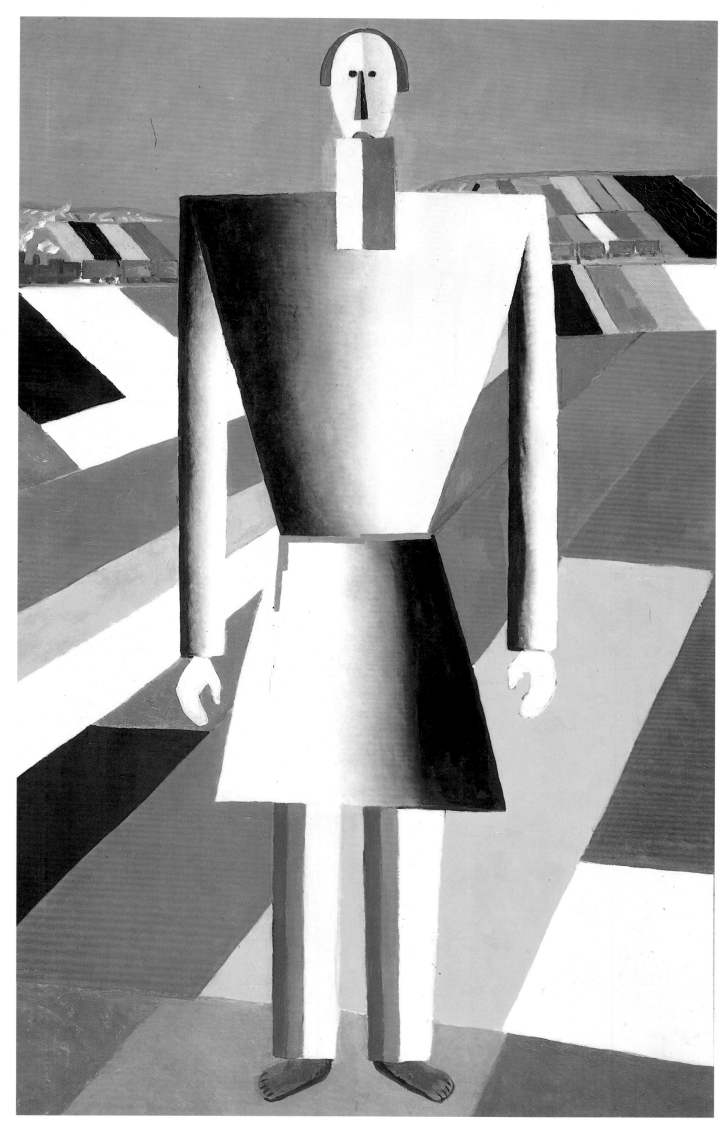

163 Peasant in the Field, 1928–32. *Oil on plywood. 71.3×44.2 cm*

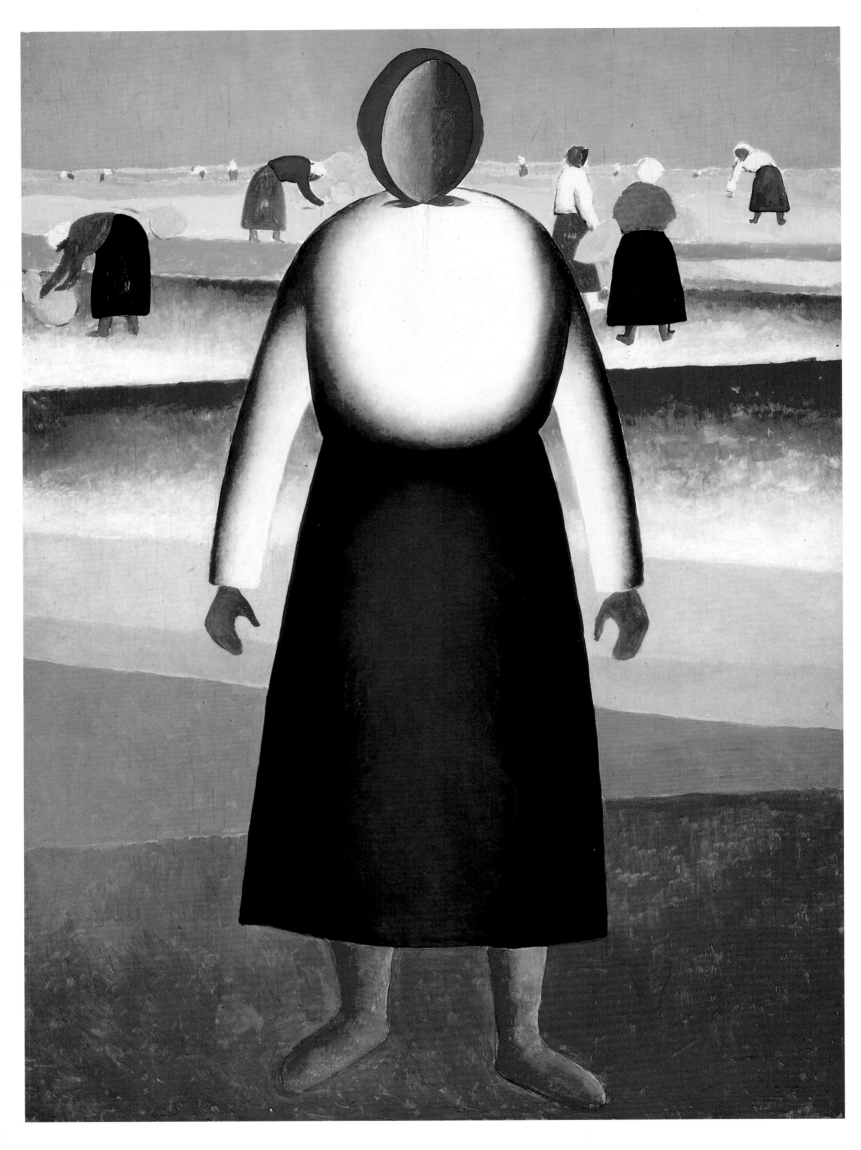

164 Harvest, study for the painting, 1928—32. *Oil on plywood. 72.8×52.8 cm*

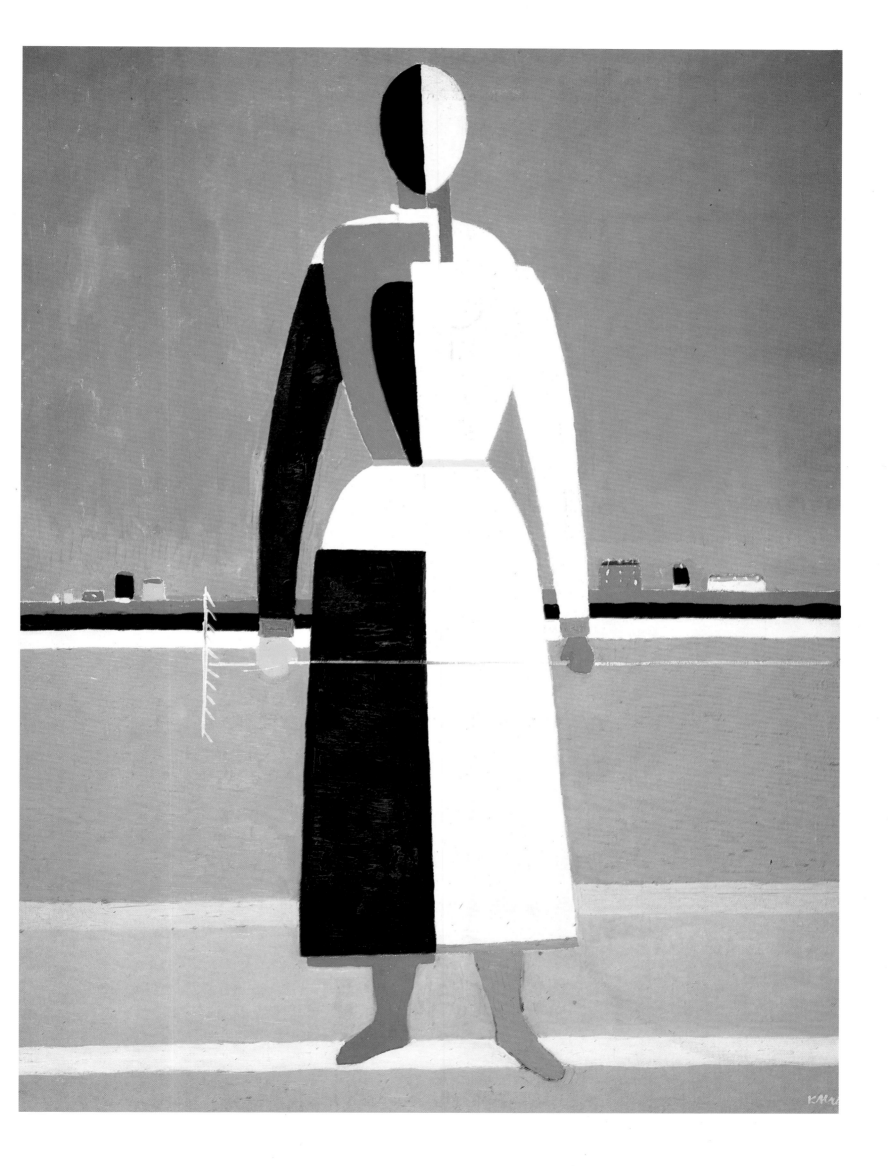

165 Woman with a Rake, 1928–32. *Oil on canvas. 100×75 cm*

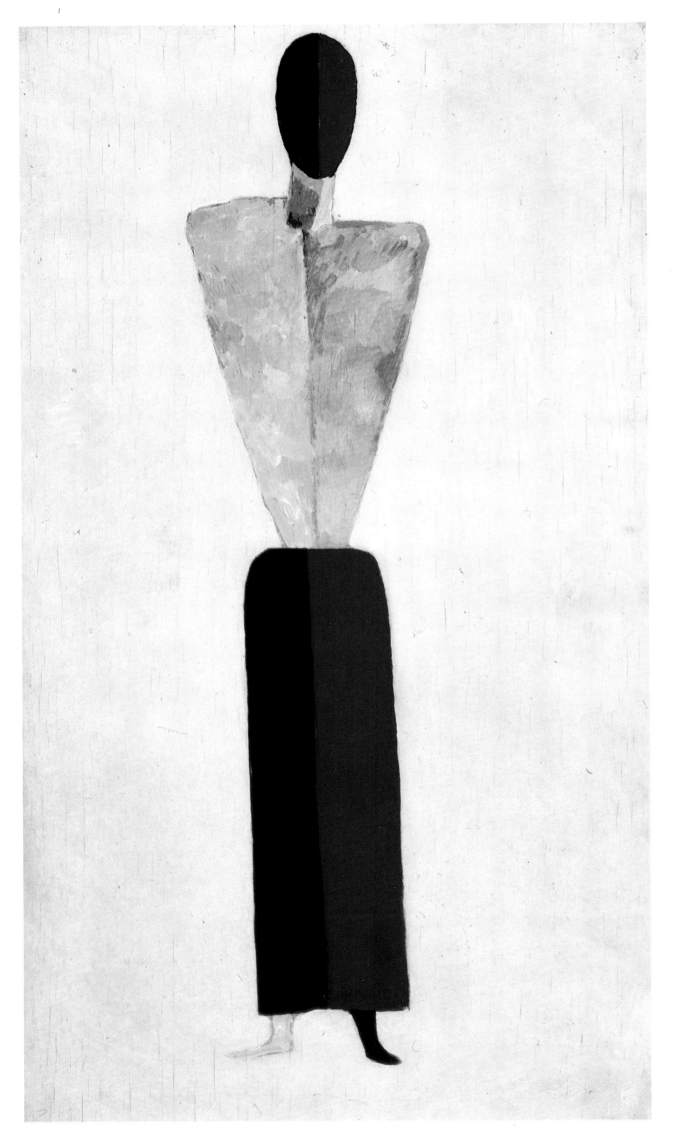

166 A Girl (Figure Against White Background), 1928–32. *Oil on plywood. 84.5×48 cm*

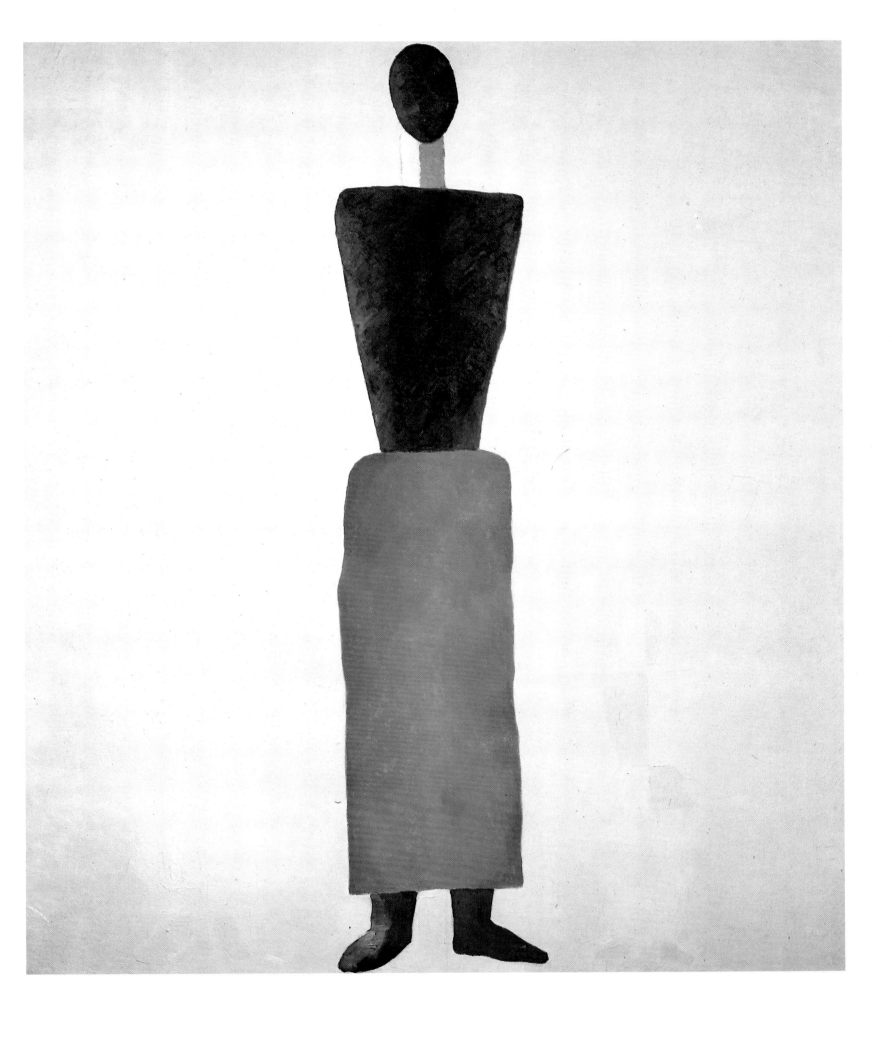

167 **Suprematism. Female Figure, 1928–32.** *Oil on canvas. 126×106 cm*

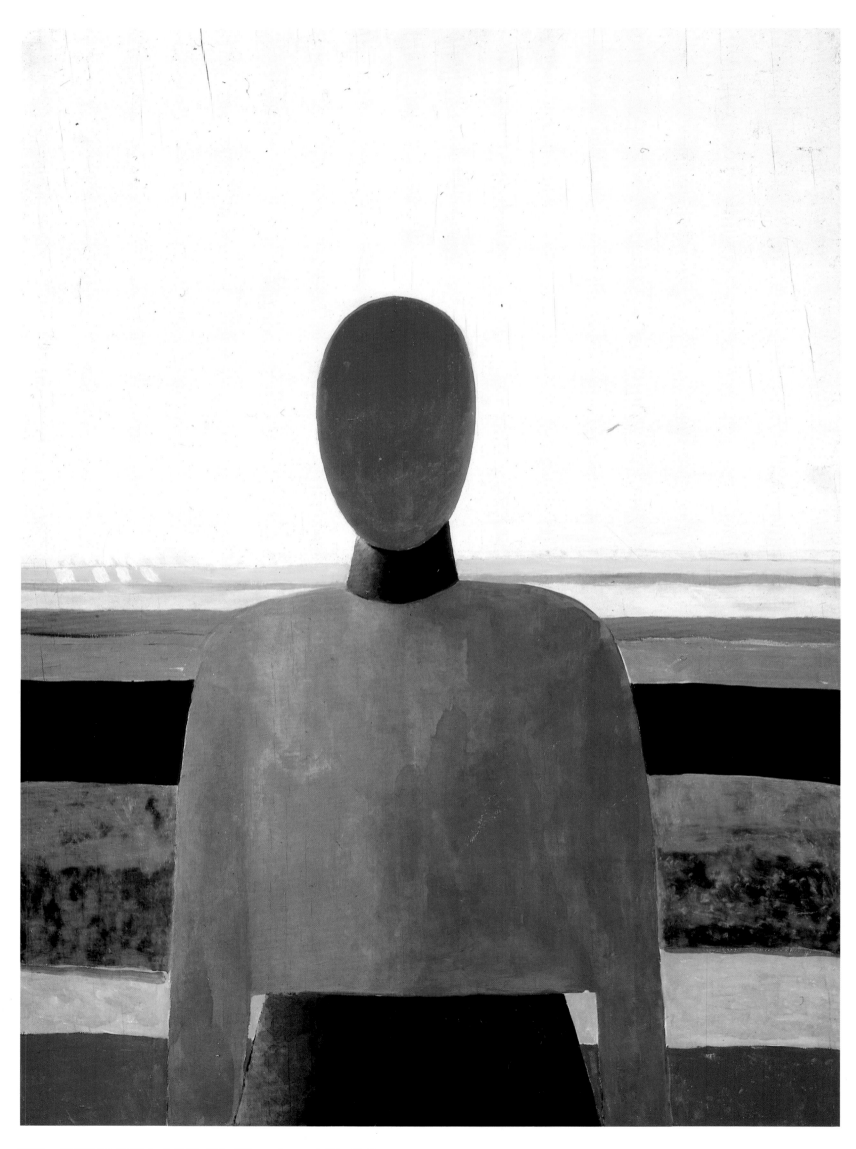

168 Female Torso, 1928–32. *Oil on plywood. 73×52.5 cm*

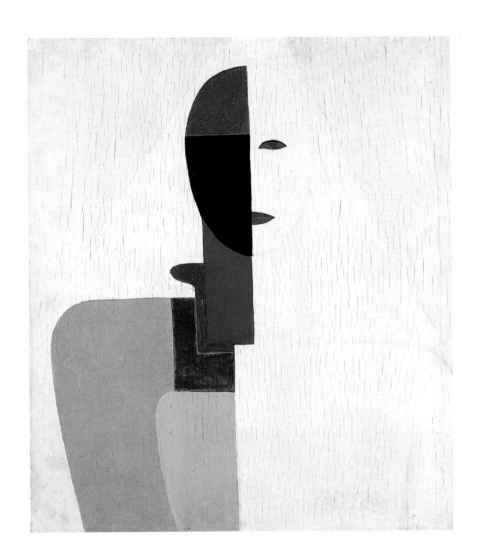

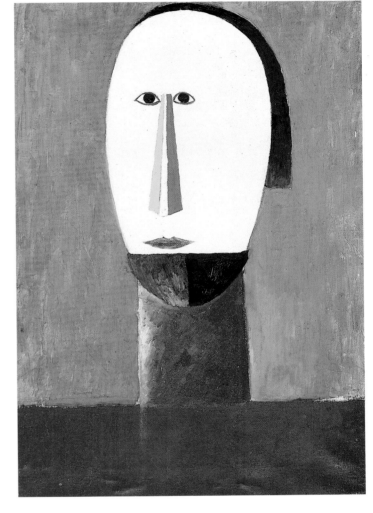

169 Female Torso, 1928–32. *Oil on panel. 58×48 cm*

170 Head, 1928–32. *Oil on canvas. 61×41 cm*

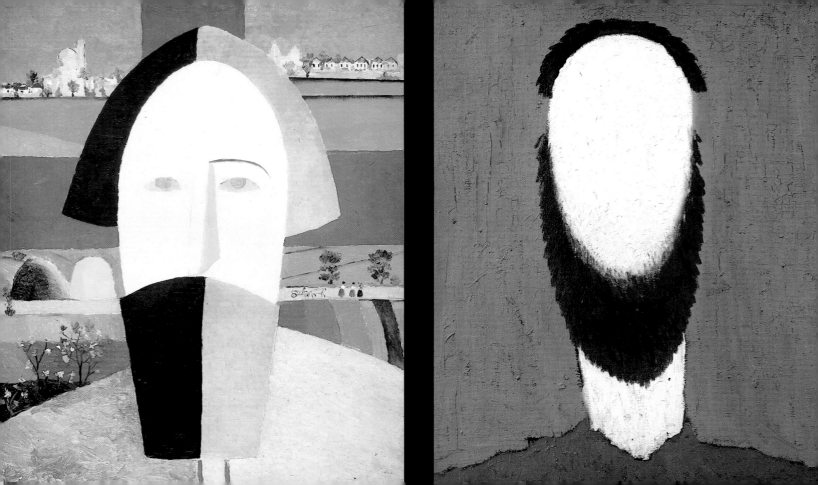

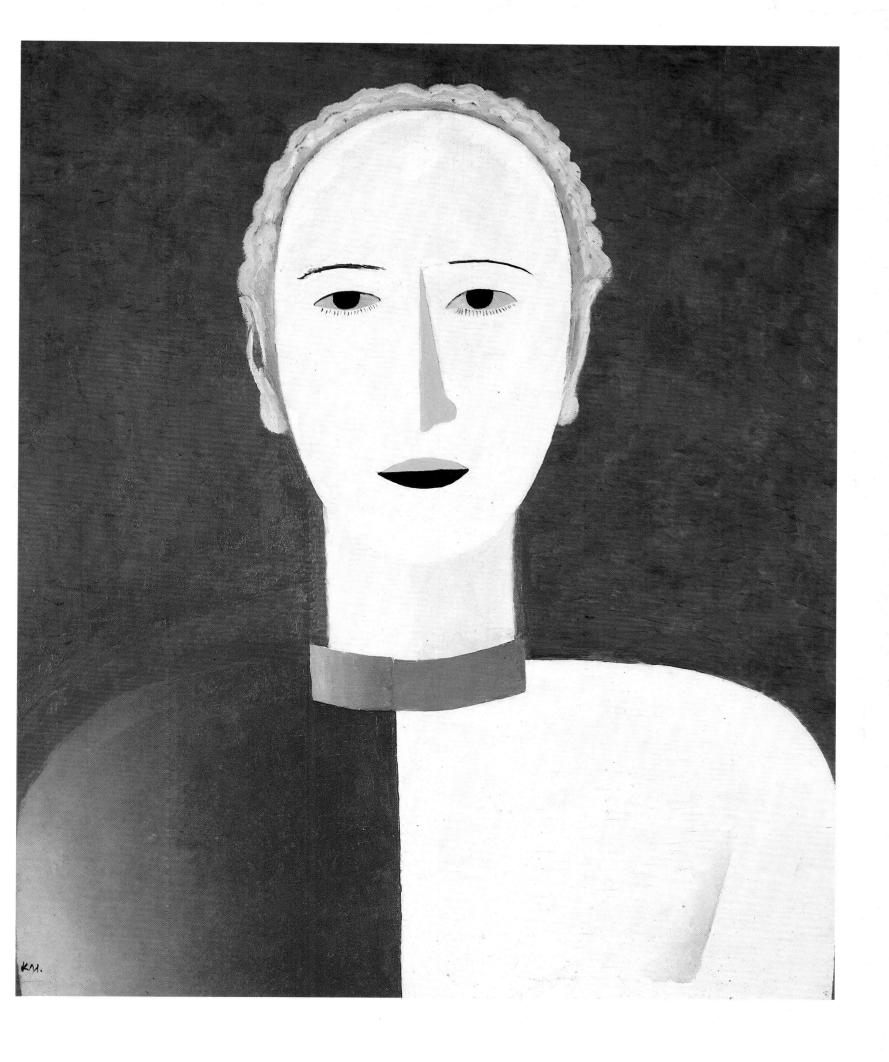

173 Female Portrait. 1928–32. *Oil on plywood. 58×49 cm*

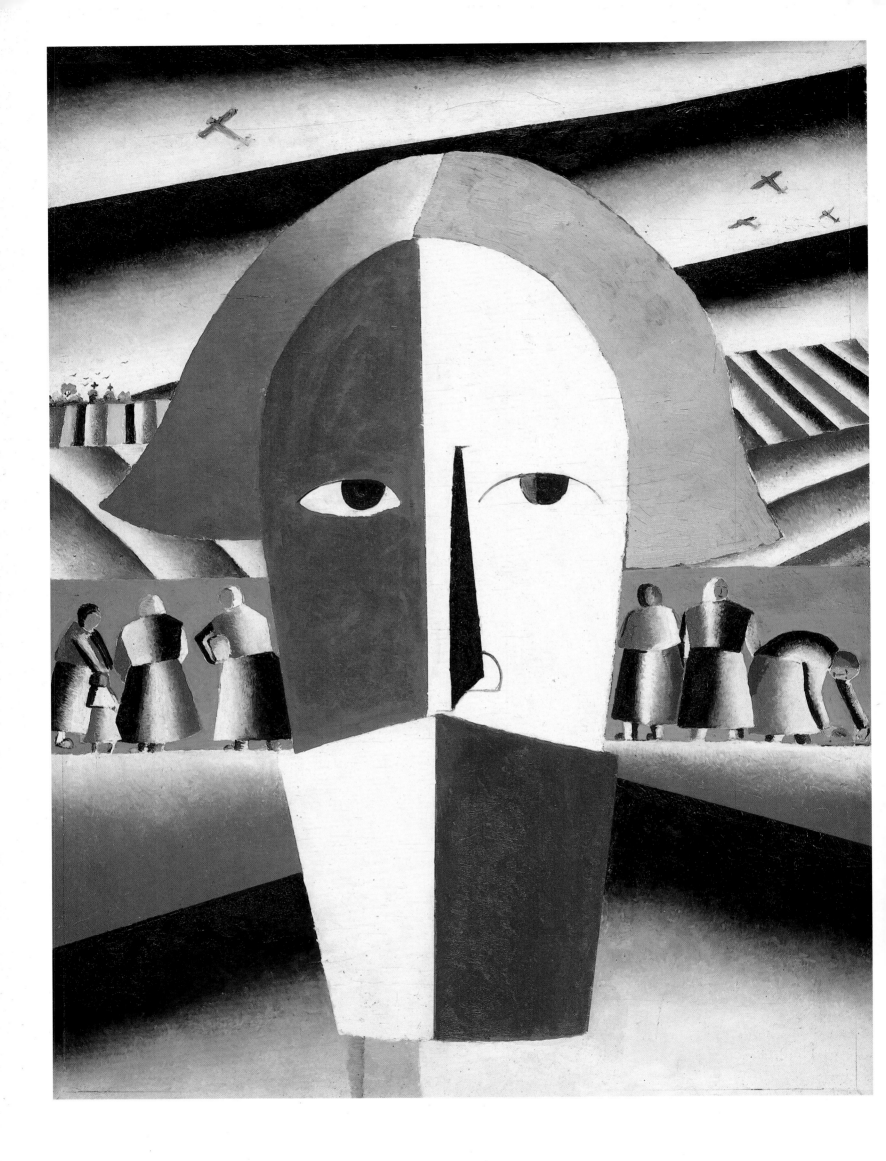

174 Head of a Peasant, 1928–32. *Oil on plywood. 71.7×53.8 cm*

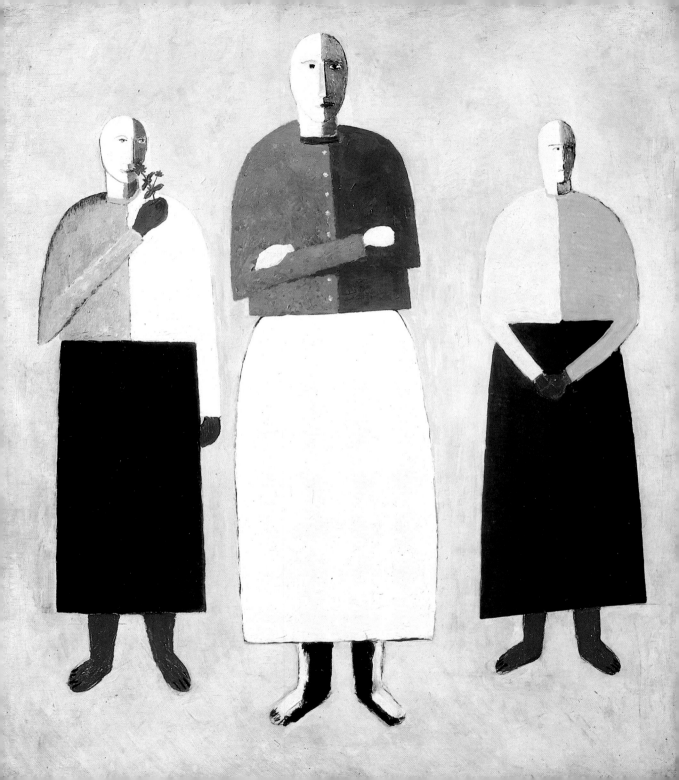

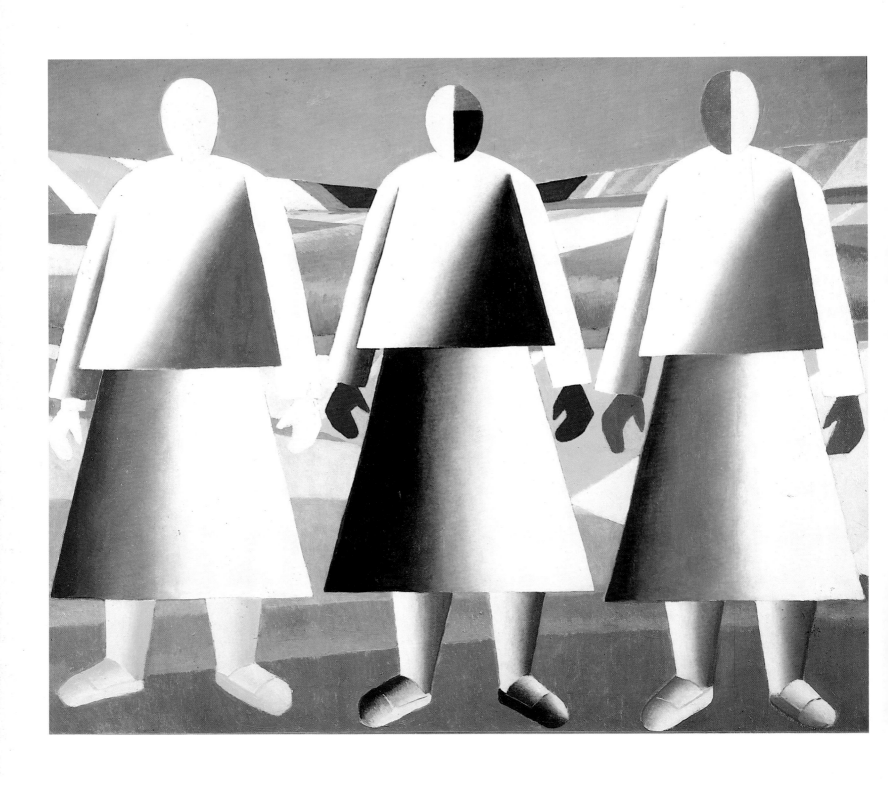

176 Girls in the Field, 1928—32. *Oil on canvas. 106×125 cm*

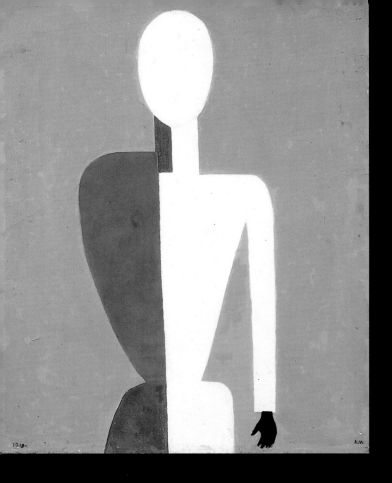 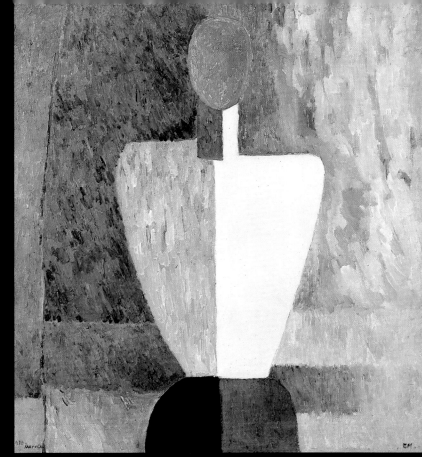

178 Half-Length Figure (Prototype of a New Image), 1928–32. *Oil on canvas. 46×37 cm*

179 Half-Length Figure (Figure with a Pink Face), 1928–32. *Oil on canvas. 72×65 cm*

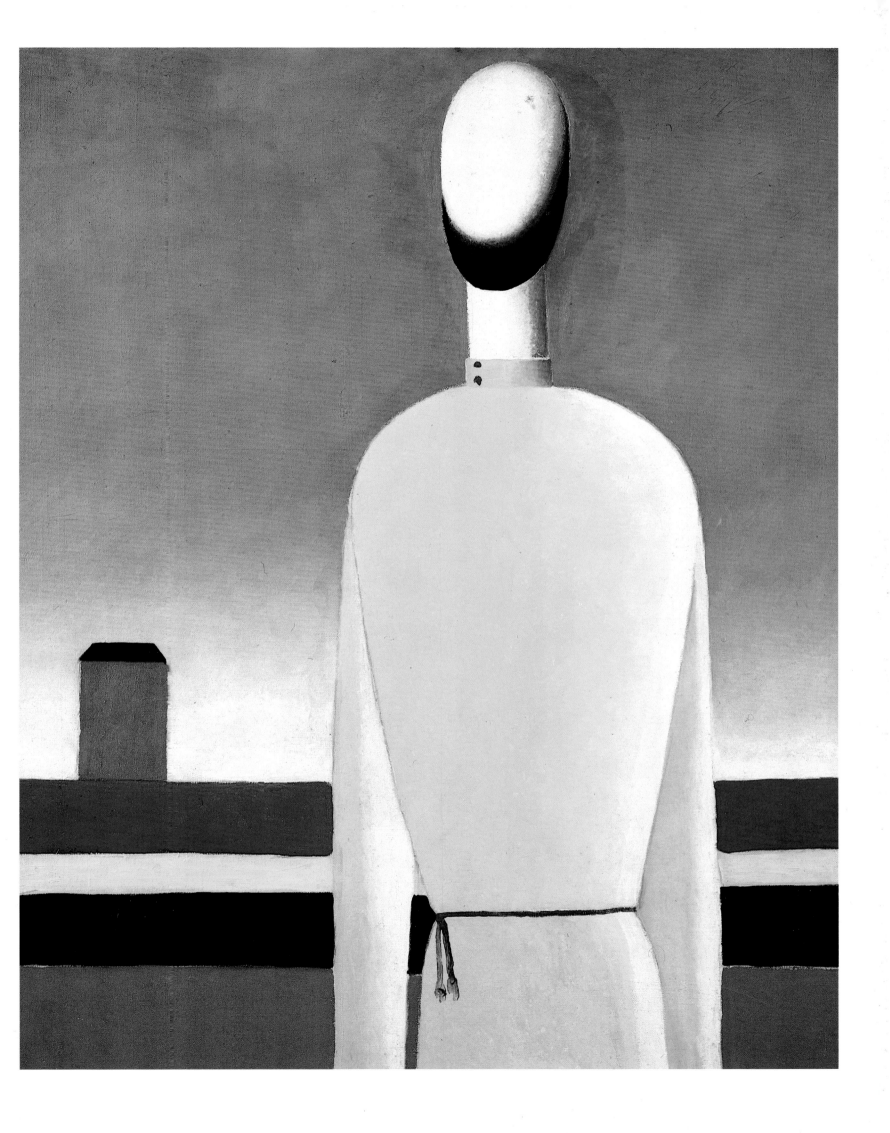

180 A Complex Presentiment (Half-Length Figure in a Yellow Shirt), 1928–32
Oil on canvas. 99 × 79 cm

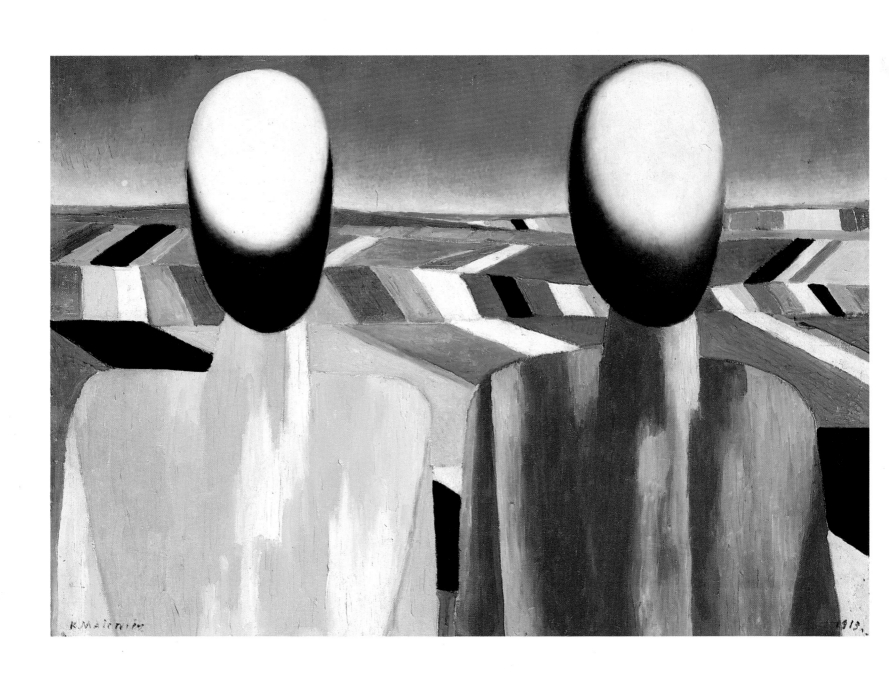

181 Peasants, 1928–32. *Oil on canvas. 53×70 cm*

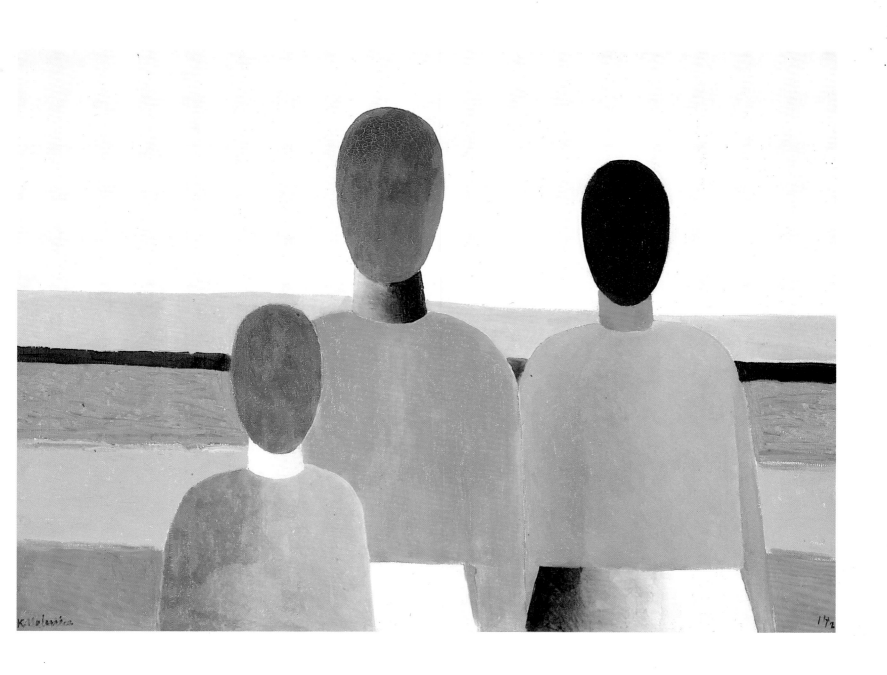

182 Three Female Figures, 1928—32. *Oil on canvas. 47×63.5 cm*

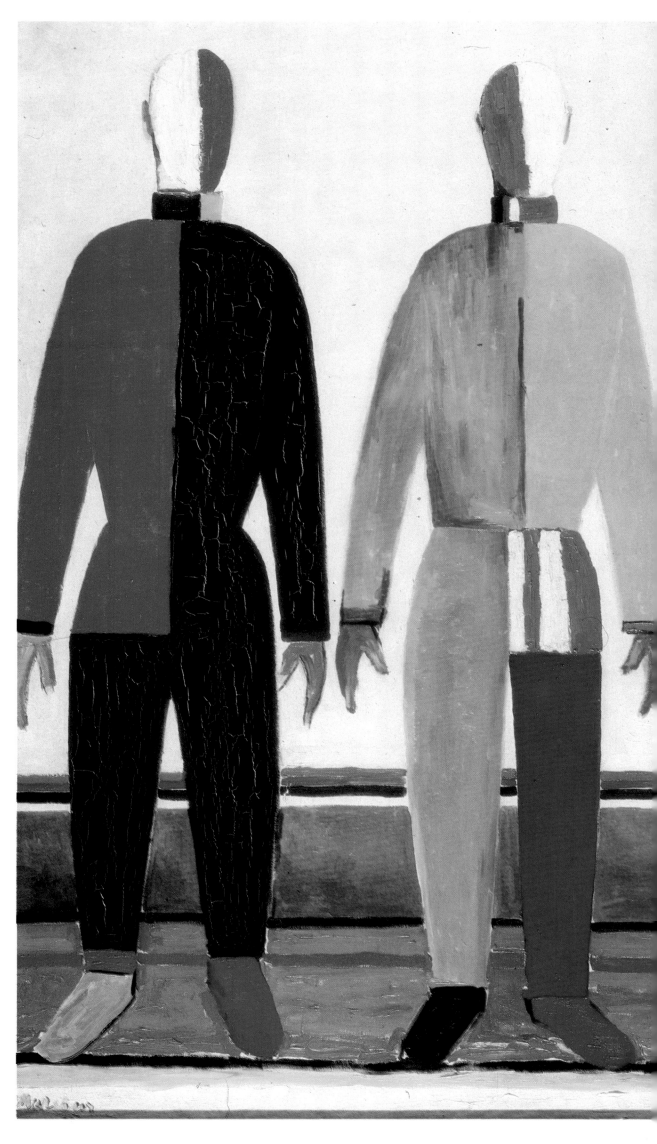

183 **Sportsmen, 1928–32.** *Oil on canvas. 142×164 cm*

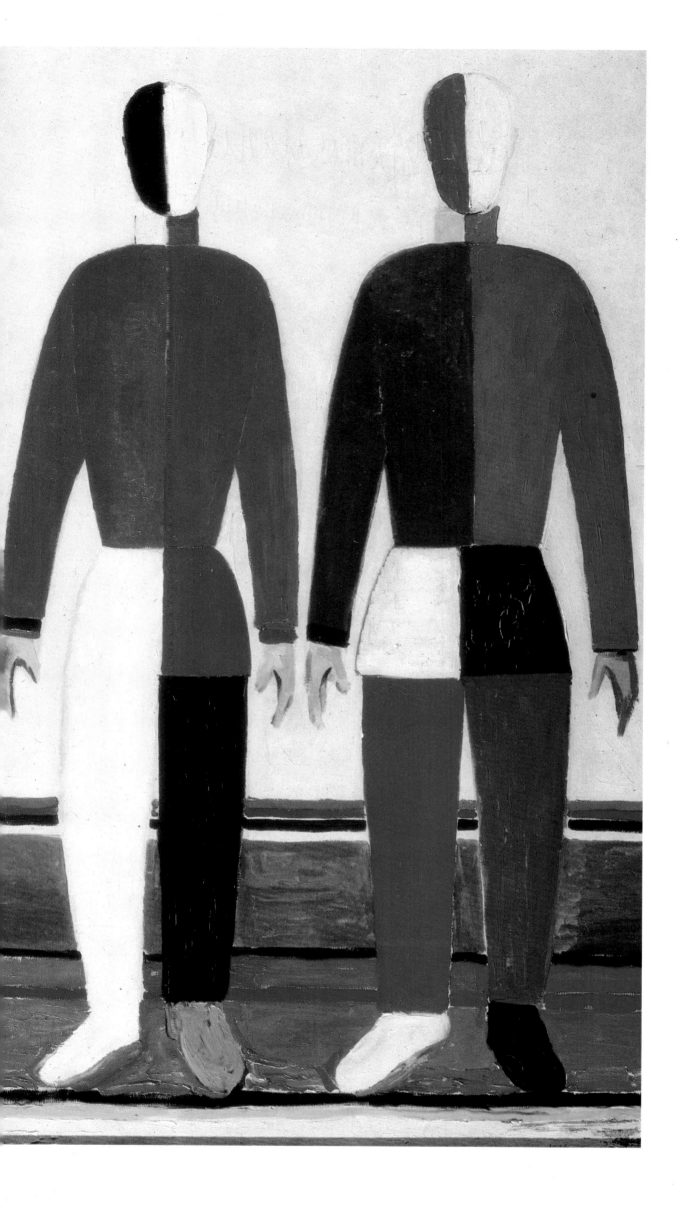

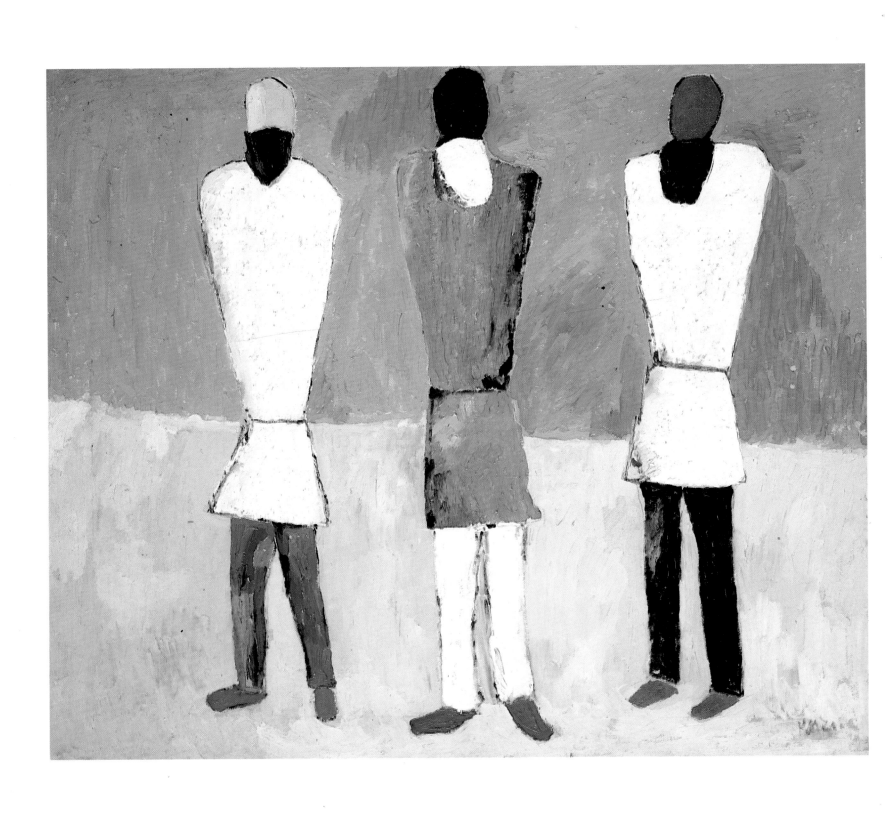

184 Peasants, 1928—32. *Oil on canvas. 77.5×88 cm*

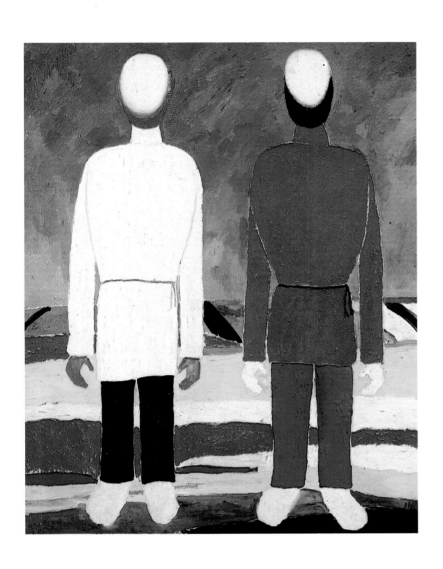

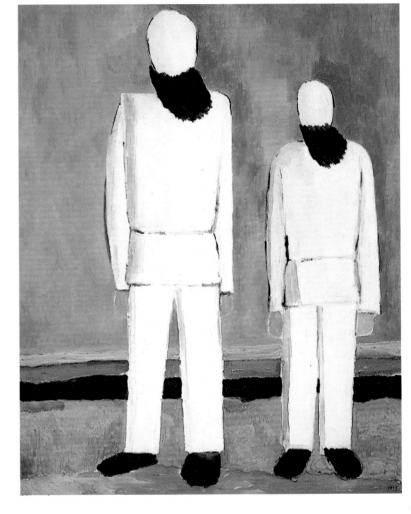

185 Two Male Figures, 1928–32. *Oil on canvas. 99×79.5 cm*

186 Two Male Figures, 1928–32. *Oil on canvas. 99×74 cm*

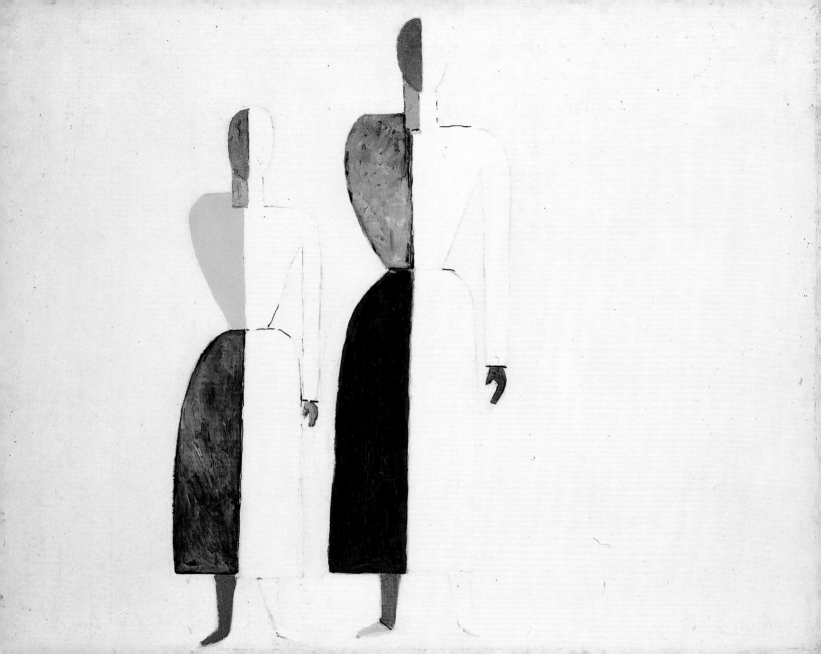

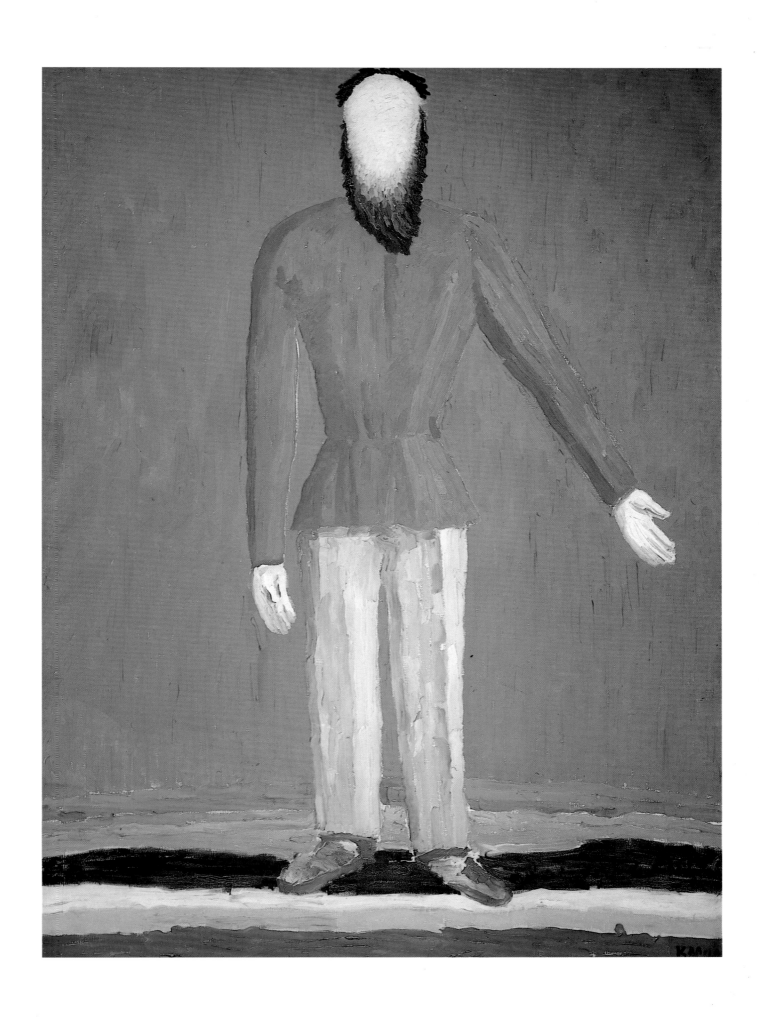

188 **Peasant, 1928–32.** *Oil on canvas. 120×100 cm*

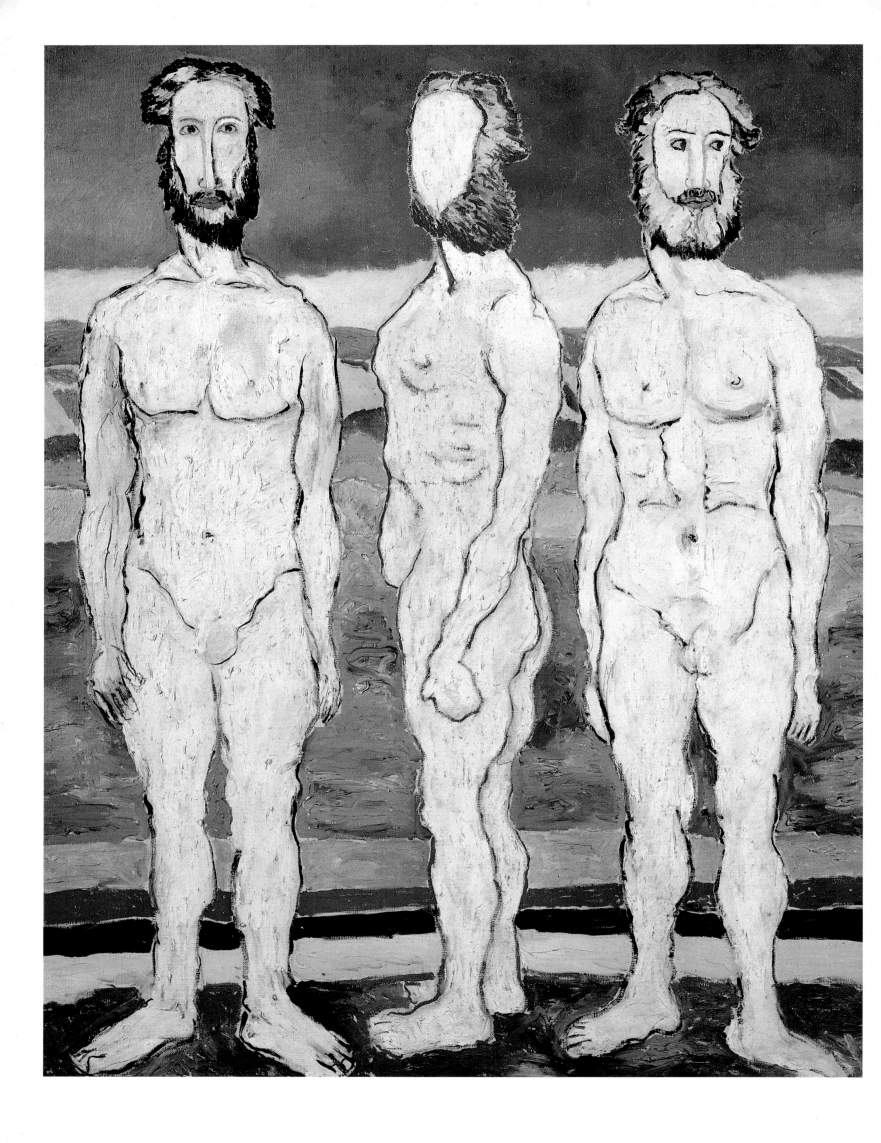

189 **Bathers, 1928—32.** *Oil on canvas. 98.5×79 cm*

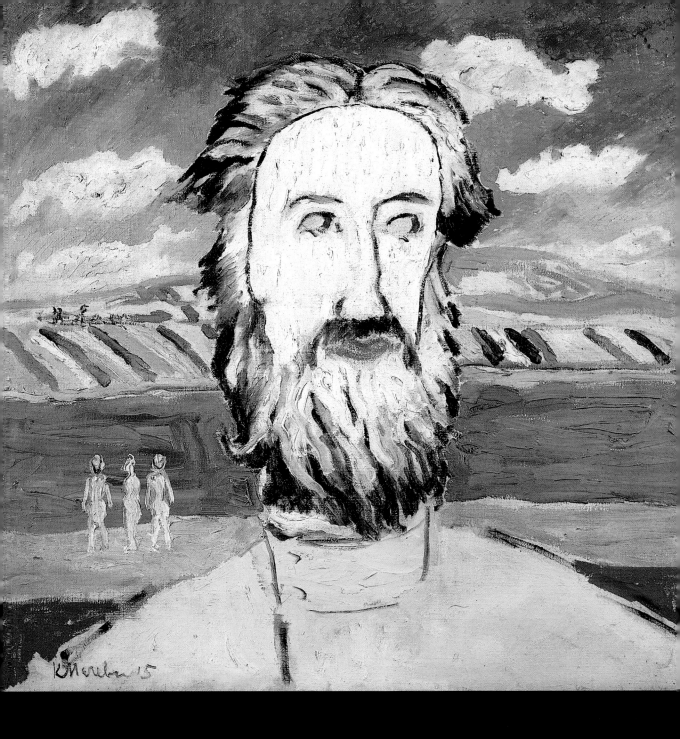

190 Portrait of a Peasant, 1928—32. *Oil on canvas. 63.5×51 cm*

191 Red Cavalry at Full Gallop, 1928—32. *Oil on canvas. 91×140 cm*

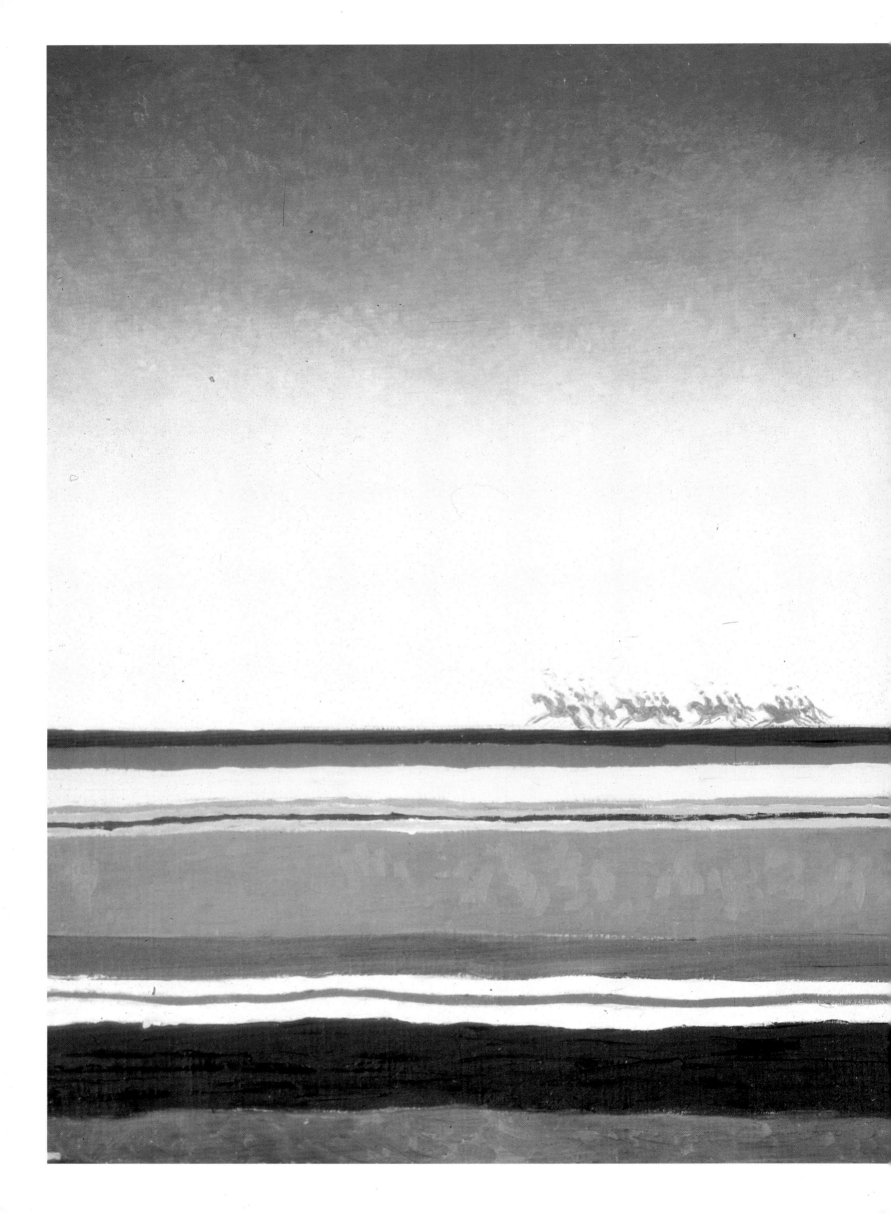

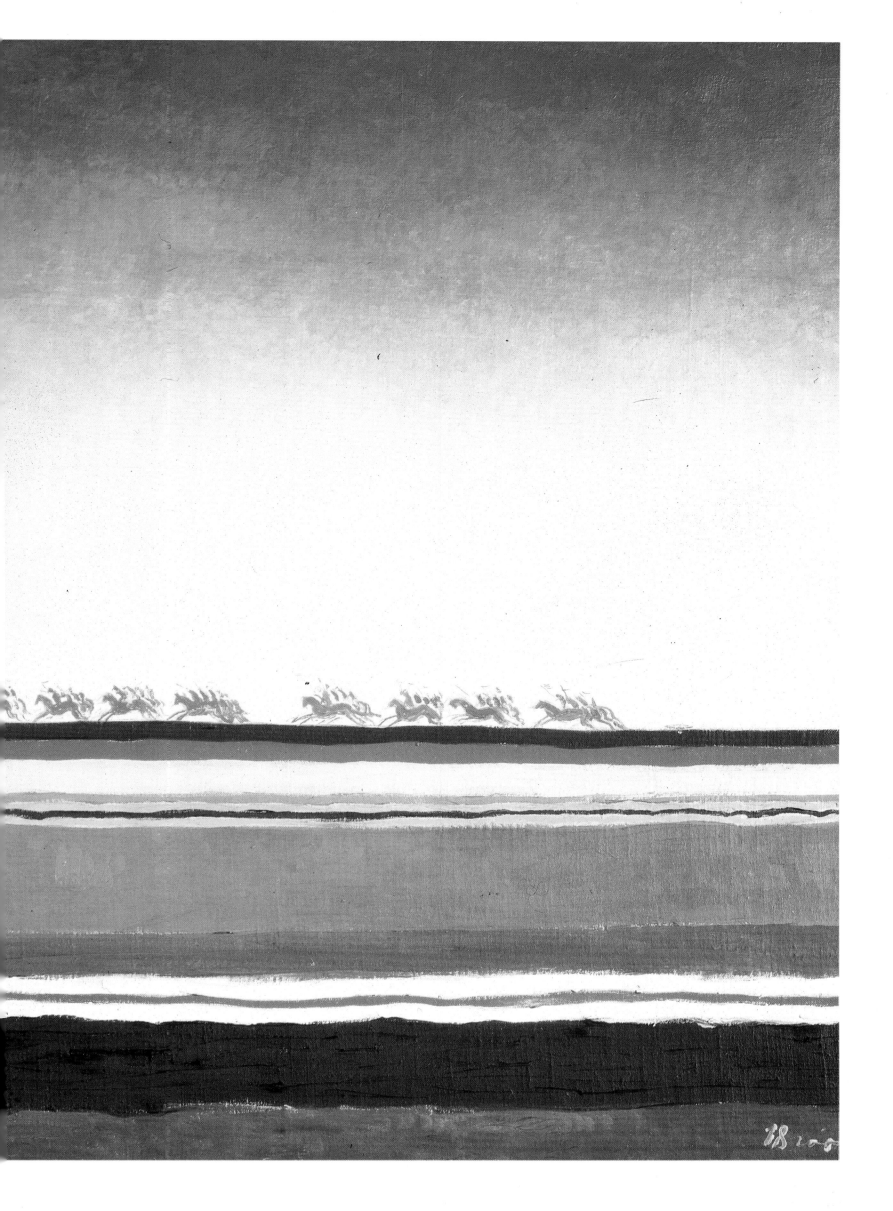

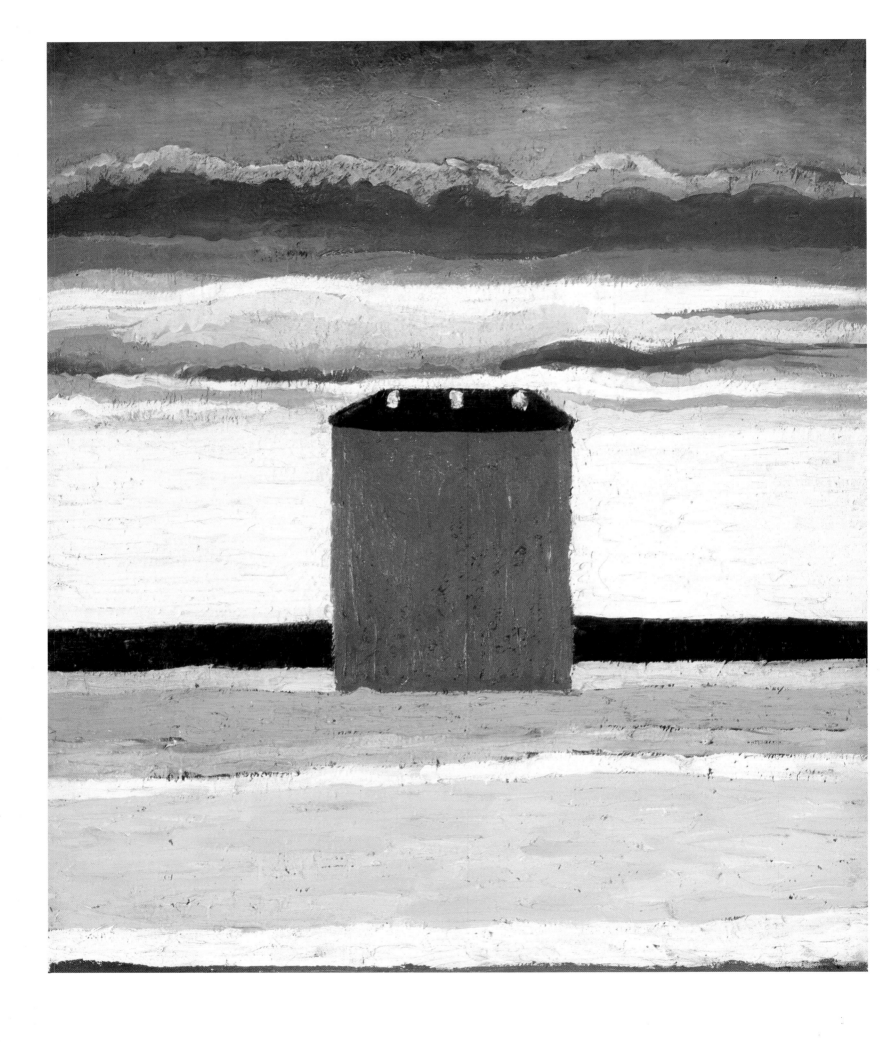

192 Red House, 1932. *Oil on canvas. 63×55 cm*

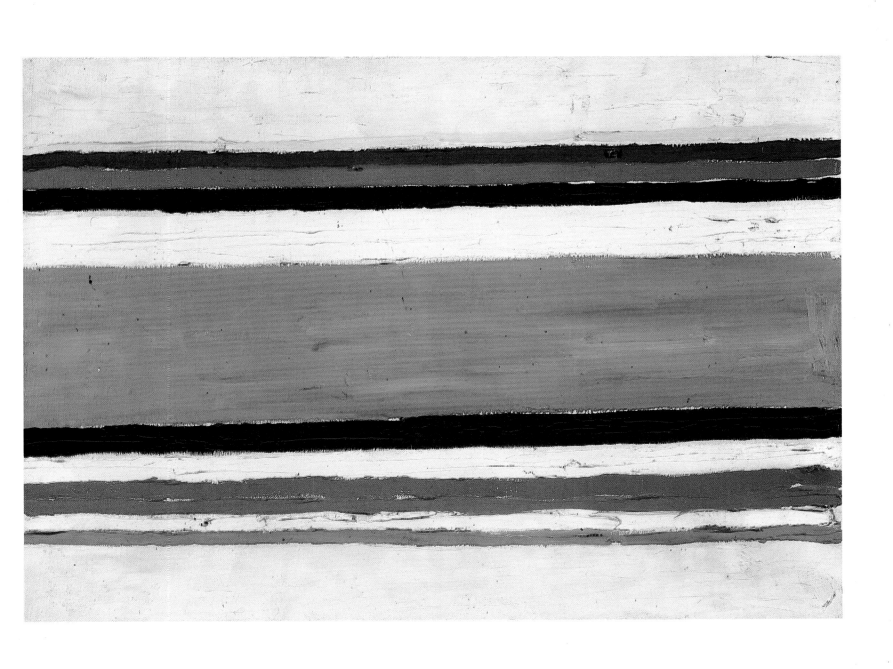

193 **Composition, 1928–32?** *Oil on canvas. 40×56 cm*

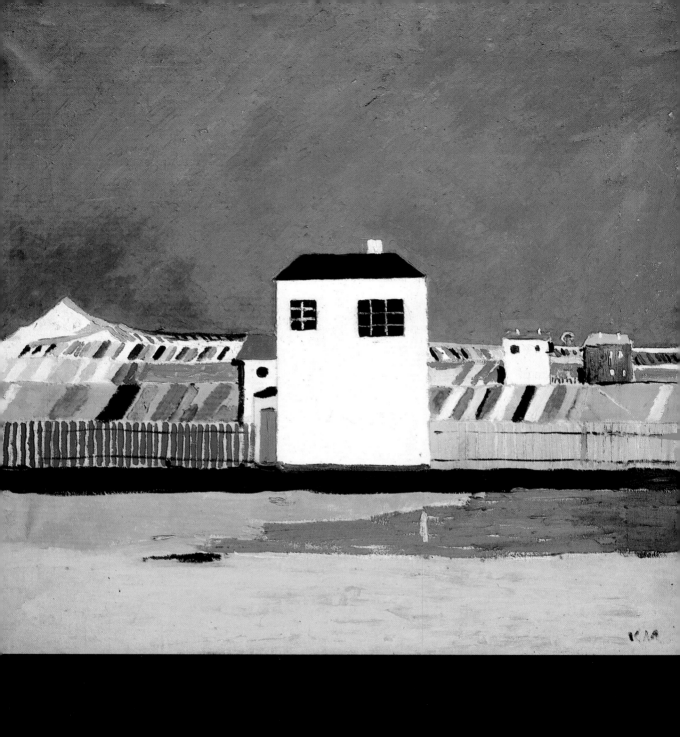

Landscape with a White House, c. 1930. *Oil on canvas, 50×50 cm*

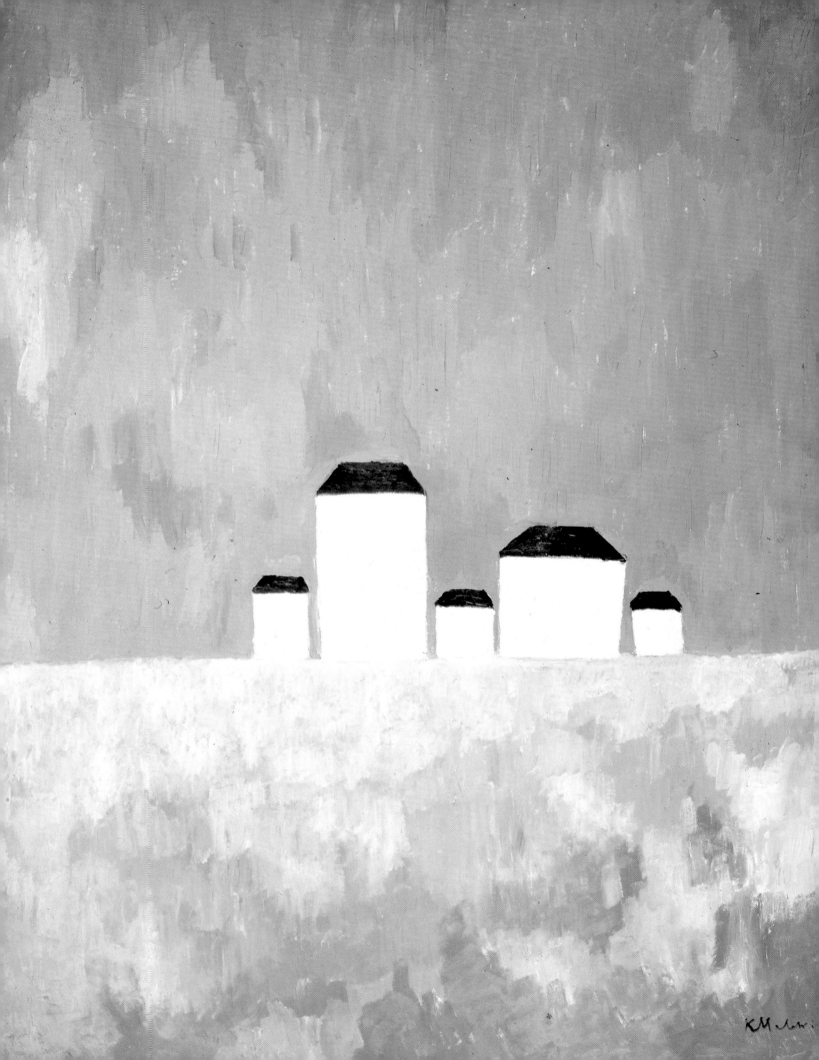

Irina Karasik

Malevich as His Contemporaries Saw Him

The notion that the avant-garde was a plastic experiment valid for all time and destined to go on developing indefinitely, formed in the 1960s, and is still entrenched today in its basic tenets. This is rightly being replaced by an understanding of the avant-garde as a profound, serious and historically important movement, both spiritual and philosophical in its impulses, imbued with broad creative ambitions. It also needs to be seen as a field of endeavour for widely differing creative wills with dissimilar notions of the aims and values of art, and difficult personal and group relations. This last aspect—which might be called psychological—was of great consequence.

The problem of the creative individual, and the notion of the socio-psychological artistic type, achieved special significance in Russian culture during the first quarter of the 20th century. Names like Vrubel and Malevich, Chekrygin and Tatlin, Filonov and Matyushin, stand not only for works of art, not only for genuine creative acts, but for a particular artistic destiny, a general concept of life encompassing everything from a manner of thinking and feeling to a style of conduct and interaction, and even to one's outward appearance. Legends have grown around these individuals—sometimes through no fault of their own, sometimes with their aid and even direct participation; and the dramas of their lives, their perception of artistic duty as a 'mission' of sorts, their exceedingly exact depiction of psychological or mundane reality, and the direct 'construction' of their own images, have only fuelled these legends. 'The Malevich Phenomenon,' in this context, is very telling.

This emphasis on 'image' has important implications, because analysis of the phenomenon may rectify certain images of the Russian avant-garde itself. Our attitude towards its leading figures has often abetted the legends and developed the myth, but we have not made the effort to examine these. This is quite understandable, given the atmosphere of subterfuge and prohibition that prevailed, but the most important thing today is not even the splendid fact that we may write freely about Filonov or Chagall or Malevich, but that we can finally abandon the roles of champion and admirer and set ourselves to serious study.

The assessments of contemporaries provide the primary source of information. The material that follows represents preliminary notes on the subject.

Myths of the kind discussed above inevitably grew up around the Symbolists, who were concerned primarily with 'creating life', not producing works of art; but a conscious orientation towards a 'personal myth' was also characteristic of members of the avant-garde, who 'worked on themselves' at least as energetically as the Symbolists did. Their working, of course, took different forms, reflecting the broad creative ambitions that defined the Russian avant-garde; but if their new 'picture of the world' was distinctly individual in origin, that did not prevent it from making claims to universality and impersonality. Innovators quickly gained a keen sense of their special vocation, their special mission in the history of world, not just Russian, culture. Witness these extracts from letters by three artists.

Alexander Rodchenko: 'I free painting (even Futuristic painting) from what it has adhered to thus far....I prefer to see common things in incommon ways....I have found the only original path. I shall compel things to live like souls....I shall find things in people....I shall compel people to die for things, and compel things to live....I shall put human things in things and things will become souls...' (1915).[1]

Vasily Chekrygin: 'My energy is considerable, and I have a sense that it will submerge everyone. There has been a colossal turnaround in my way of thinking, and in my thoughts I have attained much that I do not feel comfortable stating now because my time has not yet come, but it is close at hand; of course all of this points to something that is not at all small, but enormous and significant for Russia' (1914).[2]

Kazimir Malevich: 'I saw myself in space, hidden in dots and bands of colour; there among them I sank into the abyss. This summer I declared myself the chairman of space' (1917).[3]

The final quotation represents something more than self-observation or a personal programme: it is a vivid and distinct example of self-mythologization, presented as an ontological, not a psychological, entity. Malevich is creating not life, the process of individual existence, but existence itself. He sees himself

as 'an artist-prophet, dictating the form of the world'; and he does so not through an idea, unavoidably coloured by subjective emotions, but through a visual image, a kind of indisputable proof.[4]

The contours of this 'personal myth' are thrown into the most vivid relief by Malevich's own writings. Their substance, structure and style create a specific image, point to the 'sweep' of his self-awareness, and provide a key to understanding. We are not dealing with the bold, childish escapades of the Futurists, with their inevitable parodic devices and playful inflections, nor with the scholarly treatises of the Constructivists, or the Filonovian 'directions' of the analytic method. Instead, we have the statements of a man who possesses the Truth, and ever controls the world itself (creativity, according to Malevich, is 'supremacy over the forms of nature'),[5] a creator who gave the world a new religion: Suprematism. His works constitute pages in the great universal Book, the weighty, solemn word of one who has perceived the truth. 'The icon of my time' is how Malevich described his *Black Square* in a letter to Alexandre Benois.[6]

'I have untied the knots of wisdom and set free the consciousness of colour!

'Remove from yourselves quickly the hardened skin of centuries, so that you may catch us up the more easily.

'I have overcome the impossible and formed gulfs with my breathing. You are in the nets of the horizon, like fish! We, Suprematists, throw open the way to do. Hurry!

'For tomorrow you will not recognize us.'[7]

'I have torn through the blue lampshade of colour limitations, and come out into the white: after me, comrade aviators, sail into the chasm.

'I have set up semaphores of Suprematism.

'I have conquered the lining of the heavenly, have torn it down and, making a bag, put in colours and tied it with a knot. Sail forth! The white, free chasm, infinity is before us.'[8]

The frequent repetition of the pronoun 'I' is a distinctive feature of Malevich's writings. This somewhat impersonal 'I', its scope and emotional content, are revealed in a letter the artist wrote to Alexandre Benois: 'I am a rung.'

The magnitude of his self-awareness and the gap between the man and the image are also evident in the special relationship between his writing and his painting, unlike that of other avant-gardists. Malevich's writings cannot really be said to lay the groundwork for a method or set forth a theory. Their link with painting is at once closer and more remote. More remote because, as originally conceived, some of them, like *God is Not Cast Down*, were self-contained philosophical treatises, concerned the world in general, not art. Others are so constructed that, in the course of the discussion, the concepts of 'art' and 'creativity' on the one hand, and 'nature' and 'art' on the other, occasionally change places without explanation or transition. Art becomes not 'a picture of the world' but the world itself.[9]

At the same time, the link between the writing and the painting is closer, because they are two aspects of a single system, autonomous but mutually reinforcing. The writings are a vehicle for the special states of awareness engendered by the Suprematist canvases, without which these states would not be revealed. Once again, the system is brought full circle by the 'individual'; and the strongest evidence of the broad claims made for the individual, and the special cast of his personality, may well be the 1923 *Suprematist Mirror*:

'There is no existence either within or outside me, nothing can change anything, since nothing exists that could change itself or be changed.'[10]

Contemporaries noticed in Malevich's theoretical writings an inclination to mythologize himself. Nikolai Punin called the grim manifesto just quoted 'the Suprematist poetry of Ecclesiastes.'[11] Abram Efros spoke of 'the dark force of evangelical zeal. I really love his arduous, headstrong, intense, inarticulate eloquence; of course it is not literature—sometimes it is less, but sometimes it is more than literature: it has flashes of apostolic writing.'[12] Efros also noted the role Malevich's writings played in encouraging the Malevich myth. His reaction to the 1919 one-man show was typical: '...I do not understand why Malevich was in such a hurry to put on a retrospective exhibit of his work. I truly regret that my romance with Malevich, a romance of a viewer with an artist, has been so unexpectedly cut short. Oh, those obliging friends! They could not wait to canonize Malevich! One more illusion unmasked. Up to now Malevich has been a fairly talented artist. Not that we did not know him, but we took him in...in small doses of his work, filling in the gaps with large doses of his theory on painting. And that was intriguing and auspicious: an image endowed with unusual features loomed up out of the fog. We thought: these are illustrations from an integral body of creative work; when it is eventually gathered together, what an interesting artist will stand before us!'[13]

Malevich was apparently altogether earnest about his 'apostolic' role, at least in the 1920s, and a certain irony plays about the comments by his contemporaries. With Punin it is found in his phrasing, a direct parody of *The Suprematist Mirror*: 'Malevich even places himself in a risky position. At very least he gives the "Pillars" (to use

Filonov's terminology) of art criticism the right, as it were, to go and one day declare "absolutely without bias" and "absolutely intuitively", to declare grimly that if Suprematism is the way of Malevich, and "his ways are mysterious...", then he (Malevich) and his way are equal to zero. And nothing can be done with a "pillar" like that, because to every argument he will reply, "I spread the word and teach as would my great teacher— Malevich!"'[14] Efros's admission cannot be taken quite literally, either: 'But theories do not make art, and that is what Malevich does not understand. For him art is the product of theory. Once a dogma has been created, canvases will follow. He could paint with eyes closed. In fact, he could paint blind. Brains are more important than eyes; as long as there is an idea there will be painting; touching fetishism from a primitive nature that has discovered that it can think!'[15] Although one might not accept Efros's final conclusion, or use it as a judgement on Malevich's work, it does contain a very precise assessment of certain character traits.

More important was the position of Malevich's intelligent contemporaries, whose irony points to the existence of a gap between the man and the image he wished to project—precisely the kind of discrepancy that gives rise to legends. We therefore need to maintain a certain distance: in considering Malevich's writings today, we should perhaps regard them less as a guide, or an exhaustive explanation of his painting that makes other explanations superfluous, or even an absolutely strict theory, than as psychological evidence—as part of Malevich's history.

Is the artist a prophet, 'dictating the shape of the world',[16] or, to use Punin's apt phrase, 'giving the world order through vision'?[17] Malevich thought so. It is evident in his writings, and in his behaviour, which had a strange premeditated, visual character, recalling Pasternak's comment that 'The visual perception of biography was typical of our times.'[18] Witness Malevich's self-portraits, even the earliest, with their heavy, naive self-assertiveness, and the later regal poses 'in character'. Witness the photographs, in many of which he is playing a part. Witness the use of Suprematist symbols in ordinary contexts (the Black Square on the sleeves of the teacher and his pupils, as a mark of enlightenment, or the Black Square in letters, next to the salutation or the signature). Witness the role of the Teacher he adopted, which went far beyond the limits of educational necessity. Witness his somewhat aloof manner towards his students, demonstrated in his fixation with documents (questionnaires, protocols, letters), the formalization of teaching that established a distance between the instructor and the pupils, and the use of such impersonal terms as 'physician', 'patient', 'diagnostics', 'prescriptions', 'painterly out-patient devices', and employed without the slightest facetiousness. Finally, witness the decidedly self-important tone of the official documents issued when he was head of the GINKhUK [the State Institute of Artistic Culture]. Similar in kind is his subsequent revision of his career.

The apogee of the legend, which endowed the course of his life with the mantle of free will, was the funeral of Kazimir Malevich, which he transformed into a symbolic act. 'Malevich was buried to music in a Suprematist coffin', Lydia Ginzburg recorded. 'Crowds lined the Nevsky Prospect, and people in the crowd said, "probably a foreigner!"....The Suprematist coffin was designed by the deceased. For the lid he had drawn a square, circle, and cross, but the cross was eliminated even though it was called the intersection of two planes. The design for the coffin indicates his attitude towards death, that of others and his own.'[19] The ritual had been planned in every detail; nothing was left to chance. The clothes in which Malevich was dressed contained the primary Suprematist colours—a white shirt, black trousers and red shoes.[20] Malevich decided where his final resting place would be, and it, too, was symbolic. This self-awareness affected the way others saw him, exciting hostility among some, respect among others.

'K.S. [Malevich] arrives,' his pupil Lev Yudin wrote in 1922, 'and you immediately find yourself in a different atmosphere. He creates a different atmosphere. He really is a leader.'[21] An artist outside Malevich's circle took another view: 'I liked Malevich's work more than anyone else's, except Tatlin's of course,' Alexander Rodchenko recalled. 'They were fresher, more original, and unlike Picasso. But I did not like Malevich himself. He was somewhat square, with shifty, unpleasant eyes. He was insincere, vain, and biased in a thick-witted way...'.[22]

The desire to assert himself, the will to domineer, and the provocative side of his personality all come through sharply in Nikolai Punin's reminiscences:

'Malevich loved demonstrations, declarations, disputes and new axioms; he asserted and presumed by hanging slogans over his paintings; he gladly participated in public events, and by 1915 his boomeranging squares had hit the public and he was spreading the word. He was always surrounded by a hubbub; he had many followers and zealous pupils; they were his storm troops and he sent them into the fray whenever he found it necessary. Malevich had the ability to inspire unlimited faith in himself, and his pupils deified him as Napoleon was deified by his army; they wore their leader's insignia, the black Suprematist square, on their cuffs. But that was later, during the Revolutionary years. In the avant-garde period Malevich still advanced on "the strongholds of the old world" as a junior officer, wore a yellow shirt and sported a large wooden spoon in his buttonhole....

'When Malevich introduced Suprematism at the "0.10" exhibit, the mere novelty of a new "ism" no longer appealed. Futurism was over and none of us wanted to gallop along, lopping off the heads of clay figurines....So Malevich walked into a hostile camp and quickly sensed it; he nevertheless paced Bruni's studio, nevertheless persuaded with that astounding power that hypnotizes, compelling others to listen, transfixing, putting matters bluntly and stating ideas point-blank; to stress his point he leapt away from whomever he was talking to and shook his hand with its short, small, nervously trembling fingers—in fine, he still tried to sell the Suprematist discovery, all the while knowing, knowing as we did, that the Suprematist square was not to be hung in Apartment 5 and that Suprematism—the latest and last product of Cubo-Futurism—would pass and swerve from the one, direct path through material to quality. Of course, at the time we probably did not have a sufficiently clear notion of what part Suprematism might play in the new art. But in Malevich himself—in that splendid agitator, proselytizer, heresiarch of the Suprematist faith—and in all that he said there was then so much undefined Futurism, such a pull towards innovation to the detriment of quality, such a strain of rationalization, that we nevertheless felt Suprematism was a dead end, a void cloaked in a feat of Futurism, a void of innovation beyond the realm of material, a cold void of rationalism, defeated by the world and the square that had impotently risen over it.'[23]

Punin's reminiscences tend towards subjectivity, intensified by the complex professional relationship he and Malevich had, but at the same time they do reflect the traits that gave rise to the legend. Another source of information at our disposal, the diaries of Lev Yudin, are perhaps more objective: they do not grind any of the axes that memoirs usually grind. In them, he tells of conversations (some are plainly labelled 'historic') that were like prophetic revelations and exhortations, of how difficult the conversion to the Suprematist faith was, and about disagreements and agreements, revolts against the tyranny of the teacher and his work, the search for a personal voice. Yudin's diaries give an exalted portrait of the Teacher, a powerful individual of great drive. Again and again he comments: 'Example and comparison—the desperate steeliness of Malevich'[24]; 'When you get it from K.S., there's always a good reason'[25]; 'After all, his every word is important.'[26] These quotations date from the UNOVIS [Affirmers of the New Art] period. And as a summing up of Yudin's attitude comes the phrase quoted earlier: 'He really is a leader.' The 1930s provide another interesting characterization: '*Chapaev.** Tremendous experience. Not an "impression" but an experience. I draw a parallel between the hero and K.S. They are of one breed.'[27]

Even later, when Malevich had ceased to be Yudin's teacher in any formal sense, and despite their differences, the figure of the Teacher remained a guidepost to life and art for the younger artist. 'He is like a conscience,' Yudin wrote on December 25, 1934. And, 'A fiery man. Old ideas. Exhausting purity. He pulls us up sharp. Without him we would slide into what is murky, trite and cheap' (March 26, 1934). In October of the same year Yudin takes his young son to see the dying Malevich, so that the boy will have a memory of the great man. Finally, in one of his last letters from the front, we read: 'Malevich and Mitrokhin inspired feelings that I think can only die when I do.'[28]

His feelings about his Teacher were nevertheless mixed. On one occasion Yudin calls himself 'the prodigal son',[29] and many entries indicate that Malevich, endowed with the mind and the temperament of a leader, created a 'high pressure field' about himself. ('I am afraid that his discipline will once again be too much for us.'[30]) Pressure of this kind, created, if not by Malevich himself, then by the code of group behaviour (not without reason did contemporaries speak of a 'sect'), seeps through in the following entries: 'Suprematism is remote. UNOVIS is even more so....I want to paint, but am constrained. Painting is a whole attitude towards the artist and his purpose. It is impossible to go and study the painting of a Suprematist/member of UNOVIS. Anyone who does so is not a member of UNOVIS. The ideas of UNOVIS are not real for him....'[31]

'I just hung the Suprematist works. It is very important what you surround yourself with—and indicative, since it also reveals who you are, and just as what you do depends on what is happening inside you, so what is happening inside you affects what you do. Force a member of UNOVIS to live in the Tretiakov Gallery....'[32] Criticism appears for the first time, alongside the usual laments about lacking discipline and resolve: 'Malevich took a Constructivist approach to Cézanne. The main thing for him is weight. That caused us to make many mistakes. We sacrificed a lot for weight.'[33] And apparently it was no accident that, soon after he joined the UNOVIS order, the thoughtful novice wrote: 'The question that most interests me at present is the question of our system and in general the question of "The Individual and the School."'[34] Something has him worried and anxious, something is bothering him and making him take stock. His doubts grow during the GINKhUK period, and he continues to mull them over. On January 24, 1924, he writes:

'1. The scientific method in art. What is it? Is it the only way open to the artist at present or is it just a small part of theoretical work? 2. The objective of the scientific method. Does it hinder or help the work of the artist? Its role? Is the point that it forges links between the phenomena in painting that have gone before and creates a "psychological environment" for the development of new forms?

Author's note: Yudin is referring to a Soviet movie about a Civil War hero of the same name.

Here again two questions meet head on. 1. What is new? 2. Can only one exist at a time? This question affects me directly....Cubism...more than anything else in painting is now what I am about....I cannot bring myself to do research: for the most part it is a cipher to me. It continually provides more knowledge of forms, but as a result it continually causes fragmentation because, first, it provides knowledge of alien forms and, second, it provides knowledge, not skill. Cubism is very similar to old painting. Here is a chance to observe nature. That is the point. Suprematism frightens me as an abstract art.'

By the end of the 1920s, Yudin had found his own voice. 'I feel that for the first time in my life I now have the opportunity to approach nature in accordance with my own inclinations and desires....A real, tangible, endlessly unique and singular world. Reveal its logic. No inventions or abstractions. Everything based on touch....'[35] In capital letters Yudin records what is most important: 'And so, WORK FROM NATURE.'[36] Then he goes on to say: 'the realistic method—that is what I need.'[37]

The personal, however, comes into conflict with the general. ' "There is no feat in my pieces," Suetin said. Evidently he did not find them in any way striking. "If I show them to K.S. there will be an uproar." For the first time all of my suppositions have been taken to their logical conclusion. A parting is unavoidable....Now no one will lead me astray, because this is the way I must take, and it is the only thing I can do.'[38] The entry defines his way as dissenting, and indicates that a hostile reaction is inevitable. 'All these conversations with Suetin are just as it was with Malevich—"being rubbed the wrong way".'[39] The personal is clearly perceived as a betrayal of the common cause, both by the group, and, more important, by Yudin himself—which explains why it comes with such difficulty.

Pressure is exerted: 'The big line...has turned against me.'[40] Not surprisingly, Yudin even writes angrily of an enemy culture that threatens his state of mind, of the province, of a weight.[41] The search for a voice of his own proves to be an act of resistance, and not a natural development. Consider the emotional charge: 'I need to liberate myself completely and stop doing art for someone else.'[42] Even stronger evidence of dependence is found in the entry for September 18, 1935, after Malevich's death: 'Maybe I'm just so frightened that I take my singularity for a betrayal of principle?' The entry for January 28, 1933 is particularly eloquent: 'The five-year revolt has not been vindicated. The uprising has, as always, been crushed by "the big line." Yes, this is probably how a person feels after an uprising has been put down. The enemy tries to ferret out the tiniest feeling that may remain. To the wall! He captures and destroys.'

These were not constant thoughts. Contacts were renewed, advice was taken, Malevich's authority was as high as ever. On October 21, 1934, for example, Yudin writes in his diary, 'V.M. [Ermolaeva] spoke of my work. K.S. said: "Yes, Yudin broke away...". And then repeated, "broke away!" That support makes me so happy. It stimulates...and obliges.'

In May 1935, upon his return from Malevich's funeral in Moscow, Lev Yudin makes a fascinating entry in his diary that sums up the complex relationship he had with his teacher: 'The charge K.S.'s things give is lost when you don't see them. That's the whole joke! It's so clear now. K.S. is of an altogether different temperament, he's a different kind of artist, in some ways not just unlike me, but quite my opposite. It is also clear that N. [Suetin] and K. [Rozhdestvensky] are much more like him as individuals than I am. In that sense, I'm probably not K.S.'s pupil. And at the same time I think that I should use him as a standard of measurement for all of my attachments and enthusiasms to avoid being crushed, which is the chief, ever present danger for me. To avoid being crushed—I understand that broadly: ideas, tastes, rhythm, etc., right down to the scale of forms and even the canvases themselves. That is the key to the very special way I feel about him. You could put it like this: I am extraordinarily dependent on his great taste and profundity. Often that dependence is burdensome and constrains me. Sometimes it paralyses me altogether. Consequently, I distrust and suspect myself. But in the final analysis I think that if I can hold on, contact with that sense of taste and those high demands alone will lead me eventually to art. But that standard, which is very high for me, remains a very narrow gap for me to squeeze through. I have often been confronted by the thought that I must either discard that standard or reconcile myself once and for all to moving slowly or standing still. But the latter still remains to be seen!'[43]

This examination of Lev Yudin's diaries has concentrated on his perception of Malevich and the nature of the relations within the group. Even the quotations cited, however, make it clear that conflicts were not only caus ed by personal differences ('a very different temperament trom mine';[44] 'They are of one breed and I am of another'[45]), but reflected the very process of the 'new art's' development.

'The conversation with K.S., astounding for the unexpected way it ended, must be considered the end of a period,' Yudin wrote on June 28, 1929. 'We fully agreed with him about criticism and totally rejected the path he proposed. The greatest danger was of forfeiting the broad foundation of painting....What are the hallmarks of the new period? It is founded on the individual's desire to establish a living, concrete balance between himself and reality, relying exclusively on the plastic means at his disposal. During the first formal period, the illusory achievement arose because the first part of the equation was

absent altogether. The individual was lacking. In fact, it can also be said that the second part, reality, was lacking, too. The struggle centred on formal problems, taken as canon and raised to an extraordinarily high level. To the level of eternity. The second representational period is marked by a rejection of lofty problems, a rejection of eternity. All attention is on the individual....The desire to see work as a kind of synthesis. A protest against fragmentation and element-by-element work. A struggle against formalism....Interest in the emotional, the personal, the individualistic. What is important is what distinguishes one artist from another. Various means of destroying the impersonal, formally perceived system....The third realistic period, that we have long dreamed of, but were timid and uncertain about attempting.... You can't stay within the bounds of the individual personality. After all, we did not protest against connections with nature. All we hated were the dead clichés of Cézannism, Cubism and Impressionism that had lost all meaning. We were poisoned by knowledge of the means while lacking an end.'

Yudin's diaries do not simply record the conflict between teacher and pupil. The latter's thoughts document the evolution of the avant-garde and its inner logic. This account is supported by other sources.

The opinions of artists of the time prompt us to view rather differently the Russian avant-garde and the issues surrounding it, but it would be wrong to reduce the debate over Suprematism to the hubbub in the press, and the deliberate refusal to understand; to the campaign of discreditation, initiated by Alexandre Benois' 'art letter'[46] and ending with Grigory Seryi's notorious article, 'A State-Supported Monastery';[47] to the AKhR [Association of Artists of the Revolution] witch hunt, furthered by subsequent accusations of formalism and modernism. The debate was more complicated, more serious and more significant—and that debate largely determined the contemporary artistic process and its tensions.

Plastic experiments performed for their own sake, or spiritual quests? Elements or images, innovations or art, methodology or creativity, systems or reality? Adversaries such as Vasily Chekrygin and Nikolai Radlov confronted 'leftist' painting with questions so serious that their resolution had a decisive influence on the fate of Russian culture. Chekrygin's protest was prompted by the consciously laboratorial nature of Suprematism. In his opinion, as he wrote to Punin, Suprematism had 'done its job. It has purged painting (or rather Picasso and Cubism have purged painting), it has forced artists to be careful, but all it does is develop the elements of painting. That, of course, is no small feat, all honour and glory to it, but if the elements of painting are raised to the status of an ideal....It has great educational value for the lower classes in an art school, but you place it at the end of painting's evolution.'[48] For Chekrygin, the plastic elements were just a language; art needed 'materialized concepts' and 'synthesis'. Chekrygin also objected to maximalist pretensions: 'No one can force a method on an artist, that is a lie. Picasso's palette is Cubism, Malevich's palette is Suprematism, but neither is the one painterly truth that makes everything else false and what went before a forerunner.'[49]

Radlov argued a similar position: 'Citizen artists, now that you have laid to rest the grievous years of artistic delusions, speculation, charlatanism and ignorance, is it not time to remember artistic creativity? Is it not time to return art to art? For the ends and means of artistic activity are not to be found where people have sought them for the past decades....Neither the eyes, nor the hand, nor reason make the artist....In the strength of feeling, in the depth of emotion spontaneously seeking expression, in the inner life of the creative person recorded for all time, in his loves and hates, empathy and pity—therein lies the one true source of art.'[50]

Suprematism also had such intelligent opponents as Punin and Efros. It was challenged by people who were by all means discerning, informed and interested in the new art, who thought for themselves and recognized the importance of what Malevich was doing. Punin put Malevich, along with Tatlin, in the first ranks of the fight for 'new forms'; for him, Suprematism was not the way of the future but a summation. In 1919 he wrote in the newspaper *Iskusstvo Kommuny:* 'Suprematism has as it were brought all painting of the past full circle, and thus absorbed all the past failures of painting (as well as its achievements!)....Suprematism has sucked out all the painting that was in world art and organized it by element. At the same time it has abstracted that painting, deprived it of its flesh and blood, its *raison d'être*. That is why Suprematism is not great art. That is why it is easily employed in textiles, cafés, fashion drawings, etc. Suprematism is an innovation which should rightly have enormous significance for the applied arts, but it is not quite art.'[51]

The focal point of Punin's concept of art was the category of 'life'—which cannot be 'calculated'[52]—so he was not satisfied with the rationalism of Malevich's system, with its non-material essence, its lack of painterly motivation, and the presence of meanings comprehensible only to the initiated. He quotes the artist Lapshin: 'To understand Suprematist painting fully...one must join the "sect" (UNOVIS); otherwise one will never have more than a rough understanding of Suprematism as a phenomenon in painting.' Punin then backs that observation with his own analysis: 'The purpose of these "pure" forms: to designate, to define

through the language of painting a state of consciousness in which the tension ("excitement") of the Suprematist (and no other) sense of the world is close, as far as I can understand, to the painterly zero that Malevich has said so much about of late. Thus, it is not the clean canvas itself but an ideological system, which transforms that canvas into a painterly event, that has supreme meaning....In Suprematism, painting is not valued for itself but as an expression of a number of states of consciousness, a number of tensions ("excitements"); in other words, painting is not an end but a means....'[53]

Efros had similar complaints: 'His Suprematist experiments...are not painting but illustrations of a theory. Their justification or superfluousness is a direct consequence of the truth or falseness, the substance or tenuousness, of Malevich's theoretical structures, certainly not of their merits or success as paintings.'[54]

Serious dialogue among interested individuals presenting cogent arguments is more fruitful than blind worship, as Nikolai Punin's 1923 article, 'A Survey of New Trends in the Petersburg Art Scene', demonstrates. Even today we probably could not find a deeper understanding of Suprematism's essence or its conceptual nature. Punin calls Malevich's work a world view, in contrast to Tatlin's art, which he terms a world sense. While these words seem to be used literally, they are actually apt expressions of profound significance. 'If Tatlin's work is a pure experiment in the depths of painting-reality, then Malevich is a missile the human spirit has sent into non-existence, into the pure void of intuition, where the only realities are connections and ties. Strictly speaking—and speaking for the artist himself—the "reign of painting" ends here, and art flies off into realms where there is nothing but forms....As soon as Malevich tore space out of the system of Cubist structures, it immediately attained the status of a form; not the integrated form replete with painterly substance that is a vestige of the intersection of material and space, but the pure form of space conceivable and recognizable with the help of painterly reason.'[55]

It is more fruitful to examine this debate today than to ignore it. And the point, naturally, is not to take sides, or even merely to be aware that the viewpoints existed, but to recognize their very distinct differences. These arguments give us some notion of the variety, the wealth of alternatives, the intensity of that creative dialogue which proponents of the 'new art' conducted in search of the truth, in search of an alternative between utopia and reality. And the tragedy of the 1930s is not just a tragedy for the avant-garde, which had already lost considerable evolutionary momentum by that time, but perhaps even more, given the consequences for culture's development, a tragedy for the productive, unconstrained dialogue that never was finished.

The following manuscript by Kazimir Malevich, now in a private collection in Leningrad, is dated March 1924 and consists of 21 typed pages on lined paper, corrected and signed by the author. Comparison with another, incomplete version of the same text—nine pages, unfinished and uncorrected—reveals that the work underwent certain structural changes and a considerable expansion; it also indicates that the manuscript published here is at least the third version Malevich produced. Evidently the artist did not regard the work as complete, as the word 'draft' appears on it in pencil.

In February 1925 Kazimir Malevich wrote in a letter to *Europe Almanac*: 'My excerpts, published in *Kunstblatt* and *Europe*, are already outdated, so I would like to print newer excerpts from books I am preparing, in particular *The Ideology of Art* (an analysis of Cubism, Cézannism, Futurism, Suprematism, etc.). Therefore, I am sending an excerpt on utilitarianism and art....6.2.25. K. Malevich, Director of the Institute of Artistic Culture' (Leningrad State Archives of Literature and Art, f. 244, op. 1, ed. khr. 30, p. 26).

Enclosed with the letter was a text, probably a draft of *The Ideology of Architecture*. Some excerpts from the work were published by this author in issue no. 7, 1988 of *Tekhnicheskaya Estetika*.

It is possible that the following manuscript is also part of *The Ideology of Art*: its subject—the relationship between art and society—is fully in line with the fairly broad concept Malevich had for *The Ideology of Art*.

Malevich's text is reproduced here in full with the exception of a few brief illegible corrections, indicated by ellipses. In some instances the text has been edited, but solely for the sake of grammatical and syntactical exactitude (Malevich did not always observe the rules of agreement, particularly when making insertions). However, even a correction of this kind is indicated whenever an interpretation of meaning is involved.

Words inserted by the editor to make the text more intelligible are placed in brackets, and any areas where the reading is unclear are indicated by a question mark. Insertions made by Malevich by hand are printed in italics.

Galina Demosfenova

Kazimir Malevich

Through My Experience as a Painter

1924 Draft

I

Through my experience as a painter there have proved to be two phases: the first, early phase, on the plane of studying how colours interact, and the second plane — applying the laws elucidated to create a new organizational structure for painting, in which the forms of objects would either fall away or be subordinated to the logic of colouring unique to painting. When, during my early period, I approached an object or nature* in order to reproduce it on canvas, once I had uncovered the painterly phenomena in it, I tried to depict it precisely, i. e., in its natural aspect, with all of its qualities, *properties* of easy movement and the weight of the impression it made. These two facets of nature interested me most of all. I was not alone in applying myself to nature, to the *precise* depiction of its actuality, but one of a large group of painters. This approach, this attitude to nature clearly indicates that altering nature did not occur to me or any other painter. We considered it impossible to change. We studied it *for the future*; that was our aim. *In order to build* [new] *painterly structures based on that science.* So, there was not even any question of a type of composition that would change nature's relations. Thus, there was not even any question of creativity or aesthetic-artistic tasks, for creativity presumed changes as part of the creative process, *and that was nature without any* [additions?] *on the part of my will.* The latter was the extent of our aims, the naturalization of nature on canvas was our objective, and the achievement of an identical reproduction was the acme of perfection. We did not understand at the time why we were called artists or why our reproductions were called creative artistry. *And the greater the similarity of our reproductions to nature, the more artistry was seen in them, when all that should have been seen was nature.* It was not clear to me why the engineer who built a railway bridge was not considered an artist, or why his bridge was not considered a work of creativity. After all, he too drew on nature; moreover he turned it into new phenomena, *in contrast to us, painters, who fixed in space views of what existed in nature.* After all, he had the whole set of compositional, structural facts at his disposal. Clearly, *simple reproduction was meant* by artistry, while what should have been meant was the expression of the painter's personality through the alteration of nature, its transformation into a painting, i. e., *into a new formula, dissimilar in contour to nature*; [after all], for *the engineer*, nature in the person of the engineer was changed, and consequently it was appropriate to the engineer's creative composition, it was a mechanical drawing as a new additional element in nature.

All the data indicate that the constructed bridge should be a utilitarian work of art, but it was not recognized as such. Thus, the artistic aspect of the bridge was reflected in the decorative elements that were without use, like those little shapes that would serve to embellish naturalistic reproductions. [It is thought that] *without these decorations, no engineered bridge can be considered artistic, so all engineered structures are divided into two categories, of a lower and higher order.* These are the engineered structures that reach their culmination in architecture. *The lower, simple civil structures of the first instance readorn nature, i. e., turn it into a picture or architecture, or a reproduction, elevate it to a work of art. But I ground the first instance on*...scientific data that pursue a purely technical, utilitarian end, or the end adhered to by purely nonobjective laws discovered by science. The second is an architectural grounding on pure inspiration. Evidently it was considered aesthetic and artistic, transforming nature into paintings and architecture. *Thus, man's total activity in this instance originated in two basic principles or two categories of harmonic relationships: 1) practical harmony, and 2) aesthetic harmony.*

Structures were not considered art when they resulted from engineering, whose practical harmony is not transformed into architecture or the highest level of harmony. Like scientific revelations, artistic photography was not considered art since their data were not arranged by the principles of artistic harmony. The

*
Translator's note: Throughout the text Malevich employs the word *natura*, which is narrower in meaning than the English *nature*. It is defined by the *Slovar inostrannykh slov* [Dictionary of Loanwords] as 'that which actually exists, reality; that which serves as a subject for the artist...' (Moscow: Russky Yazyk, 1988, p. 329). Ozhegov terms *natura* 'that which exists in reality, a genuine, natural situation, condition, etc. as opposed to that which is depicted' (*Slovar russkogo yazyka*, Moscow: Russky Yazyk, 1983, p. 348).

aesthetic element belonged to art alone, and was considered artistic harmony. Painting, moving from its scientific-study state to forms of architectural painting, is considered art....civil structures with architectural elements are also works [cf art] now. But both of these nevertheless belong to the fine arts, nature. Like widely-known conclusions applied to an end, both kinds of art depict nature in practical and aesthetic harmonies. [They] are equally practical since there is a need for utilitarian or aesthetic objects. Of course, two such needs can be questioned—is aesthetic harmony necessary or purely their reality [since all of that] can merge into one formula and result in a new function *beyond practical priorities and aesthetic differences, whose logic* [the formula's—*ed.*] *establishes a different need for different goals* and reduces everything to the conclusion that [both] the former and the latter are nothing but engineering arts, through which, in one way or another, [we] study the laws of nature and on the basis of the latter build certain harmonies *as simple non-objective conclusions*, which can serve any hoopoe or insect as a hollow for its purely practical purposes, and it will think that...all of nature has come up with clever things for it. Harmony can in turn suffer collapse, for the aim of all harmonic mastery is the achievement of peace and, as peace and calm is man's only need, a non-objective need. Perhaps these are all the delusions of a brain excited by science, forever dreaming and irritated. .that eternal peace was disturbed at some point and the world disintegrated into differences and is now raging and moving once again toward a world of indifference....Aesthetic art wishes to show that it is superior because it raises a utilitarian piece of technology to a work of the highest artistic value—ennobles it, strips [it] of its crudity and makes it beautiful. *If that is so, then aesthetics is one of the tools of engineering that helps smooth all rough edges and achieve a harmonic build: and sandpaper did what a file could not.* This is just one small fact which nevertheless confirms that engineering and aesthetic art in combination strive to perfect the harmony of things as fast as possible to furnish peace. They have one goal. Aesthetic harmony cloaks naked reality, practical or grubbing, in robes of the highest spiritual-aesthetic order, i. e., it raises [reality] to a non-material, spiritual state, where there is no rust or wear, to the sphere of 'eternal beauty' and 'eternal peace', just as religion raises *souls* to a kingdom of spiritual harmony liberated from matter where all things become images, while in the aesthetic domain of art everything is *raised* and exists in a picture [as] a new type of image. To that end the engineer and the artist disturb the harmony of normal nature, in it they do not find the special sublime aesthetic or practical feature that is not formed by nature but is only formed in one or another kind of art. Beyond that feature nature is chaos—so, evidently, the engineer and artist should reason. *But perhaps that is a misunderstanding, perhaps* [on the contrary] *the engineer or the artist wants to impose his insane aesthetic state on nature, but it does not work, and that instigates a fight over a method whose validity is also questionable?* The need to force both kinds of art to put themselves in complete contact with nature, establish a harmonic relationship, establish peace and calm, not dissonance—I want to traverse all nature, all existence, in complete peace and calm, I do not want enmity and oppression. *I want to squeeze my battle-flushed brain into nature and dissolve in it, but it is my misfortune that I cannot find a chink or think of a tool that would break up nature. And I would enter—it cannot be broken up, dissolved, burned or frozen, it is like a witch that can turn into steam or water or a tree or ash; reason itself says so, not frustration. Try to overpower the witch and she changes into a dog, try to strike her and she becomes a wheel and rolls away. In the scientific world that witch is also invulnerable. She is called matter.*

A Papuan or Negro in deepest Africa is busy changing his appearance. He does not like the way he looks and decorates the organic structure of his body with additional aesthetic elements, donning necklaces, inserting rings in his nose and ears, tattooing himself. Papuans and Africans are not alone in this: our Europeans, women and men, do the same. They are busy artistically altering their impeccably engineered organism; they, too, strive tirelessly to violate their naturalness, their nature, their design with a new design, decorating it with all kinds of bows, ribbons, hats, sticking feathers in them, painting their eyebrows, lips, eyes and cheeks. All this, too, is the handiwork of the two basic principles of art, that strive to turn the organic structure into nature, into a picture, to smooth the rough edges of the engineer's work by imposing the harmony of a picture. No one pays much attention to this endeavour to alter nature, no one reproaches the individual who has distorted his natural appearance by painting his cheeks and lips and donning feathers, hats, ribbons and beads. On the contrary, such distortions are considered artistic. But if society perceives the same in painting, where the artist also paints nature and changes it to suit his aesthetic demands, finds a new correlation of the same logic which puts him at peace with nature, i. e., eliminates every hindrance to his peace and calm, overcomes them, then society sets upon him and accuses him of going against the actuality, *as the poet and the painter once took the utilitarian word and object and turned them into reality, the*

former into auditory reality, the latter into painterly reality. Society differs with them. Neither it nor they are in harmony. In this instance, of course, someone is guilty of disturbing the peace—either society, which is behind the times, or the artist, who, [first,] has discovered new harmonies which bring him and society close to the classic form of peace and calm [and, second,] *arrived at abstract, non-objective Suprematism.*

Painting may be divided into two categories or approaches to nature, as may painters: some take a scientific approach, others an aesthetic one. Those who take the scientific approach and apply themselves to nature are directly involved with it in the sense that they uncover the interaction of painterly elements; with every new surgical operation on nature, with every new disclosure of the circumstances affecting the elements in nature and their interactions, painters who take the scientific approach increase their knowledge of it; without delving into the question of harmony but establishing facts, they formulate them and reproduce them on canvas as a complete formula derived from pure scientific analysis and research into the realities of nature. This category [of painting] can also be called scientific harmony, in the sense that phenomena lead to a formula, or *to a reproduction*, just as a study leads to a picture, but with the sole difference that scientific *representation* can only establish a fact but probably will not enter into a discussion of whether or not a phenomenon is harmonious: it is a plain scientific fact of numbers. The other category of painters pursues the artistic aspect, the embellishment of these formulas. It wishes to turn them into an aesthetic type of beauty, a picture of architecture, and so it powders and paints the canvas, rouges the face, accentuates the eyebrows, and paints the lips as ladies do in nature. This category is convinced that nature is fallible and must be corrected, supplemented with auxiliary aesthetic elements.

If we take a look at Shishkin's works we see that his works that reproduce nature do not show any signs of picturesque art, painterly architecture, nor any powdering, rougeing, alterations, or the transformation of truth into a picture. Nature is presented directly, in its pristine state. It is an established fact of reality that can be used to make a picture. It is a set of facts beyond any sort of aesthetics. It is a collection of elements for a future formula of painterly logic. The connection of forms is not violated, it is also [material for] *painterly distortionism*, after all. The artist conveys the natural interaction of painterly elements, that are expressed in a given combination and create forms of a given type or phenomenon, commonly known as a fir or a fern or a ray or light, etc. He was *in essence* a painter who took a scientific approach, but not an artistic one. At [Shishkin's] time painters even went so far as to specialize in landscapes, seascapes, genre works or battle scenes. Like the scientist who chooses an established field and puts together scientific descriptions, painters, too, in choosing an established genre, describe the facts of a given event on canvas in a manner that is by no means inferior to any used by the scientist who studies the daily round or some other aspect of life. Thus, every painted record of a billowing sea or a life event is not a picture in the artistic... sense, but a fact of known authenticity about a phenomenon, on the basis of which we can create a picture. That is the advantage of making a large number of observations of painterly trends from nature.

Impressionists applied themselves exclusively to the truth of the impressions made by colour and light. That was their genre, the subject of their research. Colour as research and light as its formula. That was the content of each canvas. It is clear from Mauclair what a hostile reception their work received from society, which reproached [it] for violating what was then the standard of artistic realism, i. e., the established formula of painterly logic. The group busied itself with work on their indestructible formula [:] research on colour and light, the search for new elements to fill out the previous formula, and a purely scientific analysis of the laws of light and colour. Busy performing their scientific research and putting that truth down on canvas, they were not busy making light look artistic or seeking its ties to art [but] merely revealed its physical origin, expressing it with one of their tools—painting. Light was the substance of the Impressionists' paintings. Striving to convey naturally the action of light on objects, the Impressionists discovered its component elements by fracturing. They learned that light is a formula of colour's component elements in various dynamo-vibrations and reshowings, which cause rays to reflect and, consequently, tinge objects. They recorded all of this knowledge on canvases, which represented nothing less than aspects of their research after analysis and formulas for the latter phenomena. In working on a means of depicting the phenomena they studied, they discovered that fractured light is a complex of colour associations that create light. This

prompted the Impressionists to employ pointillism, distributing dots of colour on the canvas in such a way that they blended naturally in the eye. Thus, an original technique was born—the method of Impressionist painting. Hence, it is clear that they directed all of their activities to the study of light's physical properties, and there can be no question of aestheticization or a picture or an architecture of the former [i. e., aestheticization—*ed*.]. They scientifically demonstrated in paint how the phenomenon we call nature arises, and by what process. Thus they revealed nature to us in its rawest state. All of their work in paint was the recording of nature. Society did not understand that record, although it should have been perfectly comprehensible, for it corresponded to nature, which society orients itself on so strongly and which seems so clear to society. Orienting itself on nature, society does not see that nature is not a picture or architecture. Clearly, society has no grounds to accuse Impressionist painters of failing to reproduce nature accurately or of depicting it abstractly. That same society [would] take a different attitude to the physicist who showed light through a prism or revealed a different reality of that same nature, that same light, fractured into separate elements, merely because it is science, which should not be part of painting. [Only] the aesthetic reality of nature should be reflected in it [i. e.,painting—*ed*.]. Delacroix said that the art of colour is obviously related to some aspect of mathematics, while Constable remarked that the most charming or accurate green meadow is achieved through a multitude of green tones. Thus it is clear that both were speaking of a kind of mathematical precision that would make it possible to depict a green meadow, i. e., to deduce the formula for experience. Constable's meadow would consequently be a scientific reproduction of experience, proving the veracity of his hypotheses and observations and demonstrating the number of elements that make up the green of the meadows, for to speak of a multitude is the first determination of quantity.

V

Society and painters have always diverged when the painter revealed new facts about nature that disturbed the order established in the mind or aesthetic sensibility of society, that disturbed harmony. Innovations irritate [society] and the critics, who together with society have had their perceptions shaped by words quite incomprehensible to the scientific painter, words like 'taste', 'art', 'like', 'dislike'. Those words have defined every phenomenon in painting. They are an aesthetic standard, but not a scientific-painterly standard. This aesthetic yardstick is used to measure every occurrence in painting, and the painter is presented with the absurd demand that he place spots of paint on his canvas as the yardstick directs, to avoid violating the rules of taste and adding quinine to the cake. Confusion arises because to the critics and society a painting is something inexplicable and mysterious produced by the incomprehensible and unattainable spirit of creativity, while in fact a work of art is the result of the study of phenomena, [the formulation] of produced elements into a work, i. e., into a formula of painterly logic. A work of art reproduces what the eye and mind perceive—nature—and produces a formula or work. Here the yardstick of 'like' or 'dislike' have no bearing, especially as they are *always* subjective. Taste itself is not quite what it is supposed to be [either]. It is not in itself an element that is tasteful—everything taken together, tasty or not, creates harmony—salt, sugar, vinegar, mustard; what is needed is a scientific yardstick that the critics and society would have to use in order to approach paintings as scientific painterly formulas. By employing the taste yardstick, society and the critics reject this or that painting. They find it distasteful, not to their liking. By this measure society could overlook everything except tasty pears, oranges and cakes, and to the devil with the rest. But, as is evident, salt is all around and...salt is also tasty. There is now a saying: 'Tastes differ.' An idea strikes somebody, is painted, liked and in good taste. For the scientist no such saying exists; one phenomenon is liked, another is disliked, that comet is beautiful, but to the devil with that one, it is disliked. All that exists for him is the verification of a given element produced in a work or a formula against a natural phenomenon, on the basis of which the harmonic requirements the scientist spoke of can be created and satisfied. Thus, society is wrong to address its imprecations to the majority of painters, frequently mistaking units for sums, elements for formulas, formulas for fragments, spokes for wheels, wheels for wagons and wagons for vessels. Of course the blame for all this confusion in painting lies with painters themselves, who worked tirelessly, trusting the critics, while the latter did them no favours by invariably describing fine eyes, plump hands and thighs; talk centered on arms, legs, eros, the sense of eros, clouds, but never on painting without clouds, eyes, legs and arms. Now, however, a tiny spark has appeared in the form of the new Scientific Institute of Artistic Culture, which employs not abstruse tales about art, but painters themselves, and they may be the key link for all of art, which will give art scientific form and attempt to sort out the muddle that criticism has created. And then it is possible that judgements based on taste will be avoided and clarity in the objective comprehension of artistic phenomena will be achieved.

VI

I have already said that for the painter, nature represents processes of colour fluctuations, elements, combinations or separations, producing some phenomenon, painterly or chromatic. Where there is separation there is colouration. Where there is combination there is painting. These two actions, acting on my nervous, sensory and cerebral perceptions, create the chromatic or painterly surface. The painterly aspect does not exist for many people who study other aspects of the phenomena painters apply themselves to; thus each phenomenon is perceived by various specialists in the reproduction of one and the same element of certain aspects of this phenomenon to create a new work of science. Painting is only one aspect of studying an object. The specialists' studies can be compiled with other investigations to form a phenomenon's totality, i. e., disclose the full reality of what is [seen?] Every specialist commands his field of science, his techniques and methods for the scientific surgical investigation of a given phenomenon. All of them may discover various properties of a given phenomenon through various technological approaches, but come to one conclusion. These and other conclusions give the full cubic content of the phenomenon under study. Thus, all specialists strive to express the full volume of the phenomenon under study, and each of them strives to express the full cubic content of his special aims through that phenomenon. Consequently every object will be conveyed when the cubic dimensions sought by every specialist are obtained; the sum of the cubic dimensions constitutes the reality or naturalism of phenomena. This foundation is laid in Cubist painting— the expression of the painterly cubic content in a phenomenon. That is scientific Cubism. The strangeness of its formula as it is expressed somewhat irritates the viewer, but the viewer would be irritated by other scientific formulas; that is why he is a viewer and a critic.

Thus it is evident that the Cubists did not set out to demolish nature, as it seemed to society and 'the clumsy analysis of the critics' *(guiding the hands and eyes)*. On the contrary, they performed a more complicated surgical procedure on nature and reproduced the cubic content in painting in nature. They revealed new causes, new auxiliary elements, and innovative painterly genres; they reproduced these on canvas, as a new fact of painterly existence, obtained new formulas, and upon encountering auxiliary elements, they had to create new approaches, methods and means of conveying the latest changes.

Thus it is evident that Cubists set themselves the same task as Shishkin, as the Impressionists Signac, Cézanne and Manet. They did not depart from a single task of naturalism. They can be challenged, but challenged and checked scientifically. Is there a difference between the Cubists and Shishkin? Yes, society would say, there is. But how is it expressed? Society would say that Shishkin is an intelligible artist, while the Cubist is unintelligible. Why is Shishkin intelligible to society? Because he depicted 'firs' and 'grass'. In point of fact, Shishkin did not depict either firs or grass. As a painter he reproduced the cubic content of painting in the context of its spatial relations with regard to a given phenomenon, and he need not have known whether it was a fir or a birch or some kind of grass which is familiar only to the expert botanist and can convey that phenomenon precisely. Society insists on a system, but why does it say nothing about the blades of grass that are found in the space of a painting? Because it does not know anything about that grass and can say nothing about its accuracy. Shishkin only conveyed the painterly side of nature. The fact that certain painterly elements form a certain plant was not part of the task he set himself. He was preoccupied with the distribution of light and colour in a painting on a given plant. He was interested in spatial existence in a painting, not in the existence of rye and firs. His canvases do not contain firs, they contain a painterly correlation of elements that creates a painterly formula for nature. The fir is a formula brought about by the combination of a whole series of elements. Shishkin's painterly formula, as with those of all the Cubists and Impressionists, is just a series of combinations of cadmium, emerald green, cobalt, zinc oxide, etc. It constitutes formulas for research and their spatial relations. Every painted canvas is a painterly space, a complete conception of its [i. e. the painterly formula's] reality, and the construction of that reality is the art of painting. Painting can be defined as an art capable of providing a painterly depiction of the painterly truth of a phenomenon, but unfortunately, painters never leave any notes on the process of depicting a scientific analysis of the kind.

The exact reproduction of nature through painting is the factual truth [of those who] depict painting, nature, while society and the critics, on the contrary, cannot find it, for they are searching the forest for an elephant that is not there in reality. In painterly culture there is a culture of painting, but not a culture of the elephant, Venus.

VII

If a painter does a portrait he is primarily doing a portrait of painting. He is working not on a portrait [but] on the culture of painting without the slightest aesthetic supplementation. If a photographer does a portrait he is taking a picture of Ivan or Petr. Painting is irrelevant here. The painter does not paint character or moral perfections or state of mind—there is no such element in painting. He can organize painting scientifically. That organization will be the content of a painterly system or its culture, its fullness. It will contain painterly elements in the whole organizational structure. The moral state of an object—ideological, heroic—is a sphere of a different order, with different content (painting here is irrelevant). [That sphere] may be organized on agitational or other lines, its content may include the character of Ivan or Petr, but not the reproduction of Ivan's or Petr's painterly content. It is impossible, incongruous to combine these two contents, as the authenticity of another content, another ideology is required. Thus, painters fall into the following categories: 1) conventional, false painters, whose impeccable truth requires that a nose be placed between two accurately situated eyes; 2) [agitators] who pursue a rigorous, decisive, ideological, militant, sacred, merciful, cruel kind of representation; 3) painter-aesthetes [who] apply aesthetic lipstick to all that heroism and the nose and the eyes; and 4) scientific painters, true easel painters. Society, like the critics, presumes the opposite—that the camel was created by the wisdom of nature to convey the Kirghiz, that in true art there are portraits of certain subjects and there are portrait painters; by painting, artists mean the portrait of a face and say, 'that as long as human beings have two eyes and a nose in between no combinations in painting will be considered identical or a painterly delusion.' This clearly reflects society's misunderstanding of painting itself, for as far as the content of painting is concerned there need not be two eyes and a nose in between, *but according to society's logic, the camel* cannot take a step without the Kirghiz, the camel without the Kirghiz is an animal with no purpose, an abstraction, and this is where society is most deluded: essentially, artistic painters do not exist; there are simply painters who say more and express painterly emotion, but not the eyes, nose and ears. This is the root of the misunderstanding, because a true painter never gives any thought to whether the symmetries of the eyes, hands and feet are accurate, and he regards them not as elements of the face, characteristic of Ivan and Petr, but...as characteristic elements for the structure of his painting, the easel painter (without the addition of 'artist'). If such elements characteristic of Petr or Ivan as the nose, eyes and ears are retained as forms in a painting, it is a matter of chance. Nevertheless, a true painter will level them out in accordance with their painterly structure, where Petr or Ivan is introduced as material for painting, and his forms are subordinated to the total structuring mass of the painting, to painterly culture. In that case the face of Ivan or Petr is not a face but a detail in a painting, like an element in a formula, though not a moral formula for his heroic condition. Thus we see that neither Ivan nor Petr can ever become the Ivan or Petr of true painting, though the eyes and the nose may be visibly in place, not even with painters of the third category, the aesthetes, for the true Ivan will be photographic, objective, and if he is photographically accurate, the form has not been subordinated to artistic painterly logic, which is fundamentally different from the reality of Ivan and Petr. Thus, the artistic formula does not equate portraits of Ivan or Petr and his other particular features, it remains a formula for nature. In the first instance the face was presented and improved by the known logic of painting. Consequently, these departures and improvements should satisfy society, as in its mind they verge on the artistic. It says, 'that in the painter's hands even an ugly object acquires value.' What does that mean? It means that the ugly object was improved by the logic of painting, and as a result the ugly object was restructured into an artistic image, a picture, and elevated from its natural state to a painting of artistic value. These kinds of improvements and changes aimed at producing art have been made by Rublev, Vrubel, V. Vasnetsov and in part by the painters of the Renaissance, who constitute a special category of painting—the elevation of ugly phenomena to works of artistic value. Thus, an ordinary mother became the Mother of God, an icon, and her face departed from nature as does any other Venus, as art today strives to make an artistic image of the modern natural face of Ivan or Petr. This category of art is capable of wavering and regressing, it twists forward and back, for it has its orbit. But there is another category of painters, whose logic moves unswervingly from 'from' to 'to', but never returns to 'from'. This category is similar to the category of researchers who, in improving 'from', take it higher and higher, to 'to'. The carriage, the express, the aeroplane. The greatest of disasters would be needed to bring about a regression from the express to the carriage, in other words to 'from', but such regressions occur in aesthetic painting without any disasters. Thus, the final category of painting, basing its logic on not returning to 'from', places itself in a situation which bars it from retreating to the past, to 'TO'. That past or 'from' is always at their disposal, with [it] they clean out the half-baked ideas of yesterday and throw them into the abyss. Many aesthetes see in shells the remains of a beauty that is gone and strive to resurrect the organism from the shells, from the bits of atrophied elements, but sadly none of it can be resurrected, for everything began with the egg and developed into a fundamentally new

form. But this attempt is being made solely by aesthetes, painters, sculptors and architects, for whom archaeology is the inspiration for robbing the grave of vestiges of past culture, which they plan to clothe in new painterly garb, while the architects are putting the ramshackle Parthenon in concrete. The grave-robbing archaeologist or architect has obtained the shards of artefacts from the graveyard of time and is now racking his brains over *how to glue them together*, how to return Venus, Apollo, Jupiter and Bacchus to the earth, forgetting in which hand Venus held her shield or mirror, whom she loved and whom she did not.

VIII

Cubist painters set themselves the goal of bringing out, i. e., picking out the full cubic capacity of the painterly elements in phenomena and expressing the full cubic content of painterly culture's painterly elements. Immediately they were confronted with a new problem related purely to the technical side of painting—how can that capacity be expressed when we only see the width, height and depth of nature, i. e., nature never shows us more than one of its facets, where life has, as it were, frozen in a pose for the artist. Three relationships, three of their convergences, three planes—we see nothing more in a phenomenon. We do not see that everything is in motion, everything is in flux, while with the artist everything is frozen, everything stands still—a given phenomenon is shown first from one side, then a second, then a third and that is all. Thus, every phenomenon or object is realized as a semi-cube. The rest of the semi-cube in its second, third or fourth facets is concealed from our eyes. Life for the artist now has only three sides, while for scientists and Futurists all the sides are in motion. For the former everything moves in three dimensions, while it moves in all dimensions for the others. We begin to surmise that there is still another facet to the problem, there are sides we do not see, sides that have great significance and value in our depiction of the painterly object. [As it is] impossible to penetrate the other realm, we are denied the opportunity to depict the full cubic content of the phenomenon, and so that which is customarily termed academic realism is not actually such, for only three parts of the painterly object are depicted, only three correlations, and the content or substance of a given phenomenon is not expressed in terms of its full cubic capacity, by a painterly or, indeed, objective formula. Thus we see that the Cubists made steady headway toward expressing the full cubic content of a painterly object and found a solution through the so-called fourth state of painterly object space, i. e., while it was in motion. Picasso and Braque first revealed the cubic reality of the painterly object; they measured all six sides of the painterly object, and this represented the limits of painterly calculation and correlation. Thus, Braque and Picasso deepened the painterly object through the expression of its reality more than Shishkin and Cézanne had. They brought it to the ultimate norm. The Cubists were able to see the other side of the painterly object, find all its facets and bring it [i. e., the object—*ed.*] together in one structure, thereby violating the law of the static three-dimensional state, awareness and painterly phenomenon, which made it necessary to search for new technical means that would help them see the other side of the painterly phenomenon, and that means proved to be movement (consideration of a phenomenon while in motion).

IX

Observation of how children depict objects shows that they go through various stages in depicting visible objects. In the first stage objects are depicted as confused lines—this representation does not seem at all real to us. We do not see what the child is depicting. We have already forgotten how real these depictions [were to us when] we were their age and put our impressions down as they do, their relations direct and oblique, taken from one and the same phenomenon and juxtaposed in such a way that they are not expressions of a phenomenon for us. Such depictions have disappeared from our memories for good, and we cannot return to them, just as the Cubist painter cannot perceive a painterly phenomenon in its three-dimensional state, just as a person cannot go on seeing a cube as two-dimensional once he has seen its third side. This depictive truth of childhood has disappeared forever. During the second stage children begin to produce drawings of a different kind, closer to our notion of proper depiction, and we begin to see signs of the object we see in our reality. During the first stage we see that children record all phenomena of a voluminal origin as planes, everything is stretched into a plane without spatial depth. They perceive objects in two dimensions, by height and width, while the third aspect or dimension, expressed as depth, appears in the third stage. In the last case children [...] please us with their portrayal of reality, but they depict the object in three dimensions—height, width and depth. Older people, among whom I number the Cubists, would not be pleased by their truth. The painterly reality of such an object does not correspond to the cubic

reality, as the phenomenon is depicted as half a cube. The reality of an object evolves through time or motion. Depth, height, and width are consequences of the evolution of motion, and all the sides of all the object's facets evolve. In children's drawings we can see all the stages of an object's evolution through time, which has as it were, arrested the object in its three-dimensional state. In this state all our attention is fixed, all our relations and the changes in all facts. We find ourselves in a kind of hypnotic state, our eyes, deflected to a three-dimensional phenomenon, when the reality of that phenomenon revolves before us with its six planes and gives us a new formula for the cube. The final state of a painterly object has been called its fourth state in time or the fourth dimension of temporal relations in the process of motion by a painterly object. Thanks to that fourth dimension, the painter begins to record the painterly object, not just the part he sees but the part he is aware of, the part he remembers as well. He must develop the so-called visual memory and collect all bygone painting in his cerebral box, known as the memory. Only by drawing on all the elements of painting in his memory can [he] restore on canvas the correlations of painting corresponding to those in motion. I only record what I remember, not what I do not remember. Thus it may be concluded that there is no need to rely solely on the sensations of the subconscious state, for that state is in the semi-memory. More attention needs to be given to memory or knowledge. Sensation can record nothing if no use is made of the primal elements that are stacked in the closet of knowledge or memory, experienced once, through touch, sound, sight (delivered to the closet by our sensations), where the entire nervous system collects all the currents of the surrounding circumstances, as telegraph wires deliver the sound of a word to the machine, spelling the word out in particular dashes. On this basis the Cubists established that what the painter sees or feels counts for very little. He needs to remember, know and regard the fourth technical condition of movement and the state of the painterly objects in it as a personal law. Through them the Cubist can convey the full cubic content of a phenomenon, while the memory apparatus will collect all the interrelations of painterly elements, collect material which can be used to find a formula for the degree of intensity in a given state for each type of painterly phenomenon. In the case of new phenomena, these formulas permit every possible construction that can be employed in all of daily life's interrelations.

X

The new art was the first to take the body of the cube out of the static three-dimensional state and into the fourth state of motion, and the cube revealed its new reality, fixed in the memory as a type of six-sided body. Motion became the technical means which proved that the cube has not one but six sides. Without possessing any knowledge of the Cubist system it is clear that it [i. e., knowledge—*ed.*] is beyond understanding because understanding is a function of memory, ...which lacks the very elements found on a Cubist canvas. Implanted in the memory by sensation–touch, sight and sound–a phenomenon, in order to become real [must] pass to a new cell of knowledge, [and,] depending on the state of cell's development, a greater or lesser degree of realization is achieved. In this sense painters have overtaken the old men of the three-dimensional community, just as they outgrew the two-dimensional period of children. The brief analysis [given] here has led me to another thought, which indicates which way the body evolves. The body originates in a point. Considering this point of motion laterally we see that it makes a line, its material length. This line is nothing less than a new reality of the point's motion, while the motion of the line creates a new reality in the form of a plane, which also represents that thread's evolution through time. Under certain circumstances, this plane can create a cube as a new reality of the plane or a third state of the point, while the motion of the cube about its axis will once again form a point or a sphere. In this, as I see it, all the stages of the body's movement occur, i. e., the entire epoch of its known cultural evolution occurs, returning ultimately to the point, to its original 'from' and 'to' as it were, to itself. The new point formed is a vestige and result of the 'to' being attained, i. e., of itself. In the development of painting, according to the definition laid down by society and the critics, this point is always taken for a dead end, not just by society and the critics, but by the painters themselves, the innovators themselves. They do not recognize this 'to', they do not recognize that they are moving towards themselves, do not recognize themselves in the dimension of time. 'To' has turned into point and troubles their consciousness because it has come back to itself, or rather to the subconscious and the organ of sight and sound. There is nothing to see in a point except a point, therefore in Suprematist painting the point takes the form of the square or the circle, arousing the greatest indignation among all of society and the press. Society has perceived the collapse and ruin of all art, a complete dead end that it must retreat from, first by alleyways and then by streets, retracing its footsteps all the while. In other words, society or painters started to recoil, they were scared to arrive at themselves, for it is indeed hard suddenly to see yourself in the distant 'to'. Such is the position Western painting finds itself in. All the outstanding leaders of the new art there, on whose banners 'to' was distinctly written,

became frightened of that 'to', for the enormous, wealthy 'from', a multicoloured conglomeration, seemed wealthier to them than the point of that new type of cleansed 'from'. They became frightened of that point and turned back the way they had come. But they will not find an exit there, either, for eventually they will arrive at the point—themselves. Suprematism, on the other hand, took a completely fresh look at the point. None of the alterations in painting alarmed the Suprematists a bit. They saw that for each day they are in motion first one, then another column falls from their wagon, first one then another element of the object flies off. It is the vestiges of the point's motion that fall away, it is a shallow transitory vestige. They saw that the whole club of culture, in all its aesthetic painterly ties and connections with life, is disintegrating, as it is nothing other than the actuality of the vestiges, the motions of reality. They were threatened, as it were, by absolute poverty. They risked being denied everything of value from the past, [they] risked squandering all while in motion and remaining advocates of non-objective art. But that did not frighten them. They knew that all those riches and things of value, all the baggage we brought from 'from' crumbles quite naturally, for it is a vestige of the former material core. The vestige only afforded proof and told us of its bankruptcy, of its inability to sustain the energy, the force of the motion, that contained reality, i. e., [the point] that is moving farther away. Meanwhile, the attitude which all of society and the critics adopted to the new art brought to mind those scientists who were angry that the point, when in motion, developed into a line and a plane and, finally, [into] the cube of a body, or [brought to mind] the coachman who was bewildered when his carriage turned into an aeroplane and rose into space; frightened, he fell to the ground with a thud and fled to his stables, only to find a garage instead. Then he bawled in terror at the death of his coaching art, for the core—the point, in the form of the carriage—ceased to be existence *in his mind*, existence went on, leaving the carriage, a vestige of the existence that had been a carriage and became an aeroplane with a pair of wheels up front. Likewise contemporaneity wants to flee from the new art to the old stables of academicism, to the vestiges of a once bygone reality which has become the new art. They run to the sweet coachmen of the old technique, method and form which are so simple, so clear to every arts correspondent and the masses. Crying that only they can revive the clear-cut 'heartfelt art', which comes from the spirit of the creative or healthy strata of the Renaissance, they wish to return to childhood, but is childhood not the point and youth not the plane that animates the splendid art of the future and give it eternal life? Only they, the academicians, can deliver our revolutionary time from the abstract, cold and incomprehensible point of the new art, i. e. from the cube and Cubism. But Cubism is the plane's last step forward to maturity—to the cube. It is the culmination of a cycle in painting's development, which the press once warned society about, threatening that act would die (while we were actually just witnessing the historical course of painting's development), and fearing that the new art would gain a firm hold. The sweet coachmen assured the inventors of automobiles and aeroplanes that their abstract undertaking would not run or fly, that the horse and carriage were the only natural forms comprehensible to the masses that they could use to get about. A second group tried to persuade the new art that it was at a dead end and would get nowhere, a third said it was a louse, a fourth said it was an abstraction, a fifth that either anarchy or counterrevolution had completely lost its head, exactly [which is] now unclear. But the inventors of the automobile did not lose heart and the time came when the automobile ran and the aeroplane took off. So, too, will the new art take off, for the dead end is a point, and the point is not motionless. The forms of the new art will also run and take off into the new 'to,' which caused such fright here and in the West, where it is supposed that 'to' cannot be reached by either the aeroplane or the new art. Edison will never return to his old notions, nor will the new art turn back, their new undertakings are found in filled, not hollow forms. This needs to be noted, because it is the root of the misunderstanding between the old and the new, namely that the new is never a form in the sense understood by the community. Form for the community is something in which the life of another idea or life in general can be reflected, i. e., it is a mould* that all kinds of content can be poured into, while that content [in turn] is poured out in the mould of the Renaissance, Palladio, Phidias, or Bramante. The new art, on the other hand, is still solid, i. e., it is not yet a cavity into which the content of life can be poured, not yet a hollow in which the hoopee or some other bird can weave a nest, and that is why the birds of the forest cry that all trees are abstract except those with hollows. The hoopees will try to set up housekeeping in the new art and fill it with their content, but they will not succeed and so will shout at the top of their profane lungs that it is abstract and art should return to the healthy Renaissance, the forms of the Parthenon, ...for those forms are hollows which the hoopees can move into and express, mould their lives.

Occasionally attempts can be made to cast a leader of the Communist movement in bronze in the form of, say, Pericles, for attempts have been made to cast monuments in the mould of the new art, but nothing came of it, neither the face nor the legs nor the expression could be discerned. It cannot be moulded, it cannot be formed. And as long the new art succeeds in maintaining this position it will remain the new art, i. e., it will preserve the core of wholeness. The minute the content of life rather than life itself begins to be cast in it, the new art will become a mould and the artist a moulder. Insert: a new category of art. Duplicated.

*Translator's note: in Russian, *form* and *mould* are denoted by the same word—*forma*.

Thus, if we speak of the new art's form, it needs to be distinguished from the mould in which the content of life can be cast. There is a difference between the content of life and life itself, since life—say, matter—is non-objective; and there is life, which makes a form out of matter and this form reflects the idea of God, the object, the bureaucrat, the ruler, the tsar, the urbanite—in short, the content of life. People want to see in the form a mirror, perhaps a better mirror, where they can see their face, back, legs, head, arms, and intestines.

XI

Western painting finds itself faced with catastrophe. The painterly object has divided in two and the mirror of matter has begun to present a lifelike reflection of the distorted face; sometimes that face seems like an aesthetic object, a lovely distortion that must be worked on when stimulated by 'inspiration and intuition' and 'an animating spirit'. Sometimes it seems that beyond all the painterly elements the object contains a soul [though no one knows what a soul is], that needs to be conveyed. On the other hand it seems that the painterly object is a cold, soulless machine animated not by the spirit but by steam or an electric current, that it should be approached consciously, not subconsciously, with a scientific method, a scientific analysis, a scientific technique to bring out all its energy in a new scientific painterly formula, and that all spirits and souls need to be forgotten. As soon as the latter idea is advanced, the entire artistic mirage of 'the spirit', 'intuition' and 'the soul' starts to disappear from their minds and the illuminating soap bubble of art vanishes, is in danger of bursting. The latter forced certain innovators, certain trends to think about that soap bubble, about how far it can be stretched, without going too far and bringing about an undesired catastrophe—to the loss of form, skill and artistic technique. Lovely plays of colour, deep rich painterly tones—everything could vanish under the pressure of the new art, i. e., of the non-reflective form or the blind, dull form. So let's go back, let's blow lovely soap bubbles forever in the manner of Ingres, Turgenev, Nekrasov, the Renaissance and 'long live the Periclean Age'. They will be new heroic bubbles, representing new associations with life, new attempts to revive the old, but not the birth of anything by the new—the new would require associations with the core, not the core itself. The new art does not possess the painterly relations of the profound Ingres or any other force like him. The new art contains an element lacking in that which can be returned to. It does not have an Ingres or anyone else. It has and awaits new forces to continue the formation of that element—not in the form of a mirror to reflect the ugly face of life, which has disintegrated into two states, reflected and reflecting. Life stopped to dwell on that formula and decided that art is the mirror in which it is reflected, expressed and in this way it benefits art, that it [i. e., art] will be the content, that its ugly face will be reflected in that mirror. Then art rebelled, went on strike—proclaimed a new refraction of the mirror—and the ugly face proved to be distorted, cubic, whereupon life became angry that the mirror had told a lie or the truth, dashed it to the ground and started to look in an old, distant mirror, in which the leader of the revolution and the leader of the anti-revolution were reflected with equal veracity. Life became very angry and said, 'No, whilst I have two eyes and a nose in between you shall not portray me in distortion without a nose and one eye. I will drive you out from everywhere, for I need a mirror that tells the truth. I need an artisan who will truthfully and "conscientiously" depict my face and its ideology.' From the four corners of the earth, from the west, south, east and north the vortex of revolution is rising. From it shall come a new life, while art will go back to the grave-robbers for the remains they wish to resurrect; *or they will mould the new life in lingering holes*. But perhaps revolution is an incomprehensible phenomenon to new arts? Enough of revolution, we are off to the stadiums to build our bodies and have taken our discuses and spears, for Pericles is not far away. Let us go back to Mausolos, to the arisen gods, let us go to the beautiful sepulchres, for their spirit and ours are resurrected there, back to Turgenev, to profound Nekrasov, to the Renaissance, to Perugiro and Poussin, back to plain, comprehensible forms, for we can only rebegin developing beautiful art from them (not develop, as it is already) developed, but rather mould contemporaneity), for their forms are always beautiful and in them revolution will [always] be a thing of beauty. Away therefore with non-objectivism, Cubism, Futurism, Suprematism and other trends in painting—they are abstractions, phenomena incomprehensible to our contemporaneity. They are afraid of non-objectivism, as they perceive in it a new artistic position that will start down the new-swept path which is akin to science, join it [i. e., science] or take another path, constantly surging into a tunnel, into the future, saving itself from the hollow and the content of the hoopee, that put art at war with the past, which strives to master the future in order to relocate the old columns of a bygone classic, a bygone culture, a moving point. They intend to put all the old furniture in the future virgin lands of the new existence, in order to grasp the hand of departing time on that old furniture and turn it back. Hundreds of thousands of versts in the ages of human motion want to light its way with Nero's torches. But that will not take place, for there will be electricity, the luminous fullness of the non-objective world.

Malevich
signature authentic

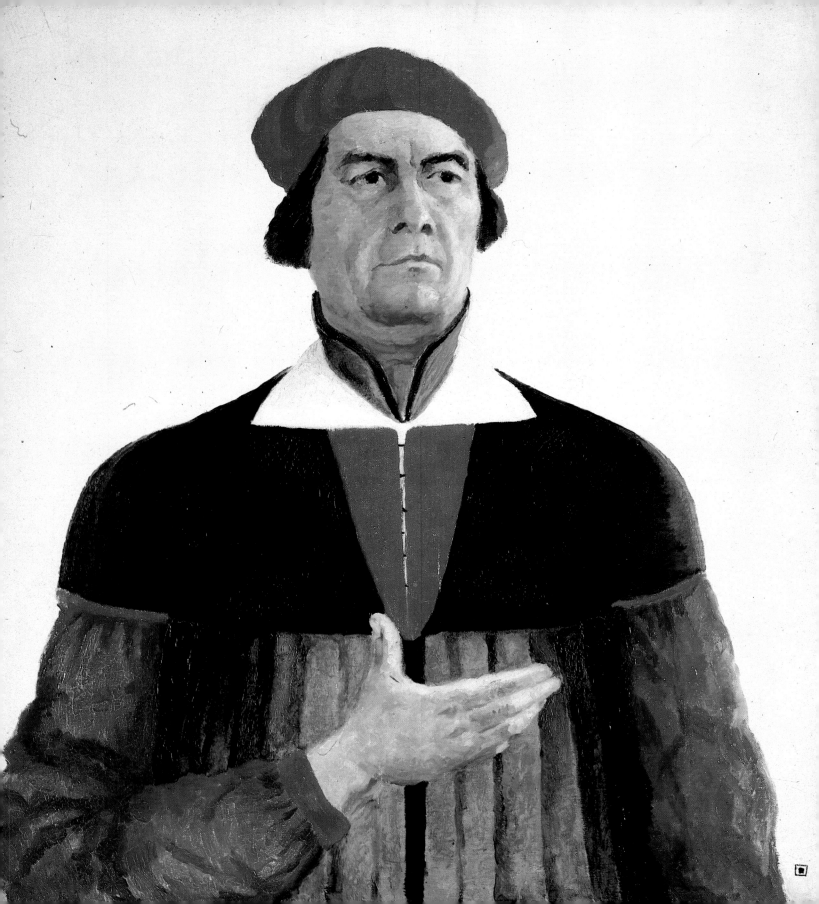

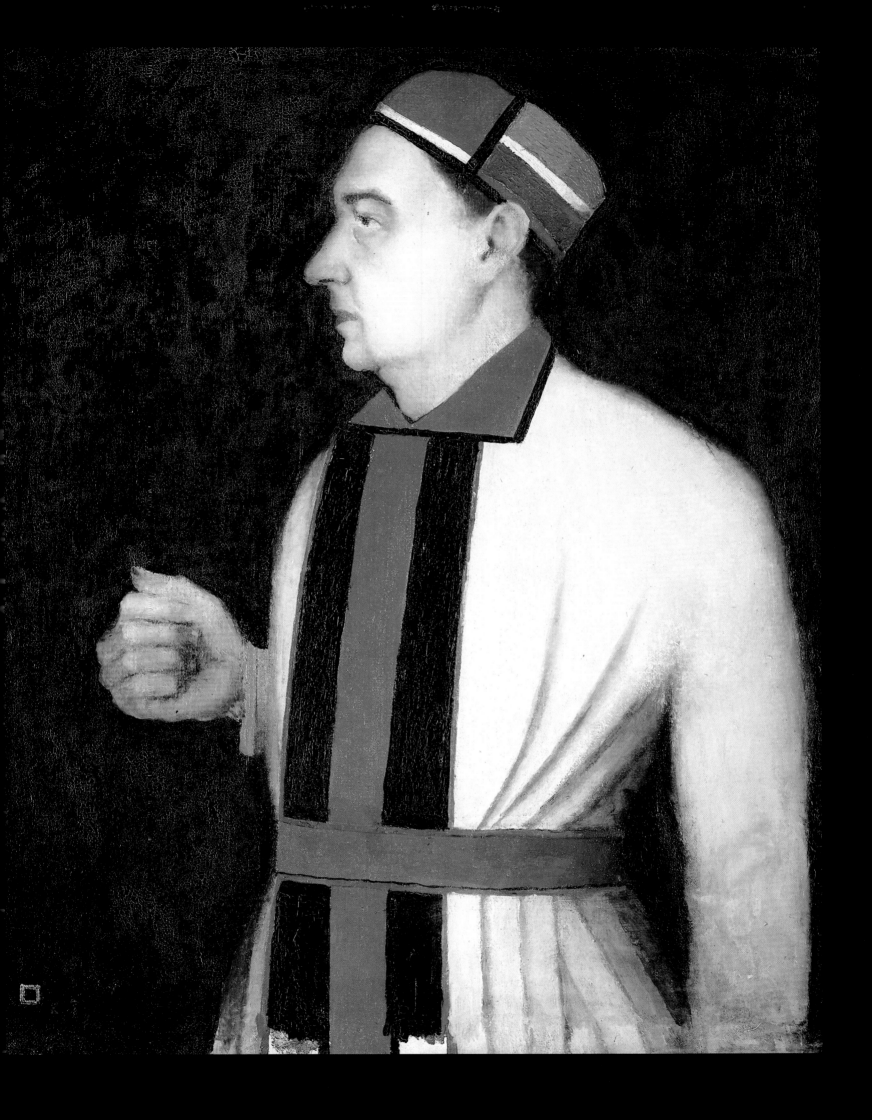

97 Male Portrait (Nikolai Punin?), 1933. *Oil on canvas. 70×57 cm*

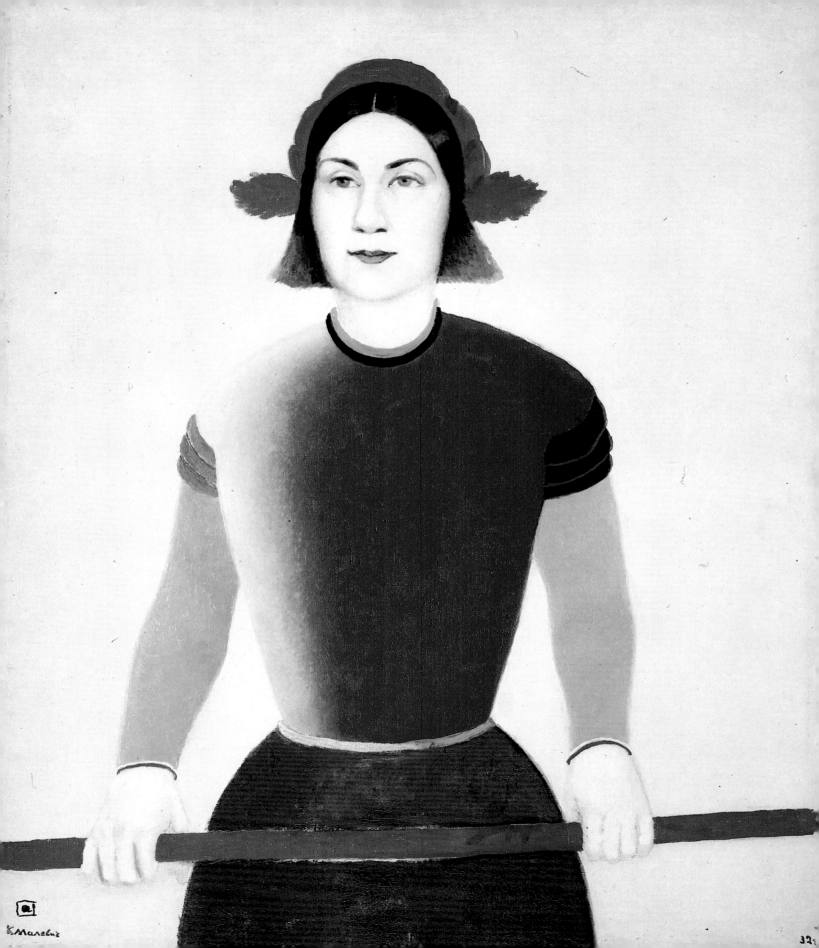

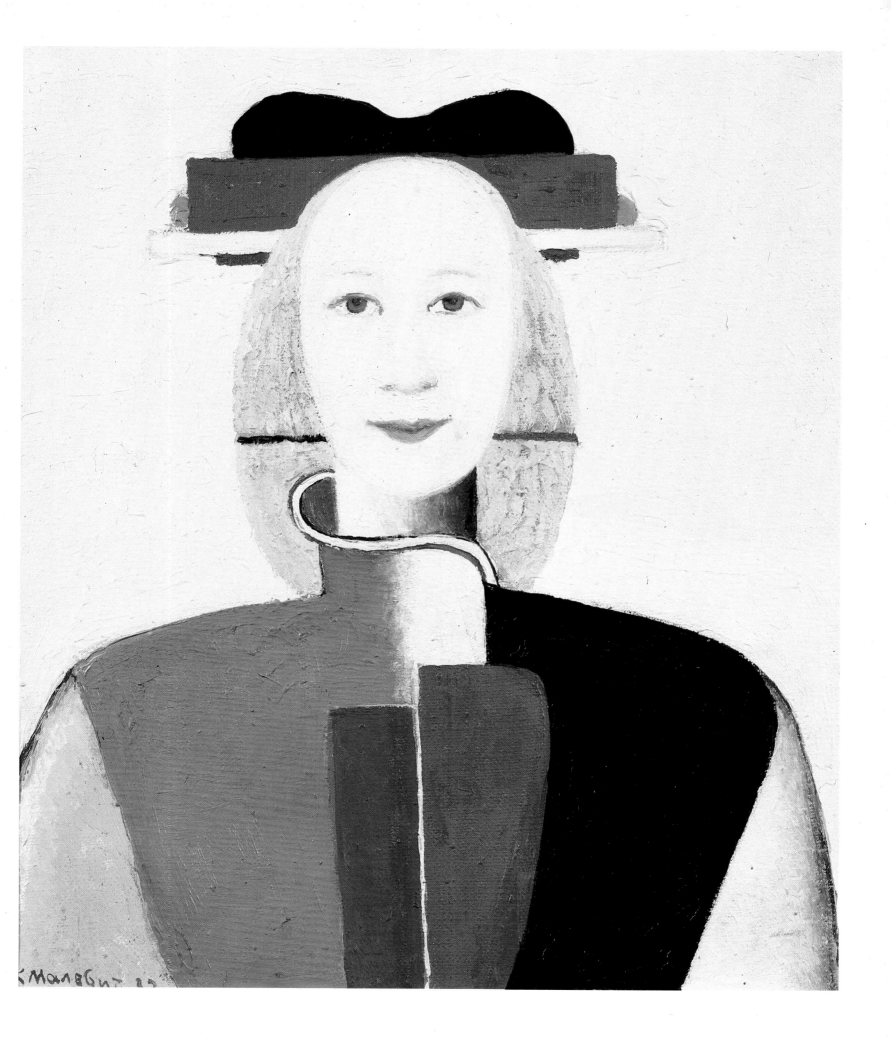

199 Girl with a Comb in Her Hair, 1932—33. *Oil on canvas. 35.5×31 cm*

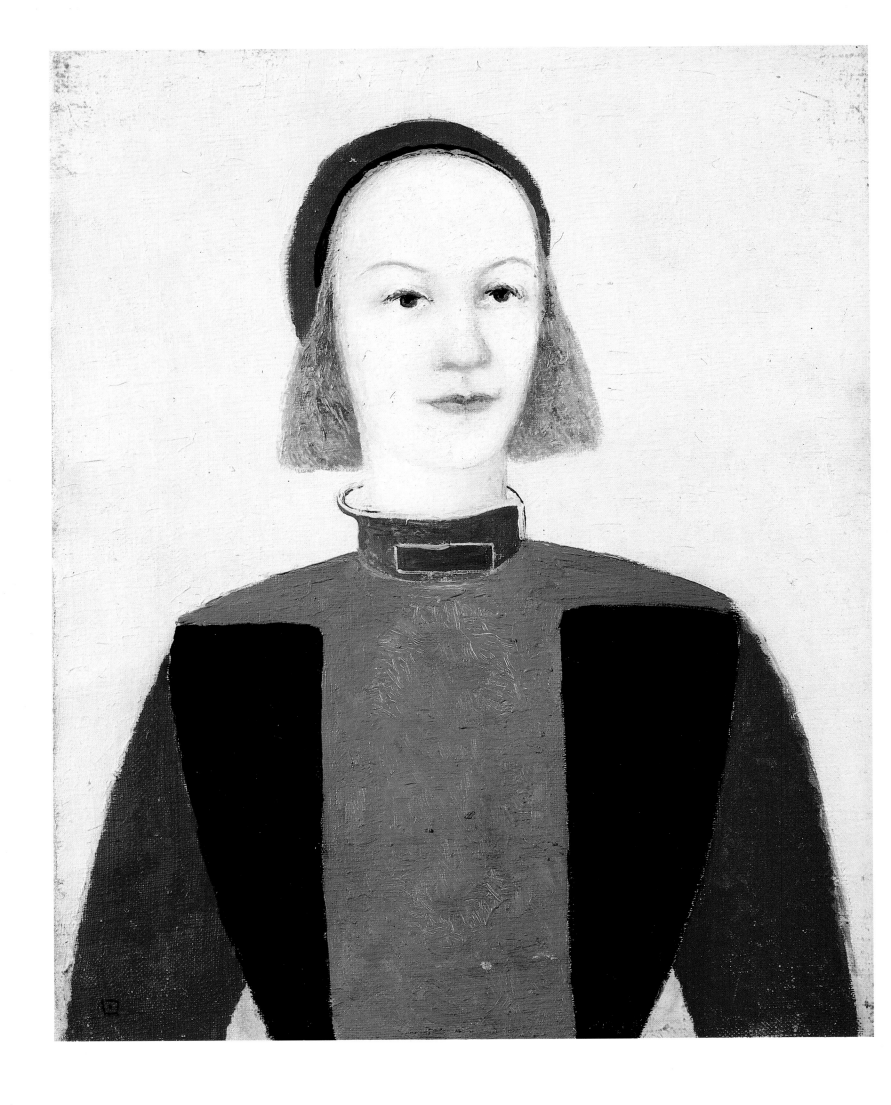

200 Girl, 1932. *Oil on canvas. 43.5×34 cm*

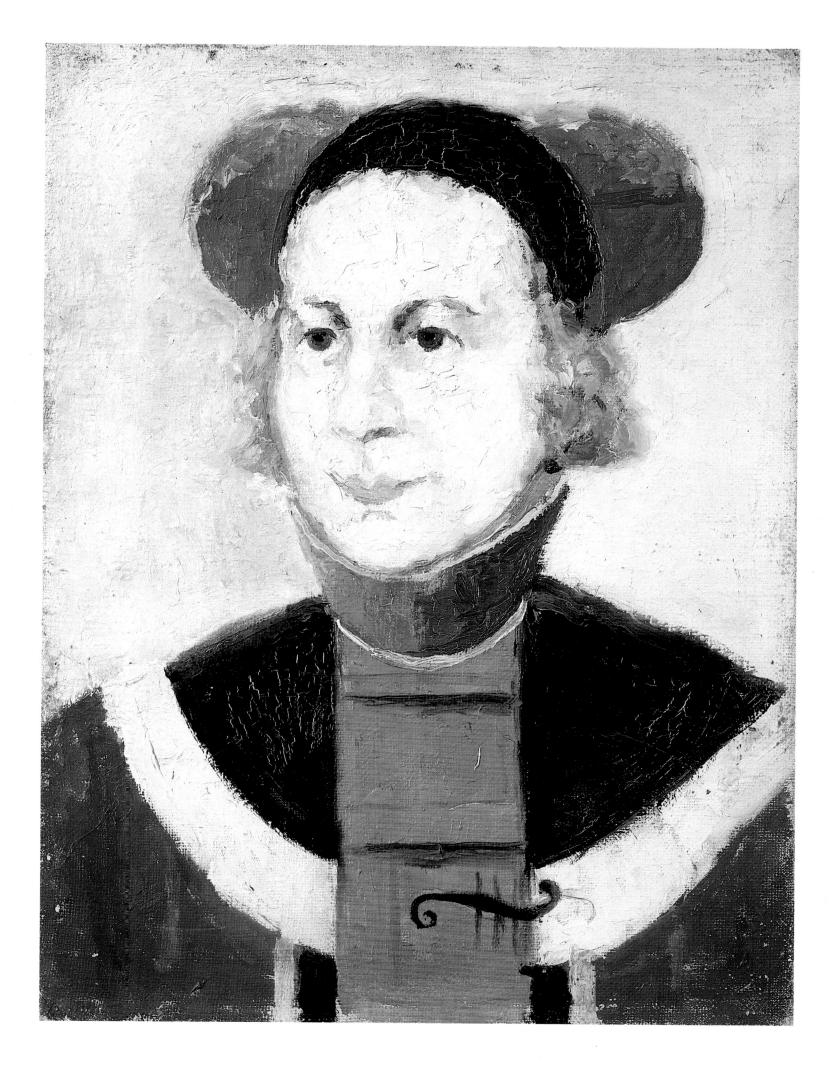

201 Portrait, 1932. *Oil on canvas. 34×25 cm*

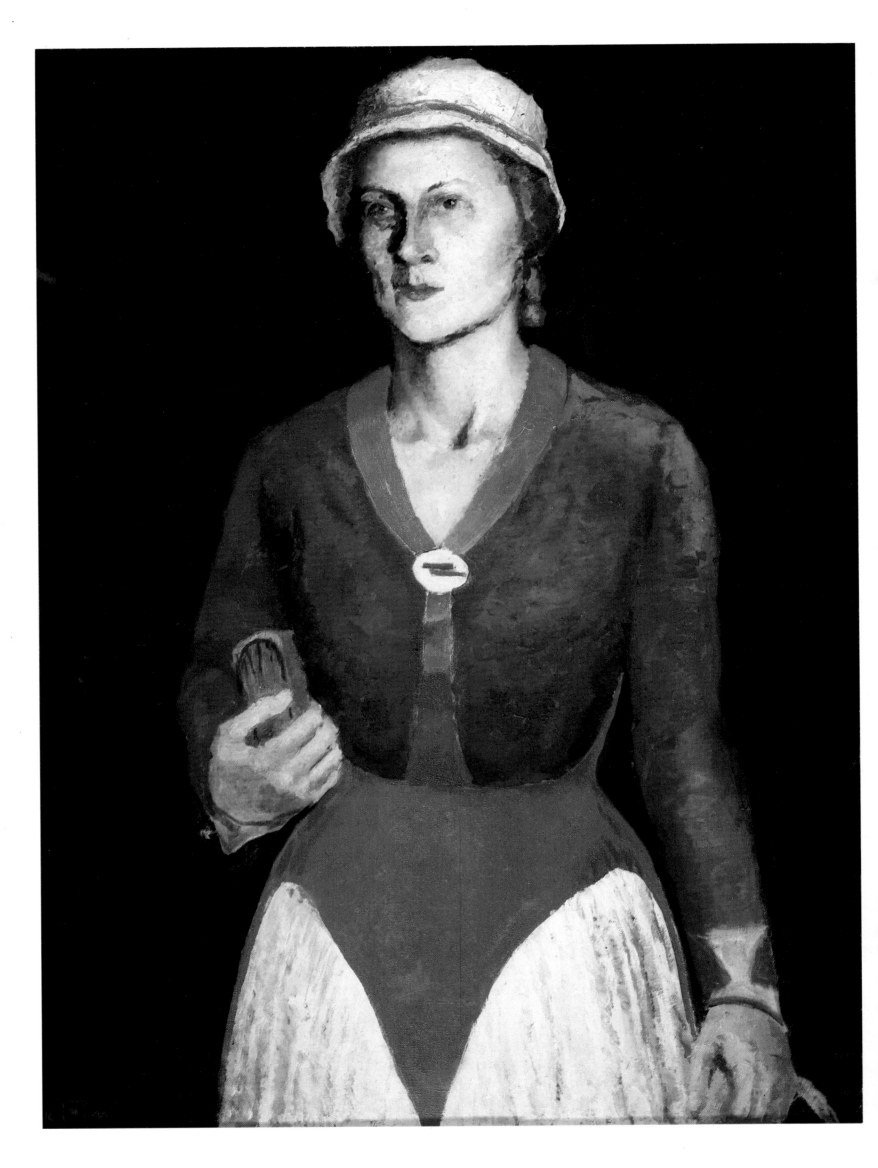

202 Portrait of the Artist's Wife, Natalia Malevich, 1934. *Oil on canvas. 99.5×74.3 cm*

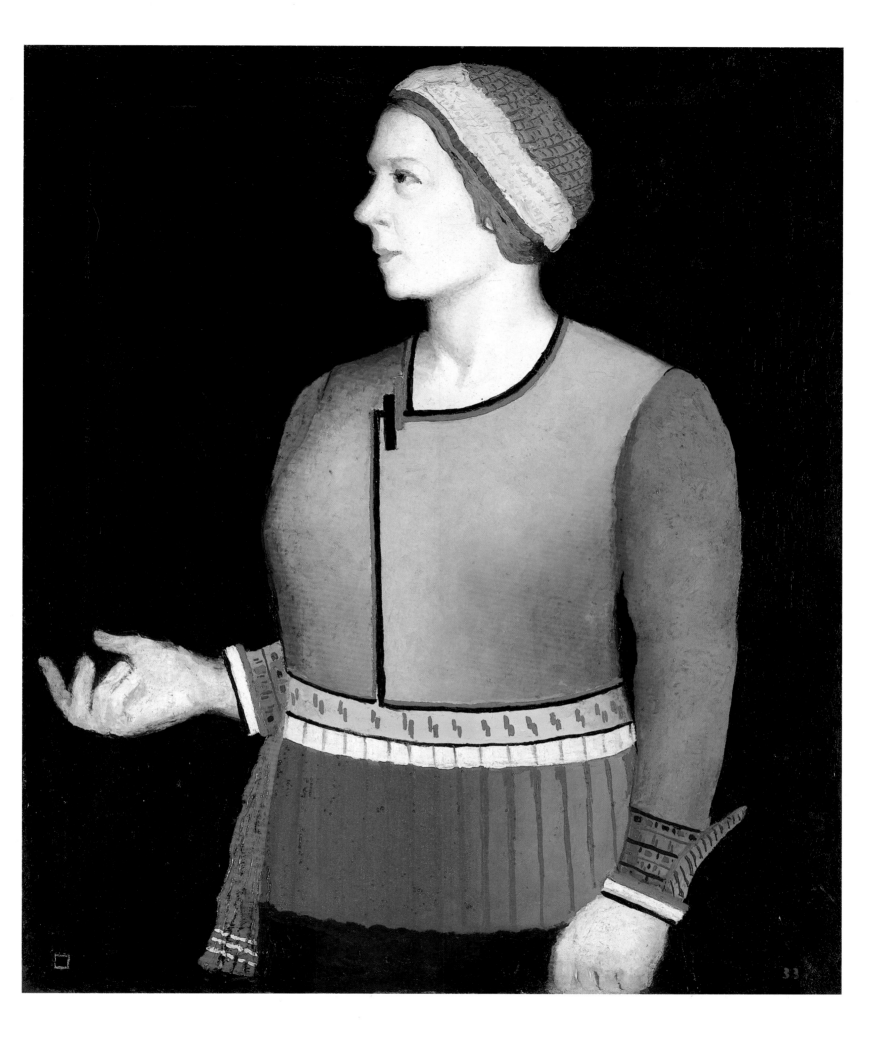

203 **Portrait of the Artist's Wife, Natalia Malevich, 1933.** *Oil on canvas. 67.5×56 cm*

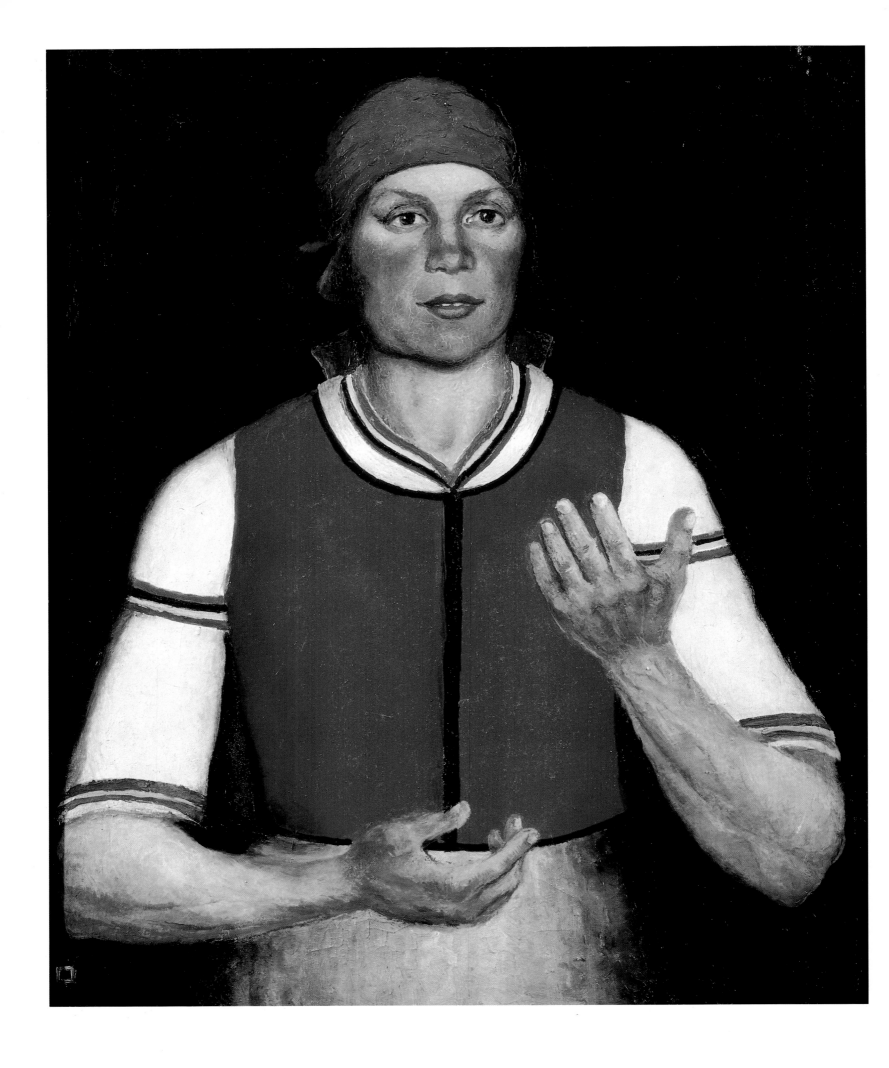

204 **Female Worker, 1933.** *Oil on canvas. 71.2×59.8 cm*

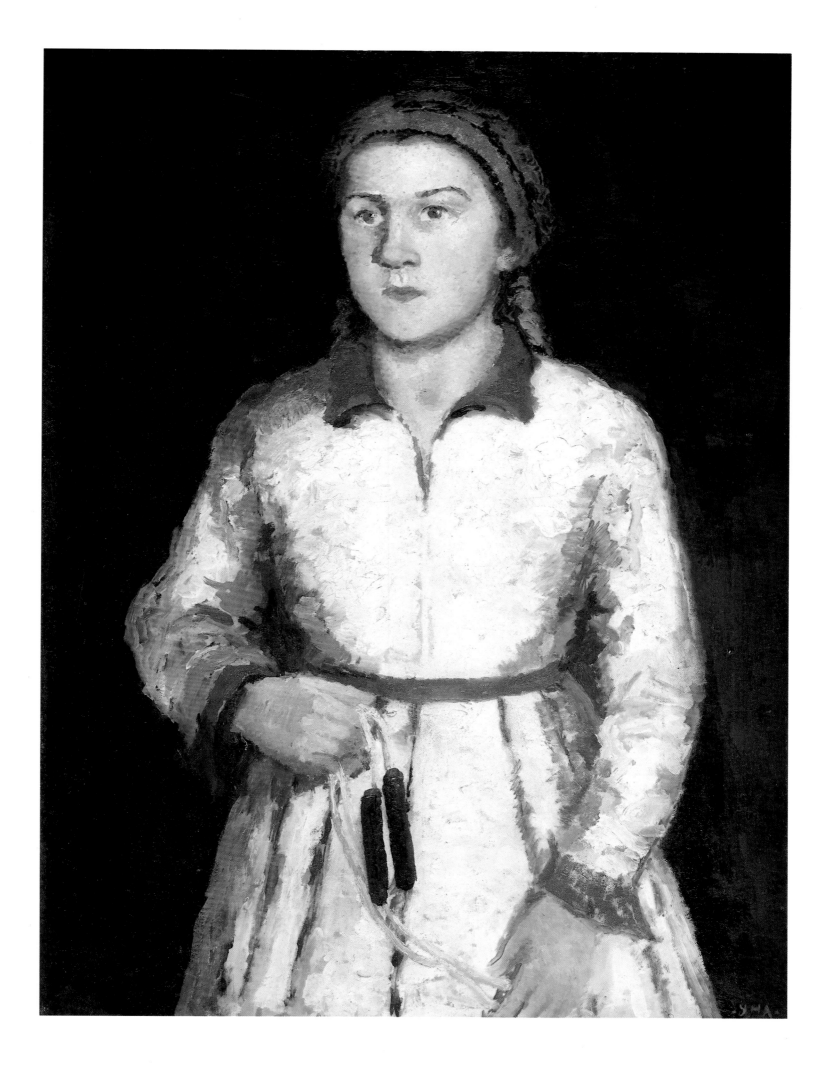

205 Portrait of the Artist's Daughter, Una, 1934. *Oil on canvas. 85×61.8 cm*

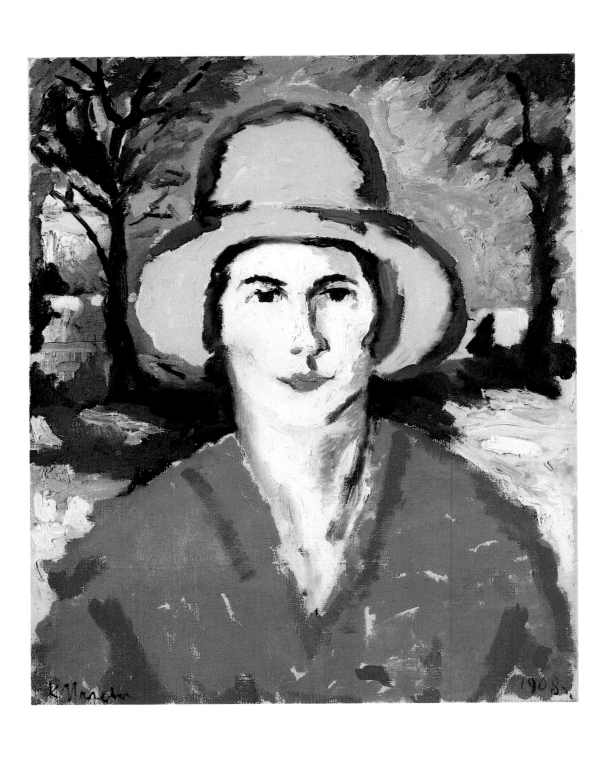

206 Portrait of a Woman in Yellow Hat, first half of the 1930s

Oil on canvas. 48×38.5 cm

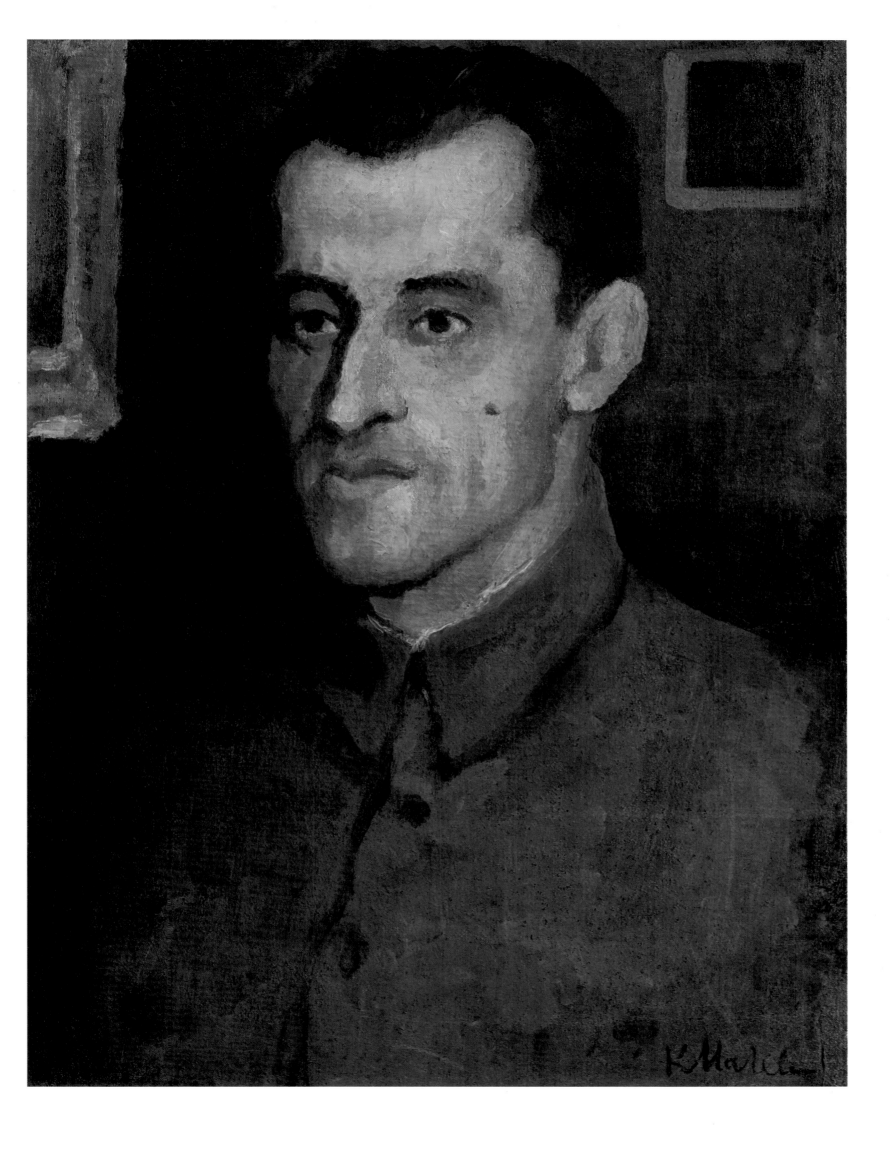

207 **Portrait of Vladimir Pavlov, 1933.** *Oil on canvas. 46.5×36.5 cm*

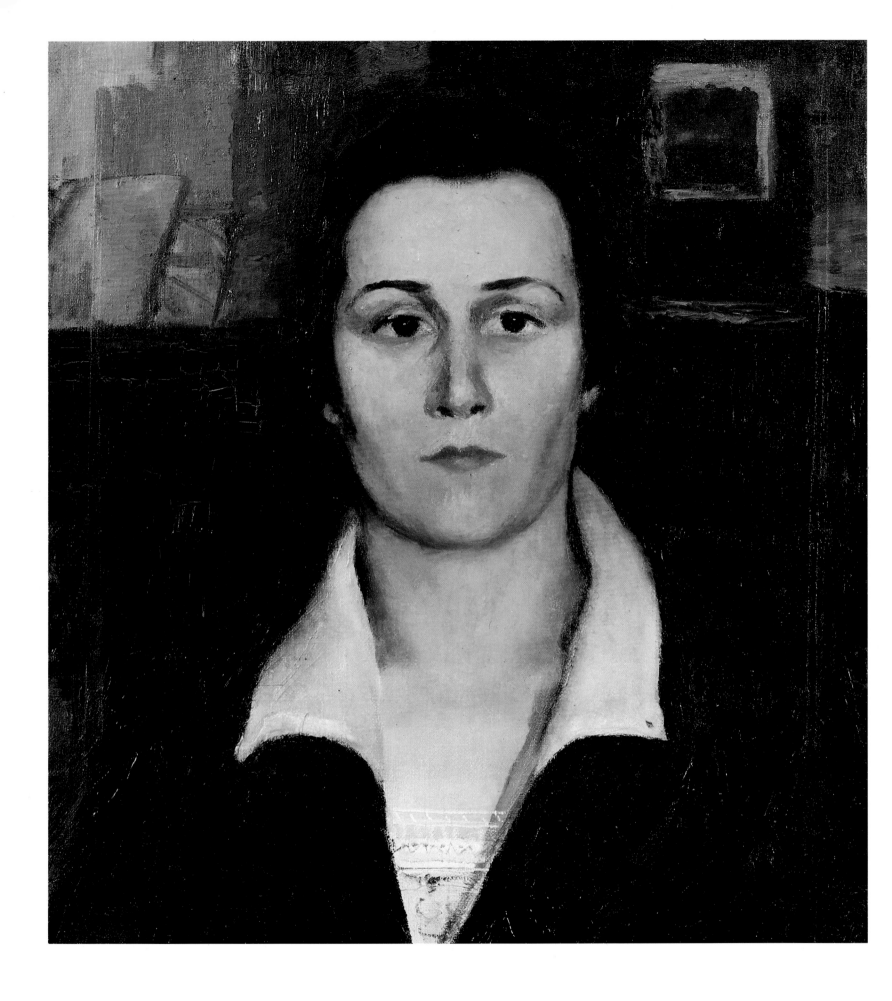

208 **Female Portrait, 1930.** *Oil on canvas. 47×41.5 cm*

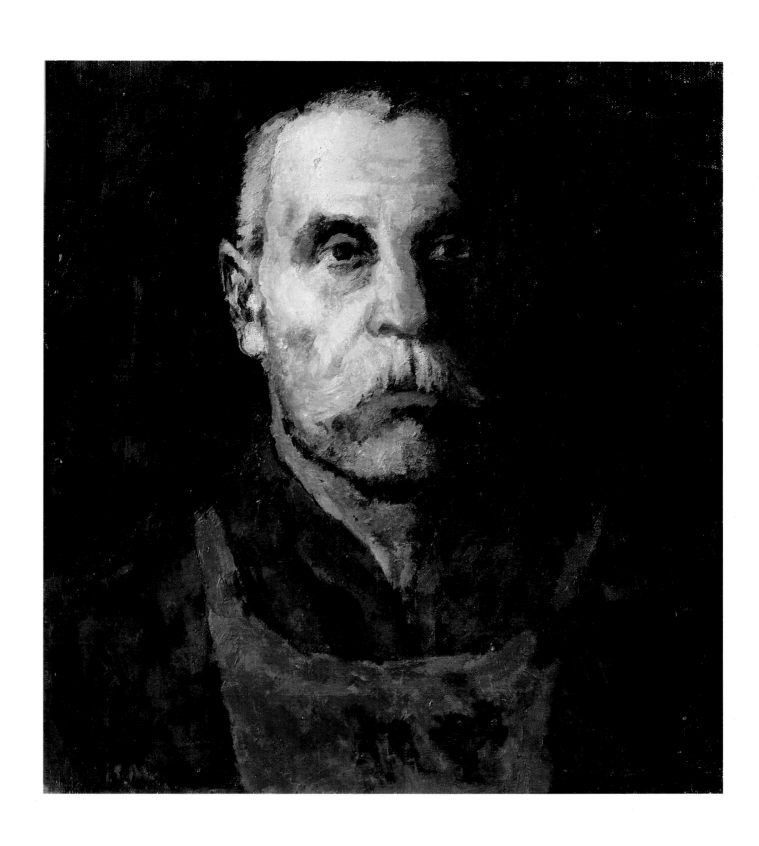

209 **Male Portrait (Portrait of a Shock-Worker), first half of the 1930s**
Oil on canvas. 54.5×49.5 cm

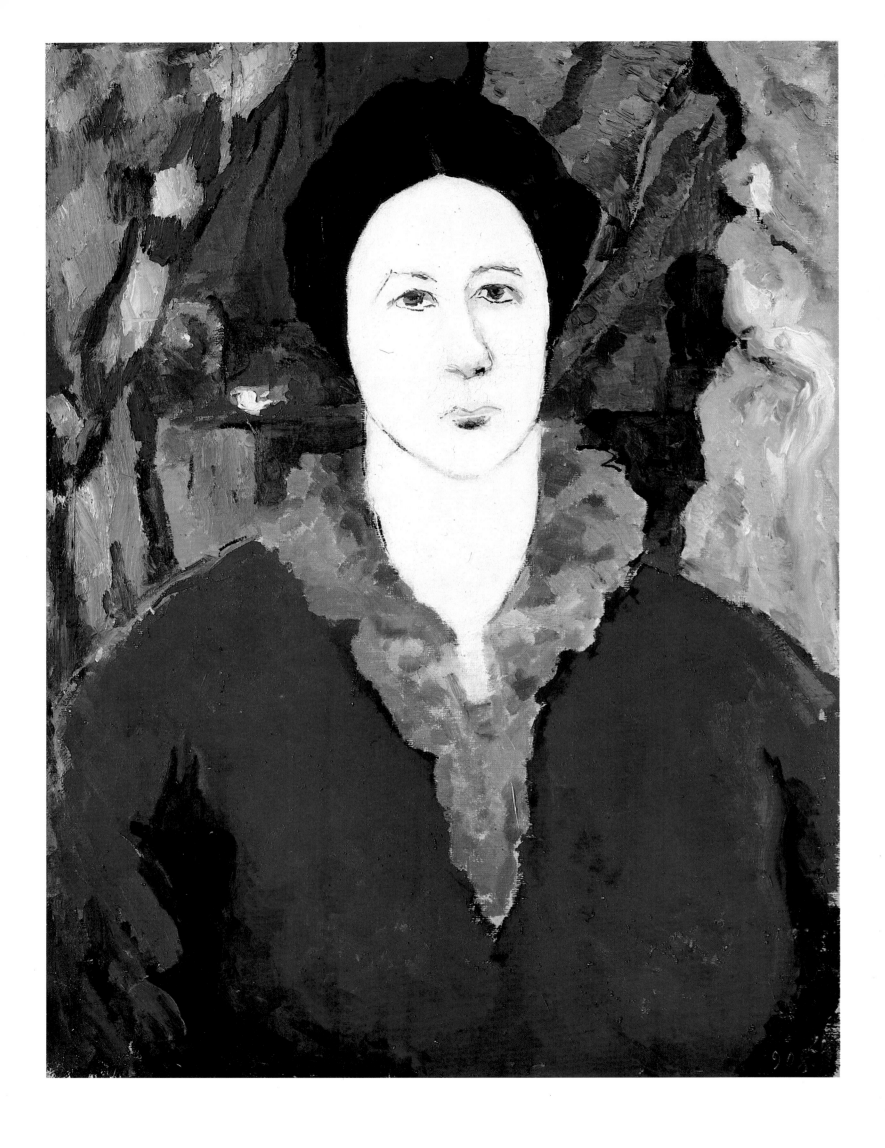

210 Portrait in Blue, first half of the 1930s. *Oil on canvas. 46.5×34.5 cm*

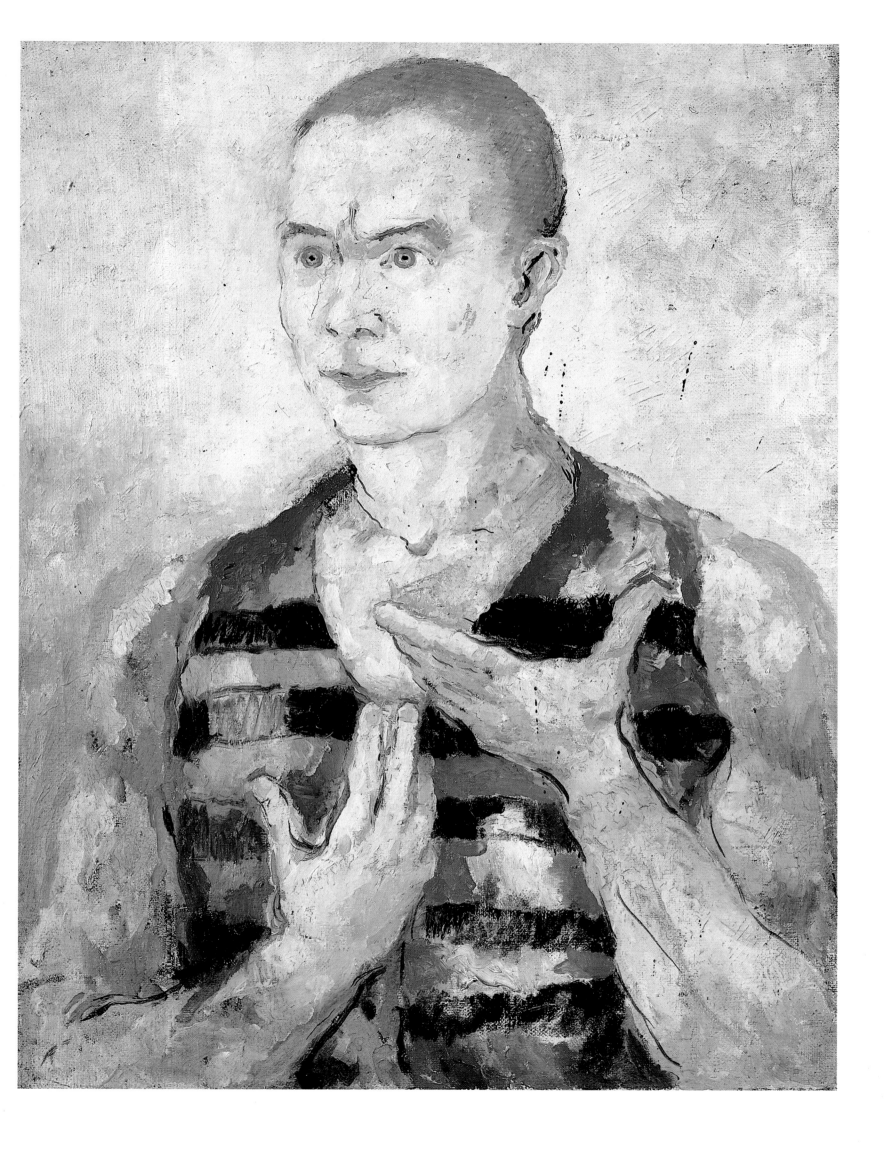

211 Portrait of a Young Man, 1933. *Oil on canvas. 52×39.5 cm*

Text References

C.Douglas:
Biographical Outline
pp. 8—27

1
Russian artists became acquainted with Picasso's Proto-Cubism primarily through the Moscow collection of Sergei Shchukin. Four of Braque's early Cubist works were shown at the 'Golden Fleece' exhibition in Moscow in January–February, 1909.

2
The Tretiakov Gallery (Moscow), MS Section, f. 25, no. 9, ll. 11–12.

3
Pobeda nad Solntsem: opera v 2 deimakh, 6 kartinakh,
St. Petersburg, 1914, p. 15.

4
These works, dated 1913, are now in the State Literary Museum, Moscow. Malevich went to considerable lengths to convince Matyushin that they contained no essential differences from his original drawings. The original 1913 designs have been widely reproduced, beginning with Camilla Gray: *The Great Experiment: Russian Art 1863–1922*, New York, 1962, p. 163.

5
Letters of September 24 and 28, 1915, in E.F.Kovtun:
K.S.Malevich: Pisma k M.V.Matyushinu, in *Ezhegodnik Rukopisnogo otdela Pushkinskogo doma na 1974 god*, Leningrad, 1976, p. 187.

6
Discussions of these issues may be found in Linda Dalrymple Henderson: *The Fourth Dimension and Non-Euclidean Geometry in Modern Art*, Princeton, 1983, p. 274, and Charlotte Douglas: 'Views from the New World. A.Kruchenykh and K.Malevich: Theory and Painting,' in *Russian Literature Triquarterly*, no. 12, Spring, 1975, and 'Tatlin and Malevich: History and Theory: 1914–1915' (forthcoming in Tatlin collection, Dumont).

7
Letter from June 23, 1916 in *Ezhegodnik...Pushkinskogo doma na 1974 god*, op. cit., pp. 194–195.

8
Under the Provisional Government, Councils or Soviets of Workers' and Soldiers' Representatives were organized to oversee the interests of their constituencies, and between February and October they became a kind of parallel source of political power. Both the Soviet of Soldiers Deputies and the Soviet of Workers Deputies had cultural commissions, divided into literary, theatrical and art sections.

9
The name of the Free State Art Studios [Svomas] was changed in the early 1920s to Higher Art-Technical Studios [Vkhutemas]. A required course in basics was to be taken by all students, who would then choose between fine and applied art for further study. A variety of specialties was envisioned in the fine arts: painting, sculpture, architecture, music and drama, and in the applied arts: photography, lithography, engraving, wood and stone working, ornamentation, pottery, orchestra, choir singing, instrument-making, dressmaking, embroidery, and weaving.

10
Boris Glubokovsky: 'Dom iskusstv,' *Svobodnoye slovo*, October 9, 1917, p. 4.

11
K.S.Malevich: 'On New Systems in Art,' in K.Malevich:
Essays on Art I, 1915–1928, Troels Andersen, ed., London, 1969, p. 88.

12
For details of Malevich's activities in Vitebsk see A.Shatskikh: 'K.Malevich v Vitebske,' *Iskusstvo* (Moscow), no. 11, 1988, pp. 38–43.

13
UNOVIS is an acronym for 'Affirmers of the New Art'.

14
Published in December, 1919.

15
The book went unpublished during his lifetime.

16
Troels Andersen was the first to suggest that the model for Malevich's book, *The World as Objectlessness*, was Schopenhauer's *The World as Will and Representation*. See his preface to K.Malevich: *The World as Non-Objectivity (Unpublished Writings 1922–1925)*, Troels Andersen, ed., Copenhagen, 1976.

17
K.Malevich: *The World as Non-Objectivity*, op cit.,
p. 348.

18
Ibid., pp. 19–20.

19
See also 'The Suprematist Mirror,' in K.Malevich: *Essays on Art I, 1915–1928*, pp. 224–225. Here under the heading 'The World as Human Distinctions,' Malevich lists God, the soul, technology, labour, art, space, time and other categories, and shows them all as equivalent to '0'.

20
K.Malevich: *The World as Non-Objectivity*, op cit., p. 323.

21
Ibid., p. 333.

22
Iskusstvo, September 3, 1919; quoted from L.Zhadova: *Malevich*, New York, 1982, p. 326. In the late twenties Malevich and the Formalists both worked for a short time under the aegis of the Institute of the History of the Arts.

23
A description of this process is given by Valentin Kurdov, who was a student of Malevich's in 1923, in 'Pamiatnye dni i gody,' *Zvezda* (Leningrad), no. 7, 1983, p. 69.

24
Vystavka kartin Petrogradskikh khudozhnikov vsekh napravlenii, Exhibition catalogue, Petrograd, 1923.

25
Sergei Isakov in *Zhizn iskusstva* (Petrograd), no. 14, 1923; Troels Andersen: 'Malévitch: polémiques et inspirations dans les années 20,' in *Malévitch*, Lausanne, 1979, p. 86. Isakov was an early supporter of Vladimir Tatlin, Malevich's opponent at GINKhUK. Malevich, in a mocking response, noted that Isakov's revolutionary fervour was quite recently acquired.

26
On February 15, 1926, Malevich was indeed replaced by Isakov, and Nikolai Punin was appointed Deputy Director. By that time, however, Tatlin had withdrawn from GINKhUK. Until its closing at the end of the year, Malevich remained on GINKhUK's board and continued to head the Formal and Theoretical Department.

Text References

27

See Troels Andersen: 'Malévitch: polémiques et inspirations dans les années 20,' op cit., pp. 8€—88.

28

The Main Science Administration [Glavnauka] was run by The Commissariat for Education, which at that time had no arts section of its own. The head of Glavnauka's Arts Department was P.I.Novitsky. The Leningrad branch was headed by Mikhail Kristi, who had been a member of Narkompros since the early days of the Revolution. He was one of the organizers of the Russian entry to the Venice Biennial of 1924, and was called upon repeatedly to mediate between Malevich and Tatlin in the administration of GINKhUK. Kristi continued to be active in the arts throughout the Stalin era.

29

The theory was, in fact, congenial with Marxism insofar as it maintained that social reality influenced the artists' consciousness. At this time the Formalists, like Boris Eichenbaum in 'The Theory of the "Formal Method",' were adopting a defensive stance similar to Malevich's. They characterized their activities as purely an objective analysis of concrete data, and thus outside the class concerns of Marxism.

30

'Protokol mezhotdelskogo sobraniia Gosudarstvennogo instituta khudozhestvennoi kultury po kritike i obsuzhdeniiu rabot vsekh otdelov ot 16 iyunia 1926 g. (Stenograficheskaya zapis),' *Dekorativnoye iskusstvo SSSR* (Moscow), no. 11, 1988, p. 38.

31

Ibid., p. 40.

32

Vera M.Ermolaeva, letter of July 17, 1926 to Mikhail F.Larionov. Archive of A.K.Tomilina-Larionova, Paris. Quoted from Evgeny Kovtun: 'Malevich: O teorii pribavochnogo elementa v zhivopisi,' in *Dekorativnoye iskusstvo SSSR*, no. 11, 1988, p. 36.

33

Suprematism. 34 Drawings (December 15, 1920), in K.Malevich: *Essays on Art I, 1915–1928*, op. cit., p. 127.

34

Malevich's exhibition opened on March 8, 1927 at the Polish Art Club in the Polonia Hotel in Warsaw. He showed 73 paintings and 25 charts and drawings. See Andrei Szewczyk: 'Malevich and the Polish Avant-Garde,' in *Kasimir Malewitsch. Zum 100. Geburtstag*, Galerie Gmurzynska: Cologne, 1978, p. 267.

35

The new Central Arts Administration was endorsed at the 6th All-Union Congress of Workers in the Arts held in Moscow from May 16–23, 1927. See *Kulturnaya zhizn v SSSR, khronika 1917–1927*, Moscow, 1975, p. 698.

36

A major role in the process of destroying the non-Bolshevik intelligentsia was played by a highly-publicized trial of mining engineers for sabotage, held in Moscow in May and June of 1928.

37

The document is reproduced in the exhibition catalogue on p. 52. Malevich's wishes were carried out in 1976 when the Danish art historian Troels Andersen published *The World as Non-Objectivity* in English, the only complete and scholarly edition of this work. Short excerpts were published as *Die gegenstandslose Welt* in the Bauhaus-book series in 1927. With the addition of a photo-reproduced Russian text for 'Introduction to the Theory of the Suprematist Element', this text was republished in 1980. *The Non-Objective World*, an English edition of the Bauhaus book, appeared in 1959.

38

Dated by their respective institutions as 1911 and 1909.

39

Reproduced in the weekly magazine *Ogonek*, no. 1, 1913, n. p.

40

Malevich dated *At the Harvest* '1909–10', and *Haymaking* 'motif 1909'.

41

With the possible exception of the programmatic black squares, circles, and crosses, there is no compelling evidence that Malevich repainted abstract works after 1927. A few Suprematist works, such as the black and red crosses, may have been painted in the 1920s before his trip abroad.

42

P.N.Filonov: *Diary*, November 4, 1932, The Russian Museum, MS Section, f. 156, op. 30, l. 51. Quoted from Evgenii Kovtun: 'Malevich: O teorii pribavochnogo elementa v zhivopisi,' op. cit., p. 36.

43

July 19, 1930. See *El Lissitzky*, S. Lissitzky-Küppers, ed., Dresden, 1967, p. 95.

44

Exhibition opened June 27, 1933. A.I.Morozov: *K istorii vystavki 'Khudozhniki RSFSR za 15 let' (Leningrad–Moskva, 1932–1935)*, in *Sovetskoye iskusstvoznanie '82*, 1, Moscow, 1983, p. 130.

45

Ibid., p. 132.

46

Ibid., p. 162.

47

For a more detailed discussion of these works see Charlotte Douglas, 'Beyond Suprematism—Malevich 1927–1933,' in *Soviet Union*, no. 7, pts. 1/2, 1980, pp. 214–226.

48

This work appears to have been painted in 1933 (54×45 cm). It was shown in the Russian Museum at 'The First Exhibition by Leningrad Artists'.

49

A description of Malevich's funeral is given in Konstantin Simonov: '...Vvidu zaslug pered sovetskim izobrazitelnym iskusstvom...,' *Nauka i zhizn* (Moscow), no. 12, 1975, pp. 126–127.

**I.Vakar: Malevich's
Student Years in Moscow:
Facts and Fiction**
pp. 28—30

1

L.Zhadova: *Malevich: Suprematism and Revolution in Russian Art 1910–1930*, London, 1978

2

Malevich, Troels Andersen, comp., Exhibition catalogue, Stedelijk Museum: Amsterdam, 1970.

3

Kasimir Malewitsch: Werke aus sowjetischen Sammlungen, J.Harten and K.Schrenk, eds., Exhibition catalogue, Städtische Kunsthalle: Düsseldorf, 1980, S. 111.

4

Malévitch: Œuvres, J.-H. Martin, Collections du Musée National d'Art Moderne: Paris, 1980.

5

This agrees with Evgeny Kovtun's information. See *Kasimir Malewitsch: Werke aus sowjetischen Sammlungen*, op. cit.

6

A.Fedorov-Davydov: *Vystavka proizvedenii K.S.Malevicha*, Moscow: State Tretiakov Gallery, 1929.

7

Central State Archives of Literature and Art [TsGALI], f. 680, op. 1, ed. khr. 1018(5).

8

N.Khardzhiev, K.Malevich, M.Matyushin: *K istorii russkogo avangarda*, Stockholm: Hylaea, 1976.

9
F.Rerberg: *Sbornik vospominanii*, introduction by I.G.Miamlin, Leningrad, 1986, p. 17.
10
See *Malewitsch* in *Maler 81: Das Grosse Sammelwerk: Leben, Werk und ihre Zeit*.
11
See G.G.Pospelow: *Karo-Bube: Aus der Geschichte der Moskauer Malerei zu Beginn des 20. Jahrhunderts*, Dresden, 1985, chapter 2.
12
TsGALI, f. 680, op. 1, ed. khr. 821.
13
Ibid., ed. khr. 833.
14
Ibid., ed. khr. 837.
15
Evgeny Kovtun suggests that the Moscow School of Painting, Sculpture and Architecture may have learned that Malevich was considered politically unreliable. To my request for information on this point, the Central State Archives of the October Revolution [TsGAOR] replied: '...No evidence was found with regard to K.S.Malevich, including evidence that he participated in the Revolution of 1905 or was under police surveillance' (Letter no. 514т, dated May 19, 1988). It should be said that this in no way refutes Malevich's assertion that he participated in the December uprising, or his account of how he managed to escape the police (see N.Khardzhiev, K.Malevich, M.Matyushin: *K istorii russkogo avangarda*). In fact, it serves to support his story. Interesting evidence pointing to the political sympathies of the Malevich family is contained in the State Archives of the Kursk Region (GAKO, f. 1642). The correspondence of the Gubernia Gendarme Authority contains a reference to the Malevich brothers—Anton, under surveillance, Meczislaw and his wife Maria (née Zglejc), the sister of Kazimir Malevich's wife, Kazimira Ivanovna.

16
If, of course, the works in the Tretiakov Gallery and Russian Museum are correctly dated to 1904.
17
It is interesting to note that the poet Alexei Kruchenykh applied to the Moscow School of Painting, Sculpture and Architecture in 1907.
18
TsGALI, f. 2443, op. 1, ed. khr. 209.
19
Ibid.
20
There are many accounts, most of them given without references.
21
River in the Forest, State Russian Museum, Leningrad.
22
The 27th Regular Exhibition of the Moscow Association of Art Lovers [MOLKh], 1907/1908.
23
Those issues of the local newspapers from the late 1890s to the mid-1900s which GAKO has in its collection do not mention a single artistic event in the city.
24
Charlotte Douglas: 'Malevich's Painting—Some Problems of Chronology,' *Soviet Union*, (Special Malevich issue), J.Bowlt and C.Douglas, eds., vol. 5, pt. 2, Tempe, 1978, pp. 301–326.
25
We know nothing about how Malevich and his family lived in Moscow (and after the death of his father he had to support his mother, wife and two children). He does not any work on the side in his reminiscences, and apparently threw himself completely into his art studies. In later letters to Mikhail Matyushin, jokes about his lack of money are a constant refrain.

C. Douglas: Malevich and Western European Art Theory
pp. 56–60

1
Sherry A.Buckberrough: *Robert Delaunay: The Discovery of Simultaneity*, Ann Arbor, 1985, p. 202.
2
Jean Metzinger: 'Note sur la peinture,' *Pan* 3, no. 10, October–November 1910, pp. 649–652; Albert Gleizes and Jean Metzinger: *Du Cubisme*, Paris, 1912; Umberto Boccioni: *La pittura futurista: Manifesto technico*, Milan, 1910; Idem: *Manifesto technico della scultura futurista*, Milan, 1912; Robert Delaunay: 'Über das Licht,' trans. by Paul Klee, *Der Sturm* 3, no. 144–145, January 1913, pp. 255–256; Idem: 'Note sur la construction de la réalité de la peinture pure,' *Der Sturm* 3, no. 138–139, December 1912, reprinted in Robert Delaunay: *Du Cubisme à l'art abstrait*, Pierre Francastel, ed., Paris, 1957, pp. 168–170.
3
At the turn of the century, science took note of many ideas now considered purely occult or mystical. This essay is concerned primarily with the comparison of Russian and Western theories of modern painting. For a discussion of the occult and mystical sources for Malevich and the Russian Avant-Garde, see Charlotte Douglas: *Beyond Reason: Malevich, Matyushin, and Their Circles*, in *The Spiritual in Art: Abstract Painting 1890–1985*, organized by M.Tauchmann, New York, 1986, pp. 184–199.
4
For a description of this archive see J.-C.Marcadé: 'La correspondance d'A.A.Smirnov avec S.I.Terk (Sonia Delaunay): 16 septembre 1904 – 8 avril 1905,' in *Cahiers du Monde Russe et Soviétique*, 1983, p. 290.
5
Robert Delaunay: *Du Cubisme à l'art abstrait*, pp. 122–126.

6
J.-C. Marcadé: Op. cit.,pp. 291–292.
7
One hundred and fifty copies of *La Prose du Transsibérien* had been published the previous February in the form of a six-and-a-half-foot length of paper that could be folded into the size of a book.
8
A.E.Parnis and R.D.Timenchik: Programmy 'Brodiachei sobaki', in *Pamiatniki kultury (1983)*, Leningrad, 1985, pp. 220–221.
9
"O knige Metsanzhe–Gleza 'Du Cubisme'," *Soyuz molodezhi*, no. 3, 1913, pp. 25–34; A.Gleizes and J.Metzinger: *O kubizme*, M.Matyushin, ed., trans. by E.Nizen, St. Petersburg, 1913; trans. by M.V. [Maximilian Voloshin], Moscow, 1913.
10
Svobodnaya Muzyka. Primeneniye novoi teorii khudozhestvennogo tvorchestva k muzyke, St. Petersburg, 1909; *Die freie Musik. Die Anwendung der neuen Theorie der Kunstichen Schaffung zur Musik*, St. Petersburg, 1910; *La musique libre. Application à la musique de la nouvelle théorie de la création artistique*, St. Petersburg, 1910; *Svobodnaya muzyka kak osnova zhizni*, in *Studiya impressionistov*, St. Petersburg, 1910, pp. 15–26; 'Die freie Musik,' *Der blaue Reiter* (Munich), 1912, pp. 69–73.
11
E.F.Kovtun: *Pisma V.V.Kandinskogo k N.I.Kulbinu*, in *Pamiatniki kultury (1980)*, Leningrad, 1981, pp. 300–410.
12
Sherry A.Buckberrough: Op. cit.,p. 106.

Text References

13
It is known that Kulbin gave a copy of the French edition of his book to the Italian Futurist poet F.T.Marinetti.
14
Albert Gleizes and Jean Metzinger: *Du Cubisme*, p. 30. English translation from *Modern Artists on Art*, Robert L.Herbert, ed., Englewood Cliffs, N.J.,1964, p. 13.
15
Boccioni: 'La Pittura Futurista' (Conferenza a Roma nel 1911), in Umberto Boccioni: *Altri inediti e apparati critici*, A cura de Zeno Birolli, Milan, 1972, p. 16. English translation from Ester Coen: *Boccioni*, Exhibition catalogue, New York, 1988, p. 233.
16
Henri Bergson: *Ecrits et paroles*, vol. 2, Paris, 1958, pp. 279, 309. Russian translations of Berkeley include: Dzhordzh Berkli, *Sob. iego soch.*, 4 vols.,1901; *Trakʿat o nachalakh chelovecheskogo znaniya...*, trans. by E.F.Debo sky, St. Petersburg, 1905; *Opyt novoi teorii zreniya*, trans. by L.O.Makovelsky, Kazan, 1913.
17
Wundt: *Grundzüge der physiologischen Psychologie* [Principles of Physiological Psychology], 1st ed.,1874; 5th ed., 1902; 6th ed.,1908–11.
18
'Chuvstvitelnost. Ocherki po psikhometrii i klinicheskomu primeneniyu eya dannykh,' separate issue of *Vrachebnaya gazeta* (St. Petersburg, 1907, p. 16). See also: *Molotochek dlia postukivaniya s opredelennoi siloi udarov (perkutometr)*, St. Petersburg, 1894, and 'Izmeritel chuvstvitelnosti ' *Vrach*, no. 47, 1894.
19
J.-C. Marcadé: Op. cit.,p.298.
20
Severo-zapadnyi golos (Vilna) no. 1246, January 8(21), 1910 and no. 1268, February 3(16), 1910. See also Kulbin's manuscript, *Psikhologiya khudozhnika*, State Russian Museum, MS Section, f. 134, no. 9.
21
Boccioni: 'La Pittura Futurista,' op. cit., pp. 13,14; *Boccioni*, Exhibition catalogue, op. cit., p. 232.
22
Sadok sudei, II, St. Petersburg 1913, p. 2; for an English translation see *A Trap for Judges*, II n *Russian Futurism Through Its*

Manifestoes 1912–1928, A.Lawton, ed., Ithaca–London, Cornell University Press, 1988, p. 54; *Troye* [The Three], St. Petersburg, 1913, p. 24; for an English translation see A.Kruchenykh in *New Ways of the Word (The Language of the Future, Death to Symbolism)*, ibid., p. 70.
23
Linda S.Boersma: *On Art, Art Analysis and Art Education: The Theoretical Charts of Kazimir Malevich*, trans. from the Dutch by Ruth Koenig, in *Kazimir Malevich*, Exhibition catalogue, Moscow–Leningrad–Amsterdam, 1988–89, pp. 219–223.
24
State Tretiakov Gallery, MS Section, f. 25, ed. khr. 9, ll. 7,8.
25
Boccioni: 'La Pittura Futurista,' op. cit., p. 14; 'Note per la Conferenza tenuta a Roma 1911,' in Umberto Boccioni: *Altri inediti e apparati critici*, op. cit., p. 34; *Boccioni*, Exhibition catalogue, op cit., p. 239.
26
Alexei Kruchenykh: *Novye puti slova*, in *Troye*, St. Petersburg, 1913, pp. 33, 34; for an English translation see A.Kruchenykh: *New Ways of the Word...*, op. cit., p. 76.
27
K.Malevich: *Ot kubizma i futurizma k suprematizmu*, Moscow, 3rd ed., 1916, p. 21; for an English translation see K.Malevich: *From Cubism and Futurism to Suprematism. The New Realism in Painting*, in K.Malevich: *Essays on Art I, 1915–1928*, op. cit., p. 33.
28
Boccioni: 'La Pittura Futurista,' op. cit., p. 11; *Boccioni*, Exhibition catalogue, op. cit., p. 231.
29
It is mentioned in a letter of March 5, 1914. See Larissa A.Zhadova: *Malevich*, New York, 1982, p. 122, no. 5.
30
K.Malevich: *Ot kubizma k futurizmu. Novyi zhivopisnyi realizm* (1915), Petrograd, 1916, p. 9. For an English translation see Charlotte Douglas: *Swans of Other Worlds: Kazimir Malevich and the Origins of Abstraction in Russia*, Ann Arbor, 1980, pp. 105–110.

**E.Kovtun: The Beginning
of Suprematism**
pp. 104—106

1
A.Gleizes and J.Metzinger: *O kubizme*, M.Matyushin, ed., trans. from the French by E.Nizen, op. cit., p. 14.
2
The paper was published in the first volume of the Congress' *Proceedings*, while the theses appeared in *Vestnik Vserossiiskogo syezda khudozhnikov* (St. Petersburg, 1911, no. 7).
3
V.V.Kandinsky: *Tekst khudozhnika*, Moscow, 1918, p. 49.
4
K.Malevich: *A Letter to Alexandre Benois* (May 1916), in K.Malevich: *Essays on Art I, 1915–1928*, op. cit., p. 44.
5
This letter was published, with blatant distortions that, in places, changed the meaning diametrically, in A.F.Diakonitsyn: *Ideinye protivorechiya v estetike russkoi zhivopisi kontsa 19 – nachala 20 veka*, Perm, 1966.
6
K.S.Malevich: *Letter to M.V.Matyushin* (May 1915), Institute of Russian Literature [IRLI], f. 656.
7
Letter to M.V.Matyushin (March 5, 1914).
8
Letter to M.V.Matyushin (November 12, 1916).

9
M.Matyushin: *O vystavke 'poslednikh futuristov'*, in *Ocharovannyi strannik. Almanakh vesennii*, Petrograd, 1916, p. 17.
10
In the catalogue for the 1915 exhibition it is entitled *Painterly Realism of a Peasant Woman in 2 Dimensions*.
11
K.S.Malevich: *Letter to M.V.Matyushin* (September 24, 1915), IRLI, MS Section, f. 656.
12
Letter to M.V.Matyushin (May 1915).
13
M.V.Matyushin: *Tvorcheskii put khudozhnika*, IRLI, MS Section, f. 656.
14
Ocharovannyi strannik. Almanakh vesennii, Petrograd, 1916, p. 18.
15
N.N.Punin: *Iskusstvo i revoliutsiya* (1930s), Punin family archives.
16
V.E.Pestel: *Vospominaniya i zapiski* (1952), Pestel family archives.
17
Letter to M.V.Matyushin (September 25, 1915).

18
Letter to M.V.Matyushin (September 28, 1915).
19
Letter to M.V.Matyushin (November 25, 1915).
20
Letter to M.V.Matyushin (October 31, 1915).
21
Apollon (St. Petersburg), no. 1, 1916, p. 37.
22
Letter to M.V.Matyushin (May 29, 1915).

23
Zhizn iskusstva (Petrograd), no. 20, 1923.
24
K.S.Malevich: *Ot kubizma k suprematizmu. Novyi zhivopisnyi realizm*, Petrograd, 1916.
25
I.A.Puni: *Letter to K.S.Malevich* (July 1915), IRLI, MS Section, f. 172, op. 971.

D. Sarabianov: Malevich at the Time of the 'Great Break'
pp. 142–147

1
This theory has been most conclusively argued by American art historian Charlotte Douglas, who presented a number of substantial arguments in favour of regarding paintings with open horizons as extensions of Malevich's Suprematist period. See: Charlotte Douglas: 'Malevich's Painting—Some Problems of Chronology,' op. cit., pp. 301–326; and Charlotte Douglas: 'Beyond Suprematism: Malevich. 1927–1933,' ibid, vol. 7, pts. 1/2, 1980, pp. 214–226.
2
Detstvo i yunost Kazimira Malevicha: Glavy iz avtobiografii khudozhnika in N.Khardzhiev, K.Malevich, M.Matyushin: *K istorii russkogo avangarda*, op. cit., p. 104.
3
Ibid., p. 107.

4
Ibid., pp. 117–118.
5
See Charlotte Douglas: 'Beyond Suprematism: Malevich. 1927–1933,' op. cit., pp. 214–227.
6
On the sketch for one such house, Malevich wrote: *Cobalt* (paint), which was incorrectly read as *Cabaret*. See *Malévitch*, Exhibition catalogue, Musée National d'Art Moderne: Paris, 1978, p. 73. This mistake has been repeated in other works: *Kasimir Malewitsch. Zum 100. Geburtstag*, op. cit., p. 111; *Malévitch: Actes du Colloque international*, Musée National d'Art Moderne: Paris, Lausanne, 1979, p. 164. It would be hard to think of a more inappropriate name for this drawing.

I.Karasik: Malevich as His Contemporaries Saw Him
pp. 192–198

1
Quoted from A.M.Rodchenko: *Statyi. Vospominaniya. Avtobiograficheskiye zapiski. Pisma*, Moscow, 1982, p. 114.
2
Quoted from L.F.Zhegin: 'Vospominaniya o V.N.Chekrygine,' in *Panorama iskusstv 10*, Moscow, 1987, p. 210.
3
Quoted from E.F.Kovtun: *K.S.Malevich: Pisma k M.V.Matiushinu*, op. cit., p. 182.
4
G.G.Pospelov: *Novye techeniya v stankovoi zhivopisi i risunke* in *Russkaya khudozhestvennaya kultura kontsa XIX—nachala XX veka (1908—1917)*, Moscow, 1980, vol. 4, p. 164.
5
K.Malevich: *The Suprematist Mirror*, in K.Malevich: *Essays on Art I, 1915–1928*, op. cit., pp. 224–225
6
K.Malevich: *A Letter to Alexandre Benois*, op. cit., p. 45.
7
K.S.Malevich: *Ot kubizma i futurizma k suprematizmu. Novyi zhivopisnyi realizm*, Moscow, 1916, p. 31; for an English translation see K.Malevich: *From Cubism and Futurism to Suprematism. The New Realism in Painting*, op. cit., p. 4.
8
Quoted in *Sovetskoye iskusstvo za 15 let. Dokumenty i materialy*, I.A.Mátsa, ed., Moscow–Leningrad, 1933, p. 116; for an English translation see K.Malevich: *Non-Objective Creation and Suprematism*, in K.Malevich: *Essays on Art I, 1915–1928*, op. cit., p. 122.
9
See, e. g.: K.Malevich: *On New Systems in Art*, op. cit.
10
Zhizn iskusstva (Petrograd), no. 20, 1923, p. 16; for an English translation see K.Malevich: *The Suprematist Mirror*, op. cit., p. 224.

11
N.N.Punin: 'Gosudarstvennaya vystavka', *Zhizn iskusstva*, no. 21, 1923, p. 5.
12
A.M.Efros: 'K.Malevich (retrospektivnaya vystavka),' *Khudozhestvennaya zhizn* (Moscow), no. 2, 1920, p. 40.
13
Ibid., p. 38.
14
N.N.Punin: Op. cit.,pp. 5–6.
15
A.M.Efros: Op. cit.,p. 40.
16
G.G.Pospelov's phrase. See note 4.
17
N.N.Punin: 'Obzor novykh techenii v iskusstve Peterburga,' *Russkoe iskusstvo* (Moscow–Petrograd), no. 1, 1923, p. 22.
18
Boris Pasternak: *Okhrannaya gramota*, in Boris Pasternak: *Izbrannoye*, vol. 2, Moscow, 1985, p. 213.
19
L.Ya. Ginzburg: *Literatura v poiskakh realnosti*, Leningrad, 1987, p. 242.
20
According to M.A.Gorokhova, Lev Yudin's wife.
21
L.Yudin: *Diary*, entry for February 12, 1922. Yudin's diaries were recently acquired by the MS Section of the State Russian Museum and have not yet been catalogued.
22
A.M.Rodchenko: Op. cit., p. 84.
23
N.N.Punin: *iskusstvo i revoliutsiya*, Punin family archives.

24
L.Yudin: *Diary*, entry for July ¯ 1, 1921.
25
Ibid., entry for February 25, 1922.
26
Ibid., entry for January 2, 1922.
27
Ibid., entry for November 25, 1934.
28
Letter to Yudin's wife, M.A.Gcrokhova, dated
November 3–4, 1941.
29
See: L.Yudin: *Diary*, entry for April 25, 1929.
30
Ibid.
31
Ibid., entry for August 11, 1921.
32
Ibid., entry for November 17, 1921.
33
Ibid., entry for August 11, 1921.
34
Ibid., entry for July 26, 1926.
35
Ibid., entry for September 28, 1928.
36
Ibid., entry for June 13, 1928.
37
Ibid., entry for September 28, 1928.
38
Ibid., entry for February 1, 1928.
39
Ibid., entry for February 20, 1928.
40
Ibid., entry for March 20, 1929.
41
Ibid., entry for March 8, 1929.
42
Ibid., entry for March 20, 1929.
43
Ibid., entry for May 26, 1935.
44
Ibid., entry for April 25, 1929.
45
Ibid., entry for November 25, 1934.

46
A.N.Benois: 'Posledniaya vystavka futuristov,' *Rech* (Petrograd),
January 9, 1916.
47
G. Seryi: 'Monastyr na gossnabzhenii,' *Leningradskaya pravda*,
June 10, 1926.
48
See Yu.A.Molok, V.I.Kostin: *Ob odnoi idee 'Budushchego sinteza
zhivykh iskusstv'. Po materialam pisem V.N.Chekrygina k
N.N.Puninu nachala 20kh godov*, in *Sovetskoye iskusstvoznanie '76*,
Moscow, 1977, 2nd issue, pp. 307, 312.
49
Ibid., p. 307.
50
N.E.Radlov: 'K istokam iskusstva,' *Zhizn iskusstva* (Petrograd),
no. 1, 1923, p. 16.
51
N.N.Punin: 'V Moskve,' *Iskusstvo Kommuny* (Petrograd),
February 9, 1919.
52
See N.N.Punin: *Risunki neskolkikh 'molodykh'*, in N.N.Punin:
Russkoye i sovetskoye iskusstvo, Moscow, 1976,
p. 156.
53
Idem: 'Gosudarstvennaya vystavka,' op. cit., p. 6.
54
A.M.Efros: Op. cit.,p. 40.
55
N.N.Punin: 'Obzor novykh techenii v iskusstve Peterburga,'
op. cit., p. 22.

Bibliography

General Texts by Malevich Published in English

K.Malevich: *Essays on Art I, 1915–1928*, edited by Troels Andersen, translated by Xenia Glovacki-Prus and Arnold McMillin, Copenhagen, 1968

K.Malevich: *Essays on Art II, 1928–1933*, edited by Troels Andersen, translated by Xenia Glovacki-Prus and Arnold McMillin, Copenhagen, 1968

K.Malevich: *Essays on Art III, The World as Non-Objectivity, Unpublished Writings, 1922–1925*, edited by Troels Andersen, translated by Xenia Glovacki-Prus and Arnold McMillin, Copenhagen, 1976

K.Malevich: *Essays on Art IV, The Artist, Infinity, Suprematism, Unpublished Writings, 1913–1933*, edited by Troels Andersen, translated by Xenia Glovacki-Prus and Arnold McMillin, Copenhagen, 1978

K.Malevich: 'Chapters from an Artist's Autobiography,' translated by A.Upchurch, *October*, no. 3, Fall 1985, pp. 25–44

Publications with Important References to Malevich

Eduard Penkula: 'Malewitschs Œuvre geboren,' *Das Kunstwerk* (Baden-Baden), vol. 11, no. 10, April 1958, pp. 3–16

Kasimir Malewitsch, Exhibition catalogue, Braunschweig, 1958

Casimir Malevic, Exhibition catalogue, Galleria Nazionale d'Arte Moderna: Rome, 1959

Kasimir Malevich, 1878–1935, Exhibition catalogue, introduced by Camilla Gray, Whitechapel Art Gallery: London, 1959

Camilla Gray: The Great Experiment: Russian Art 1863–1922, London, 1962; reissued as *The Russian Experiment in Art 1863–1922*, London, 1986

Troels Andersen: 'Malevich on "New Art",' *Studio International* (London), vol. 174, no. 892, September 1967, pp. 100–105

Evgeny Kovtun: 'Malevičova mýslenka plastické beztiže,' *Výtvarné prace* (Prague), no. 2, 1967, p. 10

Miroslav Lamač: 'Malevič a jeho okruh,' *Výtvarné umění* (Prague), no. 8/9, 1967, pp. 365ff

Malevich: Catalogue *raisonné of the Berlin Exhibition 1927 Including the Collection of the Stedelijk Museum, Amsterdam with a General Introduction*, Troels Andersen, comp., Stedelijk Museum: Amsterdam, 1970

Malevich: Dessins, Exhibition catalogue, Galerie Jean Chauvelin: Paris, 1970

Kasimir Malevic, Exhibition catalogue, Galleria Breton: Milan, 1971

Simon Pugh: 'An Unpublished Manuscript by Malevich,' *Studio International* (London), vol. 183, no. 942, March 1972, pp. 100–102

John E.Bowlt: 'Malevich's Journey into the Non-Objective World,' *Art News* (New York), vol. 72, no. 10, December 1973, pp. 16–22

N.Khardzhiev, K.Malevich, M.Matyushin: *K istorii russkogo avangarda*, Stockholm, 1976

John E.Bowlt (ed.): *Russian Art of the Avant-Garde: Theory and Criticism 1902–1934*, New York, 1976

Charlotte Douglas: 'Malevich's Painting–Some Problems of Chronology,' *Soviet Union* (Special Malevich issue), J.Bowlt and C.Douglas, eds., 1978, vol. 5, pt. 2, pp. 301–326

L.A.Zhadova: *Malevich: Suprematism and Revolution in Russian Art 1918–1930*, London, 1978

W.S.Simmons: 'Malevich's "Black Square": The Transformed Self,' *Arts* (New York), vol. 53, October 1978, pp. 116–125; November, pp. 130–141; December, pp. 126–134

L.A.Shadowa: *Suche und Experiment. Aus der Geschichte der russischen und sowjetischen Kunst zwischen 1910 und 1930*, Dresden, 1978

Kasimir Malewitsch. Zum 100. Geburtstag, Exhibition catalogue, Galerie Gmurzynska: Cologne, 1978

Kasimir Malewitsch: Werke aus Sowjetischen Sammlungen, Exhibition catalogue, J.Harten and K.Schrenk, comps., Städtische Kunsthalle: Düsseldorf, 1980

Charlotte Douglas: 'Beyond Suprematism: Malevich 1927–1933,' *Soviet Union* (Tempe), vol. 7, pts. 1/2, 1980, pp. 214–226

Malévitch: Œuvres, J.-H.Martin, Collections du Musée National d'Art Moderne, Paris, 1980

Jean-Claude Marcadé: *K.S.Malevich: From Black Quadrilateral (1913) to White on White (1917), from the Eclipse of Objects to the Liberation of Space* in The Avant-Garde in Russia 1910–1930: New Perspectives, Exhibition catalogue, Los Angeles County Museum of Art and the Hirschhorn Museum and Sculpture Garden: Washington, D.C., 1980–81, p. 29

L.Zhadova: *Malevich*, New York, 1982

L.Zhadova: *Malevich: Suprematism and Revolution in Russian Art, 1910–1930*, London, 1982

Charlotte Douglas: *Beyond Reason: Malevich, Matyushin, and Their Circles* in Charlotte Douglas: The Spiritual in Art: Abstract Painting 1890–1985, organized by M.Tauchmann, New York, 1986, pp. 184–199

A.Shatskikh: 'K.Malevich v Vitebske,' *Iskusstvo* (Moscow), no. 11, 1988, pp. 38–43

Evgeny Kovtun: 'Malevich: O teorii pribavochnogo elementa v zhivopisi,' *Dekorativnoye iskusstvo SSSR* (Moscow), no. 11, 1988

Kazimir Malevich, Exhibition catalogue, Moscow–Leningrad–Amsterdam, 1988–89

List of illustrations

1

Flower Girl. 1903
Oil on canvas. 80×100 cm
Lower right: *К. Малевичъ 1903*
State Russian Museum, Leningrad
Acquired from the artist in 1930

2

Two Women in the Garden
Oil on canvas. 28×21.5 cm
Lower right: *КМ 03*
State Russian Museum, Leningrad
Acquired from the artist

3

On the Boulevard. 1903
Oil on canvas. 55×66 cm
Lower left: *КМ*; lower right: *1903*
On the reverse: *К. Малевичъ 1903 г Этюд 'На бульваръ'*
[Study 'On the Boulevard']
State Russian Museum, Leningrad
Accessioned from the Leningrad Writers' House in 1977

4

Boulevard. 1903
Oil on canvas. 56×66 cm
Lower left: *К. Малевич*
Lower right: *1903*
On the reverse: *Этюд 2-й 'Бульваръ' 1903 годъ*
[2nd study 'Boulevard' 1903]
State Russian Museum, Leningrad
Accessioned from the USSR Ministry of Culture in 1977

5

Jobless Girl. 1904
Oil on canvas. 80×66 cm
Lower left: *К. Малевичъ 1904 Курск* [Kursk]
On the reverse: *Дъвушка без службы по живописи рыжая 'Этюд' 1904 Курск* [Jobless Girl. Painted red head. 'Study.' 1904 Kursk]
State Russian Museum, Leningrad
Accessioned from the USSR Ministry of Culture in 1977

6

Washerwoman. 1907
Oil on plywood. 39.5×39.5 cm
Lower left: *КМал...*
State Russian Museum, Leningrad
Acquired from the artist

7

Spring: Garden in Bloom. 1904
Oil on canvas. 44×65 cm
Lower right: *КМ 1904*
State Tretiakov Gallery, Moscow
Acquired from the artist in 1929

8

Fields. Study. 1904–7
Oil on canvas. 25×35 cm
Lower left: *КМ*
State Russian Museum, Leningrad
Acquired from the artist

9

Summer. Landscape
Oil on canvas. 48.5×55 cm
Lower right: *К Малев...*
State Russian Museum, Leningrad
Acquired from the artist

10

Spring. 1905–6
Oil on canvas. 53×66 cm
Lower right: *К. Малевич*
On the reverse: *Весна 1906 г* [Spring 1906] *Мале...1905 № 5*
State Russian Museum, Leningrad
Accessioned from the USSR Ministry of Culture in 1977

11

Relaxing. High Society in Top Hats. 1908
Watercolour, gouache, Indian ink, and whiting on cardboard. 23.8×30.2 cm
Lower left: *К. Малевичъ 1908*
On the passe-partout mount: *Отдыхъ. 'Общество в цилиндрах'* [Relaxing. 'High Society in Top Hats']. *К. Малевич 1908*
The passe-partout also carries a label with the words: *Серия белых...Отдых* [White Series. Relaxing] (partially erased)
State Russian Museum, Leningrad
Accessioned from the USSR Ministry of Culture in 1977

12

Study for fresco painting: Self-Portrait (?). 1907
Tempera on cardboard. 69.3×70 cm
Lower middle: *К. Малев...*
On the reverse: *Эскизъ для фресковой живописи* [Study for a fresco painting] *К. Мал...* followed by the number *428 В* (cyrillic letter *В* crossed out)
State Russian Museum, Leningrad
Accessioned from the USSR Ministry of Culture in 1977

13

Study for fresco painting. 1907
Tempera on cardboard. 69.3×71.5 cm
Lower left: *Казмiр Малевичъ*
On the reverse: *Эскизъ для фрески Эскиз для фресковой живописи* [Study for fresco painting] *Казмиръ Малев...4 эскиза* [4 studies] followed by *429 А* and signed again: *К. Малевич*
State Russian Museum, Leningrad
Accessioned from the USSR Ministry of Culture in 1977

14

Study for fresco painting: Triumph of the Heavens (?) 1907
Tempera on cardboard. 72.5×70 cm (edges lost)
Lower right: *К. Малев...* (edge missing)
On the reverse: *Эскиз для фресковой живописи* [Study for a fresco painting]. *К. Малевичъ* followed by a second *К. Малевич* and the number *426 С*
State Russian Museum, Leningrad
Accessioned from the USSR Ministry of Culture in 1977

33
Chiropodist at the Baths. 1911–12
Gouache on paper. 77.7×103 cm
Lower right: *Казимир Мал...*
On the reverse: *К. Малевич Мозольный операторъ
(в банъ)* [Chiropodist (at the baths)]
Stedelijk Museum, Amsterdam
Acquired from Hugo Häring in 1958

34
At the Bath-House. 1910–11
Pencil drawing on paper. 13.3×16.2 cm
Lower right: *К. Мал...*
State Russian Museum, Leningrad
Acquired from Levkii Zheverzheev in 1928

35
The Gardener. 1911
Gouache on paper. 91×70 cm
Lower right: *К. Малевичъ*
On the reverse: *Малевичъ*
Stedelijk Museum, Amsterdam
Acquired from Hugo Häring in 1958

36
Peasant Woman with Buckets and Child. 1912
Oil on canvas. 73×73 cm
Lower left: *K. M.*
On the reverse: *Крестьянка с ведрами* [Peasant Woman
with Buckets]
Stedelijk Museum, Amsterdam
Acquired from Hugo Häring in 1958

37
Peasant Women at Church. 1911
Oil on canvas. 75×97.5 cm
On the verso is painted *The Woodcutter* (cat. no. 48)
Stedelijk Museum, Amsterdam
Acquired from Hugo Häring in 1958

38
Peasant Women at Church. 1911–12
Pencil drawing on paper. 21.9×18.4 cm
On the reverse: *К. С. Малевичъ 1912 г.*
State Russian Museum, Leningrad
Acquired from Levkii Zheverzheev in 1928

39
Woman's Head in Profile. 1911–12
There is a rough sketch of the same on the reverse
Pencil drawing and shading on paper. 18.6×14.2 cm
On the reverse: *1912 г. К. С. Малевичъ*
State Russian Museum, Leningrad
Acquired from Levkii Zheverzheev in 1928

40
Woman in Prayer. 1911–12
Pencil drawing on paper. 18.6×14.2 cm
State Russian Museum, Leningrad
Acquired from Levkii Zheverzheev in 1928

41
At the Cemetery. 1910–11
Pencil drawing on paper. 15.2×17.7 cm
Lower right: *К. С. Малевич*
State Russian Museum, Leningrad
Acquired from Levkii Zheverzheev in 1928

42
Taking in the Rye. 1912
Oil on canvas. 72×74.5 cm
On the reverse: *Уборка ржи* [Taking in the Rye]
Stedelijk Museum, Amsterdam
Acquired from Hugo Häring in 1958

43
Woodcutter. 1913
Pencil drawing on paper. 17.1×17.7 cm
On the reverse: *К. С. Малевич*
State Russian Museum, Leningrad
Acquired from Levkii Zheverzheev in 1928

44
Study for the Portrait of a Builder (Portrait of Ivan Kliun?)
Pencil drawing on paper. 49.6×33.4 cm
Lower right: *1911 г. К Мал...*
Beneath the image: *Кубизм (Эскиз к портрету
строителя)* [Cubism (Study for the Portrait of
a Builder)] Cc [?]
State Tretiakov Gallery, Moscow
Acquired from the artist in 1929

45
Peasant Woman with Buckets. 1912–13
Pencil drawing on paper. 10.5×10.7 cm
State Russian Museum, Leningrad
Acquired from Levkii Zheverzheev in 1928

46
Peasant Woman with Buckets. 1913
Illustration from *Let Us Grumble!* [Vozropshchem!] by
Alexei Kruchenykh (St. Petersburg, 1913)
Lithograph. 9.7×10.5 cm
Below: *Крестьянка идет по воду* [Peasant Woman
with Buckets]
Lower right corner: *К. Малев...*
State Russian Museum, Leningrad

47
Portrait of Ivan Kliun. 1913
Oil on canvas. 112×70 cm
Lower left: *К. Малевичъ 1911 г.*
State Russian Museum, Leningrad
Acquired from the Museum of Artistic Culture in 1926

48
The Woodcutter. 1912–13
Oil on canvas. 94×71.5 cm
On the reverse is painted *Peasant Women in Church*, 1911
(cat. no. 37)
Stedelijk Museum, Amsterdam
Acquired from Hugo Häring in 1958

49
The Guardsman. 1913–14
Oil on canvas. 57×66.5 cm
Lower right: *К. Малевичъ*
On the reverse: *Гвардиецъ* [Guardsman]
Stedelijk Museum, Amsterdam
Acquired from Hugo Häring in 1958

50
Head of Peasant Girl. 1912–13
Oil on canvas. 72×74.5 cm
Lower left: *К. Малевичъ*
Lower right: *K. M.*
Stedelijk Museum, Amsterdam
Acquired from Hugo Häring in 1958

51
Head of Peasant Girl. 1913
Illustration in the Futurists' miscellany *The Three* [Troe] by
Velimir Khlebnikov, Alexei Kruchenykh, and Elena Guro
(St. Petersburg: Zhuravl, 1913)
Letterpress. 11.4×13 cm
State Russian Museum, Leningrad

List of illustrations

52
Through Station: Kuntsevo. 1913
Oil on panel. 49×25.5 cm
Before being reinforced in 1929, the reverse carried
Malevich's chalk inscription: *Станция без остановки*
[Through Station] followed by the signature in white paint:
К. Малевич
State Tretiakov Gallery, Moscow
Accessioned from the Museum of Artistic Culture in 1929

53
Vanity Case. 1913
Oil on panel. 49×25.5 cm
Before being reinforced in 1929, the reverse carried the signature:
K. Malewitz
State Tretiakov Gallery, Moscow
Accessioned from the Museum of Artistic Culture in 1929

54
Portrait of Mikhail Matyushin. 1913
Oil on canvas. 106.5×106.7 cm
On the reverse: *М. В. Матюшину К. С. Малевич*
[To M. V. Matyushin from K. S. Malevich]
State Tretiakov Gallery, Moscow
Gift of George Costakis in 1977

55
Woman in Tram / Woman at the Tram Stop. 1913
Oil on canvas. 88×88 cm
Lower right: *К. Малевич*
On the reverse: *У останов[ки] трам[вая?] Дама...*
[At the Tram Stop / Woman...] (remainder illegible)
Stedelijk Museum, Amsterdam
Acquired from Hugo Häring in 1958

56
Desk and Room. 1913
Oil on canvas. 79.5×79.5 cm
On the reverse: *Портрет помѣщицы* [Portrait of a
landlady] */ K. Malewicz / 73 Конторка и комната*
[73 Desk and Room]
Stedelijk Museum, Amsterdam
Acquired from Hugo Häring in 1958

57
Cow and Violin. 1913
Oil on panel. 48.8×25.8 cm
On the reverse: *Алогическое сопоставление двух форм
'скрипка и корова' как момент борьбы с логизмом,
естественностью, мещанским смыслом и
предрассудком* [Alogical juxtaposition of the two forms—
'violin and cow'—as an element in the struggle against
logic, natural order, and philistine meaning and prejudice].
К. Малевич 1911 год
State Russian Museum, Leningrad
Accessioned from the Museum of Artistic Culture in 1926

58
An Englishman in Moscow. 1914
Oil on canvas. 88×57 cm
Painted in the image: *ЗА/ТМЕНIЕ / ЧАС/ТИЧ/НОЕ* [Partial
Eclipse] and *Скаковое общество* [Racing Society]
On the reverse: *К. С. Малевичъ 1914 г. Mlody Anglik*
[A Young Englishman]
Stedelijk Museum, Amsterdam
Acquired from Hugo Häring in 1958

59
Aviator. 1914
Oil on canvas. 125×65 cm
Painted in the image: *А/ПТЕ/КА* [Pharmacy]
On the reverse: *К. Малевичъ 1914 г. Awiator*
State Tretiakov Gallery, Moscow
Accessioned from IZO Narkompros in 1920

60
Partial Eclipse. Composition with Mona Lisa
Oil on canvas
Lower left: *К. Малевич*
Painted in the image: *ЧАСТИЧНОЕ ЗАТМЕНIЕ* [Partial Eclipse]
State Russian Museum, Leningrad
Acquired in 1990

61
Woman at a Poster Column. 1914
Oil on canvas, collage. 71×64 cm
On the reverse: *K. Malewicz / Дама у афишного столба*
[Woman at a Poster Column] */ 1914 г*
Stedelijk Museum, Amsterdam
Acquired from Hugo Häring in 1958

**Futurists' miscellany *The Three* [Troe] by Velimir
Khlebnikov, Alexei Kruchenykh and Elena Guro
(St. Petersburg: Zhuravl, 1913)**
State Russian Museum, Leningrad

62
Front cover
Lithograph. 18.6×17.8 cm
Lower right: *KM*

63
Woman Reaping
Letterpress. 13.8×13 cm
Lower right: *К Малевичъ*

64
Horse-driven Coach in Motion
Letterpress. 11×9.8 cm
Lower left: *К Малевичъ*

65
Pilot
Letterpress. 13×10.2 cm

66
Death of the Cavalry General. 1914
Brown Indian ink, pen, and pencil on ruled paper. 16.8×11.5 cm
Lower right: *К. Малевич*
Beneath the image: *смерть конного Генерала* [Death of
the Cavalry General]
Lower right on passe-partout: *1914*
State Tretiakov Gallery, Moscow
Gift of Alexei Sidorov in 1969

67
Woman Reaper
Cover illustration of the book *The Word as Such* [Slovo kak
takovoye] by Velimir Khlebnikov and Alexei Kruchenykh
(Moscow, 1913)
Lithograph glued to the printed paper cover. 13.2×8.7 cm
State Russian Museum, Leningrad

**Illustrations in *Explodity* [Vzorval] by Alexei
Kruchenykh**
(St. Petersburg: EUY, 1913. 2nd edition)
State Russian Museum, Leningrad

68
Prayer
Lithograph. 13×10 cm (image size)
Lower left: *Молитва* [Prayer]
Lower right: *К. Малевичъ*

69
Arithmetic
Lithograph. 12.7×8.6 cm (image size)
Lower left: *арифметика* [arithmetic]
Lower right: *К Малевич*

70
**Simultaneous Death of a Man in an Airplane
and on the Railroad**
Lithograph. 9×14 cm (image size)
Lower right: *Смърть человъка одно/временно на
аэропланъ и/ жел. дорогъ* [Simultaneous death of a man
in an airplane and on the railroad] *К Мал*

Stage and Costume Designs for the Opera *Victory
Over the Sun*, **1913. Music by Mikhail Matyushin, with
a Prologue by Velimir Khlebnikov, libretto by Alexei
Kruchenykh**

State Russian Museum, Leningrad (nos. 71–74, 82, 88).
Acquired from the artist's family in 1936 (nos. 71–74) and
Levkii Zheverzheev in 1928 (nos. 82, 88)
Leningrad Museum of Theatrical and Musical Arts (nos.
75–81, 83–87, 89–94). Accessioned from the Music
Scientific Research Institute, Leningrad, in 1937 (nos.
75–80, 83–87, 89, 90, 92–94); acquired from F. A. Orlova
in 1934 (no. 81) and Levkii Zheverzheev in 1928 (no. 91)

71
Futurist Strongman
Watercolour and pencil on paper. 53.3×36.1 cm
Above the image: *Петербург театр Лунапарк Офицер.
ул.* [St. Petersburg, Lunapark Theatre, Ofitserskaya St.]
In the right margin: *рост 3 аrш[ина] / Будетлянск[ий]
силачъ* [3 arshins tall. Futurist strongman]
Lower left: *К Мале...*
Lower right: *[19]13*
Beneath the image: *'Победа над солнцем' / опера
Матюшина слова / Крученыхъ* ['Victory Over the Sun'.
Opera by Matyushin, words by Kruchenykh]

72
Futurist Strongman
Watercolour and pencil on paper. 54.4×36.2 cm
Lower left: *К. Мал...*
Lower right: *[19]13*
Beneath the image, in blue watercolour: *'Победа над
Солнцем'* ['Victory Over the Sun'] followed by the
inscription in pencil: *опера Матюшина М. / слова /
Крученых* [opera by M. Matyushin, words by Kruchenykh]
Lower, in blue watercolour: *Будетлянскiй / силачъ*
[Futurist Strongman]
Lower: *черное с бѣлымъ 2 кост[юма] для 2 силачей*
[black and white: 2 costumes for 2 strongmen]
Lower left corner: schematized costume design accompanied
by the note: *По этому эскизу зделан костюмъ ростъ
силача фактическiй 3 арш[ина] 1 верш[ок] / измѣнилъ
по публикации* [Costume was made after this design. The
strongman's height is virtually 3 arshins [over 2 meters] 1
vershok [4.4 cms]. Changed after publication]

73
Turkish Warrior
Watercolour and pencil on paper. 54.3×36.4 cm
Lower left: *КМ*
Lower right: *[19]13*
Beneath the image: *Турецкiй Воинъ / 'Победа над
Солнцем' / Опера Матюшина / слова Крученого
Алексея* [Turkish Warrior. 'Victory Over the Sun', opera by
Matyushin, words by Alexei Kruchenykh]

74
Warrior
Watercolour, Indian ink and pencil on paper. 54.2×35.6 cm
Lower left: *К Малев...*
Lower right: *[19]13 г.*
Beneath the image, in blue watercolour: *'Победа над
солнцемъ' / костюмъ воина* ['Victory Over the Sun'.
Costume for a warrior]

75
Singer in the Chorus
Black chalk and watercolour on paper. 27.3×21.3 cm
Beneath the image: *Кост[юм] Хориста такой же одинъ
голубой или / синiй* [Costume for singer in the chorus is
the same: one blue or dark blue] and lower: *1*
In the right margin: *хор[ист?]* [singer in the chorus?]
(crossed out)

76
Traveller
Black chalk on paper. 27.2×21.3 cm
Beneath the image: *Путешественникъ костюмъ бѣлый и
черный* [Traveller. Costume in white and black] and lower: *2*

77
Many and One
Black chalk, watercolour, and Indian ink on paper. 27.1×21.2 cm
Beneath the image: *Костюмъ многих и одного тотже / ...
но зеленый* [Costume for Many and One is the same
(illegible) but green]
Lower left corner: *3.*

78
Futurist Strongman
Black chalk on paper. 27×21 cm
Lower right: *КМ*
Beneath the image: *I Будетлянскiй силачъ / -2 штуки*
[Futurist Strongman. 2 pieces]
Lower left corner: *4*

79
Coward
Black chalk, watercolour, and Indian ink on paper
26.9×21 cm
Beneath the image: *Костюм трусливых* [Costume for one
of the cowards]
Lower left corner: *5*

80
Pallbearer
Black chalk and watercolour on paper. 27×21.1 cm
In the right margin: *Костю[м] похоронщика* (remainder
illegible) [costume for a pallbearer] and lower right: *2
шт[уки]* [2 pieces]
Lower right corner: *6*

81
Enemy
Black chalk, watercolour, and Indian ink on paper. 27.1×21.3 cm
Below: *К Малевич 1913 г.* and *Непрiятель* [Enemy]
In the right margin: *На формъ / мѣшокъ / —голова* [over
the uniform (?): sack—head], lower: *ноги* [feet]/*мягк[ие]*
[soft]
Lower left corner, in red: *7.*

82
The New
Black chalk, watercolour, and Indian ink on paper
26×21 cm
Beneath the image: *Костюм Новыхъ* [Costume for the
New] and in the right corner: *мягкiй* [soft]
Lower left corner, in red: *8*

83
Mugger
Black chalk and watercolour on paper. 26.7×21 cm
In the right margin: *Забiяка* [Mugger]
Lower left corner, in red: *9*

84
Nero
Black chalk on paper. 27×21.5 cm
Right in the picture: *Неронъ* [Nero]
Lower left corner, in red: *10*

85
Reciter
Watercolour, Indian ink, and charcoal on paper
27.2×21.4 cm
Lower right: *К Малев*
Beneath the image: *Чтецъ* [Reciter]
Lower left corner, in red: *11.*

86
Someone with Bad Intentions
Black chalk, watercolour, and Indian ink on paper
27.3×21.3 cm
Lower right: *Некiй / злонамеренный* [Someone with bad intentions] *КМ.*
In the right margin: *Мягкiй* [Soft]
Lower left corner, in red: *12*

87
Old Timer
Black chalk, watercolour, and Indian ink on paper
27×21 cm
Right in the picture: *Старожилъ* [Old Timer]
Lower left corner, in red: *13*

88
Sportsman
Watercolour, Indian ink, and charcoal on paper
27.2×21.2 cm
Right, in the picture: *Спортсменъ* [Sportsman] and *К Малев*
Lower left corner: *14*

89
Attentive Worker
Black chalk, Indian ink, and gouache on paper
27.2×21.2 cm
Beneath the image: *Внимательный рабочiй* [Attentive worker]
In the left margin: *грибан* (?) [griban ?]
Lower left corner: *15*

90
Fat Man
Black chalk, watercolour, and Indian ink on paper
27.2×21.2 cm
Right, in the picture: *Толстяк* [Fat man]
Lower right: *К. Малеви*
Lower left corner, in red: *16*

91
Stage design for Act 1, Scene 3
Black chalk on paper. 17.7×22.2 cm
Beneath the image: *Похоронщики 3 карт.* [ина] / *I дъймо* [Pallbearers, Scene 3, Act 1]
In the right margin: *до/Разговорщик* [Chatterbox]

92
Stage design for Act 1, Scene 1
Black chalk on paper. 25.9×20.2 cm
Above the image: *до появ*[*ления*] [Until the appearance ?] (remainder illegible)
Beneath the image: *Iª Сцена / бълая с черной / Iᵉ Дъймо* [Scene 1 (white on black) Act 1]
In the right margin: *Фигуру человъка* [Figure of a man]

93
Stage design for Act 2, Scene 6, depicting a house
Black chalk on paper. 21.3×27 cm
Beneath the image: *2 дъйс.*[*твие*] *(2 кар.*[*тина*] — stressed out) *6 кар.*[*тина*] [Act 2 (Scene 2—crossed out) Scene 6] and lower: *домъ* [house] (underlined)

94
Stage design for Act 1, Scene 2
Black chalk on paper. 17.5×22 cm
Beneath the image: *2ª картина зеленая и черная / Iᵉ*

Дъймо (the last word is underlined) [Scene 2: green and black. Act 1]
In the right margin: *зеленая / до / похоронщ*[*иков*] [green until the appearance of the pallbearers]

Anti-German Posters. 1914
Text by Vladimir Mayakovsky
(Moscow: Segodniashnii Lubok Publishing House, 1914)
Lithograph in 5 colours
State Russian Museum, Leningrad

95
'Look, oh look! Near the Vistula...'
51.3×33.4 cm
Lower right: *КМ*
Beneath the image: *Глядь, поглядь, уж близко Вислы / нъмцевъ пучитъ, значитъ кисло!* [Look, oh look! Near the Vistula, the German bellies are swelling up, so they don't feel so good]

96
The Carousel of Wilhelm
33.3×52.3 cm
Lower right: *КМ*
Above the image: *Вильгельмова карусель.* [The Carousel of Wilhelm]
Beneath the image: *'Под Парижемъ на краю / лупятъ армiю мою, / А я кругомъ бъгаю / Да ничего не сдълаю'* ['Under the walls of Paris they beat my army up. I'm just running around and can't do a thing']

97
'The French Allies...'
33×51 cm
Beneath the image: *У союзниковъ французовъ / Битых нъмцевъ полный кузовъ, / А у братцевъ англичанъ / Драных нъмцев цълый чанъ* [The French Allies have a wagon full of defeated Germans. The English brothers have a whole basket full of skinned Germans]

98
'What a boom, what a blast!..'
33.2×51.1 cm
Lower right: *КМ*
Beneath the image: *Ну и трескъ-же, ну и громъ-же / Былъ отъ нъмцевъ подлъ Ломжи!* [What a boom, what a blast the Germans made at Lomza!]

99
'The Austrian went to Radziwill...'
32.8×49.5
Lower right: *КМ*
Beneath the image: *Шелъ австрiецъ въ Радзивилы, / Да попалъ на бабьи вилы* [The Austrian went to Radziwill. He fell on the pitchfork of a peasant woman]

100
'A butcher came along to Lodz...'
34×53.9 cm
Beneath the image: *Подошелъ колбасникъ къ Лодзи / Мы сказали: 'Панъ добродзи!' / Ну, а съ Лодзью рядомъ Радомъ / И ушелъ с подбитымъ задомъ* [A butcher came along to Lodz. We said: 'Good day, Sir.' Well, Radom is near to Lodz, and off he went, his backside hurting]

101
Black Suprematist Square. 1914–15
Oil on canvas. 79.6×79.5 cm
State Tretiakov Gallery, Moscow
Accessioned from the Museum of Artistic Culture

102
Suprematism: Self-Portrait in 2 Dimensions. 1915
Oil on canvas. 80×62 cm
Stedelijk Museum, Amsterdam
Acquired from Hugo Häring in 1958

List of illustrations

103
Suprematism: Painterly Realism of a Football Player. Colour Masses of the Fourth Dimension. 1915
Oil on canvas. 70×44 cm
On the reverse: *Футболист 1915 год* [Football Player 1915]
Stedelijk Museum, Amsterdam
Acquired from Hugo Häring in 1958

104
Suprematism (with Eight Red Rectangles). 1915
Oil on canvas. 57.5×48.5 cm
Stedelijk Museum, Amsterdam
Acquired from Hugo Häring in 1958

105
Red Square: Painterly Realism of a Peasant Woman in 2 Dimensions. 1915
Oil on canvas. 53×53 cm
On the reverse: *Крестьянка супре...* [Peasant Woman supre...] (remainder illegible)
State Russian Museum, Leningrad
Accessioned from the Museum of Artistic Culture in 1926

106
Suprematism (with Blue Triangle and Black Rectangle). 1915
Oil on canvas. 66.5×57 cm
Stedelijk Museum, Amsterdam
Acquired from Hugo Häring in 1958

107
Suprematism. 1915
Oil on canvas. 101.5×62 cm
Stedelijk Museum, Amsterdam
Acquired from Hugo Häring in 1958

108
Suprematist Construction
Oil on plywood. 72×52 cm
State Russian Museum, Leningrad
Acquired from the artist

109
Suprematism
Oil on plywood. 71×45 cm
State Russian Museum, Leningrad
Acquired from the artist

110
Suprematism. 1916
Oil on canvas. 80.5×81 cm
State Russian Museum, Leningrad
Acquired from the artist

111
Suprematism. 1915
Oil on canvas. 87.5×72 cm
State Russian Museum, Leningrad
Acquired from the artist

112
Suprematism (Supremus no. 50). 1915
Oil on canvas. 97×66 cm
On the reverse: *K. Malewicz / Supremus / № 50 / Moskwa*
Stedelijk Museum, Amsterdam
Acquired from Hugo Häring in 1958

113
Suprematism (Supremus no. 56). 1916
Oil on canvas. 80.5×71 cm
On the reverse: *Supremus № 56 К Малевичъ Москва* [Moscow] *1916 г.*
State Russian Museum, Leningrad
Accessioned from IZO Narkompros in 1920

114
Suprematism (Supremus no. 58: Yellow and Black)
1916
Oil on canvas. 79.5×70.5 cm
On the reverse: (*Sup № 58*—crossed out) *K.M.*
State Russian Museum, Leningrad
Accessioned from the Museum of Artistic Culture in 1926

115
Study Suprematis 52 System A4. 1917
Black crayon and watercolour on paper. 69×49 cm
Lower right: *этюд / супрематич[еский] 52 / система A4* [Study suprematis 52 System A4] *191[?]*
Beneath the image: *Кунцево* [Kuntsevo] *К Малев* and *круг должен иметь / теплого цвета / удаленной* [The circle should have the warm colour of a distant]
In the right margin: *Средній диск / находится во / вращении между двумя супре/матичес[кими] постро/ениями* [The middle disc is whirling between two Suprematist constructions]
Stedelijk Museum, Amsterdam
Acquired from Hugo Häring in 1958

116
Suprematism. 1917
Black crayon on paper. 32×24.5 cm
Lower left, beneath the image: *К Мал...*
Beneath the image and in the right margin: *дугообразные линии представляют собою поиски законного установления / шара или круглой плоскости в таком положении чтобы избегнуть катастро/фы продольного движения черной и серой плоскости 1) / катастрофическое / положение 2.2. верное установ[ке] по вопросу разрешится нужно какой из них / даст при проходе построения супрем[атической] плоскости больше выражения дина/мического и пространственного ощущения. 2а) увеличивающая напряжение / а потому достигает цели / казалось бы что такое установление является рассуждением разума, но в действительности оно проходит / через противоестественное действо, после чего может быть выведено суждение и установлена / формула.* [The arched lines represent a search for the legitimate establishment of a sphere or a curved plane. 1) A catastrophic position. 2.2. It is necessary to ascertain with certitude which of them will give the greatest expression of dynamic and spatial sensation in passing through the construction of Suprematist planes. 2[a] the increasing tension achieves the aim. Such an ascertainment would appear to be intellectual reasoning but in reality it originates from a natural action, after which the reasoning and ascertainment of the formula may be deduced.] *KM*
Stedelijk Museum, Amsterdam
Acquired from Hugo Häring in 1958

117
Suprematism. 1915
Oil on canvas. 44.5×35.5 cm
Stedelijk Museum, Amsterdam
Acquired from Hugo Häring in 1958

118
Suprematism. 1917–18
Oil on canvas. 106×70.5 cm
On the reverse: *К. Малевичъ*
Stedelijk Museum, Amsterdam
Acquired from Hugo Häring in 1958

119
Suprematism. 1918
Oil on canvas. 97×70 cm
Stedelijk Museum, Amsterdam
Acquired from Hugo Häring in 1958

Beneath the first cube: *объемный пространственный / супрематизм / формула 1915 г* [volumetrical spatial Suprematism: formula 1915]
Above the second drawing: *Распадение куба или формулы* [Breakdown of the cube into formula]
Beneath the third drawing: *удлиненный куб* [elongated cube]
In the right margin: *супрематич[еский] цвет / основные: красно / черное / зелен[ый] изумруд / белый / голубой // дополнительные редкие случаи: ультрамарин / желтая лимон / розовая крапплак* [Suprematist colour. Basic are red, black, emerald green, white, blue. Supplementary in rare cases are ultramarine, lemon yellow, rose crimson] and lower: *Такимъ образомъ / можно получить / новый вид архитектуры / Вид чистый вне всякихъ / практических целей, ибо / архитектура начинается тамъ, гдъ нътъ практич[еских] целей. Архитектура как таковая* [In this way we can arrive at a new type of architecture a pure type outside of any practical aims, because architecture begins where there are no practical aims. Architecture as such]. *К. Малевич*
State Russian Museum, Leningrad
Acquired from the artist's family in 1936

135
Design for a Suprematist Dress. 1923
Watercolour on paper. 18.9×16.9 cm
Lower right in watercolour: *К. Мал...*
In the right margin: *Гармонирование / архитектурных / форм в каком бы то не было стиле индустри/альной архитектуры / или супрематично-ди/намичной или статич[ной] / или кубистичной, по/требует к себе смены / существующей мебели / посуды, платья роспи[си] / и живописи. Предус/матривая что движен[ие] / архитектуры будет иметь в значительной мере супрематическую гармонию функциональн[ых] форм, я сделал эскиз / платья, согласно росписи / стен по цветному / контрасту / К Малеви... / 1923 г /* [Harmonising of architectural forms in whichever style of industrial architecture whether Suprematist-dynamic, static or Cubist will require a change in existing furniture, ceramics, clothes, murals, and painting. Foreseeing that the movement of architecture will carry a predominantly Suprematist harmony of functional forms I have made a dress design in accordance with the mural painting based on colour contrast. K. Malevich 1923]
Beneath the image: *Супрематич[еский]* [Suprematist] (remainder illegible)
State Russian Museum, Leningrad
Acquired from the artist in 1930

136
Design for a Suprematist Dress. 1923
Watercolour and pencil on paper. 19×17 cm
Lower right: *KM*
In the right margin: *Синтез архи-/тектурного здани[я] / наступит тогда, / когда все формы / вещей в нем нахо- / дящихся будут / связаны единством / их формы и цвета / по этому живопись, скульптура архи-/тектура должны / быть сильно связаны / между собой. Старая / их связь основанная / на классицизме прошлого должна сейчас / быть заменена / современным состо/янием новых форм / и формирования / современных функц[ий] / К Мал... / 1923 г.* [The synthesis of an architectural building will be attained when all forms of the objects therein will be integrated by the unity of their form and colour. Consequently painting, sculpture, architecture must be tightly interconnected. Their old interconnection founded on the classicism of the past must now be replaced by the contemporary state of new forms and the formation of contemporary functions. K. Malevich 1923]
Beneath the image: *Супрематическ[ое] платье*

[Suprematist dress] followed by *Принимая во внимание, что новая архитектура будущего / примет вид формы супрематические необходимо будет / вырабатывать и весь ансамбль формы строго связанный / с архитектурной формой. Этот эскиз предусматривает платье.* [Realizing that the new architecture of the future will assume Suprematistic forms, it will be essential to elaborate an entire complex of form directly related to architectural form. This design is intended for a dress.]
К. Малевич
State Russian Museum, Leningrad
Acquired from the artist in 1930

137
Principle of Mural Painting. 1919
Watercolour, Indian ink and gouache on paper
34×24.8 cm
Above the image: *Принцип росписи стены плоскости или всей / комнаты или целой квартиры по системе / супрематизма (смерть обоям)* [Principle of surface mural painting or of an entire room or an entire apartment according to the system of Suprematism (death to wallpaper)] *К Малевичъ / 1919. Витебск* [Vitebsk]
Beneath the image: *Это значит, что раскраска стен комнат или ансамбля / окрашивается по супрематическому цветному контрасту / скажем окна рамы в один или два цвета, двери в другие / (приним—* crossed out) *потолок в один стены в другие принимается / во внимание об'ем, что все его стороны, могут быть / раскрашены в разные цвета, чтобы разная точка / смотрения была другого цвета, эта цветная таблица / есть таблица изображающая пропорции цветов и их / отношений, с [в]ведением элемента динамического в средине* [Which means that painting the walls of a room or an entire complex is coloured according to Suprematist colour contrasts, let's say the window frames, in one or two colours, the doors in other colours, the ceiling in one colour, walls in others. Volume is what we have in mind here — all its different sides can be painted different colours. This is a colour table depicting the proportions of the colours and their correllations, including the element of the dynamic in the middle] *K M*
State Russian Museum, Leningrad
Acquired from the artist in 1930

138
Arkhitekton. 1926–27
Gypsum
Lost

139
Arkhitekton Zeta. Not later than April 1927
Gypsum
Lost; formerly in the Helena and Szymon Syrkus Collection, Warsaw

140, 141
Arkhitekton. 1926–27
Gypsum
Lost

142
Malevich's work at the 'Artists of the RSFSR over Last 15 Years' exhibition held at the Russian Museum, Leningrad, in 1932–33

143
Two cups. 1923
Porcelain. 7.8×11.7×7 cm (left), 7×8.7×8.5 cm (right)
No mark
Factory: GFZ [State Pottery, Petrograd]
Museum of the Lomonosov Porcelain Factory, Leningrad

144
Two cups *Suprematism.* **1923**
Porcelain with underglaze painting
Each has a hand-painted mark in black of a sickle, hammer
and part of a cogwheel; dated *1923.* Also carries the
UNOVIS symbol of an enframed black square and the
inscription in black: *супрематизм* [Suprematism]
Factory: GFZ [State Pottery, Petrograd]
State Russian Museum, Leningrad
(left) Cup decorated by Ilya Chashnik
7×12.5×5.9 cm
Inscribed in black: *по рис. Чашника* [after the drawing by
Chashnik] *474/587*
Accessioned from the State Hermitage, Leningrad, in 1938
(right) Cup decorated by Nikolai Suetin
6×10.7×5.3 cm
Inscribed in black: *рис. Суетина* [drawing by Suetin]
Accessioned from the USSR Ministry of Culture in 1956

145
First Fabric with Suprematist Ornament. 1919
Indian ink and gouache on canvas. 20×9.6 cm
Beneath the image: *Первая ткань супрематической*
орнаментировки / выполнена в 1919 г. в Витебске [First
fabric with Suprematist ornament executed in 1919 in
Vitebsk]. *К. Малевич*
State Russian Museum, Leningrad
Acquired from the artist in 1930

146
Fabric Ornament. 1919
Watercolour on paper. 36.2×27 cm
Lower right: *KM*
Beneath the image: *Мотивы для ткани /*
супрематиче[ские?] [Designs for a Suprematist fabric?]
1919 г
State Russian Museum, Leningrad
Acquired from the artist in 1930

147
Fabric Ornament no. 12. 1919
Watercolour and Indian ink on paper. 36.2×27 cm
Beneath the image: *Эскизъ / орнаментировки материи*
[Design for an ornament on fabric] *К Мал...1919 г* and
lower: *№ 12*
State Russian Museum, Leningrad
Acquired from the artist in 1930

148
Fabric Ornament no. 10. 1919
Watercolour on paper. 35.8×27.1 cm
Lower right: *KM*
Over the image: *Эскизъ / образцы для текстиля* [Study.
Textile designs]
Beneath the image: *Орнаментировка ткани / Ситец № 10*
[Fabric ornament. Cotton print no. 10]. *1919*
State Russian Museum, Leningrad
Acquired from the artist in 1930

149
Fabric Ornament no. 15. 1919
Watercolour and pencil on paper. 35.6×27 cm
Lower right: *KM*
Beneath the image: *1919 / № 15 орнаментировка / ткани*
(батист) и ситец [Fabric ornament (cambric) and cotton
print]
State Russian Museum, Leningrad
Acquired from the artist in 1930

150
Three Women on the Road
Oil on canvas. 28.5×43 cm (image size)
Lower right: *K.M.*
State Russian Museum, Leningrad
Acquired from the artist

151
Landscape near Kiev. 1930
Oil on canvas (relined). 48.3×68.5 cm
State Tretiakov Gallery, Moscow
Gift of George Costakis in 1977

152
Reaper. 1928–32
Oil on plywood. 72.4×72 cm
Lower right: *K. Malew...*
On the reverse: *Мотив 1909 года* [Motif 1909] *К. Малевич*
Жница [Reaper] *№ 11*
State Russian Museum, Leningrad
Accessioned from the USSR Ministry of Culture in 1977

153
Reaper. Study
Oil on panel. 29.5×31.3 cm
Lower right: *K.M.*
State Russian Museum, Leningrad
Acquired from the artist

154
Reapers. 1909–10 or after 1927?
Oil on panel. 71×103.2 cm
Lower right: *К. Малевич*
On the reverse: *Малевич 'Жницы'* ['Reapers'] *1905*
(or 1915?)
State Russian Museum, Leningrad
Accessioned from the USSR Ministry of Culture in 1977

155
At the Dacha. 1910–12 or after 1927?
Oil on panel. 108×72 cm
On the reverse: *№ 17 1909–1910 'Дачник'* ['At the Dacha']
State Russian Museum, Leningrad
Accessioned from the USSR Ministry of Culture in 1977

156
Carpenter. 1920 (?)
Oil on plywood. 71×44 cm
Lower right: *К Малевич*
State Russian Museum, Leningrad
Acquired from the artist

157
Peasant Woman. 1928–32
Oil on canvas. 98.5×80 cm
Lower left: *К. Малевич*
Lower right: *1913*
State Russian Museum, Leningrad
Accessioned from the USSR Ministry of Culture in 1977

158
Standing Figure. 1927 or later?
Colour pencil on paper. 35.5×22.5 cm
Stedelijk Museum, Amsterdam
Acquired from Hugo Häring in 1958

159
Boy (Vanka). 1928–32
Oil on plywood. 72×51.5 cm
State Russian Museum, Leningrad
Acquired from the artist

160
At the Harvest (Marfa and Vanka). 1928–32
Oil on canvas. 82×61 cm
Lower right: *К. Малевич*
On the reverse: *№ 14 1909–10 (На жатву)* [At the Harvest]
On the stretcher: *Малевич*
State Russian Museum, Leningrad
Accessioned from the USSR Ministry of Culture in 1977

161
Haymaking. 1928–32
Oil on canvas. 85.8×65.6 cm

List of illustrations

Lower right: *К. Малевичъ мотив* [motif] *1909*
State Tretiakov Gallery, Moscow
Acquired from the artist in 1929

162
Girl in the Village. 1928–32
Oil on panel. 70.5×44 cm
State Russian Museum, Leningrad
Acquired from the artist

163
Peasant in the Field. 1928–32
Oil on plywood. 71.3×44.2 cm
On the reverse: *Москва* [Moscow] *K. Malewicz/
Крестьянин в поле* [Peasant in the Field] *1909 г. № 24*
State Russian Museum, Leningrad
Accessioned from the USSR Ministry of Culture in 1977

164
Harvest. Study for the painting. 1928–32
Oil on plywood. 72.8×52.8 cm
On the reverse: *№ 22 Эскиз к картине* [Study for the
painting]... (illegible) *'Жатва'* ['Harvest'] *1909 г*
On the stretcher: *K. Малевич*
State Russian Museum, Leningrad
Accessioned from the USSR Ministry of Culture in 1977

165
Woman with a Rake. 1928–32
Oil on canvas. 100×75 cm
Lower right: *КMal...*
On the reverse: *Москва* [Moscow] *K. M. 1915 г.
Супрематизм в контуре крестьянки* [Suprematism within
the Contour of a Peasant Woman]
State Tretiakov Gallery, Moscow
Acquired from the artist in 1932

166
A Girl (Figure Against White Background). 1928–32
Oil on plywood. 84.5×48 cm
State Russian Museum, Leningrad
Acquired from the artist

167
Suprematism. Female Figure. 1928–32
Oil on canvas. 126×106 cm
On the stretcher: *Супрематизмъ* [Suprematism] *№ 35
1915 г. фигур[а]* [figure]
State Russian Museum, Leningrad
Accessioned from the USSR Ministry of Culture in 1977

168
Female Torso. 1928–32
Oil on plywood. 73×52.5 cm
State Russian Museum, Leningrad
Acquired from the artist

169
Female Torso. 1928–32
Oil on panel. 58×48 cm
State Russian Museum, Leningrad
Acquired from the artist

170
Head. 1928–32
Oil on canvas. 61×41 cm
State Russian Museum, Leningrad
Acquired from the artist

171
Head of a Peasant. 1928–32 (?)
Oil on plywood. 69×55 cm
State Russian Museum, Leningrad
Acquired from the artist

172
Head of a Peasant. 1928–32
Oil on canvas. 55×44.5 cm
State Russian Museum, Leningrad
Acquired from the artist

173
Female Portrait. 1928–32
Oil on plywood. 58×49 cm
Lower left: *КM*
On the reverse: *K. Малевич Malewicz Мотив 1909 год*
[Motif of 1909] (this has been corrected and the date *1919*
entered in red above). *Писано красками Досекина Поль
Веронез, белило кадмий розовая Поликап 'Elido' dunkel*
[Painted in Dosekin's paints — Paolo Veronese, whiting,
cadmium pink Polikap 'Elido' dunkel]. The words *Женский
портрет* [Female Portrait] have been added above this
State Russian Museum, Leningrad
Accessioned from the USSR Ministry of Culture in 1977

174
Head of a Peasant. 1928–32
Oil on plywood. 71.7×53.8 cm
On the reverse: *Малевич I № 13 1910 г Голова
крестьянина* [Head of a Peasant]
State Russian Museum, Leningrad
Accessioned from the USSR Ministry of Culture in 1977

175
Three Girls. 1928–32
Oil on plywood. 57×48 cm
State Russian Museum, Leningrad
Acquired from the artist

176
Girls in the Field. 1928–32
Oil on canvas. 106×125 cm
On the reverse: *1912 Девушки в поле* [Girls in the Field]
1912 г № 26 'Супранатурализм' ['Supranaturalism']
State Russian Museum, Leningrad
Accessioned from the USSR Ministry of Culture in 1977

177
Red Figure. 1928–32
Oil on canvas. 30×23.5 cm
Lower left: *K Ma*
State Russian Museum, Leningrad
Acquired from the artist

178
Half-Length Figure (Prototype of a New Image)
1928–32
Oil on canvas. 46×37 cm
Lower left: *1910 г.*
Lower right: *КM*
On the reverse: *№ 3 'перво-образование нового образа'*
['prototype of a new image'] *проблема/цвет и форма/ и/
содержание* [the problem: colour and form and content]
followed by *'Торс'* ['Half-length Figure']
State Russian Museum, Leningrad
Accessioned from the USSR Ministry of Culture in 1977

179
Half-Length Figure (Figure with a Pink Face). 1928–32
Oil on canvas. 72×65 cm
Lower left: *1910/Москва* [Moscow]
Lower right: *K. Мал...*
On the reverse: *1910 г Торс* [Half-length figure]
State Russian Museum, Leningrad
Accessioned from the USSR Ministry of Culture in 1977

180
**A Complex Presentiment (Half-Length Figure in a
Yellow Shirt).** 1928–32
Oil on canvas. 99×79 cm

243

On the reverse: *K Malewicz Сложн[ое] предчувствие
1928—32 г. Композиция сложилась из элементов
ощущения пустоты, одиночества, безвыходности жизни
1913 г Кунцево* [A Complex presentiment 1928—32. The
composition is made up of the elements of the sensation
of emptiness, loneliness and the hopelessness of life in
1913 in Kuntsevo]
State Russian Museum, Leningrad
Accessioned from the USSR Ministry of Culture in 1977

181
Peasants. 1928–32
Oil on canvas. 53×70 cm
State Russian Museum, Leningrad
Acquired from the artist

182
Three Female Figures. 1928–32
Oil on canvas. 47×63.5 cm
Lower left: *K. Malewicz*
Lower right: *[19]14 г*
On the reverse: *K. Малевич 1918* followed by the word
эск[из] [study] and the signature *K. Малевич*
State Russian Museum, Leningrad
Accessioned from the USSR Ministry of Culture in 1977

183
Sportsmen. 1928–32
Oil on canvas. 142×164 cm
Lower left: *K. Малевич*
Lower right: *K. Мал...*
On the reverse: *Спортсмены* [Sportsmen] *K. Мал* followed
by *супрематизм в контуре 'спортсменов' 1915 го*
[Suprematism within the contour of the 1915 'Sportsmen']
State Russian Museum, Leningrad
Accessioned from the USSR Ministry of Culture in 1977

184
Peasants. 1928–32
Oil on canvas. 77.5×88 cm
Lower right: *K. Малев*
On the stretcher: *1909 г 'Крестьяне'* ['Peasants'] *№ 18*
and *Малевич*
State Russian Museum, Leningrad
Accessioned from the USSR Ministry of Culture in 1977

185
Two Male Figures. 1928–32
Oil on canvas. 99×79.5 cm
Lower left: *K M*; lower righ: *1913*
State Russian Museum, Leningrad
Acquired from the artist

186
Two Male Figures. 1928–32
Oil on canvas. 99×74 cm
Lower left: *K. Малевичъ;* lower right: *1913*
State Russian Museum, Leningrad
Accessioned from the USSR Ministry of Culture in 1977

187
Suprematism. Two Female Figures
Oil on canvas. 60.5×72 cm
State Russian Museum, Leningrad
Acquired from the artist

188
Peasant. 1928–32
Oil on canvas. 120×100 cm
Lower right: *K. Мал...*
On the reverse: *K. Малевич 1919 'Крестьянин'* ['Peasant']
Москва [Moscow]
State Russian Museum, Leningrad
Accessioned from the USSR Ministry of Culture in 1977

189
Bathers. 1928–32
Oil on canvas. 98.5×79 cm
Lower left: *K. Малев...15 г [1915]*
State Russian Museum, Leningrad
Accessioned from the USSR Ministry of Culture in 1977

190
Portrait of a Peasant. 1928–32
Oil on canvas. 63.5×51 cm
Lower left: *K Малевич [19]15*
State Russian Museum, Leningrad
Acquired from the artist

191
Red Cavalry at Full Gallop. 1928–32
Oil on canvas. 91×140 cm
Lower left: *K Малевич*
Lower right: *18 год* [1918]
On the reverse: *Скачет красная конница (из октябрьской
столицы), на защиту советской границы* [The Red
Cavalry gallops from the capital of the October Revolution
to defend the Soviet border]
State Russian Museum, Leningrad
Accessioned from the USSR Ministry of Culture in 1977

192
Red House. 1932
Oil on canvas. 63×55 cm
On the reverse: *'Красный дом'* ['The Red House'] *1932
K. Малевич*
State Russian Museum, Leningrad
Accessioned from the USSR Ministry of Culture in 1977

193
Composition. 1928–32
Oil on canvas. 40×56 cm
State Russian Museum, Leningrad
Acquired from the artist

194
Landscape with a White House. c. 1930
Oil on canvas. 59×59.6 cm
Lower right: *KM*
State Russian Museum, Leningrad
Acquired from the artist

195
Landscape with Five Houses. 1928–32
Oil on canvas. 83×62 cm
Lower right: *K. Malevic*
State Russian Museum, Leningrad
Accessioned from the USSR Ministry of Culture in 1977

196
Self-Portrait. 1933
Oil on canvas. 73×66 cm
Lower right: a black square
On the reverse: *K. Malewicz 1933 г (Ленинград
'Художник')* [Leningrad. 'The Artist'] and a black square
State Russian Museum, Leningrad
Acquired from the artist's family in 1935

197
Male Portrait (Nikolai Punin?). 1933
Oil on canvas. 70×57 cm
Lower left: a black square and *K [19]33 г*
State Russian Museum, Leningrad
Accessioned from the Leningrad Soviet in 1940

198
Girl with a Red Pole. 1932–33
Oil on canvas. 71×61 cm
Lower left: a black square and the signature *K. Малевич*
Lower right: *[19]32 г*

List of illustrations

On the reverse: № 8 'Девушка с красным древком' ['Girl with a Red Pole'] 1933 К. Малевич
State Tretiakov Gallery, Moscow
Acquired from the 'Artists of the RSFSR over the Last 15 Years' exhibition in 1934

199
Girl with a Comb in Her Hair. 1932–33
Oil on canvas. 35.5×31 cm
Lower left: К. Малевич [19]32
On the reverse: № 6 (painted over the figure 4) Эскиз к портрету (абстрактный) [Study for a portrait (abstract)] 1933 К. Малевич
State Tretiakov Gallery, Moscow
Acquired from the 'Artists of the RSFSR over the Last 15 Years' exhibition in 1934

200
Girl. 1932
Oil on canvas. 43.5×34 cm
Lower left: a black square
State Russian Museum, Leningrad
Acquired from the artist

201
Portrait. 1932
Oil on canvas. 34×25 cm
On the reverse: Study of a head [Эскиз головы]
State Russian Museum, Leningrad
Acquired from the artist

202
Portrait of the Artist's Wife, Natalia Malevich. 1934
Oil on canvas. 99.5×74.3 cm
State Russian Museum, Leningrad
Acquired from the artist's family

203
Portrait of the Artist's Wife, Natalia Malevich. 1933
Oil on canvas. 67.5×56 cm
Lower left: a black square
Lower right: [19]33
State Russian Museum, Leningrad
Acquired from the artist

204
Female Worker. 1933
Oil on canvas. 71.2×59.8 cm
Lower left: a black square
On the reverse: 'Работница' |'Female Worker']
№ 10 1933 г. Малевич
State Russian Museum, Leningrad
Accessioned from the USSR Ministry of Culture in 1977

205
Portrait of the Artist's Daughter, Una. 1934
Oil on canvas. 85×61.8 cm
Lower left: КМ [19]34 and a black square
Lower right: УНА [Una]
State Russian Museum, Leningrad
Accessioned from the Leningrad Soviet in 1940

206
Portrait of a Woman in Yellow Hat. First half of the 1930s
Oil on canvas. 48×38.5 cm
Lower left: К. М.
Lower right: 1908 г
State Russian Museum, Leningrad
Acquired from the artist

207
Portrait of Vladimir Pavlov. 1933
Oil on canvas. 46.5×36.5 cm
Lower right: К. Малевич (in black paint)/[19]33 (in red)
On the reverse: a black square bordered in red and the dedication: Владимиру Александровичу Павлову от К. С. Малевича Ленинград 1933 г 17 октября [To Vladimir Alexandrovich Pavlov from K. S. Malevich. Leningrad, 1933, October 17]
State Tretiakov Gallery, Moscow
Gift of George Costakis in 1977

208
Female Portrait. 1930
Oil on canvas. 47×41.5 cm
State Russian Museum, Leningrad
Acquired from the artist

209
Male Portrait (Portrait of a Shock-Worker)
First half of the 1930s
Oil on canvas. 54.5×49.5 cm
State Russian Museum, Leningrad
Acquired from the artist

210
Portrait in Blue. First half of the 1930s
Oil on canvas. 46.5×34.5 cm
On the reverse: Эскиз к Портрету 'Синий портрет' 1907 г отвергнутый Голубой розой [Study for the Blue Portrait of 1907 rejected by the Blue Rose]
State Russian Museum, Leningrad
Acquired from the artist

211
Portrait of a Young Man. 1933
Oil on canvas. 52×39.5 cm
On the reverse: a black square and 1900 г. К.Малев
State Russian Museum, Leningrad
Acquired from the artist

Index